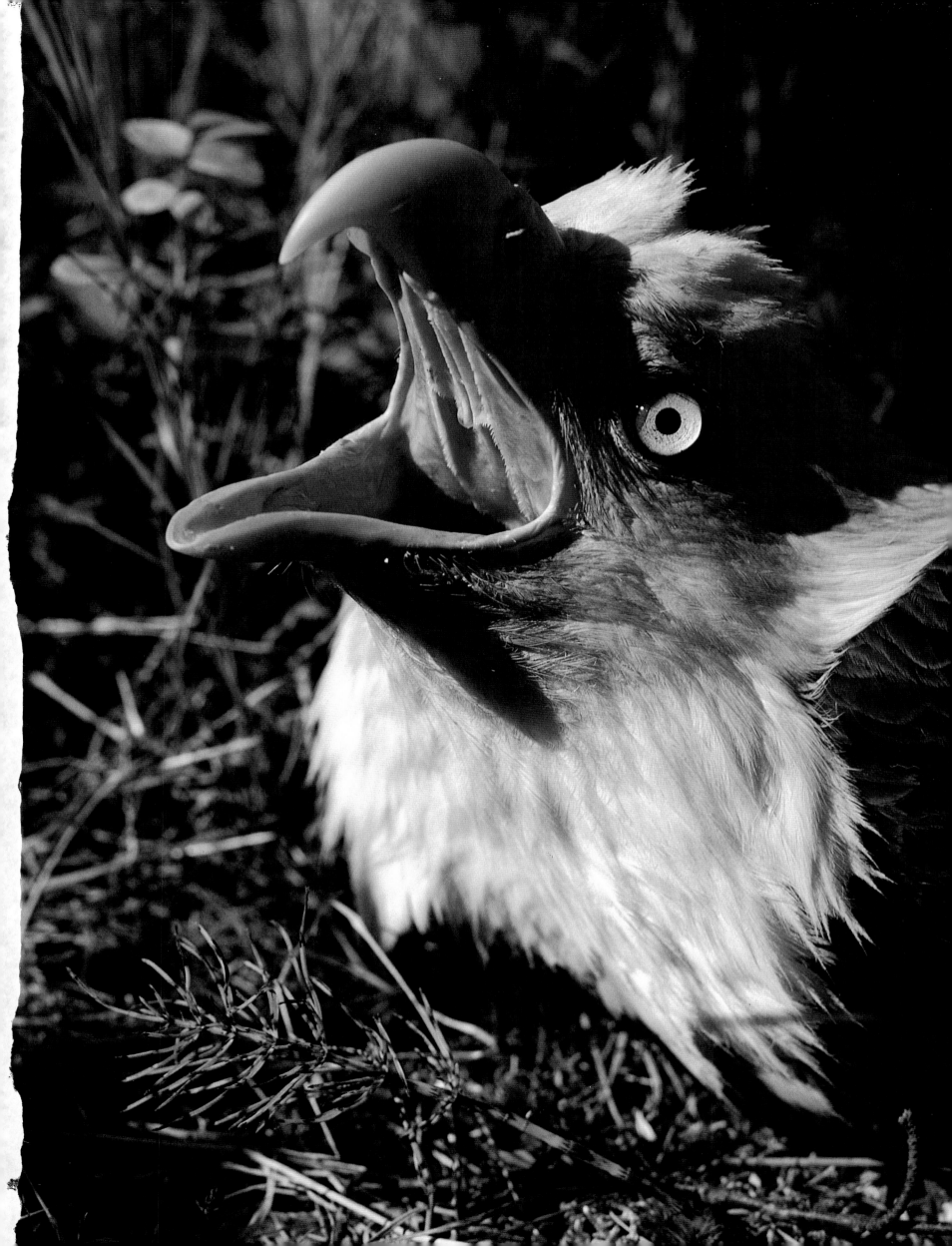

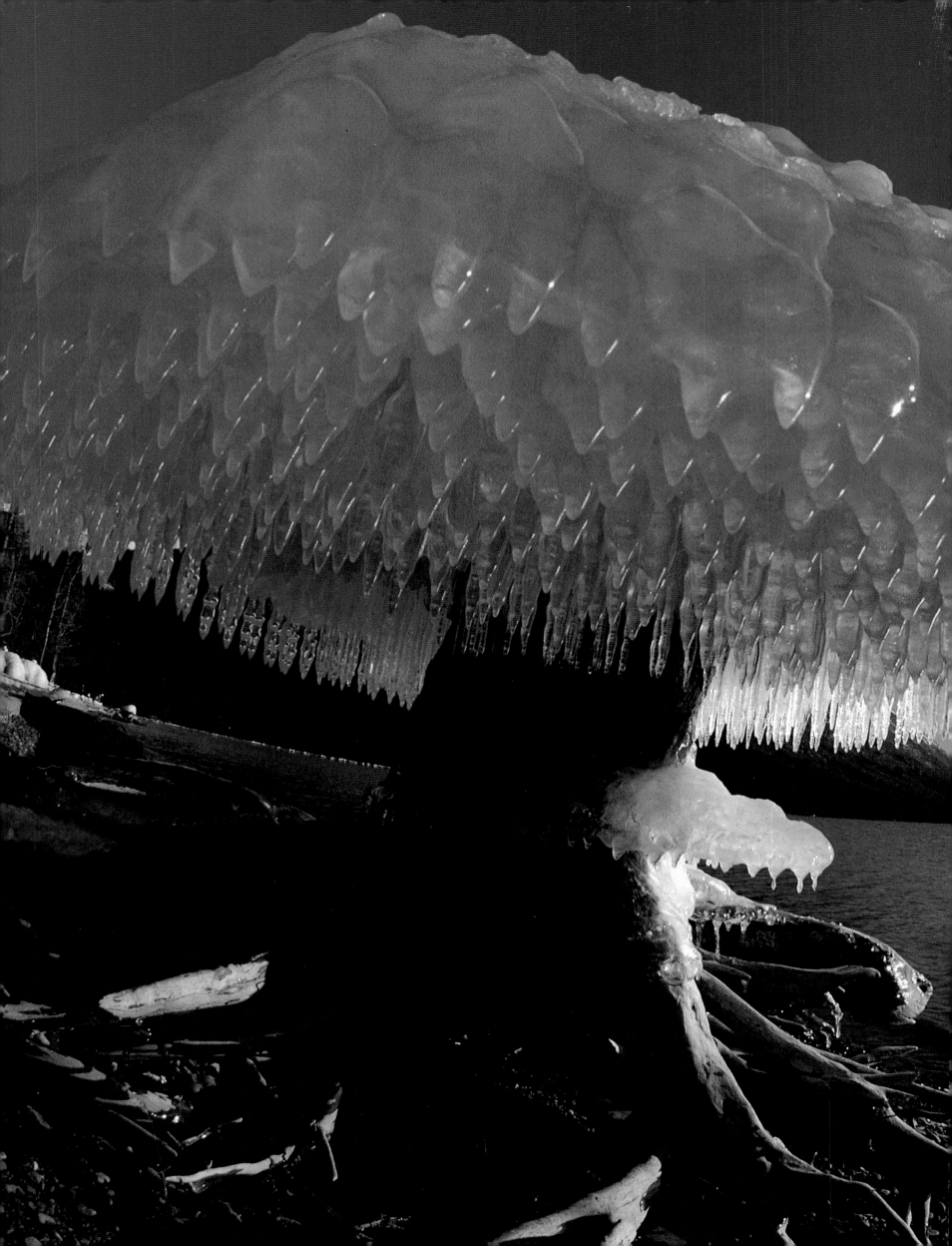

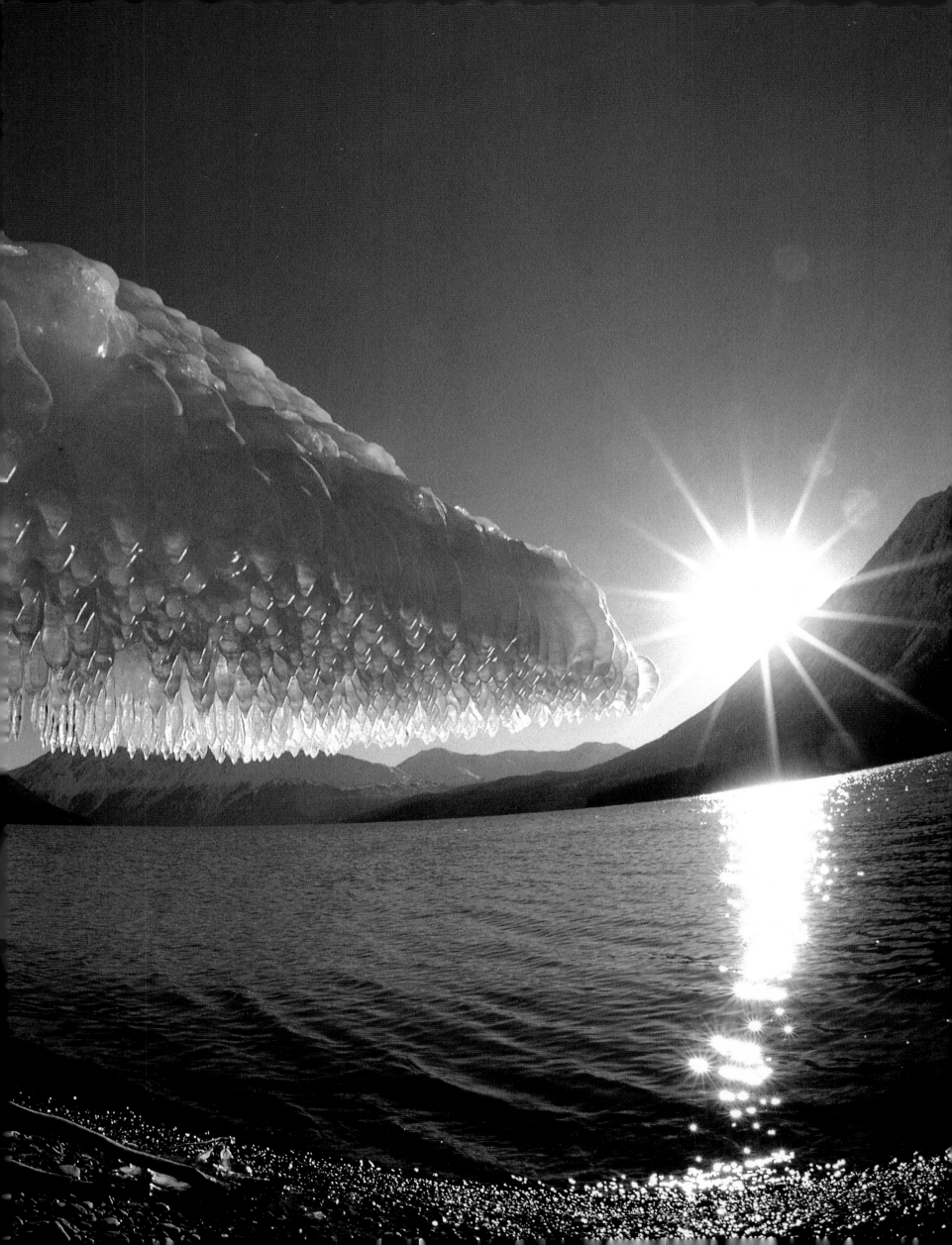

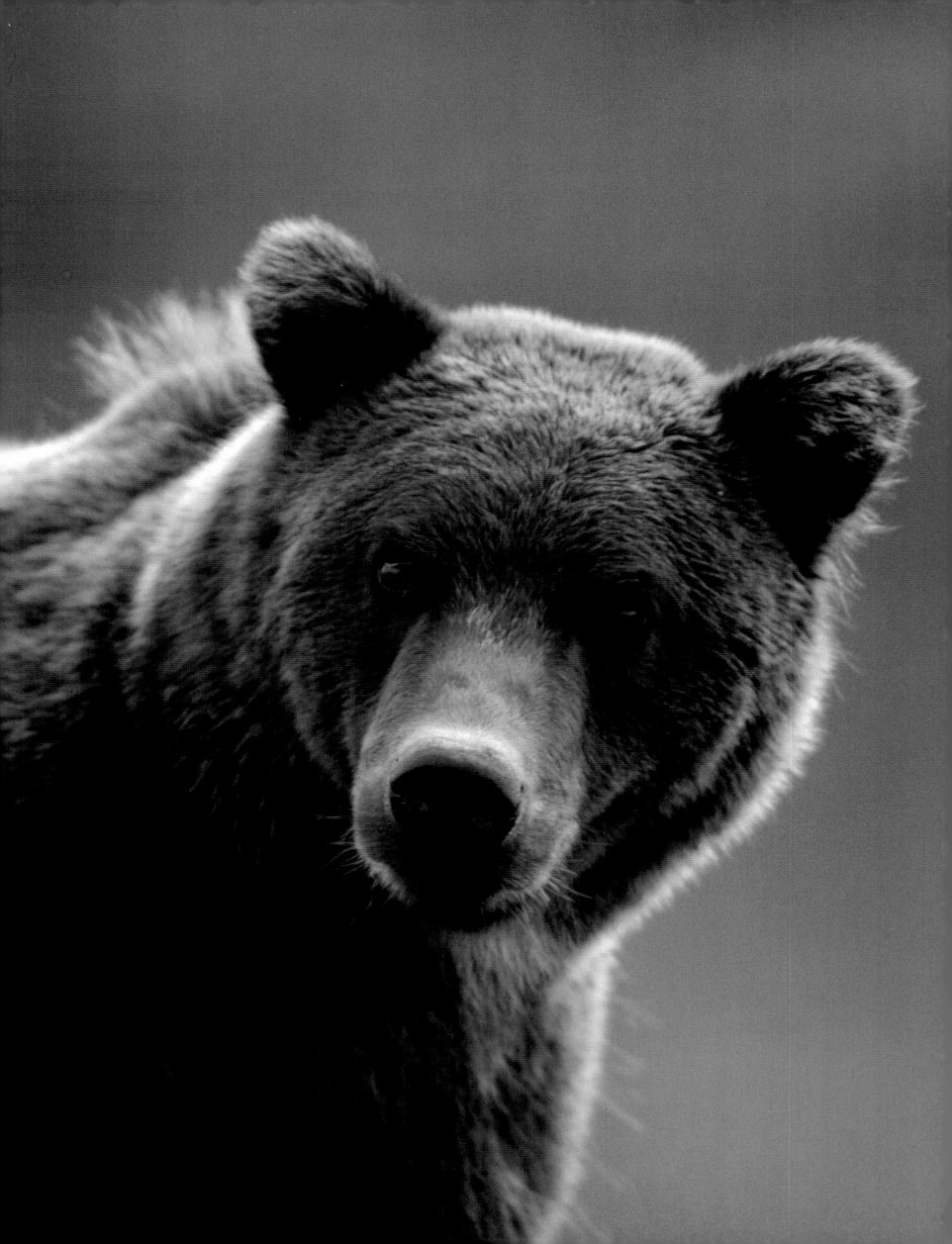

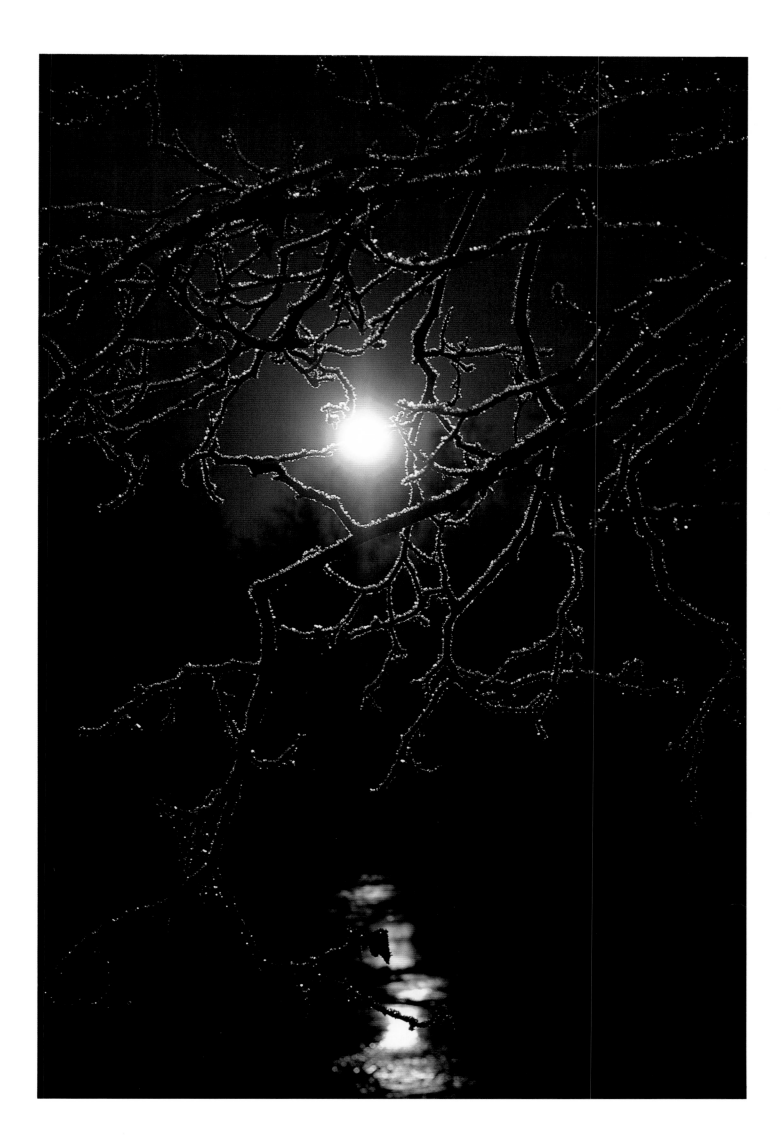

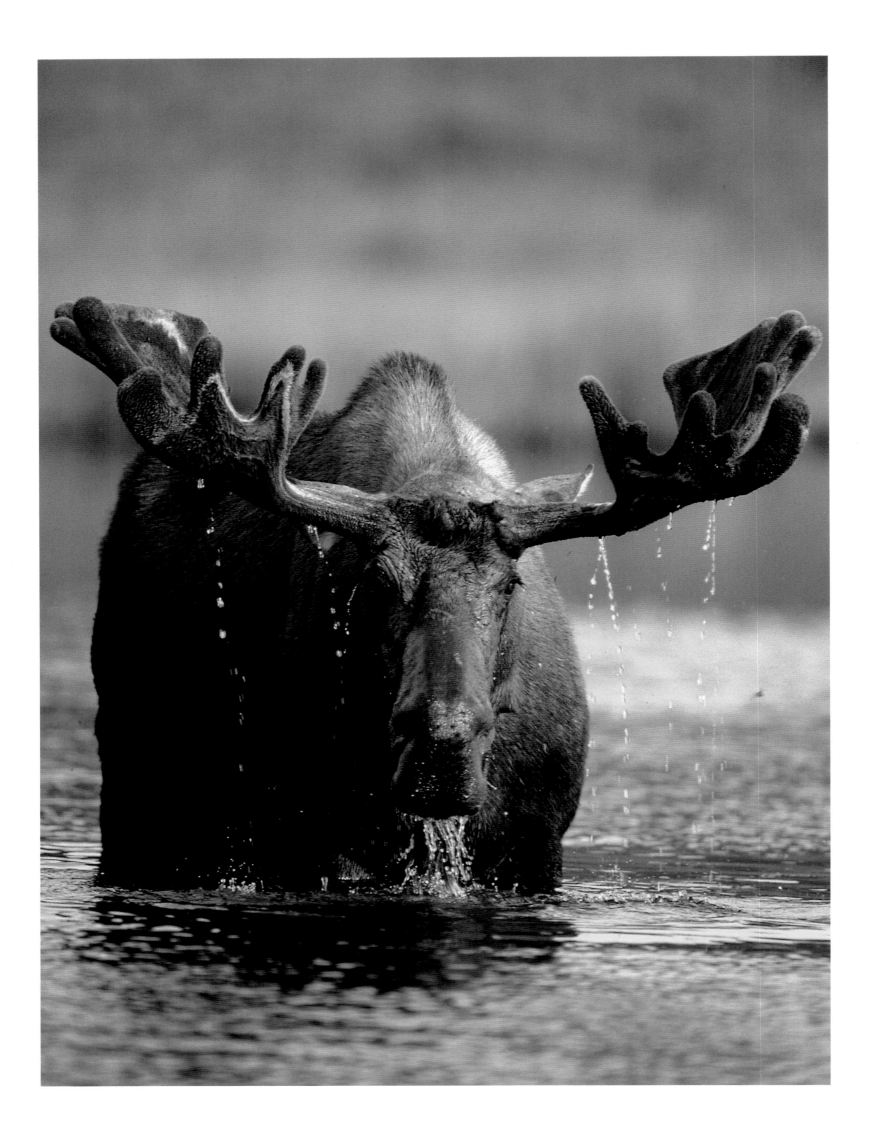

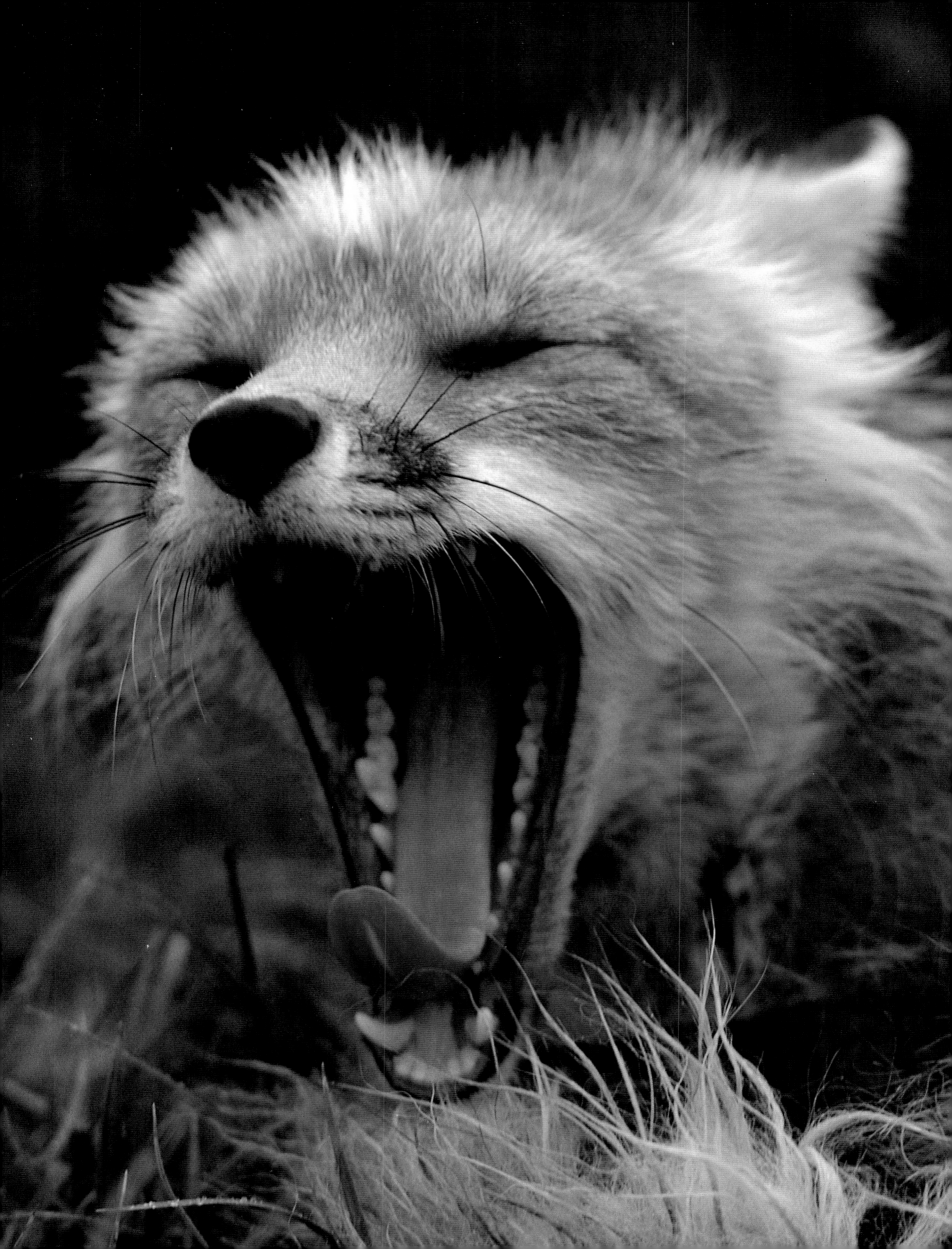

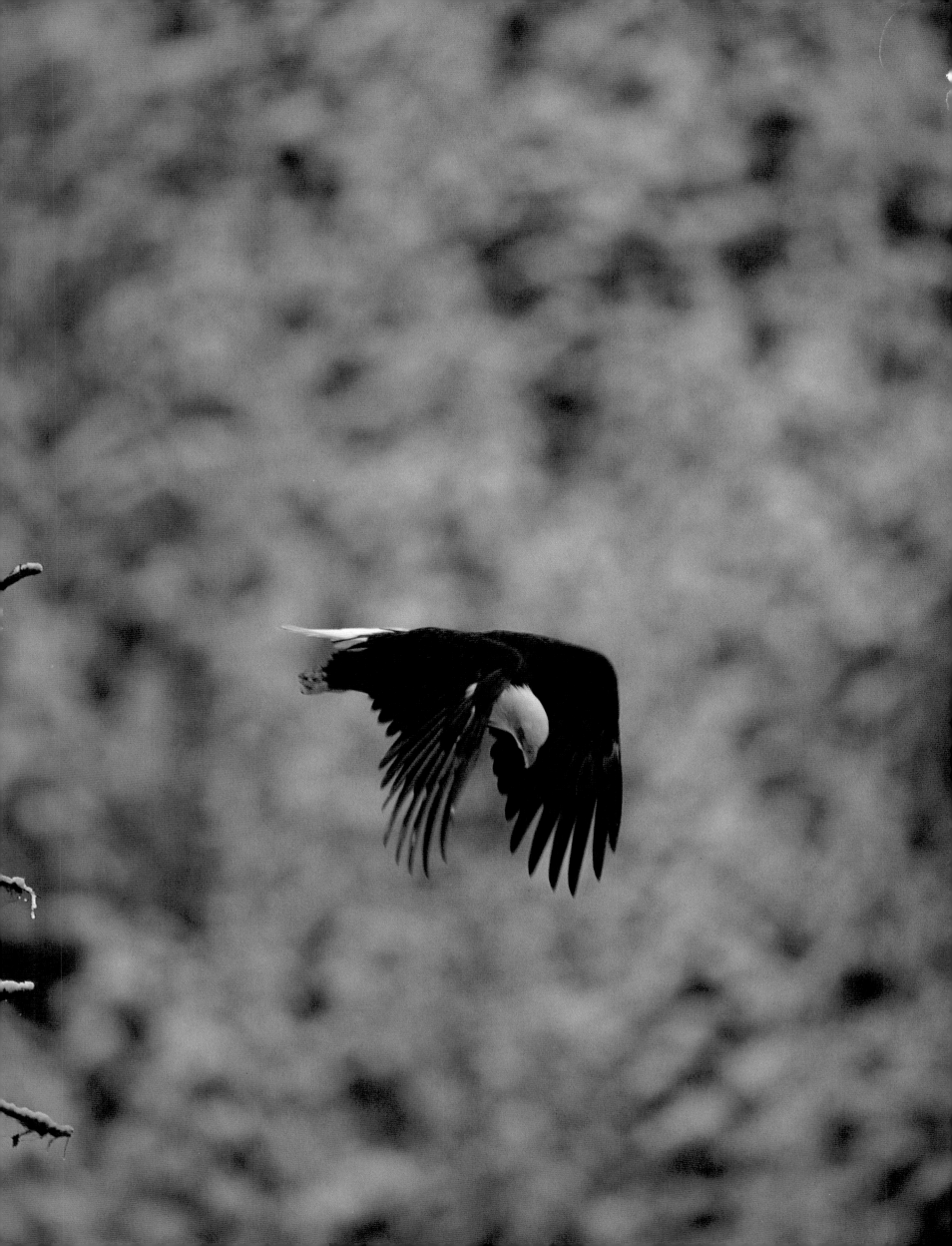

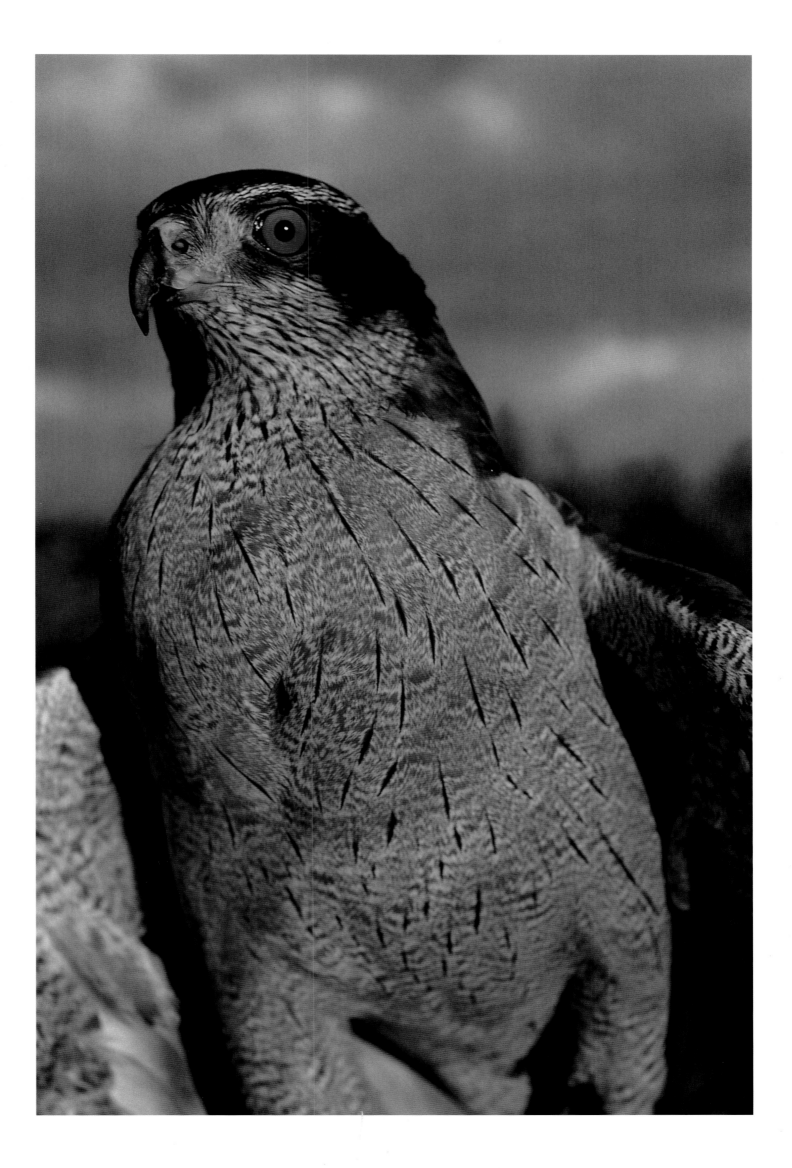

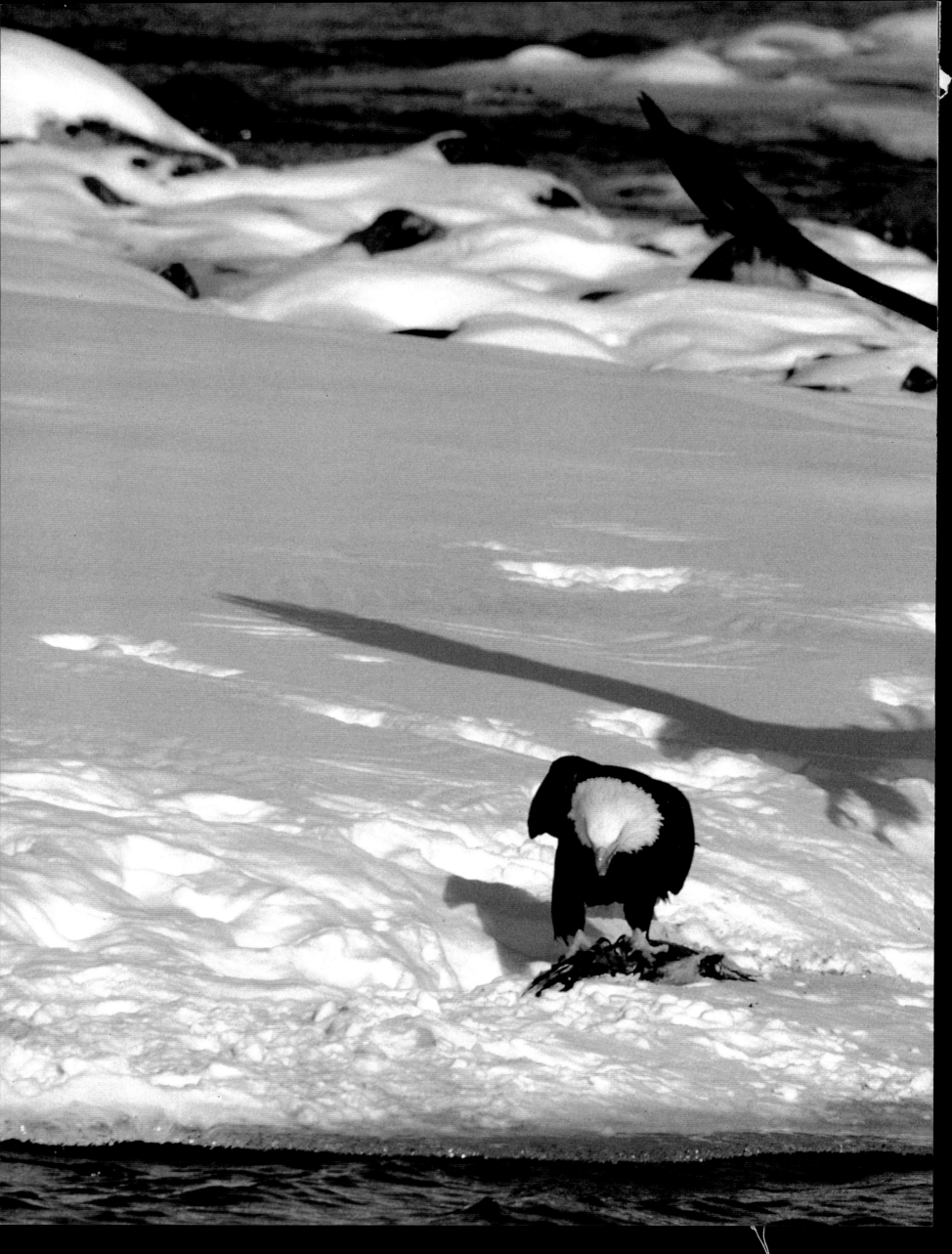

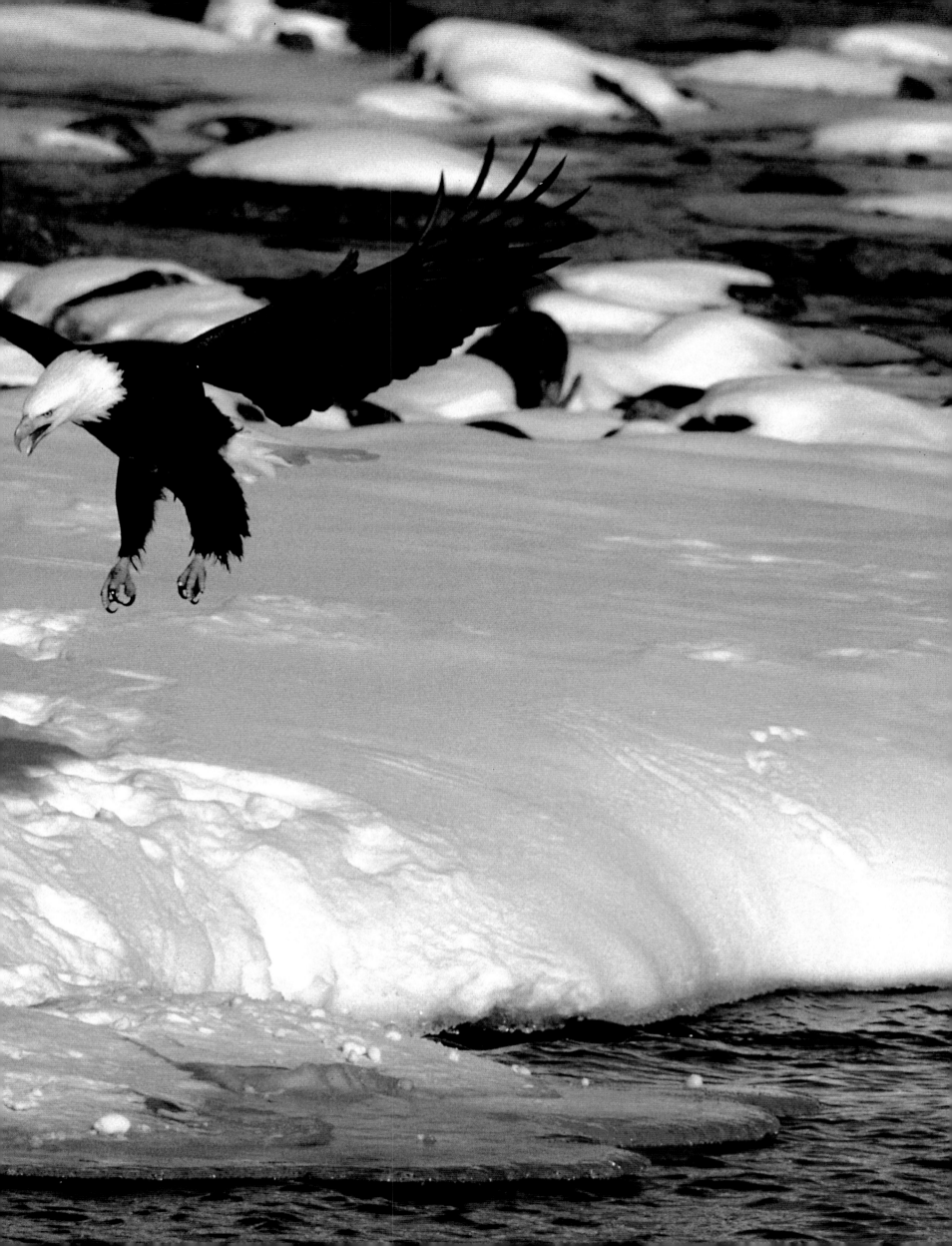

A PHOTOGRAPHIC JOURNEY THROUGH
The Last Wilderness

John Pezzenti, Jr.

INTRODUCTION BY
Leonard Lee Rue III

DESIGNED BY
Alexander Isley Inc.

PENGUIN
STUDIO

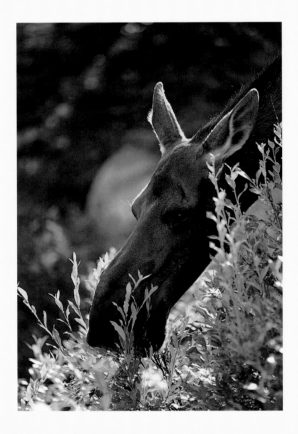

PENGUIN STUDIO
Published by the Penguin Group
Penguin Putnam Inc.,
375 Hudson Street,
New York, New York 10014, U.S.A.
Penguin Books Ltd, 27 Wrights Lane,
London W8 5TZ, England
Penguin Books Australia Ltd, Ringwood,
Victoria, Australia
Penguin Books Canada Ltd,
10 Alcorn Avenue,
Toronto, Ontario, Canada M4V 3B2
Penguin Books (N.Z.) Ltd,
182-190 Wairau Road,
Auckland 10, New Zealand

Penguin Books Ltd, Registered Offices:
Harmondsworth, Middlesex, England

First published in 1997 by Penguin Studio,
a member of Penguin Putnam Inc.

10 9 8 7 6 5 4 3 2 1

Copyright © John Pezzenti, Jr., 1997
Introduction copyright © Leonard Lee Rue III, 1997
All rights reserved

CIP data available
ISBN 0-670-87094-3

Printed in Hong Kong

Art prints and stock photography from the color
plates in this book are available through:

It's Our Nature Company
John Pezzenti, Jr.
P.O. Box 111668
Anchorage, AK 99511
Tel. 907-345-8999
Fax 907-345-0910

The larger part of the author's royalties from this book
project goes to the treatment for leprosy, through:

American Leprosy Missions
1 Alm Way
Greenville, SC 29601

Dedication

To my parents, John and Jane, who lovingly gave their only son to Alaska's frontier more than twenty-six years ago.

To the employees of the National Park Service, the United States Fish and Wildlife Service, the United States Forest Service, and the Alaska Department of Fish and Game. They are truly our last unsung wilderness heroes.

To Michael Fragnito, for his help, patience, and guidance throughout this project. It was through his extraordinary vision and his incomparable values that this book came together.

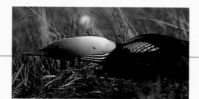

Acknowledgments

Without many of the folks listed here, this book would never have become a reality. In several cases these folks aided and assisted beyond the norm and, more than a few times, saved my life.

Christopher Sweet
Kate Griggs
Alexander Isley
Karen Healey
Geneva Craig
Kenai Lake Lodge
Tina Edge
John and Midge Garber
Joe Cassasa
Wayne Carpenter
Bill and Marie Tracey
Dale Neilson
Brian McTeague, Castle
 Sedans and Limousines
Wayne Anthony Ross
Max Lowe
Irvin Campbell I.R.B.I.
Dr. John Gerster
Kenny Eisenhour
Ardith Hunt
Jeff Vanderwall
Bob Barclay
Lisa Marrett

Bayside Inn
Jim Hamilton
Mallory and Harley Hamilton
Tom Walthers
Katmai Wilderness Lodge
Dr. Clay Nunnlay
Tom Willis
Dr. Theodore Bailey
Joni Stephon
Chancey Croft
Charter Options
Simmons Skis
Alaska Sales and Service
Kodak Film
Kodak Professional Imaging
Richard Pignataro
Cathleen Morran
Cathleen Fritsch
Dave Chipkin
Kodak Processing,
 Fairlawn, New Jersey
Nikon, Sharon Lebowitz
Dave Landfear

Robert Sabin
John McDonald
J. D. Jeff Daniels
Lee Raiter
Clinton Holloway
Fritz Plier
George Uleman
Tito's Discovery Cafe
Lands' End
John Faulkner
Nikki and Loren Stewart
Sharon and Al Allen
Victor Hill
Old Town Canoes
Gary King's Sporting Goods
Alaskan Regal Hotel
The Nolan family
Pat J. Michelle
Wilbur Garret
Lowell Thomas, Jr.
Yvonne Evans
Alaska People magazine
Lew Freedman

The Daily News, Anchorage
Ludwig Laab
Terry Marlett
Tim Davis
Chapel by the Sea
Eldy and Walter Covich
Castleton's Custom
 Processing
Bob Underwood,
 ABC Television
Black Hawk Studios
Russ Tremmel
Alaskan Marine Highways
Frank Zazarek
Bill Hysom
Ken Kard
John Tipit
Alaska Summertime Charters
Yukon Venture Services
Ray Green
Loussac Library
Ben Benedictson
Jan Van Den Top

CONTINUED ON PAGE 16

Acknowledgments continued

C. J. Mayer

John Botkin

Photo Craft Labs

Russ Guttshell

Noel and Alice Hanson

Betty Fuller

Larry Casey

Gary Bloom

U.S.A.F.

A.M.H.

REI

Al Bergstrum

Wiggy's Sleeping Bags

Johann Hammerski

SnoStuff Company

HyMark Corporation

Russ King

Jimmy Such

Jeff Pierson

Wolf Color Chrome Lab

Myles Wolf

Compaq Computers

Chevrolet Trucks

Cleaning World

Obeidi's Fine Art and Framing

Said Obeidi

Torgny Englund

Alaska Camera Exchange

John Carrol (Bodine)

Ted Miller

Kenai Air

Dr. Horst Niesters

Dr. Fredric Van Grough

Colonel Norman Vaughan

Arctic Recreational

Jim Day

V and H Enterprises

Victor Knott

Huffman Post Office

Fast, Incorporated

Kenai Coastal Tours

Nova River Runners

Jim Galbrith

Jay Dole

Husky Manufacturing

Richard Ballaugh

United States Army
 National Guard

United States Coast Guard

Former President
 Ronald Reagan

Homer News

The Willard family

Caribou Lodge

Rick Johnston

Carl High

Gary Staples

Great Alaskan
 Sportsman Show

Tangle River Inn

Anita Flowers

Clinton Bair

Tom Cooper

Harry Dodge

Gates Rubber Company

Village of Larson Bay

Jimmy Willies

Nadine Johnson

Katmailand, Incorporated

Perry Mollan

Tony Pezzenti

Harold James

Tom French

Stephanie Hunter

Kip Dougherty

Captain Chuck Girard

Carey Collins

Carrol Galbrith

Sonny Cough

Jules Roinnel

The World Trade Center

Evert Porter

R. David Purinton

Dr. Harry Reese

Mrs. Evangeline Atwood

Robert Atwood

The Anchorage Times

Great Northern Printing

Ed Bailey

Ken Kehrr, Jr.

Tim Smith

Mikel Dickenson

Dave Cobb

Village of Point Lay

Point Lay Fire Department

Barbara Bolton

Donning Publishers

Bert and Paul Grubb

Suzy Crosby

The Map Place

Turnagain Chevron

Harold Nicholas

Del's Camera

Joe's Body, Paint
 and Frame

Jim Robinson

Fred Macatan

The Honorable John Reese

Carlile Trucking

Alaska Air National Guard

Scott Tompkins

Dale Fett

Bob McIntosh

Marie and Toby Williams

BP Explorations

Dr. Steven Meneker

Dr. Hans Hager

Providence Hospital

Linda Shogren

Judy Hannawan

Cabela's Sporting Goods

Tom Ricardi

Helen Rhodes

The North Face

Tony Kinderknecht

KEH Cameras

Dean Bower

Gentle Giant

Michael Geldirt

Mike and Monique
 Prozeralik

Princess Tours

Oscar Milligan

Don Cole

Bobby Foreman

Gordy Maynar

John Clapprach

Alaska Airlines

Penn Air

Alaska State Troopers

Richard Hale

Dawn Chapels

Innovations

David Danielson

Dr. Barth Richards

Andy Chayer

John Rankin

John Westland

Kenai Peninsula Clarion

Commander James T. Bankhead

Joe Gauna

Fred Koster

Sam J. Evanoff

Governor Tony Knowles

John Viziha

Alaska Visitors Association

Jeff Schultz, Alaska Stock

Ken and Connie Williams

Michael H. Francis

Holly Geoghegan

Karren Ferreira

DDC. John Cocur

KTUU—Ch. 2

Tangle Lakes Lodge

Rich Holmstrum

Sandy Wilbur

Challenge Alaska

Kachemak Air Service

Bill and Barbara de Creeft

Mrs. Ely and Mrs. Nashnur

Mr. Silver

Warren Witkofsky

George Sloane

Governor Walter J. Hickel

Aurello Flores

Dr. Scott, Bird Treatment
 and Learning Center

Brewster's

Tom Fogerty

Fran Hut

Bob Reardon

Paul Urban

Willis Schroeder and family

Debra Pignone

Sharon Sullivan

Jim Lindroth

Chip Buckland

The Deer Hunter

Raggedy Man

Frank Burke

The entire staff of Denali
 National Park and Preserve

Publisher's Note

I remember the day I first spoke to John Pezzenti. I was attending a typical publisher's luncheon—not a power lunch at the Four Seasons, but a sandwich at my desk while I scanned the sales reports. Since my assistant was away on her lunch break, I happened to answer the phone myself. This is a dangerous practice because the individual calling could very well be one of the many hopeful people who have recently sent book proposals—drawings, photographs, grandmothers' recipes, bizarre cartoons, and other materials on a variety of topics that are by and large unsuitable for publication. Because publishers are constantly facing deadlines, such submissions are relegated to the lowest priority and consequently tend to pile up in the corner, and unfortunately the person submitting the work often feels anxious, impatient, and sometimes irate at not having received an instant—favorable—response.

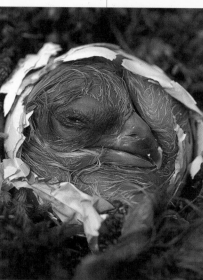

So, when John began to talk about his desire to send me a large package containing photographs of his work in the wilds of Alaska, I was hesitant, but I was so struck by his obvious sincerity that I offered that if his work was even half as powerful as his passion, then we might make a wonderful book.

In a few weeks the large package arrived, and I discovered that John had not been exaggerating. Here were incredible views of some of the most spectacular and unblemished parts of the world. The pictures seemed to capture the earth as it might have appeared in its infancy. And the wildlife! The two moose who John had described as "beautiful ladies" were indeed every bit as lovely as the most famous fashion models, but with far greater dignity, and without a hint of anorexia.

As I pored over the photos, I felt the excitement of the discovery of a new and very major talent.

When John and I next spoke he was on a satellite hookup alone in the Brooks Range, above the Arctic Circle. He described the area as magnificently beautiful, without a tree in sight, where one could see the curvature of the earth. Back in Manhattan I could see the Hudson River and the majestic Statue of Liberty through my window. John, of course, was delighted when I told him I would be honored to be his publisher.

In an age when most photographers frantically snap as many photos as possible in the hope that a small percentage will succeed, John Pezzenti stands out as an anomaly—a sort of throwback to the days of glass plate negatives and cumbersome equipment when one had to set up and wait for just the right moment to snap the shutter. John is a man who studies the landscape until he finds his subject, then he waits, sometimes for hours in unthinkably cold temperatures until he is able to capture just the perfect moment. He then packs up and heads back to the relative warmth of his tent, and plans his next shot.

Aside from the marvelous photographs you are about to see, you will be treated to the tales of a true adventurer. John expertly takes you with him as he heads into the wilderness, alone, to places such as Denali National Park, the Aleutians, and Kodiak. Go along with him to the edge of a cliff where he dangles for hours, determined to capture the most intimate scenes in the moments following the birth of a baby eagle, or accompany him as he strolls about in the company of a giant bull moose.

These extraordinary photographs could only have been taken by someone who is possessed by his subject. And his subject is Alaska, whose quiet and bold beauty lured him to that part of the world to devote his life to capturing and preserving the very essence of her soul.

We are all the richer for his work, and it is my sincere hope that you will be as moved by this book as we are pleased to publish it.

—*Michael Fragnito, March 1997*

20
Introduction

22
Alaskan Notes

47
*On Nature
Photography*

49
Plates

Contents

Introd

by Leonard Lee Rue III

Hanging from the rearview mirror in my Suburban is a little cross made out of olive wood that John Pezzenti got in the Holy Land and gave to me in Alaska. It is a constant reminder of our friendship, but even more important, it is an affirmation of our commitment to God and His creatures.

I start every lecture that I give with the following statement: "I am a wildlife photographer to glorify God. My reason for being is to photograph the beauty that God has created, make other people aware of it, and see that He gets the credit." John has not put it in those exact words, but those are his sentiments exactly, as shown in his photographs.

John Pezzenti is an artist with a camera. That's not just my opinion—it is borne out by the fact that his photographic prints are displayed in the offices of some of the country's most prestigious companies as well as the White House.

His photographic trips have taken him all over the world, but the bulk of his work has been done in his adopted state of Alaska. I share John's love for Alaska and have spent twelve summers there since my first trip in 1965. I have been to most spots in Alaska but John has been to all of them. The siren call of Alaska keeps luring me back. John opted to stay. The magnet is Alaska's scenic grandeur, its wildflowers and its wildlife.

Unfortunately, most folks will not get to Alaska and most of those who do will never have the opportunity to see many of the subjects depicted in John's photographs. I haven't seen some of the subjects depicted in John's photographs—it's the reason I keep going back. Now everyone, vicariously, can thrill to, and enjoy, the many-faceted wonders of Alaska through the pages of this beautiful book.

Not only is John an outstanding photographer, he is also an outstanding writer. He uses words with the surety with which he clicks his camera, capturing the essence of his life. A picture is still worth a thousand words, but I always say that the best pictures are recorded not on film but in your heart and mind. There are so many events that are impossible to photograph that John has brought to life through his written words. While reading them,

uction

you are there. After reading many of them, you will probably be glad that you were not there.

I have had many close encounters, some too close, with bears, moose, Cape buffalo, poisonous snakes, and so on. When it comes to bears, John has had many more close encounters than I have because he lives among the big bears more than I do. I have no intention of trying to spoil his record. As I write this, John and I are planning a trip for next summer so we can do more bear photography and, the good Lord willing, there will be no incidents to talk about later.

I can't speak for other wildlife photographers, but I can speak for John and myself. When we work on potentially dangerous animals, we do so with a prayer on our lips and in our hearts. We use our knowledge of the wild creature and its habits to minimize the possibility of an incident occurring. We take no unnecessary risks, yet just by being in the proximity of some of these creatures, we are risking our lives. We take comfort in the words of the Twenty-third Psalm: "Yea, though I walk through the valley of the shadow of death, I will fear no evil for Thou art with me." We are not braver than others, we just have faith in Divine protection. Each day I pray, "Dear God, don't let me get so busy today that I forget You. I pray that You don't get so busy that You forget me." And He has never forsaken me, or John.

So sit down, kick back, and enjoy yourself. Let this book be the magic carpet that will transport you to Alaska so that you can partake in the wilderness and its wildlife. You can do it in the warmth and comfort of your own home. You don't have to be out in the bone-numbing cold of minus fifty degrees to see the shimmering northern lights. You don't have to feel the bears' breath to appreciate their size and strength. The various activities of the majestic bald eagle are sights you probably would not otherwise see even if you actually spied the bird, because of the time it took the photographer to observe the eagles and record these images. And so it goes, on and on, for each of the many scenes and species.

John is not only my friend, he is one of my competitors, but he is my friend above all. I can pay him no higher compliment than to say, when looking at many of these photographs, "I wish they were mine."

Alaskan Notes

Aerial View

My right leg was wedged up against the forward seat and wall and began to throb as I struggled to fall into a deeper sleep than the half stupor, the debilitating limbo nap that was all the constant roar of the prop plane would allow. The five days and ten trips back and forth to Anchorage Airport had left me worn out and rummy waiting for the ungodly cloud cover to lift over Kodiak. I was filled with an elation mixed with exhaustion as the DC-3 finally roared down the runway at 5:00 A.M. on the sixth day.

Someone muttered something about Soldotna, the Kenai Peninsula, and clouds, and I adjusted my leg. In my lethargic state I wondered why we were flying the west side of Cook Inlet. Weather or storms along the Alaska Range was my sleepy assumption, and again I dozed. Later, the piercing scratch of the antique intercom clamored for attention at about the same time my now-inflamed leg sent tremors to my brain. I had awakened.

It was 6:00 A.M., and the intercom made its announcement after a fifteen-second static check. The captain's words were music to my ears—actually, his message was the voice of triumph announcing victory in the Great Battle of the Clouds. I painfully readjusted my leg, rubbing it, as the pilot told us through the static that we were over Homer, heading southeast for the Barren Islands, and that Kodiak was miraculously clear. The intercom adjusted itself as he concluded, "You folks ought to look out the window. It's an incredible sight this morning."

Everyone on board did just that. My mouth hung open in awe as the sleepy passengers stirred and looked out the windows and gasped in surprise and wonder. I sat upright in my window seat and gazed glassy-eyed at the seemingly prehistoric world. My mind rushed back over the twenty-five years I had been in Alaska. I shook off the memories in order to concentrate on the moment, not wanting to lose the feeling, the view, the sense of the wild that only God could create. The awesome nature of Alaska was why I had come here all those years ago.

I rubbed my bleary eyes, tilted my head back to douse them with Visine, popped a dry toothbrush in my mouth, and reached for a camera—an automatic reaction. I smiled to myself as I checked the impulse and left the camera alone. The scene, the visual extravaganza, the prehistoric spectacle, could not be captured on film. The Visine ran down the side of my face. An English gentleman in front of me turned around, I figured to complain about my foot in the back of his seat, but the smile on his face and the words he spoke so elegantly were only to ask excited questions. My mind drifted while I talked with him—back, back to why I had come here, how it had all started. We were both gazing out the window, but then his wife moved to the seat beside me, and two Norwegian biologists chimed in from behind, and I began to focus my attention and described for them the view below.

We were cruising at ten thousand feet over the Barren Islands that separate the Pacific Ocean and Cook Inlet. There was no better view of Southcentral Alaska to the Alaska Range and Denali, I explained to my new friends. The mountains melted into Cook Inlet and the staggering view north exceeded three hundred miles, exposing volcano after volcano. A north wind swirled the early morning's army of clouds into submission.

Defeated, they clung to the mountain ranges in surrender, causing a heavenly display. I pointed out the four volcanoes visible, stretching out some two hundred miles to our left. Iliamna Volcano rose up through the fog and sun dogs, while a full moon was sitting level with us behind Mount Redoubt. Augustine was in the foreground, and Mount Spurr brought up the rear.

The Englishman, engrossed in the view, was silent, but his wife, peering over my shoulder, blurted out questions, which I tried to answer. The Norwegian biologists put it best, when they said almost simultaneously in their broken English, "This looks like a land of densors!" I figured they meant dinosaurs, and agreed with them. In fact, I almost expected to see a plegasaurus pull himself out of a thirty-foot surf and jump up on the Barren Islands.

We talked a little about the mountain ranges arrayed below us. They were stunned by the multitude of peaks, the vast area, the countless rivers, ice fields, and glaciers visible from our vantage point. They were well informed and I was impressed that they knew the Aleutian Range, the Chugach Range, and Denali and Foraker, which stood in the distance.

It turned out that both the stately English couple and the unshaven Norwegian biologists had been all over the world. And, like many others I had encountered before, these folks were searching for the ultimate wilderness. Each time I heard it anew, it brought a glow to the inner depths of my wilderness soul. I gradually faded out of the conversation, but my eyes remained transfixed on the prehistoric view that lay before my eyes. I only half heard the discussion, which had turned to woolly mammoths and the great Alaskan grizzlies.

A Rock Ledge

I was twelve when I obtained my first camera, and by the time I was fifteen I had an array of camera equipment that would make any professional envious. I spent all my spare time working to afford what I called my wilderness tools. And it was with my cameras one summer at the age of fifteen that I traveled to the Rocky Mountains from the populated hills of New England. I stayed only a few months and returned disillusioned. Sure, there were mountains and wilderness, but it struck me as bound, limited by surrounding overdevelopment.

On my return from Colorado, I sought refuge in the Appalachian Mountains on a secret rock ledge I had stumbled across during my adventures. The place was littered with white-tail deer carcasses and commanded a view of the entire valley floor. None of the deer had been shot, and I came to realize that I had found a final resting place where the deer from this part of the Blue Ridge Mountains would come to die of old age. I was elated at my find and built a small lean-to near the spot out of rock, logs, moss, and oiled canvas. To this day, it is the only place I miss in the Lower 48.

I was an estranged youth, I played no sports and followed none of the pursuits typical of other kids. All my heroes were people of the wilderness: John Muir, Aldo Leopold, John Audubon, and my photography studies brought me to Elliot Porter, Len Lee Rue III, and the incredible Andreas Feininger. My parents encouraged my wilderness endeavors, often dropping me off at certain parks and forests and returning a week or so later with fresh supplies and equipment to sustain me. I would consume the forest, tramping through the woods, sometimes covering twenty-five miles a day. In my mind, I was the last of the Mohicans.

One late October morning, dreaming my dreams of the wild, I was lying in my lean-to when a voice in a low tone said, "Son, what are you doin' here?" I was startled to see a large man looming over me, filling the view.

"I come here a few times a year to check out the deer carcasses," he explained. "This is a secret place, ya know. How'd you find it, anyway?" We talked awhile over hot chocolate, and I could tell that this man was warming to me. We had the wilderness experience in common. He did most of the talking, telling more hunting

stories than I cared to hear. I listened politely as I poured him cups of cocoa and showed him my new longknife.

"Well, just came by for a last look, leavin' for Alaska," he explained, as he put his filson cap back on. "Don't expect to be back this way; movin' lock, stock, and barrel to the Last Frontier on Earth. Nice to meet ya, son," he said as he started down the side of the ridge in front of the lean-to with the agility of a mountain lion. A moment later he was gone—vanished.

Alaska, the Last Frontier on Earth, echoed through my body. I was sixteen and could hardly comprehend the idea of this place on the other side of the earth. Until then, it had not even come to mind, but from that moment on, I was consumed by the thought of Alaska. Every article, note, picture—anything—was a godsend, and before the year was over, I was a walking almanac on the subject of the Last Frontier.

It took me two years of planning, working, and saving while I explored all my options of education, living, and travel in Alaska, before I was ready to leave. A few months before my departure and in the strange perpetual motion of life, disaster struck—at least in my mind. Alaska hit the newspapers across the country with something called the TransAlaskan Pipeline. I went to sleep at night praying that this frontier would not fall the way Colorado had before I could arrive.

I suppose if it had not been for those newspapers crying, screaming about the TransAlaskan Pipeline, I would not have planned my life's work at such an early age—before even reaching this prehistoric place of dreams. It was through photography that I would capture the essence of nature on the Last Frontier, this place called Alaska.

I brought a jar to my lean-to and left a note in it to the deer hunter thanking him for his visit that morning two years earlier. I bid my family a loving farewell (it would be ten years before I saw them again) and headed northwest in a Jeep Commando with a top speed of forty-five miles per hour. I traveled with a guy named Bill Tracy at the wheel. Bill was the only person I knew,

young or old, who also believed in this place called Alaska.

Of course, there were others. "Florida to Alaska," "Texas to Alaska," "Germany to Alaska" read the signs taped, wired, and bolted to the vehicles traveling the fifteen hundred miles of the infamous Alaskan highway in the early 1970s. Lots of signs stated "Or Bust," and bust they did. Dozens of vehicles dead in their tracks littered the Alcan. Vast stretches of the highway had washed out, and the rerouting of the road over hill and down dale was killing cars. The road was not much better under normal conditions.

Once we passed a green MG convertible, top down, looking intact. No one was around. I still remember vividly that scrawled in the dust on the trunk was the word "Bust." But the car was pointed south, and I figured that at least they had made it one way, and applauded them.

"Whose turn to go for gas?" Billy would ask. It was an adventure going off with the gas can, as gas stations were anywhere from thirty, fifty, to one hundred miles apart. One would go; the other would sleep. We must have run out of gas eight times.

Along the way we also lost our windshield, but when we pulled into Livengood, Alaska, hundreds and hundreds of mud and dirt miles later, we knew we would never leave. What separated us from the rest of the world was too immense, and it was already more wilderness than I could conceive of. I decided I was no longer the last of the Mohicans, but an Alaskan. We felt like sixteenth-century explorers discovering a new world. Alaska allowed us that sort of sensation.

A month or so after arriving in Alaska, which time we had spent hiking, fishing, camping, and making photographs, Bill got a job offer from a man in Fairbanks as a carpenter in Point Hope. He went north to the Arctic Ocean, where he has remained to this day, twenty-five years later. We wrote often, but it would be several years before our paths crossed again. I left for the Aleutian Islands, trying to avoid the pipeline rush and intending to photo-document rare moments of Alaska's wildlife and wilderness.

The Aleutians

It wasn't the constant bellowing from the sea lion rookery, or the driving rain, sleet, and snow. It wasn't even the twenty- to forty-foot surf pounding against the volcanic coast, with the impact of sonic booms. It was the foxes that were driving me insane. They surrounded my camp and took turns urinating on my tent. At one time I burst through the door of my tent shouting like a maniac. The foxes dispersed for a full ten minutes.

Relief came in two forms. First, I dug out a bank and built a dwelling half into the cliff—following Aleut design. Rock walls supported the patchwork metal roof, the materials for which I had easily obtained from debris that had littered the island since World War II. But the real relief came from Ambrosia, my knight, my hero, my fox.

Ambrosia—named after a character in a book I once read—took charge immediately. His fur glistened and he was twice the size of all the other Aleutian blue-black foxes, which were no bigger than large house cats. They all looked emaciated and rabid. For the four months I inhabited the island, he kept the other foxes at bay.

My camp on Shemya commanded a view of a sea lion rookery, and each day with every wave more and more arrived on this barren rock at the end of the Aleutian Islands. I was nearly two thousand miles from Anchorage, more than twelve hundred treacherous miles into the Bering Sea, and fifty miles from Russia.

To me, the Aleutian Islands are Alaska's umbilical cord where rich, unknown currents filled with nutrients from the depths of the Pacific pass through to the Bering Sea, sustaining myriads of marine life. The archipelago is the longest in the world and, out of the one hundred and fifty islands, only about five or six are inhabited. They are the remotest settlements on American soil, with some of the roughest weather in the world.

I know this to be true, for I stayed in my camp for four months and managed to have only ten days of full sunlight. But I was most concerned about—even fearful of—the monstrous waves. They took getting used to, and it required a good deal of timing to maneuver among them as I moved up and down this remote, perilous coast. Perhaps this is where God comes to contemplate man, I thought.

I made little, if any, progress on my photographic project that first month, but camp was cozy with Ambrosia standing sentinel. His reward was half a can of Spam every morning, sardines at lunch, and corned-beef hash for dinner. Oftentimes a band of ten or so pesky foxes would rush us, but Ambrosia would swat them away in a flash like bothersome bugs.

This afforded me the luxury of spending long days away from camp with my spotting scopes focused on otters to the left and the sea lions in front. Marking my camp as his territory, Ambrosia would urinate around the perimeter, but never on my belongings. And he would hold would-be intruders at bay. My old tent lay in utter ruin on the rocks below, after numerous washings in the creeks flowing from the cliffs above.

Days turned into weeks, weeks into months, and every moment I was filled with awe. I had managed to photograph every aspect of sea lion life on shore. With increasing familiarity, the great bulls would even allow me to sit with them. But the sea otters—those comical, beautiful creatures—would have nothing to do with me.

About the same time that Thomas Jefferson, George Washington, and the boys were writing the Constitution, the Russians were plundering the Aleutian Islands. Vitas Bering and his even-worse predecessors, Shelikof and Braranof, brought sea otters to near extinction, killing thirty million of them from Alaska to San Francisco. It was no wonder I couldn't get close—the only thing they knew of man was death.

Tap, tap, tap, came my familiar morning wake-up call. Ambrosia was my alarm clock, tapping the top of his Hi-C can, signaling me it was time to get out of bed and pour him a cup. It was an unusually foggy, quiet morning except for the whines and yips of the foxes behind the camp on the cliffs. The sea lion rookery, lost in the fog, was quiet and the water was forebodingly still.

Taking advantage of the damp, lazy morning, I lit a huge driftwood fire, cleaned cameras, and talked to Ambrosia about sea cows. Sea cows, those extinct, mystical creatures, weighed in at over eight thousand pounds and resembled the persecuted manatee of today. They vanished off the face of the earth for one reason—they tasted good. That was also the case with the spectacled cormorant and the great auk, the penguins of the north. I am not sure if Captain Cook's expedition of 1778 ever saw a sea cow, as he was late to the party or, more appropriate, massacre. The last one seemed to have been cooked around 1768.

In this land of fire and water, with over forty-six active volcanoes, the Russians would kill and plunder everything in sight for one hundred years, and, but for the grace of God, they would have done the same to the Aleut Nation. This magnificent race of natives, peaceful and happy upon the seas in their birdikas (skin kayaks), would valiantly fight the Russians to defend themselves against a total annihilation planned by the so-called civilized white man.

The wind surged in from the east as I threw another piece of driftwood on the fire and opened sardines for Ambrosia and myself. With only two hours until dead low tide, the sun began to dance through the fog. I decided to pack my cameras and head down to the labyrinth of channels with which I had become so familiar.

I scurried out onto the first rock jetty like the billy goat I had become. The first five hundred feet were easy, as they were above the high-tide mark and not as kelp- and seaweed-infested as the remaining, slow-going last five hundred feet. In all, it took twenty minutes to cover the one thousand feet of rock that protruded into the crystal-clear water of the Bering Sea.

The sea lion colony to my right, on the largest rock jetty, was still somewhat lost in fog, but I could tell by the sounds that hundreds must have left at night with the high tide. But why? Why so many, so quickly? They had been leaving for the last week or so on a daily basis, in groups of twenty to fifty. It was obvious that at least five hundred had swum off that night during high tide, and the rest were stone silent, at least quieter than I had ever heard them before.

The sun burned off the coastal mist, but the strange easterly wind, which now exceeded twenty miles per hour, kept blowing the sea fog back. Finally, after an hour of waiting for Mother Nature to make up her mind about what to do, the fog dissipated.

Some two miles out to sea was a wall of water twenty to thirty feet high that covered the horizon like an advancing army, not unusual for an incoming tide, although about ten feet higher. I attributed that to the strange and fierce easterly wind. Scanning the wall of waves through a telephoto lens, I saw the reason for the abrupt departure of the sea lions.

As many as two hundred killer whales had encircled a group of fifty or sixty sea lions. The inner circle, even from a distance of two miles, was visibly red with the blood of my companions of the last four months.

Within moments the entire tragic episode was gone from sight, swept out on the tide, engulfed by the waves. I believe that morning was one of the most emotional points of my life. Tears filled my eyes, but the day was to get worse, much worse.

I studied the deadly horizon and saw nothing but fog and waves. I counted the remaining sea lions on the opposite rock jetty. About eighty remained, barely fifty feet away. Then I noticed little heads popping in and out of the water at the far end of the jetty. The sea otters had finally come within reach, searching out the safety of the rocks. Man had been their enemy for a few hundred years, but killer whales were an ancient, primeval enemy.

As I threw my camera pack over my shoulder to head back down the treacherous rocks and out on the next jetty toward the sea otters, the strange easterly wind grew to near gale force. Making my way onto the second jetty, I decided to snap my camera pack to a piton I had driven into a massive rock months before, far above mean high tide. Taking only a camera with a 300-mm lens, I was off like a leaping elk. Shed of over sixty pounds of equipment, I could make better time. However, I still managed to fall twice covering the length of the larger of the two jetties. Forty-five minutes had passed, and I was

nearly at the point where I had seen the bobbing sea otters. I stopped to calm myself, not wanting to blow it by letting my excitement frighten my comical subjects out to sea where the killer whales awaited.

The wind tapered off, and I found the otters rafting together not fifty feet away from me. One otter was so close I could see a crab on his belly. Focusing all my attention on the otters, I was not aware that the tide had turned and risen four feet in a matter of moments. I looked up to see forty- to fifty-foot ground-swells breaking through the remaining fog less than fifteen hundred feet away. I turned and ran for my life, cursing the wind—fearing for my impending demise.

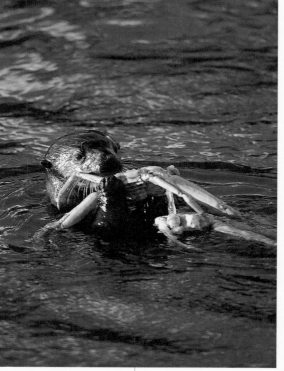

Two hundred feet, three hundred feet, four hundred feet I ran, as the intensity of the first swell hit me, knocking me into a hole between the rocks. I held on lest the backwash drag me out to sea. I came out of the hole running, and made two hundred feet more before the surging tide struck again. This time the backwash grabbed me and dragged me back. I grabbed a rock and held on until the water receded and then I was off again, running for my very life.

I approached the elevation of the shore when the third wave crashed and washed around my legs as I ran up the beach toward safety. I stopped and turned around for a moment to look at the monstrous waves. Shaking with fear, I ran up the shore another two hundred feet and was finally out of danger.

The camera bag, with all my film and Nikons, was a different story, however. Four feet of backwash had submerged the rock on which I had placed the cameras. That rock had remained dry during all the months of my stay on Shemya until that day. As I watched, wave after wave—thirty-footers and higher—struck the rock with rare fury.

All my equipment was carried off into the depths of the Bering Sea. Had I lingered five minutes more on that jetty, mesmerized by the sea otters, I would have been carried off as well.

The fire was still smoldering as I staggered into camp. Ambrosia threw me a look as if I were his comic relief for the day. I guess I was.

Still shaking from my ordeal, I gathered all the firewood my strength would allow. I shuddered when I looked out at the massive walls of water before me and hastened my firewood efforts. It would be the last driftwood on this beach for months. The waves would see to that.

As I lay by the roaring fire in a heap of wet clothes and frustration, I looked at the fractured camera that I had hung on to while scrambling for my life. It was done in, smashed by the rocks and soaked through and through. That night there was a full moon and the waves flattened out. A new quiet, seemingly devoid of life, had settled on the island.

I realized that the entire disaster could have been avoided. I had known that the moon would be full that night, causing a higher tide. I had also sensed that the strange wind and waves were out there just waiting for the tide to turn, but I had not anticipated just how fast it would come in. Well, I wanted to be an Alaskan. I thought this, then, was my christening and threw the urine-soaked tent onto the fire, as some sort of sacrifice. I poured Ambrosia a cup of Hi-C and turned in for a restless night's sleep.

The following morning brought rain and the normal wind from the northwest, in from Siberia. I cautiously climbed around the rocks, but nothing remained—not a sea lion, not an otter, not a killer whale, not even a camera bag. They had all put out to sea.

As I opened all the cans of food for Ambrosia, I worried about his fate. I knew that government officials were killing all the foxes on the Aleutians, descendants of fox-farming ventures of a hundred years before. They were eradicating them so that the bird life would have a chance, especially the Aleutian Canada goose, which was nearing extinction. But I knew in my heart that Ambrosia would survive—this incredibly beautiful fox, my camp sentinel and companion. He was my saving grace from my watery disaster, as I would think of him with a smile thousands of times over the years.

I left the island searching for a drier ecosystem but vowed to return. And although I would come back to the Aleutians, to Cold Bay, Dutch Harbor, Unalaska, Adak, and Amchitka, I have yet to set foot again on Shemya, where God comes to contemplate man.

My New Domain

It didn't take me long to figure out my next area of exploration. With cameras in hand, I would spend the next six years crisscrossing a remote yet accessible region of the vast Alaskan frontier, an area equal to the size of Texas. My new domain would extend from the Yukon River to Petersburg and include parts of Southcentral and Southeastern Alaska, and the Interior. I suppose I divided up the state differently than others, but it suited me. I was looking for remoteness and diversity with reasonable access, and in this eastern region that paralleled the Yukon Territory and British Columbia I would find all that and more.

This territory fascinated me. I traversed it by vehicle hundreds of times, logging better than a half million miles in my now long-since-deceased

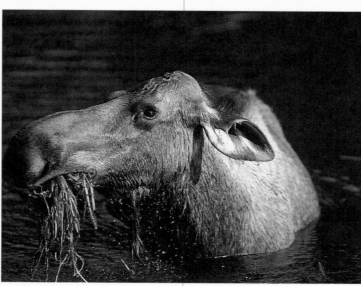

four-wheel-drive vehicles. A lot of the driving wasn't so much working as it was roaming around figuring out where to work and what to work on. You could always catch glimpses of quintessential details of Alaska's wildlife at a distance with binoculars—that is, with enough patience and persistence. The road system in Alaska, although limited, does provide countless opportunities for viewing wildlife in pristine settings.

Mother Moose

Femininity in wildlife is hard to recognize, and a protective mother—that is, one that will lay down her life for her young— is rare in the animal kingdom. Female moose, however, are exceptional in this respect. In all my years of wilderness travel I have not encountered a more protective mother, or a more beautiful female creature. I would come to name them the Ladies of the Forest. But the food chain is cruel and moose are persecuted by wolves, bears, and man.

In any given year, but especially those with heavy snows, even more devastation is wrought upon them by cars and trains. One winter, trains killed over eight hundred moose on a three-hundred-mile section of track. The railroad has made an effort to stop the carnage by running pilot cars ahead of the trains to chase the moose off the tracks. It's taken a few years, but in the 1990s the number of moose killed by trains has dropped by seventy-five percent.

The highways and byways present the same problem, only multiplied. Alaskan roads are often extremely hazardous during the winter months— becoming like ice-skating rinks. It is a danger for auto and moose alike, and the results of collision are always devastating. Over the years, I

have had to shoot ten moose to put them out of their misery after collisions with motor vehicles. It is the only circumstance in which I have ever fired a weapon at an animal with the purpose to kill.

One January night while driving to the Anchorage Airport I happened across one of the most magnificent bull moose I had ever seen, sitting in the middle of the road on a high mountain pass. From a distance I could see how regal he was, but I couldn't see why he was sitting there. I thought maybe he was just exhausted from attempting to plow through the deep snow, which extended like giant white walls along the passway. Leaving my vehicle, I approached on foot and realized when he attempted to move that his legs were broken, crushed from falling under a semi-truck. The cracking of his bones still haunts me. I had traded my .44 Magnum to a guide only the week before and was in anguish that I couldn't relieve this handsome creature of his suffering. I sat in the road with him for five hours at thirty-five degrees below zero until a passing motorist happened by with a weapon. In Alaska the law of the wild is the same as it was ten thousand or a million years ago, but when you add motorized transportation into the equation, it seems even more cruel.

It was early June in Thompson Pass, where summer comes late, as in all the mountain passes, and the world was a shimmering, brilliant, baby green. The mountain foliage was displaying its exuberant new life amid the last receding fields of ice and snow. Many times over the previous months I had crisscrossed this pass with skis and crampons and had looked forward to the spring. The snowfall here is so high, it's not uncommon to have forty feet of snow a winter. The snows are caused by the warmer weather blowing in from Prince William Sound and colliding with the Arctic wind currents from the Glenallen Plateau and the north side of the Wrangell–St. Elias Range. In the summertime this means some of the highest rainfall in the world—it is matched only by the rain forests of Brazil.

It had rained the entire month of May, so I was thoroughly enjoying this unusual week of sun and traversed the pass several times while keeping my attention on a mom moose with two new calves,

climbing in from the south. She had been working her way toward the top of the pass for the last four days as her calves, about a month old, would leap about her like gazelles. They were eating the sweetest and youngest willows and following their ripening toward the top ridge and into my camera lens, I was figuring.

A warm and gentle breeze was blowing in behind them and, knowing they couldn't catch my scent, I closed the gap between us to a little less than fifteen hundred feet. Repositioning my spotting scopes, trying to determine their likeliest path, I was horrified as I watched three black bears also moving stealthily into position. (Several years later three black bears would ambush me as well, but with a different outcome.)

The black bears, a mother and her two grown cubs, were of incredible size and, after a few instinctual sniffs of the air, laid a plan between two willow patches. This terrible trio was extremely dangerous, and rare in that the mother hadn't sent the cubs off on their own two years earlier. The four-year-old cubs, all of two hundred and fifty pounds each, settled in one thicket while the mother chose the patch on the other side of the game trail. The same breeze that had allowed me to draw closer was the fatal factor for this gentle moose family.

It took two hours for the moose to eat and meander their way into the trap that had been so skillfully laid. Just as the calves danced their way in between the thickets, the mother, sensing something wrong, bellowed out a warning. But it was too late.

The mother bear emerged in a split second and snapped the first calf's neck with a single bite, while the two four-year-old cubs did the same to the second moose calf, although not as skillfully. But there was a price to pay as the mother moose quickly closed the gap and killed the first bear cub with a single blow of her razor-sharp hoof. Meanwhile, the mother bear dragged her catch into the thicket as fast as she had killed it, and she did not come back out of that thicket. I caught a glimpse of her face peering through the bushes as the mother moose stood on her hind legs savagely slashing out with her hooves at the second four-

year-old bear, still in the open and trying to drag its kill into the bushes. In less than a minute the mother moose, exacting her revenge, killed the young bear. From my location fifteen hundred feet away, I could hear the mother moose bellowing in despair as she sniffed and nudged her precious calf that lay dead in a heap on the trail.

In outrage, the mother moose jumped up and down on the bear cubs' bodies for a full half hour. She thrust her savage weight onto the bear carcasses, literally driving them into the marshy tundra. She then frantically ran around the thicket of willows and thrust herself through it in an attempt to drive the mother bear out. Each time the moose emerged, blood was streaming from her chest or hindquarters. This continued for a full two days, and both night and day she encircled those bushes and made charges through the thicket until, finally, I heard the growls of the bear no more.

The mother moose was clawed so many times that her entire lower body was red. On the third day she limped off about two hundred yards and took a position commanding a view of the entire pass and lay down so regally and stately it brought a lump to my throat. She never got up again and the mother black bear never left the thicket.

In the days of Genghis Khan and up to the early 1900s, man would pit animal against animal and lay their barbaric wages on the outcome. The main event was always a five-hundred-pound black bear against a five-hundred-pound Siberian tiger. The goal was to get unsuspecting gamblers to bet on the tiger. If you looked at both combatants, it would seem obvious to bet on the tiger. On the contrary! Within moments of the start, a black bear could kill a tiger, with its combination of speed, agility, and power. There was no contest. Pound for pound, a black

bear is the toughest animal on earth. I will always remember that mother moose on the Mountains of the Moon in Thompson Pass. I have devoted hundreds of hours to photographing these beautiful creatures, the Ladies of the Forest, in honor of her.

Mishaps

My camps were stretched out over a range of several hundred miles. A tent here, a lean-to there, and I traveled among them on a continuous basis. My only problem was that it seemed that every time I got out of my Jeep, disaster would strike. I have had a series of calamities, one after another. You could say Lady Luck wasn't traveling with me during those years, although I'm quite sure now that the Lord sent some angel (probably one being penalized for something, and I was his penance) to watch over me; otherwise I would have been a death statistic long, long ago. It has been sadly true of many of my friends.

It was hard for me to figure out at first the balance between that magical moment you captured on film and the endless perseverance it took to put myself in a position to do just that. I have wrestled with this equation now for years and have decided that, for ninety-nine percent of the time I spend in the wild, it gives me back one percent of what I am attempting to capture. I have spent thousands upon thousands of hours in the field and if there were an award to be given for determination, I would win it. But in the same respect, I should get the booby prize for things going wrong. Luckily, no one is giving out awards.

One time, en route to Dawson City, Yukon Territory, over the Top of the World Highway, I

became so engrossed in watching the curvature of the earth, which lay before my eyes on the horizon, I ran my truck over an embankment and rolled it. I'm quite sure that my poor guardian angel guided my truck's fall that day. It rolled through a cluster of rocks and didn't hit one, and everywhere the truck did hit the ground, a blanket of thick moss softened the impact. The vehicle landed upright—virtually unscathed. The only real damage occurred when I broke a mirror winching the truck back onto the dirt roadway.

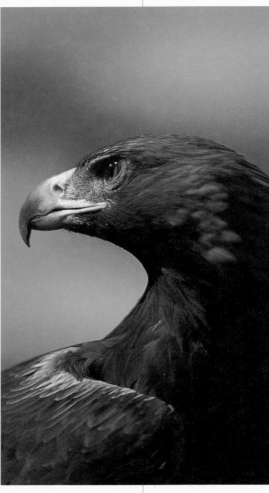

Another time I had a dory custom-built to work on marine life in Prince William Sound—prior to the *Exxon Valdez* oil spill in 1989. It was a unique twenty-eight-foot craft with a thousand-mile range. Unfortunately, on the first test drive the bow split open—thanks to inferior workmanship. It sank at the dock moments after completing the twenty-minute-long maiden cruise.

While climbing in the Wrangell–St. Elias Range in pursuit of Dall sheep—I call them the High and the Mighty—I fell down an ice shoot and became wedged in a crack with a broken upper arm. I was stuck there for four days. A blood clot developed, which turned my arm purple. I finally managed to free myself and get to a hospital. That mishap almost cost me my life, and they very nearly had to take my arm.

One summer I lost my raft on a trip down the Copper River. I had planned the trip with great care, as I was a little nervous to begin with. The Copper River is treacherous, filled with ferocious rapids, floating trees, and sweepers. It was none of these, however, that sank my expedition. Unbelievably, I ran into a fish wheel—a Native American fish trap—in calm water and sank less than a mile from the start of my journey, and twenty feet from shore. Swimming twenty feet in thirty-eight-degree water is dangerous as it is, with your lungs collapsing and kidneys shutting down, but in my case I was also dragging a one-hundred-pound waterproof camera bag. It was a long way to go, but I made it to the bank. Shivering, I watched the rest of my gear and raft drift down the river aways, half submerged before they sank out of sight.

Golden Eagles

During my constant travels, I once happened across two golden eagles constructing an aerie on a four-hundred-foot cliff. I set up shop and watched them every day for two and a half months through a spotting scope. The nest was accessible by rope, but I didn't want to intrude lest they abandon the nest. I spent my time plotting the sun, and I constructed a sundial to gauge shadows that would fall over the nest so I could plan my approach under optimum light conditions. My intention was to set up three cameras on remote control so that I could photograph rarely seen events inside the aerie.

I made my first descent of the cliff extremely cautiously; it was a difficult climb, and my confidence in my mountaineering abilities had been shattered by my fall in the Wrangells. I also didn't want to spook these regal birds or get a talon in my back from an outraged parent. I secured a canoe paddle to my back with duct tape to prevent such an occurrence as I rappelled off the cliff with the grace of a water buffalo. Sliding clumsily over the cornice, I got my first look into the nest after two and a half months of observation. The eaglets, two of them, were beautiful. However, I had mis-

judged their age and found them to be seven weeks old instead of four.

I quickly mounted the control board that would support the three remote control cameras, pausing to take only two photographs.

As soon as I completed my task, I left the site hoping that the eagle parents would be unaware of my visit. I would have to repeat the climb the following week when Nikon had delivered my remote devices. I hoped that would be ample time for the birds to get used to the strange apparatus newly perched near their nest. To my relief, I didn't see the parents, and the whole episode went off without a glitch—or, at least, that's how it seemed at the time.

Back at my scope location, I waited to see the parents' return. Two hours—nothing; four hours—nothing. Eight hours later, I noticed a golden eagle carrying grass to a ridge that ran parallel to the cliff where the nest was situated. On the next day, I saw that the parent eagles were now totally engaged in building a new nest on the opposite and lower ridge. Not once did they fly by their offspring.

At the end of that second day, both parents sat in the newly constructed nest and called to their chicks until finally both chicks perched themselves on the edge of their nest and jumped. Without the beat of a wing, they glided straight into their new home, where they crashed into their parents' outstretched wings. So much for my not having been seen.

My intrusion had been so intolerable to these magnificent, regal birds that they would endanger their young to move them away from the nest that I had intruded upon. The new site allowed no approach. I lingered a little longer and watched all the eagle antics I wanted to capture on film. As if to scorn me, the eaglets, now eight and a half weeks old, would fly back and forth between the nests. Their parents would accompany them with the agility of falcons and the grace of angels, but they themselves would never land in the old nest.

I had put three months and many thousands of dollars into the project, for ten minutes of photography. My ratio of ninety-nine to one held true.

Prior to statehood, Alaska offered a bounty of two dollars to anyone for a dead eagle—golden or bald. Over fifty thousand eagles were brought in. I guess those two golden eagles still somehow remembered that. Over the years I have turned in a couple of eagle poachers to authorities, but only one of them was prosecuted. He received a $100 fine and later, I learned, he had sold the body parts for over $3,000 and continued to poach eagles.

Southeastern, Haines

One of my camps was located near Haines. From there, with the aid of the Alaska Ferry System, I explored Southeastern Alaska's amazing fjords, inlets, and channels. This incredible marine highway is the most impressive way to visit this mystical section of Alaska that nudges up against British Columbia.

One summer I made a plan to fold up my camps at the end of the season and follow the onset of fall down through Southeast Alaska and see what I could come up with photographically. After journeying along stretches of the Yukon, Tanana, and Nenana Rivers, the principal waterways of the Interior, and enjoying a deliciously warm summer of eighty to ninety degrees, I had no desire that year to put on my down jacket too soon. It is possible to follow the seasons around the state, as it is so vast and the temperature ranges vary so greatly.

Following the changing leaves led me to a spectacle in Southeastern Alaska I had heard of but not quite believed: the gathering of bald eagles near Haines at the Chilkat Bald Eagle Preserve. Bald eagles by the thousands lined the banks of the Chilkat River, feasting on a late-season run of salmon. I stayed for four months, and it rained the entire time.

I set up six different blinds to work from at various spots along the Chilkat River. I was miserable, uncomfortable, and often sick during those months during which I watched eagles by the thousands act out their lives in an environment unfit for camera and film. Little did I know at the time that my determination to capture these magnificent winged creatures would turn into a lifelong pursuit.

On one unforgettable day while sitting in my blind off an old logging road above the village of Klukwan, several eagles surrounded my camouflaged shelter. It seems they, too, were tired of the rain and were seeking out refuge from the unrelenting drops beneath the trees where I had erected my observation post. Watching through a tiny opening, I struggled to remain perfectly still. The eagles, mostly immatures, were walking about within two feet of my position.

A few hours later, still maintaining absolute immobility, I heard a low hiss behind me. At that same moment the eagles took flight, and the deafening screech of a lynx blasted the stillness just as four flailing legs with claws fell through the roof of my blind and within a fraction of an inch of my face.

The lynx screamed even louder as he struggled to free himself from the entangled cluster of debris from the collapsed roof. It took him a few seconds to pull away from the mess, with his legs flying furiously about my head. His claws caught my camera lens, and that seemed to give him the leg up he needed to scramble free and clear. His push-off sent the twenty-pound camera and lens hurtling into my chest, and I tumbled into the wall of the blind.

I spent the rest of the day dismantling the blind I had sat in for countless hours and thought about what had happened. It seems the lynx had tried to use my blind as a springboard to grab an eagle on the wing, but to his surprise the springboard was hollow. All I ever saw of him was his legs, but his screech still echoes in my mind.

Southeast Alaska has a spiritual beauty all its own. Its ecosystem is unlike that of any other area in the Great Land; and it is small and confined as compared to the rest of the state. Its mountainous walls jut up from the sea, and its entire existence evolves around the forests and the inland waterways.

In the four rainy months of my visit, I would shoot only three rolls of film, but they would include photographs of an eagle flying in perfect formation through the first snow of the year in the Tongass National Forest, and of an eagle in midair with talons outstretched as he attempts to steal a fish from a fleeing counterpart. I'm still amazed that I captured these images on film.

Valdez

The following spring, I landed back in my main base camp, near a town feverish with activity. Valdez, so named by Captain Fidalgo of Spain in 1790, is the terminus of the TransAlaskan Pipeline. When I visited the town for the first time in the mid-1970s, it was a chance to view firsthand what a gold rush is like. Even though I had avoided it for so long, I became fascinated with this town that looked as though it had been plucked from the Swiss Alps and set down on this beautiful shore.

Unsurpassed beauty surrounded the town, and yet contained within it was to be found the largest gathering of radical personalities on the face of the planet. It made for a real Wild West–type scenario.

Spring in Valdez brings a few thousand tourists from around the world. Those tourists added to the well over five thousand work-hard, play-hard pipeliners— and the result was like a hornets' nest. Everything you could imagine of, say, Tombstone in the 1800s

was true of Valdez: gunfights, mobbed streets, barroom brawls, women of the night, and gambling to the extreme.

My first close-up look at an Alaskan brown bear was marred by drunken pipeliners throwing rocks at him from the side of the road. They wanted the bear to react in a way that provided them with a better snapshot. I was outraged at their behavior and told them so. Instantly forgetting the bear, they approached me on all sides—and just as the largest man of the group threw a punch at me, he stumbled backwards into the dirt before his fist could make contact with my face. Frank Burke, a quiet man who was with me that spring evening, had struck the man in the blink of an eye. I never even raised my hand to ward off the blow—it was all so quick. As the man lay on the ground whining, Frank apologized for his coworker's conduct. I just smiled at him and thanked him for being there. Frank was a guy who loved the outdoors and had come to Valdez to work on the pipeline, hoping it would give him the grubstake to remain in Alaska after the pipeline was completed. He spent a lot of his time off the pipeline helping me on various projects.

Meanwhile, the bear had wandered off, but he reappeared the next day outside my cabin at Robe River, a mile away. He was a comical old creature that weighed in at over one thousand pounds, and his scruffy appearance and slow, lumbering movements brought a smile to my face as I watched him examine everything on the premises. Eventually he strolled through the woods and arrived at my neighbors' cabin, where they were having a birthday party for their five-year-old.

The old-timer walked through the middle of the party, causing an upheaval of chairs and party plates as everyone scrammed. As the bear sauntered past the birthday cake, he simply took it into his mouth and swallowed it with one bite. With frosting on his nose, he slowly shuffled down the dirt road to the next small homestead and fell asleep in their front yard.

Word of the first spring bear who had crashed the birthday party quickly spread, and within a few hours the slumbering giant had dozens of onlookers—all keeping a safe distance. They marveled at the opportunity to view this magnificent animal. The children from the party were all there telling the story of their comical guest who ate the cake. Just as everyone was getting comfortable in the presence of the sleeping bear, a shot rang out.

That beautiful moment between bear and man had been suddenly and gruesomely destroyed by one person with a demented passion to kill a bear. The killer had crept through the bushes into his neighbor's yard and, while dozens of onlookers watched this old monarch in his slumber, shot the bear in the back with an elephant rifle. He could very easily have killed some of the people as well, having fired right through the crowd.

When the Alaska State Troopers arrived, the man stated that he was concerned for his life and property—which is a justifiable reason for shooting a bear in Alaska, but that didn't wash. All the folks, even the children, demanded that the man be punished for his actions. Finally, but only after everyone signed a petition, he was arrested.

The Birthday Cake Bear, as he was so named, was autopsied by the State Department of Fish and Game. The poor old fella had only one tooth in his mouth and but a few claws left. They determined his age to be forty-six years old, and he weighed in at about twelve hundred pounds. I like to think of that lumbering old giant and hope that when those children—now grown—tell the story of the Birthday Cake Bear, those who hear will understand that man is the intruder in the bears' domain.

Another encounter between man and bear occurred only a few days later. A friend of mine had parked in a pull-out alongside the Robe River, then teeming with salmon. Johann, new to Alaska from Sweden, didn't have a clue as to the number of brown bears fishing right behind his truck along the thickly forested riverfront. It was dinnertime when they pulled in and as Johann and his children remained in the cab of their

pickup, his wife went around back to climb into their camper and prepare the meal.

A moment later, out of the corner of his eye, he saw a mother brown bear and two cubs dragging his wife by the hair across the road. Horrified, he grabbed the only weapon available—his Stanley Thermos—and ran at full speed toward the mother bear, screaming. He brought the thermos down across the bridge of the bear's nose with such force that she instantly dropped his wife and ran off screaming in both pain and fright. His wife, although shaking from fear, did not have a mark on her. I can still see the look of horror on Johann's face as he told me the story. The Stanley Thermos looked as if it had been hit with a sledgehammer.

When news of the encounter spread, a posse was formed to search out the bear. But Johann put a stop to it. He explained that they had been in the wrong place at the wrong time and no one needed to be shooting any bears because of his mistake.

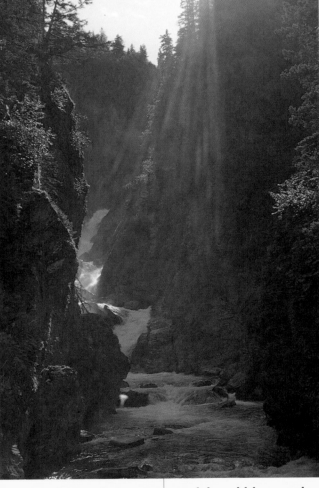

Later, before moving out of the Valdez area, I wanted to photograph a waterfall near the town before it was altered by a planned power plant. Solomon Fulch Falls was to be disfigured forever and I wanted to preserve a memory of its beauty.

I had been to the falls hundreds of times and had not taken a single photograph. Although I didn't know what it was, somehow that magical essence was missing. That missing factor is what distinguishes an average photograph from a great one—one that evokes an emotion that engulfs the viewer.

I had already moved most of my gear to Denali Park and Preserve. Back in Valdez, I traveled slowly down the road to the falls for that one last visit. On the way, I pulled over at the spot where I had first seen the Birthday Cake Bear, and thoughts of both Frank Burke and the old monarch stirred my heart. It was here that Frank had rescued me from the belligerent pipeliners, and I sat for a moment remembering this remarkable man, my friend.

Frank left the pipeline some months before, having saved up the grubstake he had worked so hard for. He stayed in Alaska and bought a plane to explore the wilderness of his Last Frontier. The month before my last trip to the falls, however, his plane crashed into the side of a mountain. Both he and his cousin were killed. That same week and in the strange perpetual motion of life, I received in the mail all the notes left in the jar in my old lean-to back in the Appalachian Mountains. One of the notes told me that the deer hunter who first told me of Alaska had also died in a plane crash that month, during an Alaskan moose hunt.

Mixed sun and rain and high winds were the conditions that day of my last visit to the falls. I tarried for two hours in the shifting weather when suddenly, as if by divine intervention, the waterfall was literally blown backwards by the wind. This unreal effect produced a spectacular rainbow. And I was able to capture the moment I had waited for for so long.

My photograph *Misty Valdez* always reminds me of that old bear, a dear friend, and the deer hunter who first told me about Alaska. All three are gone now, lost to the Great Land.

Denali

In my opinion, there are few places on earth where you can actually touch the call of the wild, few places that make the blood surge through your veins as you become engulfed in the flow of nature. Denali Park and Preserve is such a place. All nature comes together in sheer perfection, the perfection of Alaskan wildlife and wilderness. Formerly known as Mount McKinley National Park, it was founded in 1917 by Charles Seldon. I constantly return to this beautiful place. And whenever I leave it, my parting thought is to return as soon as possible. It has shown me so many things and stirred me so deeply. It is where my heart resides. I'm sure there are many wilderness souls who feel the same way, but no one could love it more than I do.

My first trip into the park—this void of modern man—lasted seven months, and those moments of initial discovery have stayed with me my whole life. They stirred in my memory even on the morning of my flight into Kodiak.

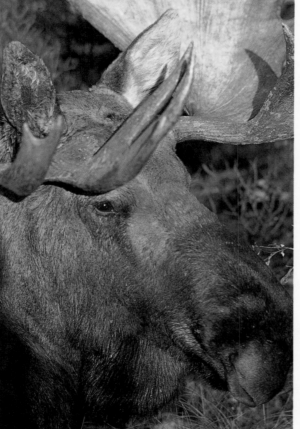

I spent weeks walking with a bull moose, not photographing, just being with him. The noise of the cameras made him nervous, and I, being in total awe standing so close to a fifteen-hundred-pound bull, was content to just be there. My goal, if I had one, was to get this giant bull to be so at ease with my presence that he would do things naturally—as he normally would.

The first thing he did was to start following me around. I guess he was as curious about me as I was about him. Hiking with a bull moose by your side through his territory, around and among his fifteen-or-so lady moose, is an awesome experience. However, with each click of the camera, he would back off, and it would take a few more days of waiting nearby for him to regain his ease and walk with me.

On the last day I spent with him, I decided to sit down and take a nap as he browsed through the willows. In my sleepy state I could hear him moving about close by, but I was thrilled to open my eyes and discover that this giant bull moose had walked up to me and started licking my boots.

He could have killed me in the blink of an eye simply by turning his head around and catching me with his giant antler, but at that moment I wasn't worried about the danger. This was my aspiration in life—to commune closely with nature at its purest.

I slowly moved to put a smaller lens on my camera and disconnect the motor drive. I simply had to photograph him when he went to sleep next to me. I didn't want to betray his confidence yet again with my noisy apparatus. So I snapped a shot as quietly as I could. He woke up and tossed me a dirty look—animals have as many facial expressions as humans. I, being a stupid human, clicked off two more shots and he promptly stood up and walked away and didn't look back—as he had always done before when he left me.

He had let me know enough times that he wasn't comfortable with the noisy box, and I was never able to get near him again. It was as though he had lost trust in me. I have regretted it ever since.

In all my years in the wilderness—with the exception of my fox, Ambrosia—I had never been able to enjoy such oneness with a wild animal as I had with that great moose. I betrayed that giant, gentle creature for the sake of one photograph. When will I ever learn anything?

Sable Pass

The one road that winds into Denali some eighty miles is extraordinary. It is the path into the greatest national park in the Western Hemisphere, with treacherous bends and turns and steep grades; around each corner lie spectacular panoramic views as well as grizzly bears, wolves, caribou, Dall sheep, and the largest bull moose in the world.

There is one place in the park that particularly fascinates me. Sable Pass is one of the largest grizzly bear denning areas in the world. It is a primeval place of mythic proportions, and it is filled with grizzlies. I photographed them eating Dall sheep, dragging moose carcasses, digging up squirrels, and satisfying their never-ending appetite for berries. Grizzly cubs would hang on to my front spare tire, and a few times as many as six bears have surrounded my truck.

It's illegal to walk off the road in Sable Pass. And in the domain of the high-mountain grizzlies, that is one park rule that needs no justification. With patience, however, you can see and film from a vehicle some of the rarest moments of grizzly life. My first year in Denali I worked on more than forty bears, and each one had a different personality. That photographic work would lead to thousands more hours spent with grizzly bears and continue from Kodiak, Katmai, the Alaskan Peninsula, Admiralty Island, to the Brooks Range. I would come to realize that this creature represents the true essence of Alaska.

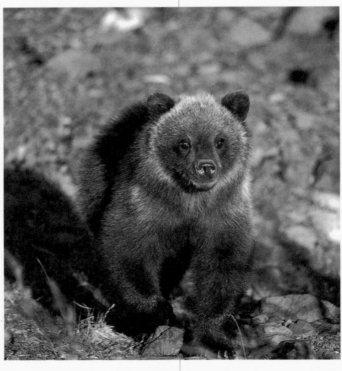

There is no animal, no mountain range, no person, poem, or song that is so quintessentially Alaskan as the great grizzly. The grizzly bear is the true symbol of the Last Frontier.

Bull Caribou

The thermometer knotted to my jacket read sixteen below zero, while the air was so dry it felt as though it could crack, shatter like glass with a sudden movement. I had been watching a giant old bull caribou that was challenged once too often over three days of vicious battles to keep his harem.

It was that magical fifth season. Everything was ready for its blanket of snow that October, but the sky wouldn't release the overdue moisture that would transform the entire northern world into a spectacular winter wonderland. If the snow had come earlier, the park would have been closed to visitors and I would have never captured one of the most memorable photographs of my life.

Through my scopes I watched a drama of nature played out, witnessing this magnificent old bull caribou fight off rivals seeking to become the new leader of the herd. The first two contenders were younger bulls and no match for this proud defender, but they did manage to break one of his antlers and leave him exposed and vulnerable.

A third bull then took up the challenge. This one, though, was more of a match in size and strength for the aging leader, and he took advantage of the unprotected side of his head. At last the battle ended. The old bull's legs wobbled as he turned away from the victor and gave up the fight. He had battled three bulls for seventy-two hours straight.

He limped, staggered, and struggled his way toward me, and as he rounded the knoll I was on, he passed into a beam of light that flashed on his chest, illuminating this lone defender in his last proud moment before he fell and died out of sight of the victorious challenger.

It snowed that evening, and I and another photographer and a few rangers all struggled to get out of the park with our vehicles, lest they become entombed in snow. I remember thinking as I slithered up the last hill sideways above Sanctuary River that now Mother Nature would play out her dramas unseen by human eyes until the following summer when the snow receded and people once again were allowed the supreme privilege of passing into the incredible wilderness of Denali Park and Preserve.

Kenai

Standing fly-fishing in the jade-green waters of the Kenai River is like playing the violin in Carnegie Hall—and the applause comes in the form of rushing water or the beating of eagle wings.

I had just released an eighteen-pound male rainbow trout with a breastplate as red as a fire engine—not to mention that he was longer than my leg—when from the opposite bank a moose and two calves exploded into the river downstream from me and were quickly caught up by the current. A moment later I saw the reason for their quick dip as six or so wolves ran past me along the bank, reluctant to take the plunge.

The Kenai Peninsula looks as though God simply picked up New Zealand and placed it in the middle of Southcentral Alaska. It is Alaska's playground and has a long, rich history of discovery, fishing, timber, and gold. It is a sort of condensed version of Alaska—under half the size of New England—and it draws millions of tourists each year who come to fish the amazing rivers and surrounding waters.

The wolves went past, and I didn't even bother to walk back to my truck, where my camera was set up on an eagle's nest. Instead, I floated my line gingerly across the green-hued water in an attempt to land another large rainbow. I was standing in the middle of a natural phenomenon: a school of some two to three thousand giant rainbows, all weighing from five to twenty-five pounds, was

swimming past me en route to their spawning grounds in the beautiful Russian River.

I had a Russ King fly rod in my untalented hands, but it still performed like a Stradivarius. It was ten feet long and well tuned. Mr. King, the master guide for Kenai Lake Lodge, had taught me the art of fly-fishing, and now here on the banks of the Kenai River, surrounded by moose, wolves, giant rainbows, and eagles, I felt ready for my first figure-eight cast. I had over one hundred feet of line in the air as I made the fly rod dance into its figure-eight position. The line came back around with a slow artistic "whiss," and as I moved with a fluid motion to the eleven-o'clock position, the line slapped around my neck, embedding the hook in my jugular vein.

I was chest deep in the river with blood gushing out, and I had to get to the bank before I passed out and drowned. I made it as far as the door of my truck and fell to the ground unconscious.

I awoke a few minutes later covered with blood, staring up hazily at a bottle of Jack Daniel's and a pair of vise grips wavering in the air. "That fly needs to come out, son," said this old-timer as he doused the vise grips with the bourbon. "Lucky I found you and not that old bear," he added. Try as he did, he couldn't get it out, or push it through. He drove me sixty-five miles to the Seward Hospital, where the doctor smiled and pointed to the collection of flies and lures on the wall of the emergency room.

Bald Eagles

The Kenai Peninsula is a treasure trove of opportunity for filming year-round. But in the winter bald eagles flock to Kenai by the thousands, seeking the ice-free upper waters of the incredible Kenai River.

For over nine winters I would continue my work on this magnificent jade-green ribbon of water, completing a substantial part of my work on bald eagles—the work that I began in Haines and Southeastern all those years ago.

When I began my studies of our national symbol in the early 1980s, no one really knew why the eagles came to Kenai in such large numbers. In 1982, the Year of the Eagle, the United States Fish and Wildlife Service launched a study on this world-famous river and for years I would work with the service on every aspect of eagle life. After many years of scientific study by Dr. Theodore Bailey of the National Wildlife Refuge—whom I worked with closely—they determined that five winter runs of silver salmon occur in the waters of the upper Kenai, thus creating a rich food source for this gathering of eagles—the second-largest concentration of bald eagles in the world after that in Chilkat.

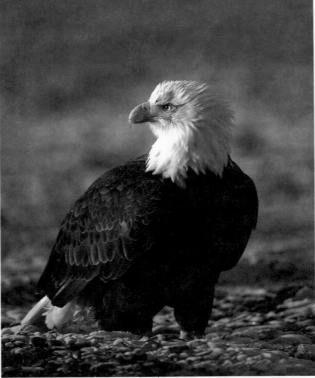

Over time, I came to know all the places they roosted. The same eagles would return to the same trees year after year. Every waking moment for five months, from late fall to early spring, I would photograph them fishing, fighting, and playing, and I slowly began to capture on film some of their essence, their freedom.

I spent more time over the course of those years with eagles than with humans. When spring came and the eagles dispersed I would miss my giant feathered friends. Although my work would continue with nesting eagles in the summer, it just wasn't the same as living with the thousands of eagles on the Kenai Peninsula during the winter.

In the summer when I wasn't working on eagles nesting, I explored the Kenai swamps. Over the side of my swamp boat I went, once again to pull my small watercraft through a bog. My flat-bottom johnboat was decked with a trolling motor, batteries, and solar panel chargers. I had spent a lot of time in the Kenai swamp and had finally burst through a thousand feet of bog to discover a small pond where I knew no person had ever been. After removing the leeches, I hit the motor and was off flying at two miles per hour.

My swamp work paid high dividends, and each trip produced results more precious to me than a kilo of fine diamonds. In the course of my swamp adventures I would capture a loon hatching, the poetrylike perfection of an Arctic tern feeding its babies in midair, or the beautiful symmetry of a long-billed dowitzer. I have had two river otters actually jump into the bow of my boat and scamper around. And even more amazing, I had a giant beaver swim up to me and reach out his paw and touch my leg.

I felt safe in those backwaters, and I enjoyed that feeling immensely. And then again I heard the plane's intercom crackle and whine as we neared our destination. "Beer! Beer!" shouted the Norwegian biologists as they shook my left shoulder, rousing me from a nap. They were pointing to a rock on the beach and felt certain it was a brown bear just off the runway on Kodiak.

Kodiak

The memories of the past twenty-five years vanished, and the piercing scratch of the cranky intercom brought me smartly into the present. As I walked off the plane and into the airport on Kodiak, I was concerned for where I was going, concerned for my health, and concerned about how many bears would be at the head of Uyak Bay on the backside of this, the Emerald Island of the Giant Bear.

The stately English couple had come to Kodiak to flight-see for brown bears. We exchanged address-

es as they dashed off to their aerial bear tour. The unshaven Norwegian biologists left for a cannery to analyze fish scales and were still talking about the giant rock bear they had seen on the beach as their cannery-row taxi pulled up to take them to the fish-processing plant.

My flight for Larsen Bay was leaving and, after I paid an extra fifty cents a pound for my excess gear—three hundred pounds of it—we took off. I was glad when the pilot took the Cessna 207 back out around the tip of Kodiak and Afognak to follow Shelikof Strait down to Larsen Bay. It would be longer this way, but we wouldn't have to weave through the mountain passes. A flight had done so just a few days before and hit a peak, killing everyone on board. Funny, I noticed the rock at the end of the runway still hadn't moved. I fell fast asleep.

The plane pulled a few g's as we did a fly-by over Bayside Inn, signaling the owners they had a client landing at the Larsen Bay airstrip in about two minutes. The fly-by was unnecessary, as the owner, Jim Hamilton, was already standing outside his van alongside the dirt airstrip. I cursed the pilot for the unnecessary g-force turn, as my stomach was still in my throat. Nonetheless, it was sure good to see Jim—just being around him gave a person confidence. He had the personality, hair, and beard of Kris Kringle, along with the stamina and physique of Arnold Schwarzenegger.

He greeted me with his usual gentle bear hug, and I forgot for a moment why I was there until he spoke up and said, "Are you sure you want to go to the head of the bay?" The fact is that I wasn't sure, not at all.

Jim and his charming wife, Mallory—cook extraordinaire—were helping me finish my bear book. With each trip to their lodge on Larsen Bay the various pieces were coming together. We cruised the backwaters of Kodiak's bays time and time again. This trip would be different, however. Jim would be dropping me off at the head of secluded Uyak Bay, fifty miles from nowhere, and I was extremely nervous about it.

Kodiak brown bears are world-famous. Their dispositions are milder than those of their Interior brothers, the grizzlies, but that's not to say there are any Yogis or Boo Boos among them. They can be fierce. In 1994, a television documentary was done on the Village of the Bear, Larsen Bay, as it had so many brown bears walking through town. Soon after the special aired, people from all over the world flocked to this small, sleepy native village to get a glimpse of the bear population. The result was a disaster. Residents—still unknown—took offense at the human invasion and shot fourteen of the local bears by the end of the season, bringing a sad end to the Village of the Bear.

Gunga Din—my nickname for Jim—was tying the ocean kayaks to the side of his dory as I downed as much of Mallory's cooking as I could. MRE military rations would be my bill of fare for the next week. Jim walked in and said, "Got to go," and we left for the head of Uyak Bay, the heart of the Kodiak National Brown Bear Preserve. I was as nervous as a deer drinking water.

The dory ride out was as beautiful as ever, as we cruised the fifty uninhabited miles to my dropping-off point. Otters, eagles, whales, and foxes were everywhere in this glory-hole island of Mother Nature, but my mind was on one thing: bears. A few years ago I had stopped working on bears after a series of nightmarish incidents. I have been charged or challenged for a trail over fifty times. I have had my ribs broken and legs clawed and I've been followed for two miles by a six-hundred-pound grizzly clacking his teeth twenty feet behind me the whole way. Baby cubs have played at my feet as their mother grunted warnings, a scant thirty feet away. Twice I've awakened to find grizzlies walking around my tent. Once, while on a twenty-five-mile hike up Crescent River in the Chigmit Mountains, I had to pick my way through thirty-five brown bears fishing.

None of these events, not the charges or the challenges, not the followings or the broken ribs, ever occurred when I had a camera poised in my hands. They were not the outcome of photographing bears, they were the by-products of living with them. When you live in the wilds of Alaska working on just bears for ten thousand hours, things happen. How one reacts to these encounters determines the outcome; only an inexperienced amateur—or an idiot—prods a giant bear for a photograph.

We rounded the last point and Gunga Din slowed the boat to half speed and told me to get up on the bow and look for rocks. A few minutes later we were at the head of the bay and it was exactly high tide, just as Jim had planned. The tide spilled out in an instant as we unloaded my gear and the kayaks. In fact, we watched it drop one foot in five minutes. For this reason, the shore is uninhabited by man and remains the domain of giant bears. The tide is so quick, even an expert seaman can get trapped by it here.

This was our third trip here; the previous two had been preparations leading up to this adventure. "You sure you want to do this? Sure wish I could join you," Jim called out as he pushed off. He didn't wait for an answer from me; he knew I was staying. "One week, high tide, East Creek. Be there and stay alive," he yelled as the skiff kicked up mud on his departure.

It took all of five minutes to realize I couldn't stay where I was. It would have been not only foolish, but insane. No Trespassing signs were everywhere. They came in the form of bear trails, bear scat, half-eaten salmon, and tracks everywhere. It looked as though a hundred or more bears had recently been where I was now standing. "I don't think so!" I said to myself, as I loaded the kayaks to look for another campsite.

I paddled about a mile and a half until things didn't look so foreboding—at least from the shore. The next week would bring extremely low tides, so I picked a spot that afforded me a view of the entire top of this small headwater bay. The short hill behind camp was a maze of age-old bear trails meandering through five feet of grass. No way I was camping there. I unpacked the kayaks and loaded my guns, thinking, "What on earth am I doing here?"

As I set up my tents, one for sleeping, one for gear, an eight-hundred-pound sow with two cubs came to the point about five hundred feet away. It was actually heartwarming to watch her play with her young in the twilight, and I felt at ease somehow in her presence as they waited for the tide to go out and expose the tens of thousands of pink salmon.

I wasn't ready for the entire bay to drain, but drain it did, save a few small channels running back to my original dropping-off point. The channels exploded with salmon, and I watched the sow and cubs gorge themselves until darkness fell. With the tents in place, I lit a huge driftwood fire and stuck a Coleman lantern on a tree limb I had planted in the sand. "This should tell them I'm here," I thought. Dragging the kayaks around back of the tents made me feel more relaxed as I propped them in place to avoid having any neighbors drop in through my back door unannounced.

At 3:00 A.M., I awoke to fill the lantern, and although I couldn't see the bears, I could still hear them snorting, grunting, and growling. They were now out in front of me on dry ground that was supposed to be a bay.

Feeling safe, I went back to sleep, thinking the morning should bring superlative, once-in-a-lifetime photographs. Feeling that the mom bear had accepted my presence, I was confident. I prayed she would be there when dawn broke and that this point was her fishing grounds—making it off-limits to other bears and—in my deluded mind—thus making it safe for me.

The next morning, however, they were gone, but I witnessed a spectacle not unlike the Miracle of the Fishes. Hundreds of thousands of salmon

came in with the tide. The small cove, now nearly full of water, surged with vast schools of fish stretching out across the bay. At any given moment, a thousand fish were jumping and it was as if raindrops had taken the form of salmon. I have never seen anything like it. Before or since.

With a cup of coffee in my hands, I watched and waited for the tide to go out again. In the full light of day I wanted to see the cove drain and the salmon trapped and just how many bears came out to eat. A few moments later, I turned around and saw my first bear in camp.

He was a-huffing and a-puffing as he jogged along the beach in between the boulders and straight toward me with his head jacked toward the water. He didn't even notice me. Do I grab a camera or stand and yell? If I take the time to grab the camera, he'll be ten feet from me. I stood and yelled, "Heeeey, bear!" Stopping dead in his tracks, he stood and glared straight at me from forty feet away. I yelled again, and again my shotgun was in the tent. He finally turned, ran up the hill behind me, and came back out on the beach a safe four hundred feet up the bay.

"Well, that wasn't so bad," I thought to myself. "Four bears in twelve hours, and I'm handling it just fine." I loaded a kayak, mounted my Nikon 600 f4 on the front, and paddled out to position myself in the middle of the bay when it drained. I found a large rock and tied up, securing the kayak against the massive, swift outflow of water. There were more fish in the bay than stars in the sky. I waited for dead low tide.

Twelve bears came out on cue. That cue was the thunderous noise of thousands of salmon trying to fit into the remaining tiny channels. The rest of the cove, nearly four miles around, went bone-dry, and my kayak along with it. I sat for eight hours watching and learning about the bears of this remote bay—a place where no person in his right mind should be camping in a tent, I thought. But somehow I felt safe—that was a delusion.

High tide floated me back into camp and as I dragged my kayak up to replace it as a back door, another sow popped up, this time in the grass with two monster cubs (two-year-olds). "Heeey,

bear!" I yelled. Three times didn't do it and the shotgun was still in the tent, so I started beating the side of the kayak until they lumbered back into the grass. "Okay," I thought, "seven bears in camp the first twenty-four hours and no problems, but no photographs either."

After lighting the lantern and stoking the fire, I fell into a deep sleep and dreamed about the swamps off the Kenai, where I always felt safe. "*Clack, clack, clack, aruugghh, aruugghh.*" Those sounds didn't belong in my dream, so I bolted upright from my bedroll and stared straight into a huge bear's glaring eyes. She was standing fifteen feet from me on the other side of the fire. She was in full view, completely illuminated by the fire and the lantern. She had three four-hundred-pound cubs jumping at her sides. This was not a normal-size sow, not even for Kodiak. On all fours she started charging the fire, ripping up the sand with each jump, a few yards from my face. This was almost certain death, as her cubs joined in the bluff charges.

This was her cove, this was her bay, and she was most definitely Queen Bitch of all she surveyed. I yelled my usual "Heeeey, bear," while grabbing the shotgun, but this made her even angrier. I unzipped the tent fly in a flash and winced when I got a clearer look at the anger on her face and the drool slobbering from her mouth. I didn't know what to do, so I clicked the safety off the shotgun. Her anger intensified with my every movement. The shotgun was a joke, and I knew it; this close, even with four rounds in her, she'd still kill me and the cubs would rip me apart. I was dead, and I knew it. The fire wouldn't stop her much longer. I have worked on hundreds of bears but never saw one this angry, this furious. Fear gripped me as I remembered Gunga Din's last words, "Stay alive!"

The cubs spread out and, as I tried to keep track of all four bears, I noticed the bucket of fuel a foot from my hand outside the tent, put there for an emergency. This situation more than qualified. If I moved too fast, I knew she'd come in for the kill, so I slowly extended my arm—which felt as if it weighed a thousand pounds—and grabbed the bucket and without hesitation threw it into the fire. Flames leaped ten feet in the air, followed by a mini–sonic boom.

The bears backed off twenty feet and growled ferociously at the fire and then veered off, snorting and growling, and trotted down the beach. I gripped my head and said over and over, "Oh my God! Oh my God!" I was shaking and trembling uncontrollably, and my teeth were clacking. My guardian angel was on overtime that night.

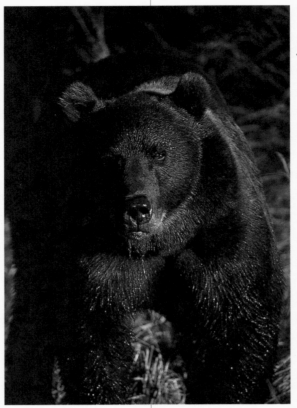

I stayed up all that night stoking the fire so that it would not go out. Falling asleep at sunrise outside the tent, I awoke mid-morning to find another bear walking into camp. Screaming "Heeeey, bear!" wasn't enough for me; I chucked rocks at him even as he was running off. I was a fool in a dangerous situation, and I knew it. To make matters worse, an arthritis attack ravaged my body. A few years ago my doctor had labeled me one hundred percent disabled with a rare and aggressive form of rheumatoid arthritis. He said it was from too many broken bones and too much time outdoors, and he put me on mild chemotherapy so I could walk again. I took my medicine that morning. Each day brought more bears into camp, twenty-eight all told in seven days. If I walked up a creek, a bear would charge me from the grass. If I hiked through the woods, I would encounter any one of the sixty bears in my immediate proximity. I shot less than a roll of film the whole week I was there, but somehow—by the grace of God—I stayed alive.

Gunga Din was waiting at our appointed rendezvous as I paddled out in one of his kayaks, towing the other against the incoming tide. I had to force my body to work. As I climbed in the boat, he told me he was extremely relieved to find me safe and that a friend of mine, doing a bear survey for the National Parks, had been mauled a couple of days before, not far from Larsen Bay. All the bear biologist could say was that "It wasn't the bear's fault. It wasn't the bear's fault." He was right; we're the unwanted intruders in their domain.

That night, safely back at Jim and Mallory's lodge, I decided to go up to the dump to film a mom bear with two cubs picking through the garbage. After all, I needed a few dumpy bear shots, as well, for the bear book. She was wallowing in garbage, and I felt secure enough to exit the truck and set up a camera. After a few shots she started to growl, so I decided to get back in the truck, and as I turned around, an eight-hundred-pound bear clacked its teeth at me. He was between me and the truck and I felt totally helpless and thought how I had survived the head of the bay only to die in a dump. It seemed a fitting end for a foolish man.

The bear, however, sidestepped me and went on to challenge the sow for the town's garbage. He lost. I flew home.

Coming Home

Evening had settled over the valley where I live. I was home again. Thoughts ran through my head of the risks I had taken, of bears, of photographs. The phone rang, and when I answered I immediately recognized the voice. It was Bill Tracy, the man I had traveled with to Alaska all those years ago. He was calling from Point Lay, on the Arctic Ocean. "Okay, okay, Pezzenti, I'll go along," he said before I even said hello. "It won't be easy, ya know, John? I have to figure how to get over the Brooks Range, but we can manage it safely if we take our time and use an Inupiat Eskimo as a guide—maybe the mayor of Kaktovik, ya know the man, George Targarook, who's helping you on

polar bears next year? Can't talk right now, emergency just came over the radio. Gotta go, 'bye."

"Bill Tracy," I thought. "God bless him." He wouldn't be going along on my concocted trip of four thousand miles, crossing Arctic Alaska by snow machine, except for one reason: to watch over me. He'd kept an eye on me all these years, helping me out countless times. We are even partners now on the humble, little mountain ranch where I live high above Anchorage in Bear Valley.

I was thrilled that he'd be going along. Actually, if he had canceled, I would have scrapped the whole expedition.

Bill Tracy had become quite a figure, even a pillar, of the Arctic. He has been a mayor, a fire chief, and so many other things in his twenty-five years on the Arctic coast. I can hardly keep up with his positions and adventures.

Alaska, the Great Land, has captured so many hearts and souls. It is a wilderness unlike any on earth. I thought of the people who have come here: such folks as John Muir, Robert Service, Jack London, Wyatt Earp, John Wayne, Sir Edmund Hillary, Lowell Thomas, Jr., Wiley Post, Will Rogers, James Michener—and Bill Tracy. They all came for the same reason—to actually touch the face of nature, to feel the perfection of the wilderness that only God could create. It is a feeling that leaves one in awe of heaven and earth.

I sat for a moment in contemplation. The door was open, as it always is when I'm home, so my dogs can run in and out freely. Suddenly I heard the familiar "*clack, clack, aruugghh, aruugghh!*" I thought to myself, "Oh my God, this can't be happening," as I got up to step out the front door. The high-mountain grizzly, all seven hundred pounds of him, was in a midair leap, gnashing his teeth, going for my wolf, Katmai. In the same instant, my yellow lab, Buddy, was landing on the bear's right shoulder. I froze for a moment. I knew this bear that wanted to eat my dogs—I had just received a report that a bear had killed two people about a mile or so from my cabin when they accidentally stumbled across his buried moose kill on McHugh Creek Trail. This was definitely that bear.

I yelled and screamed as he stood up with his paws waling away at the dogs. Then he charged me, but the dogs stopped him twenty feet from the front door. I ran in the cabin half screaming, half crying, "No, no, no! Please God, no!" The shotgun was empty, so was the .44 Magnum, so I grabbed a target rifle, snapped in a thirty-round clip, and stumbled outside again. As I screamed for the dogs to back off, I leveled the semiautomatic at his chest.

As I started to squeeze the trigger, I jerked the gun down to his feet and shrieked, "No!" I fired ten rounds to the right of him and the night exploded in muzzle blast and smoke. He didn't stop and I knew the look on his face. It was the same look of outrage and fury the Queen Bear had displayed just a few nights before in Kodiak. But one thing was different, this bear had no fear of humans. He had just gruesomely killed two people.

I took a step toward him, screaming at the top of my lungs, and let the remaining twenty rounds go to his left. I was still pulling the trigger when he veered off at a slow pace to exit the war zone. He lumbered slowly into the bushes. He didn't even seem upset—except for the loss of a meal (my dogs).

Running back into the house, I snapped in another thirty-round clip and came out to fire it into a dirt bank just in case he was still in the bushes. I fell to my knees and thanked the Lord he hadn't kept coming. The target rifle would never have stopped him—it was too small a caliber. I got on the phone to my neighbors, warning them, then called the Alaska State Troopers, who casually said, "Well, you should have shot him. He's bad news."

"Shot him" echoed through my mind. "How could I have done that?" I thought as I sat in my lawn chair in my front yard with the empty gun across my lap and my dogs begging for attention. At that moment I realized that even if it meant my life, I couldn't kill a grizzly bear, the true persona of the Last Frontier. That was the first time I had ever fired a weapon at a bear, and that's saying a lot after the week I had just been through.

The next day I would leave for the Kenai swamps and photograph the poetry of Alaska's wildlife and wilderness in the backwaters where I always felt safe. And that feeling I needed now more than ever.

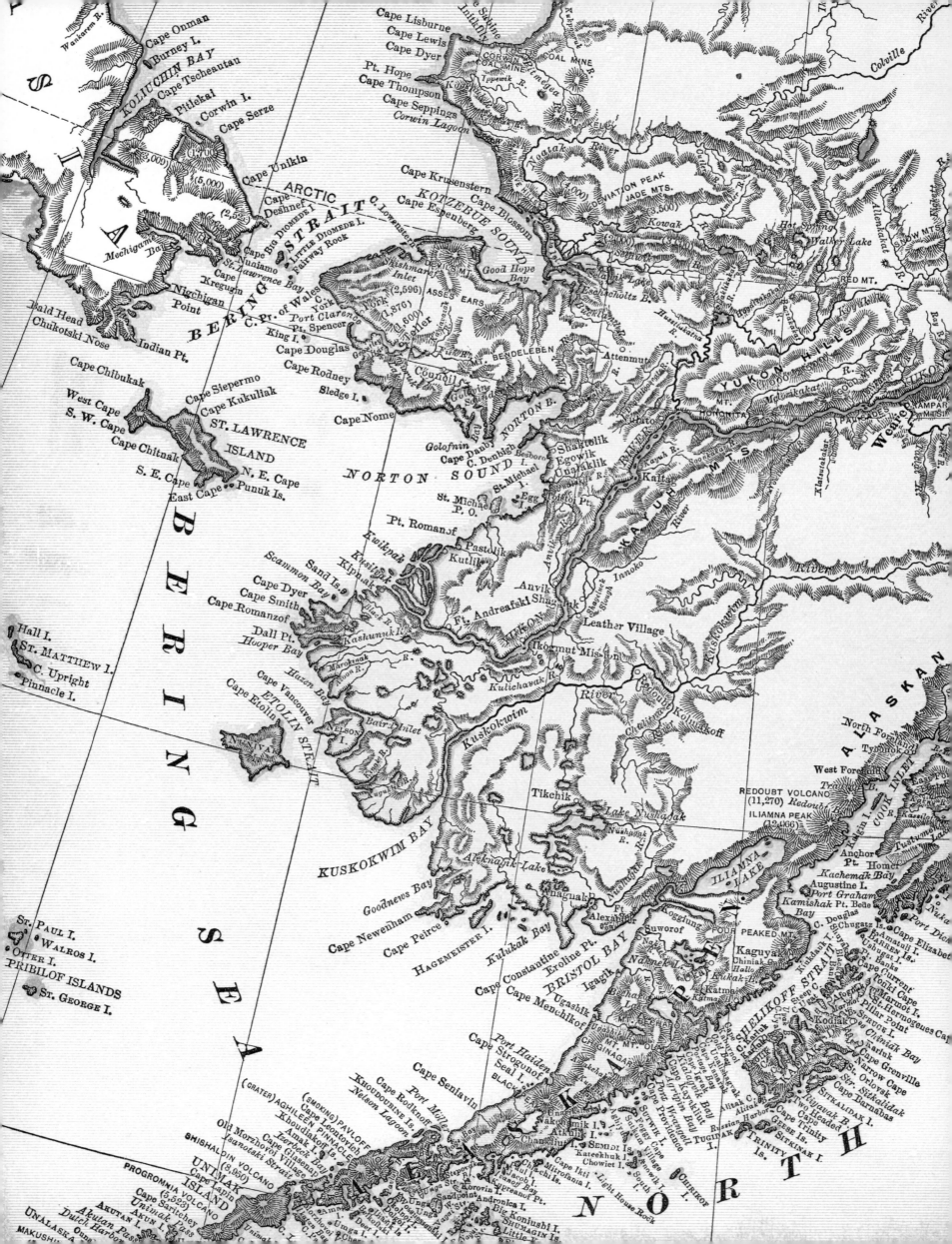

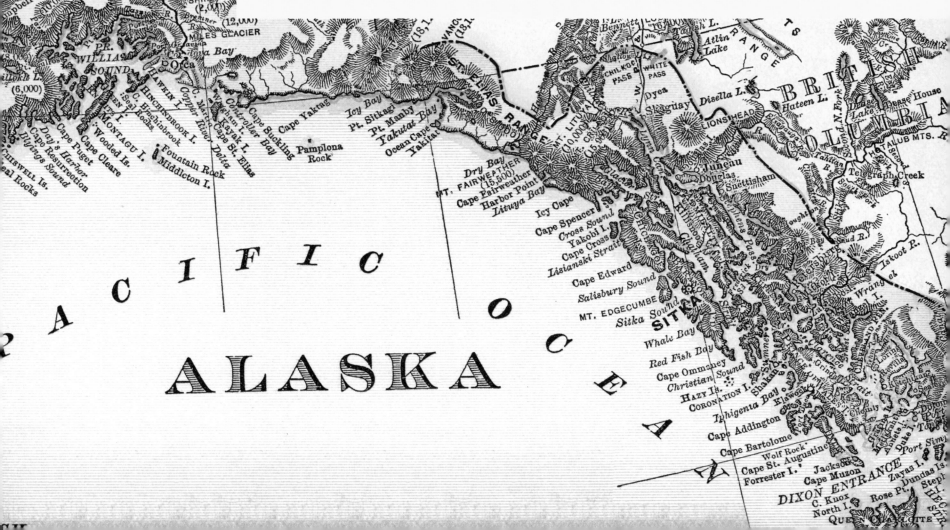

On Nature Photography

For all the visual arts, light is the key element for creating compelling images. Light shows no favoritism; it is easily accessible, but only a few really ly ever master its majestic rays. To my mind, the greatest quest for elusive, artistic light is that of the always vigilant nature photographer. We, with box, glass, and tripods, attempt to capture nature's essence, hoping to transfer our vision onto film—artistic reflections of our wild subjects, subdued by natural light.

Light, the first element of creation, is a mysterious force that comes and goes faster than we can comprehend. It travels the ninety-three million miles between the sun and the earth in about eight minutes, and changes color and quality quicker than the beat of a hummingbird's wing. In fact, science shows that the intensity of light can vary billions of times a second. So, as a nature photographer with the goal to photograph wild and majestically lit subjects, I must spend thousands of hours in pursuit of my image, its composition, and rare qualities of light—at once natural and artistic.

My greatest aspiration is to create, or capture, an image of nature so sharp and exact that it allows the viewer to see it as I saw it. I want the viewer to get the sense of energy I felt when finding the image. I want the photograph to engulf the viewer. I want to take you there to the wilds where I stood and become part of that intense moment of seeing.

Composition is second only to light in creating a compelling photograph. And when composition and light combine to frame and illuminate a subject, I achieve my goal. This, however, takes commitment. A year's work can sometimes produce only a couple of photographs. It has taken me nearly a lifetime to capture the birth of an eagle, loons walking on water, sunrises at fifty below zero, dandelions in forest fires, volcanic eruptions, and the aftermath of sub-zero floods.

These images are the result of luck and patience—and by that I mean thousands of hours of positioning myself in the wild in all conditions, waiting and watching for the right moment, fully prepared to capture it when it occurs—or appears.

Those moments that allow me to assemble all the key elements—magical light, unique composition, and artistic technique—are rare. They may well abound in the realm of Mother Nature, but they are rarely seen and more rarely recorded.

Equipment plays an important role in capturing these cherished, wild images. Film and lens are the most important. Over eighteen years ago, I traded or gave away my zoom lenses. The clarity and quality I was looking for wasn't there and, in my opinion, still isn't. I can't seem to get around the fact that a straight focal length lens of, say, 220 mm, has five pieces of glass to go through, while a zoom of 80–200 mm has fourteen. Also, all of my straight focal lenses are extremely fast and perform beautifully under low-light conditions.

The Nikon lenses I used to make the photographs in this book are, I believe, the sharpest in the world—while still being able to use Kodachrome 64 film. They are 15 mm, 16 mm, 18 mm, 20 mm, 28 mm, 35 mm, 50 mm, 55 mm, 85 mm, 135 mm, 180 mm, 300 mm, 400 mm, and 600 mm. All have the lowest apertures available. The cameras I used for this book were 35-mm Nikons. In my gallery work, along with the Nikons, I used 2¼ Hasselblads and Linhoffs. They are all manual cameras.

Last year, while I was finishing work on this project, my sweetheart, Tina, and I spent some time traveling on the Dalton Highway. It was a leisurely, pleasant drive—that is, if you believe that three flat tires in one day, a thousand miles of dust, and millions upon millions of mosquitoes is leisurely and pleasant. I do.

We had been delivering my photographic wares to my few accounts along this remote Arctic highway. After leaving Deadhorse we noticed a white van following us. It did so for the better part of two days. Finally, after pulling over to the Yukon River Bridge to have coffee, the driver of the van approached us. It turned out that he had been buying the cards and posters that I had been distributing. He was a kindly gentleman who was working at becoming a nature photographer himself. Someone along the way had pointed me out to him and he was hell-bent on talking with me. His intensity made me feel like he was in search of the Holy Grail. According to him, I knew the way. He asked me for my opinions and the secrets of my work. So there on the banks of the Yukon, I gave him a photography lesson.

I told him he would need to dedicate years of study to other people's work, and to pay close attention to those masters whose work transcends the more commonplace variety of nature photography. I told him to study the art of landscape photography and try to adapt it to his own style of what I call "roaming nature." He must learn the technical aspects of photography as well as anyone alive. "Everything in your life should become subservient to your work, almost as with the dedication of prayer," I said. "Then learn how and when to sacrifice that technical learning for artistic appeal and composition when needed. Everything you own, from your socks to your truck, should aid you in your work. Make photography become such a passion to you that you can feel the images when the right light dances your way."

I went on in this fashion for nearly two hours and concluded by saying, "Now spend the next ten to twenty years mastering this and you'll realize your photographic vision one day, the good Lord willing."

As he turned to leave he said, "How could I do all that? It would take a lifetime. A person would have to be both obsessed and possessed to work like that." That's right.

Nature photography has illuminated my life with images of natural beauty that have transported me out of the reach of man and into the arms of God.

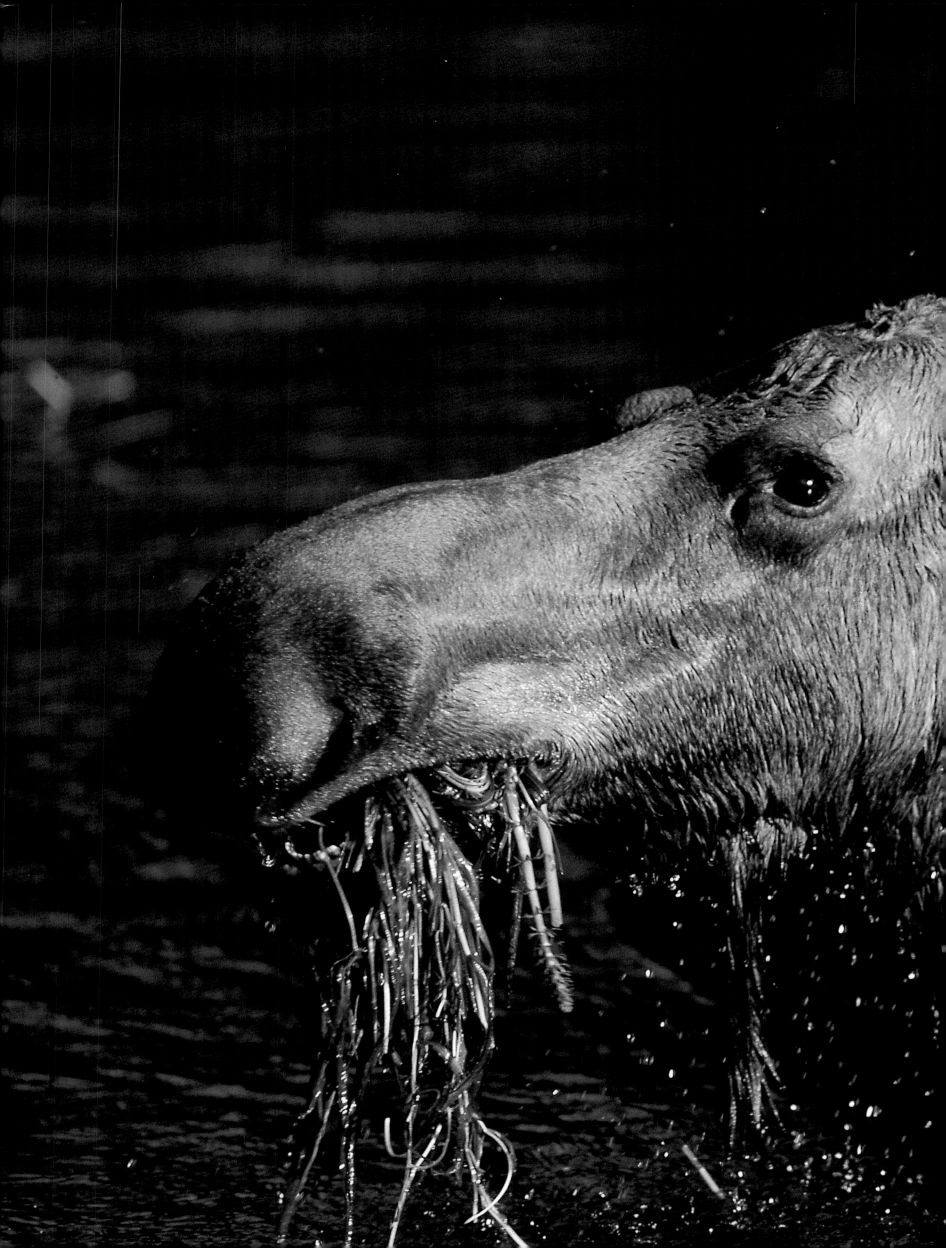

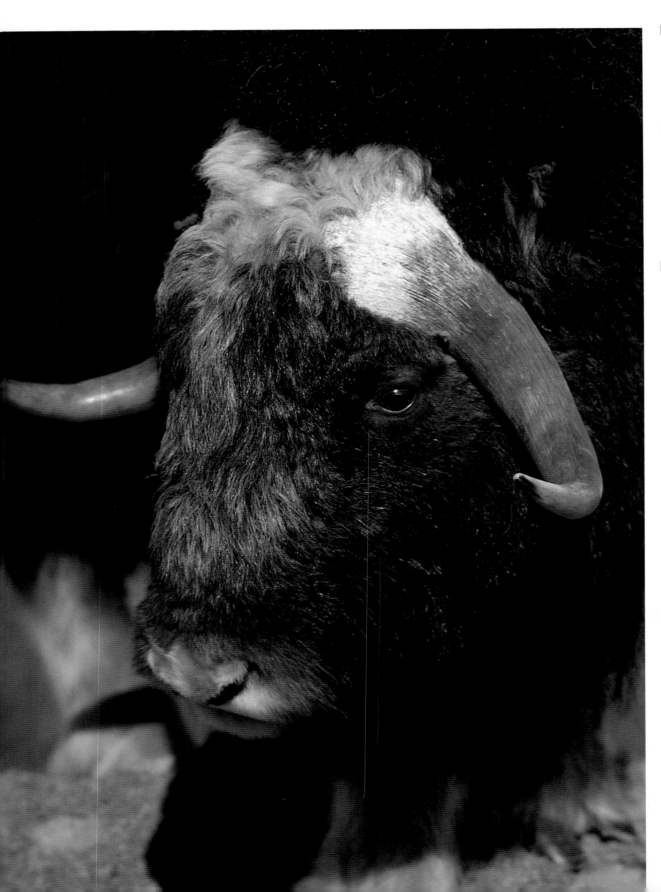

In the heart of the swamps of the Interior, a female moose emerges from the depths of a small pond where she's feeding off the sweet fresh vegetation of spring.

A musk ox lowers his head and shows the tip of his horn as a warning to another musk ox during rutting season. Bearded One (ox oomingmak) is the Inupiat Eskimo name for these ice-age relics. Gates of the Arctic National Park.

This trumpeter swan (Cygnus buccinator), at midnight, glides gracefully across a pond near Tok, Alaska, and the Yukon border. These beautiful birds with wingspans of up to eight feet inhabit various inland waters throughout Alaska.

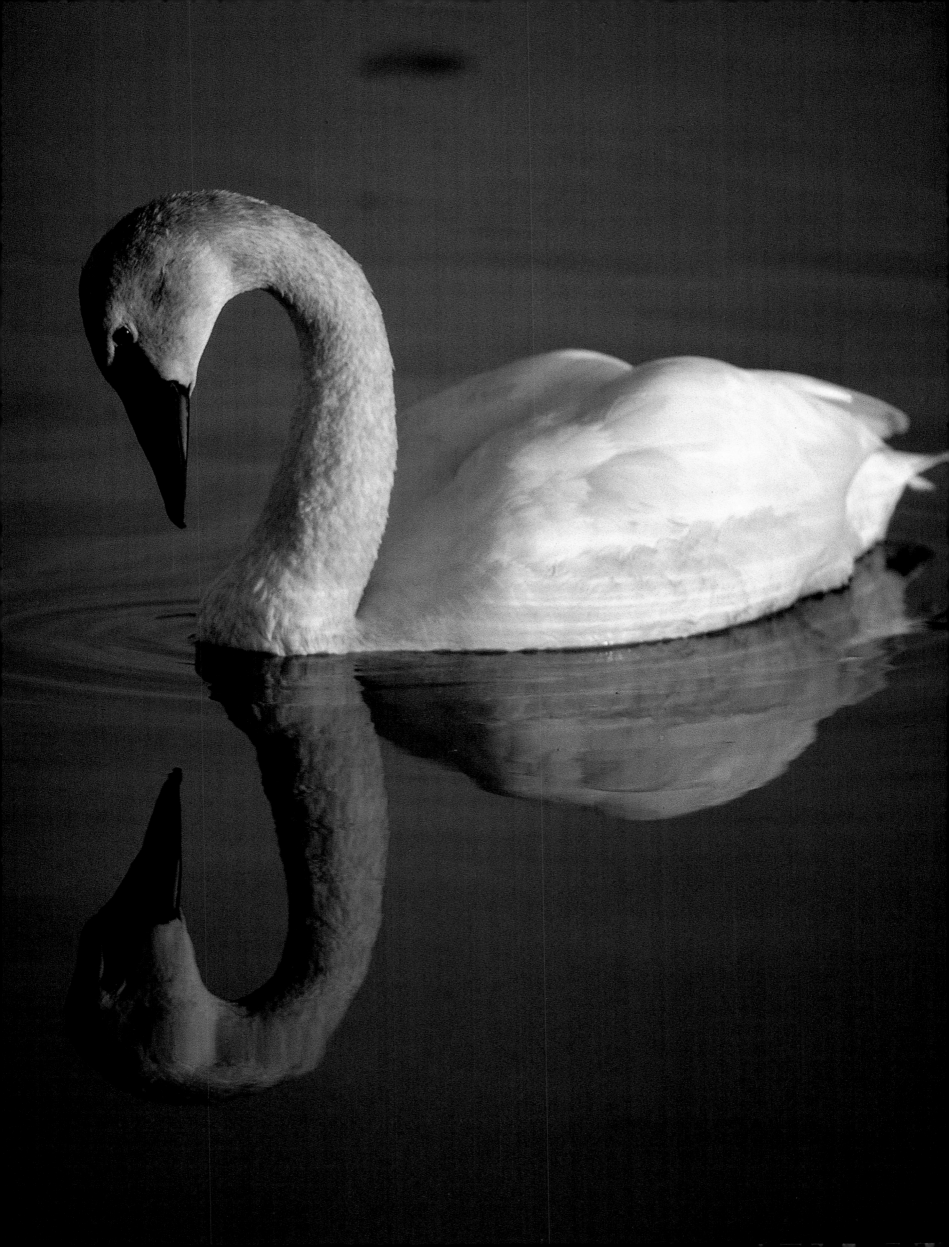

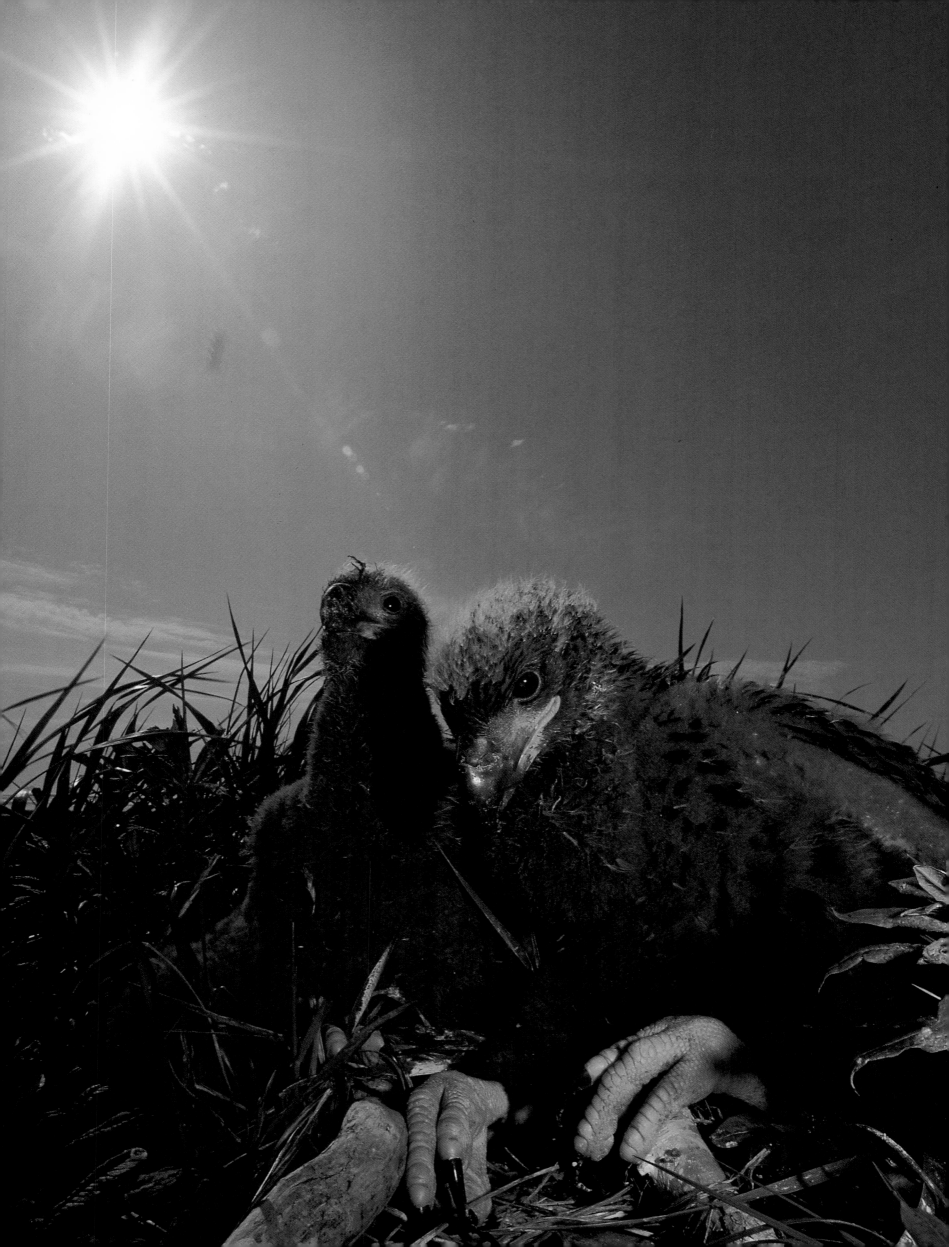

OPPOSITE PAGE

With down still on their heads and undeveloped wings, two thirty-day-old bald eaglets perch on the edge of their ground nest. Tugidik Island, Gulf of Alaska.

LEFT

Fox tracks along the Beaufort Sea in the Arctic winter light.

BELOW

This young red fox awakens after a nap in the rain outside his den on the Yukon River. Yukon Charlie River National Preserve.

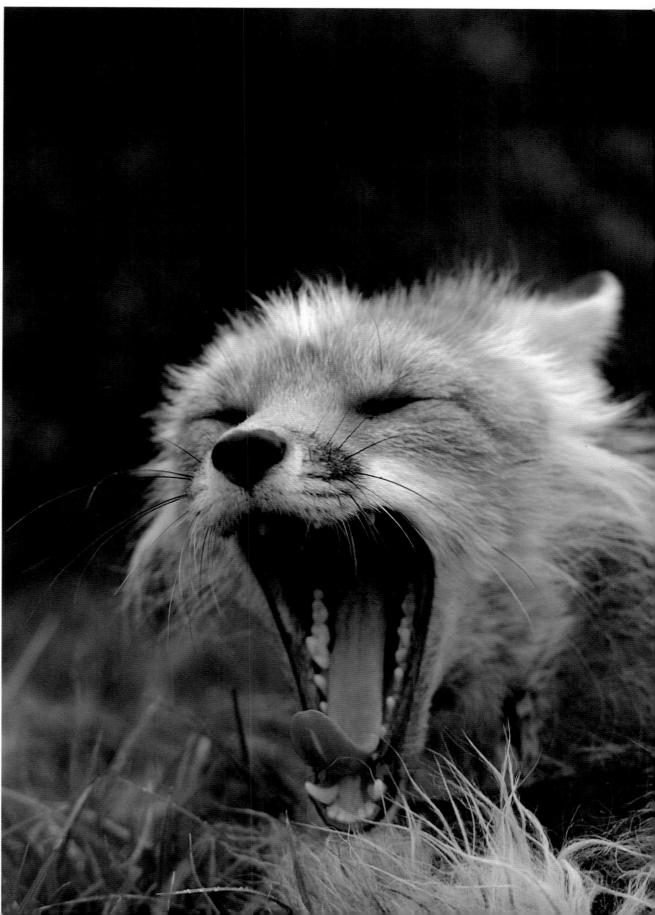

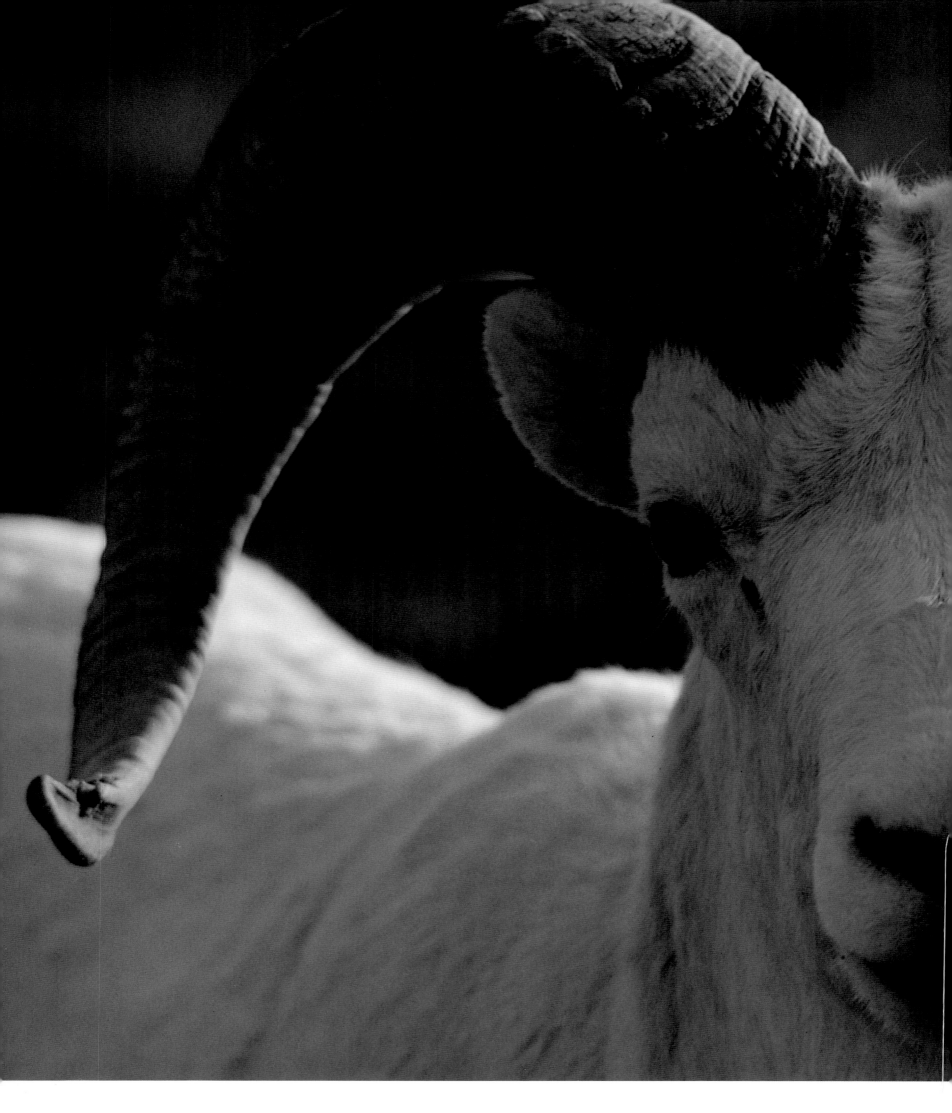

ALASKA

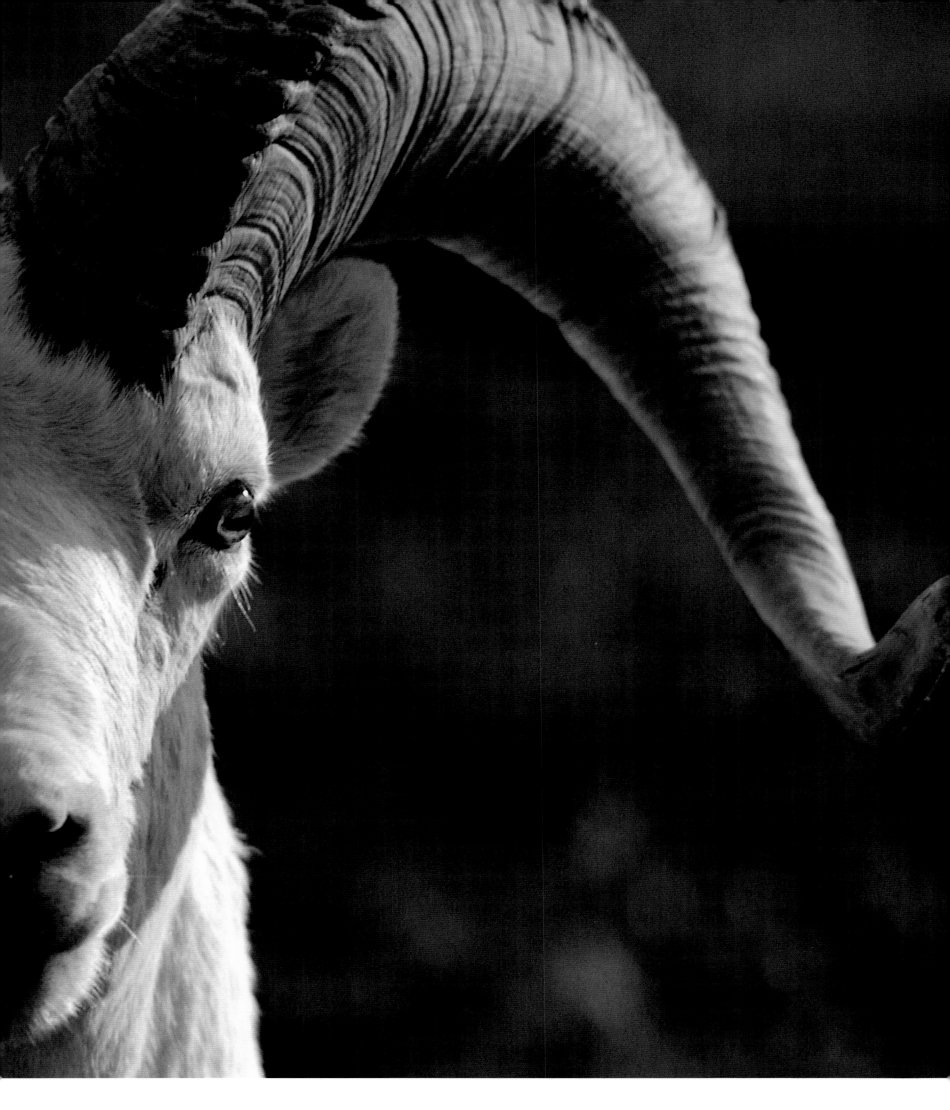

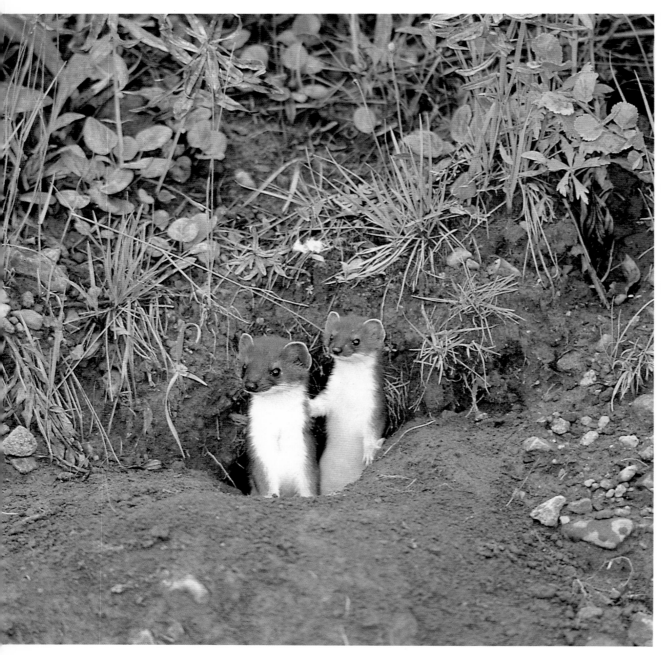

A Dall sheep searches out grasses and lichens high in the Wrangell–St. Elias Range. Alaska's Dall sheep are the only pure white wild sheep in North America. Both male and female Dalls grow horns, which are made of keratin. They live throughout all of Alaska's mountain ranges and have only two predators: wolves and man.

LEFT

These two short-tailed weasels in their summer phase are watching a grizzly bear digging up the burrow they are inhabiting. Denali Park and Preserve.

OPPOSITE PAGE

A night hunter, this rather large cross red fox stalks voles and mice. Below the Maclaren Summit off the Maclaren River in the Alaska Range.

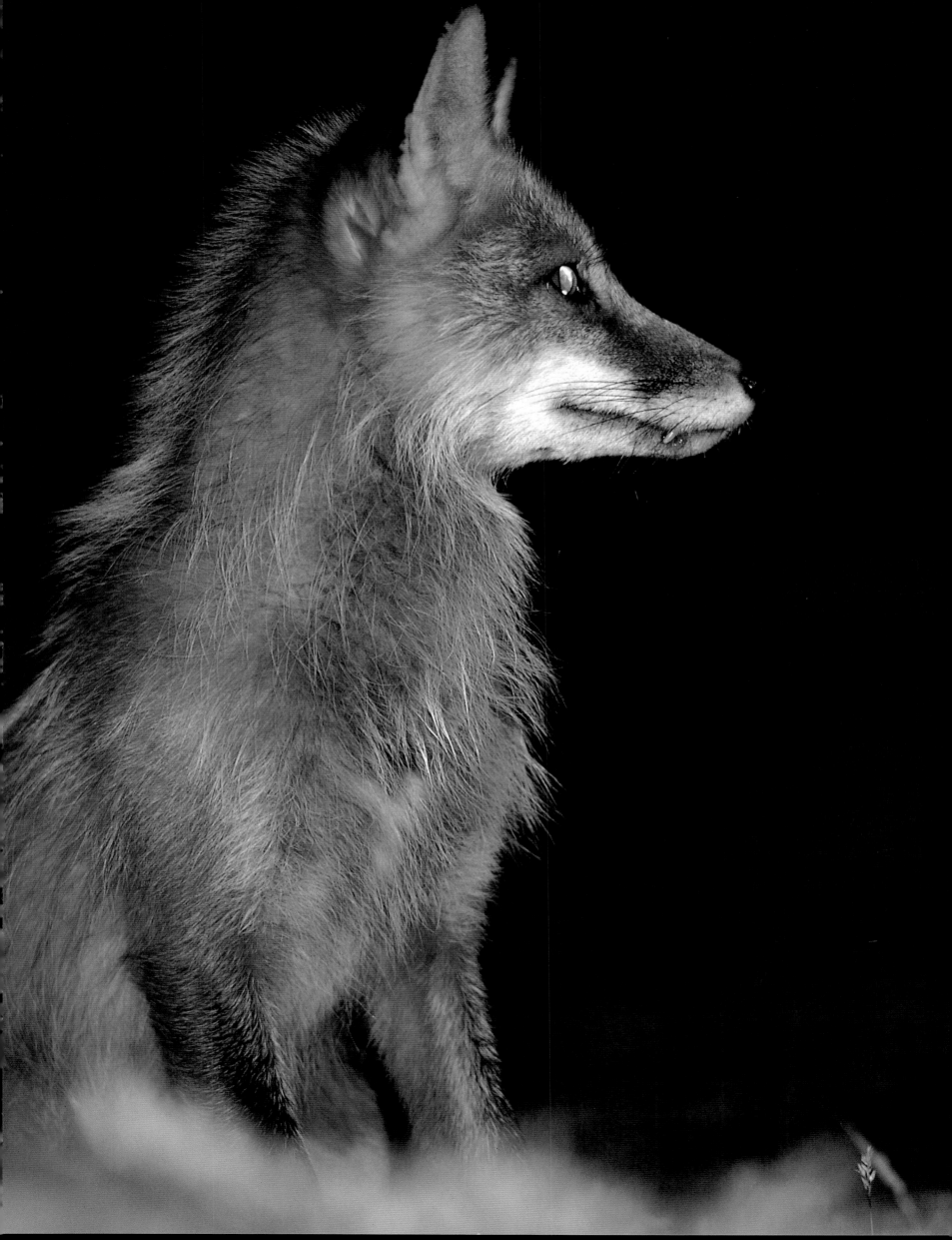

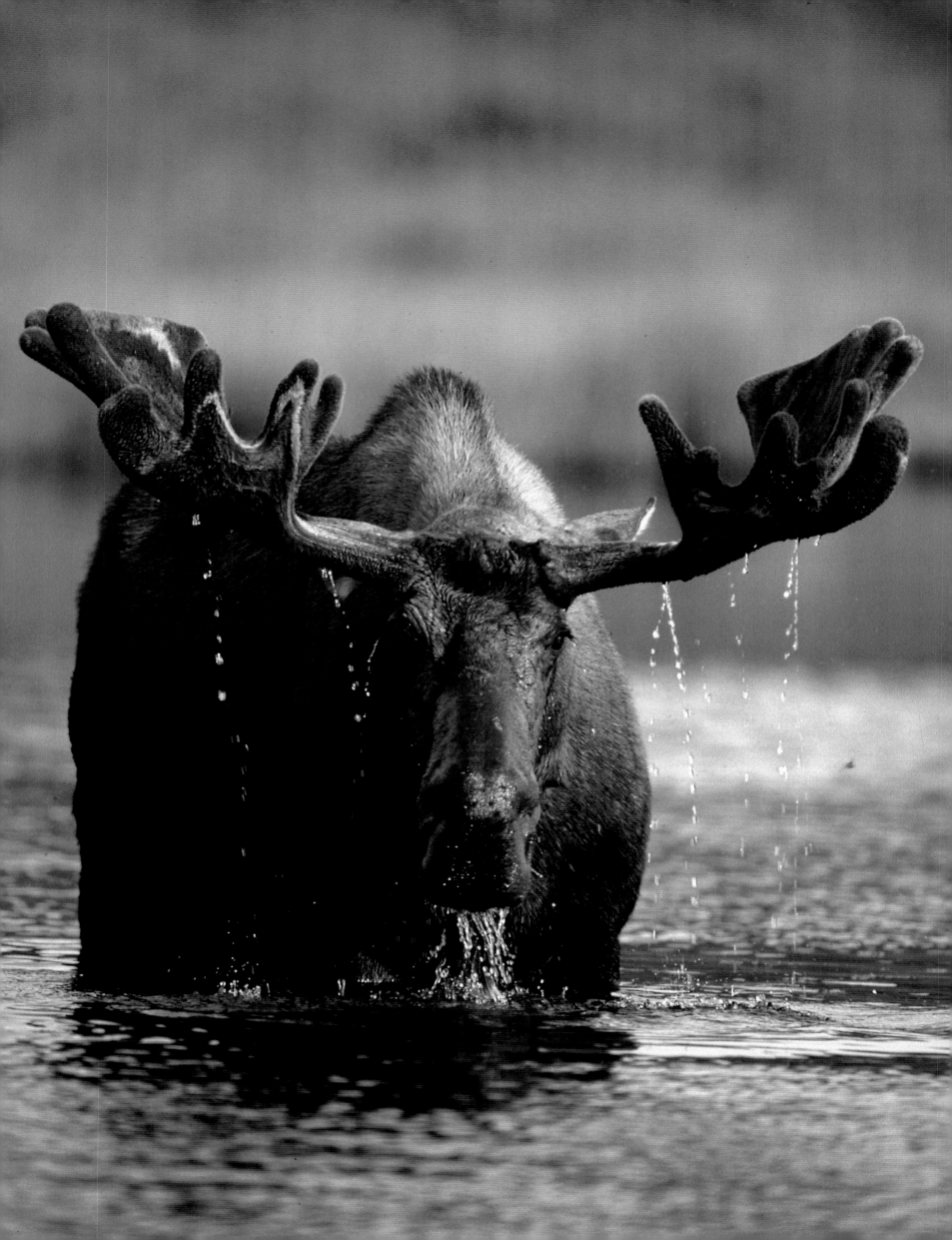

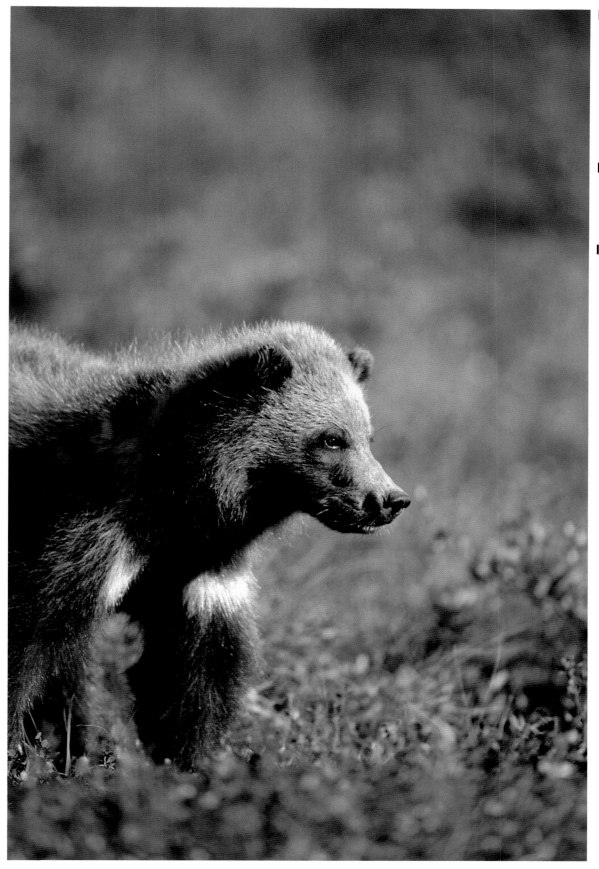

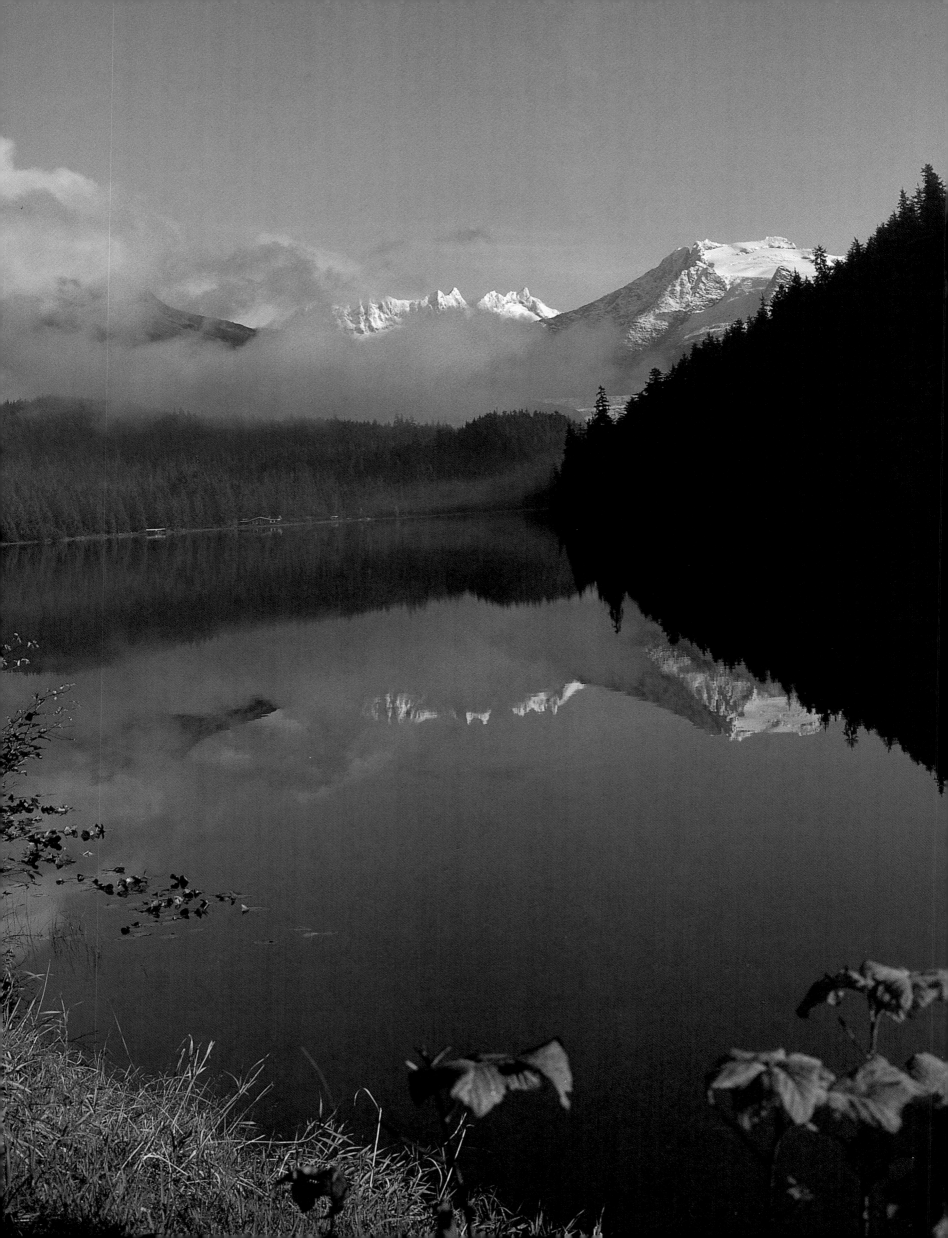

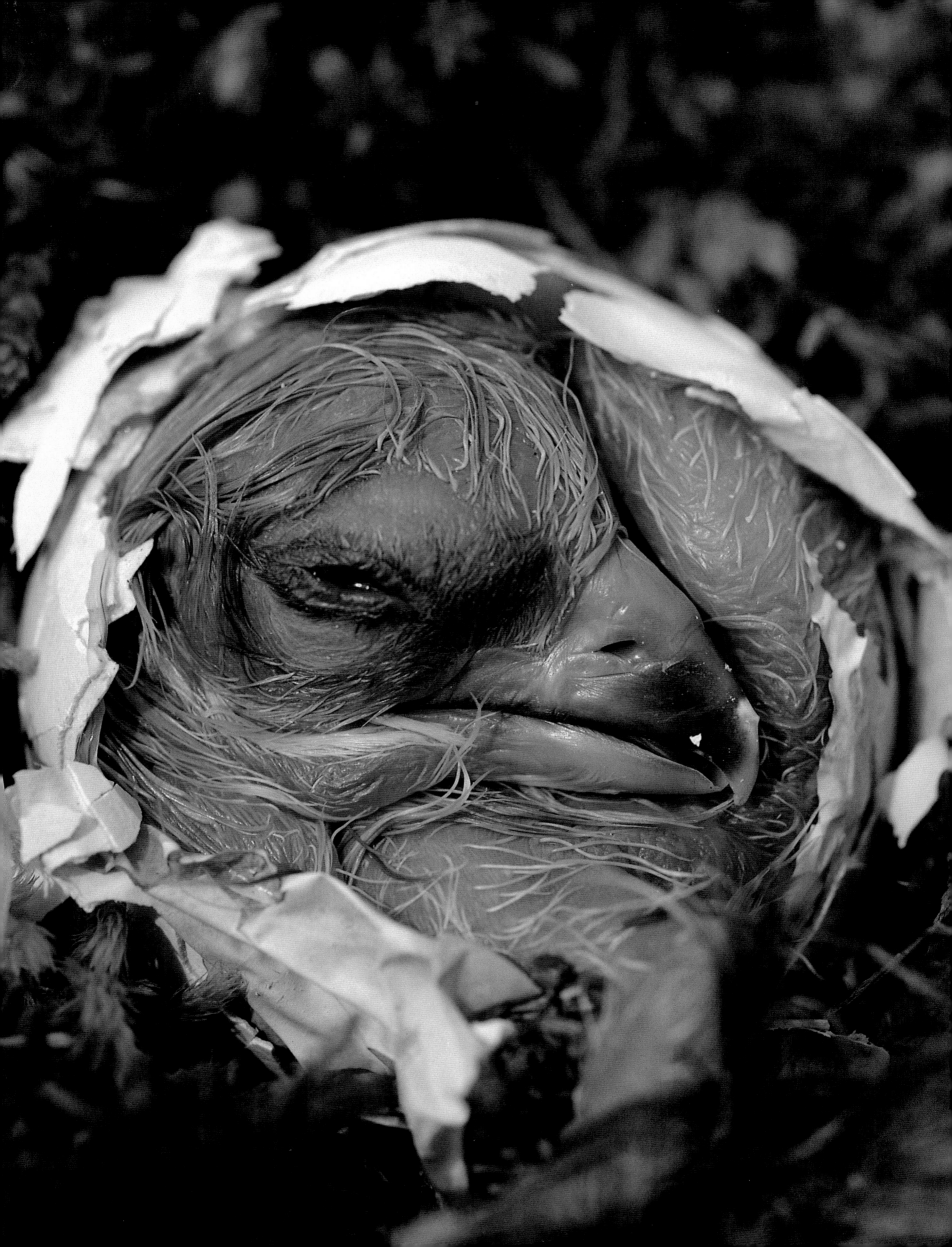

A baby bald eagle hatches with great difficulty after chipping open the egg from inside with its pippin tooth atop its beak. Eagles are the fastest-growing birds in North America: in less than eight weeks a baby eaglet will grow from the size of a softball to nearly three feet tall.

Normally, seagulls are found near the ocean, but young gulls seem to prefer inland waterways and can be found on remote ponds and swamps of the Interior. Eureka Summit, Richardson Highway.

A high mountain grizzly forages through the bushes in search of berries and roots. Sable Pass, Denali Park and Preserve.

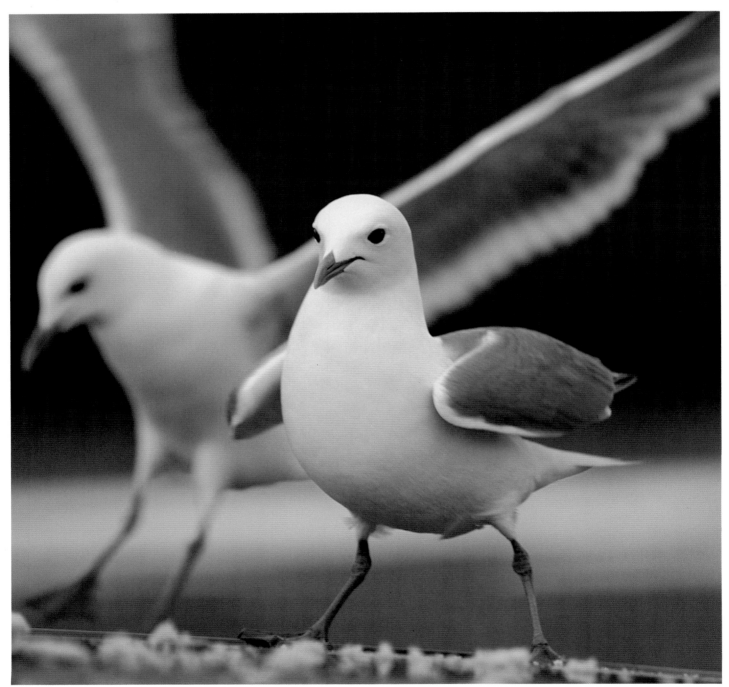

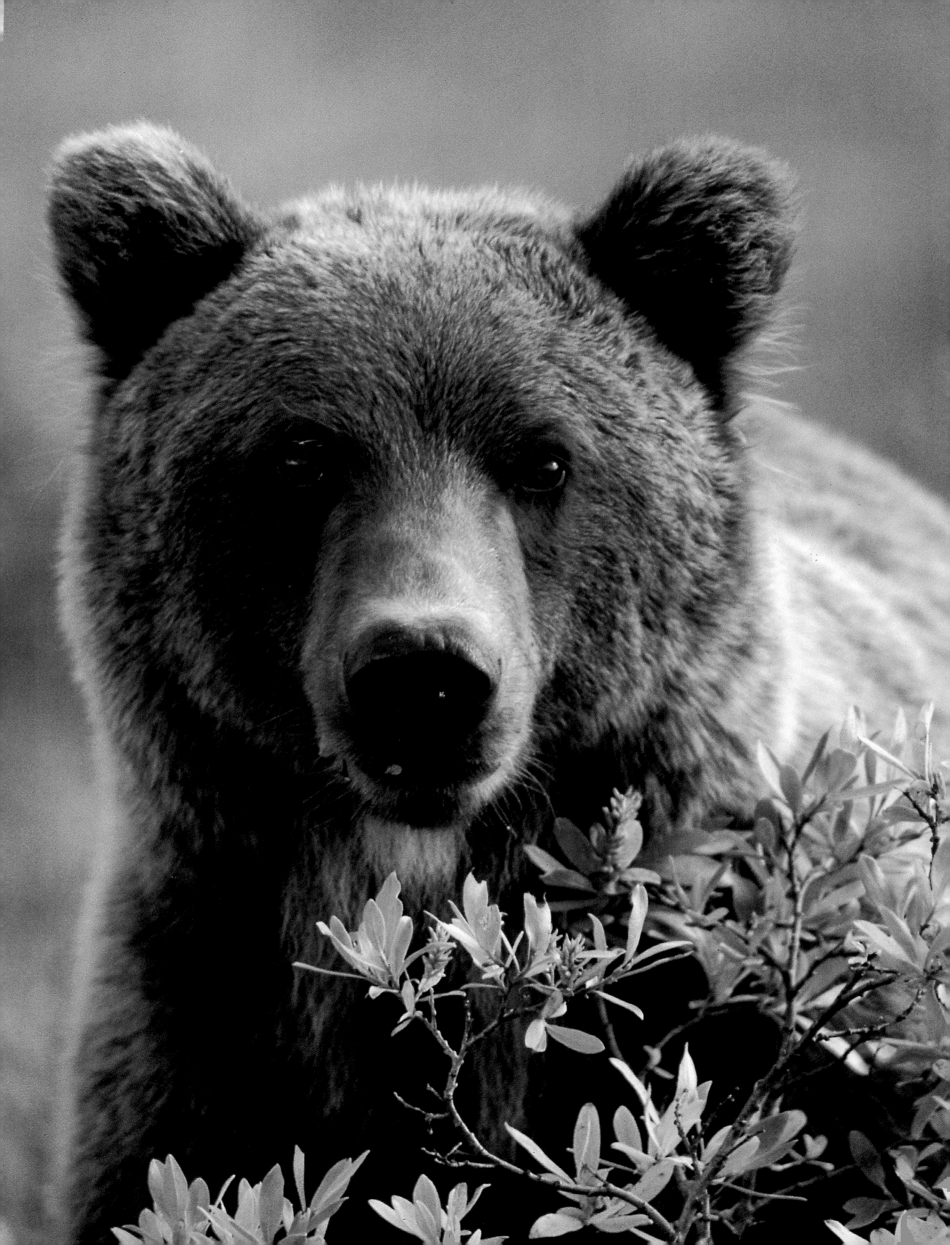

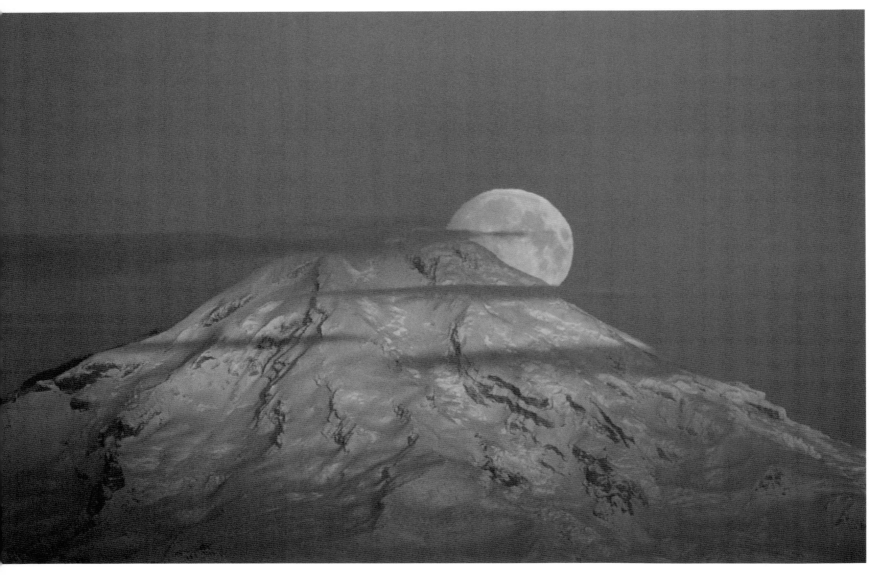

Mount Redoubt catching the first rays of sunrise as the moon sets behind it. This unpredictable volcano has erupted three times over the last several years. Chigmit Mountains, not far from Anchorage.

Majestic Mount Redoubt, an active volcano, towers over a small float plane landing on a remote lake.

A female moose and her two-year-old calf browse the remaining foliage before winter. Along Snug Harbor Road near Cooper Landing.

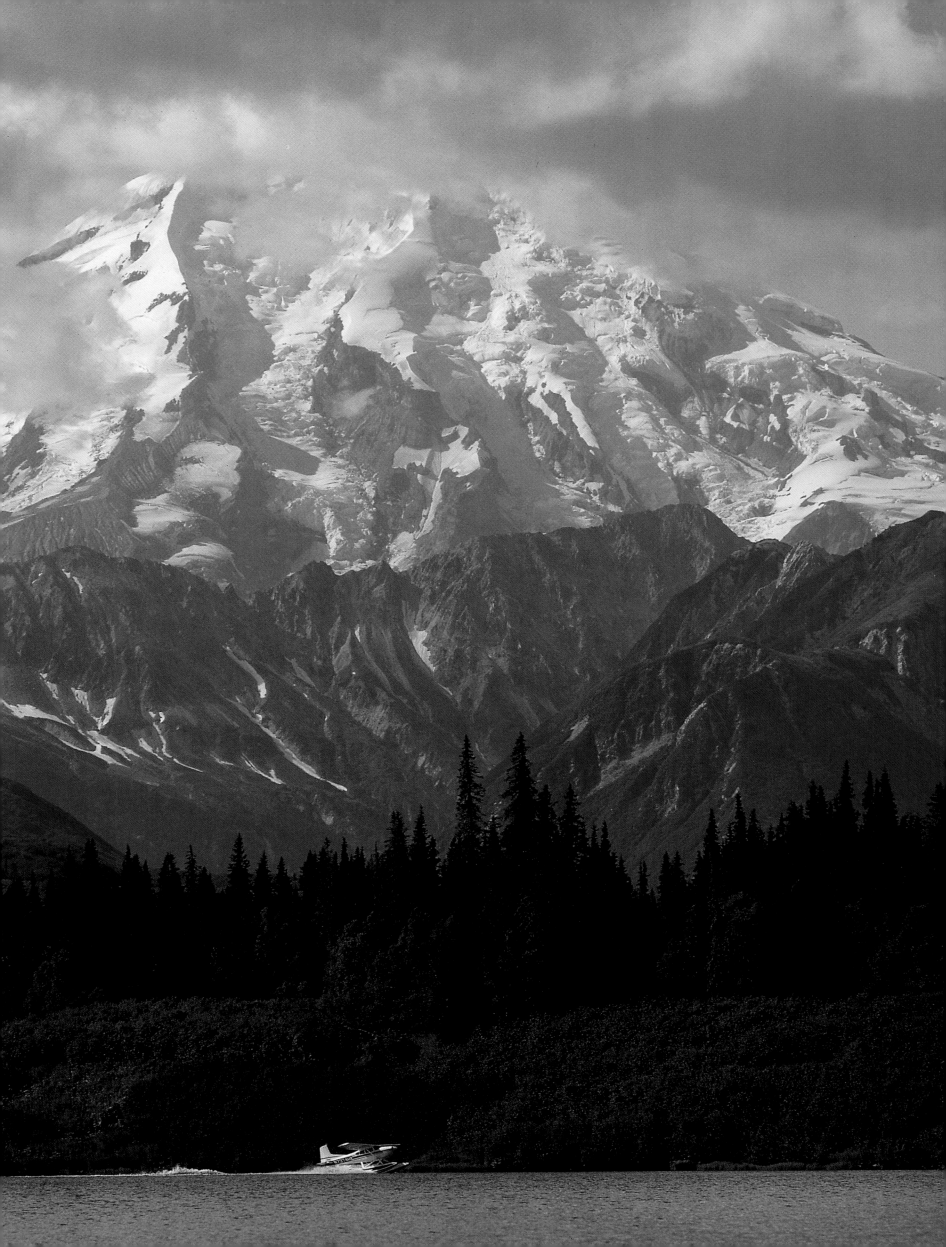

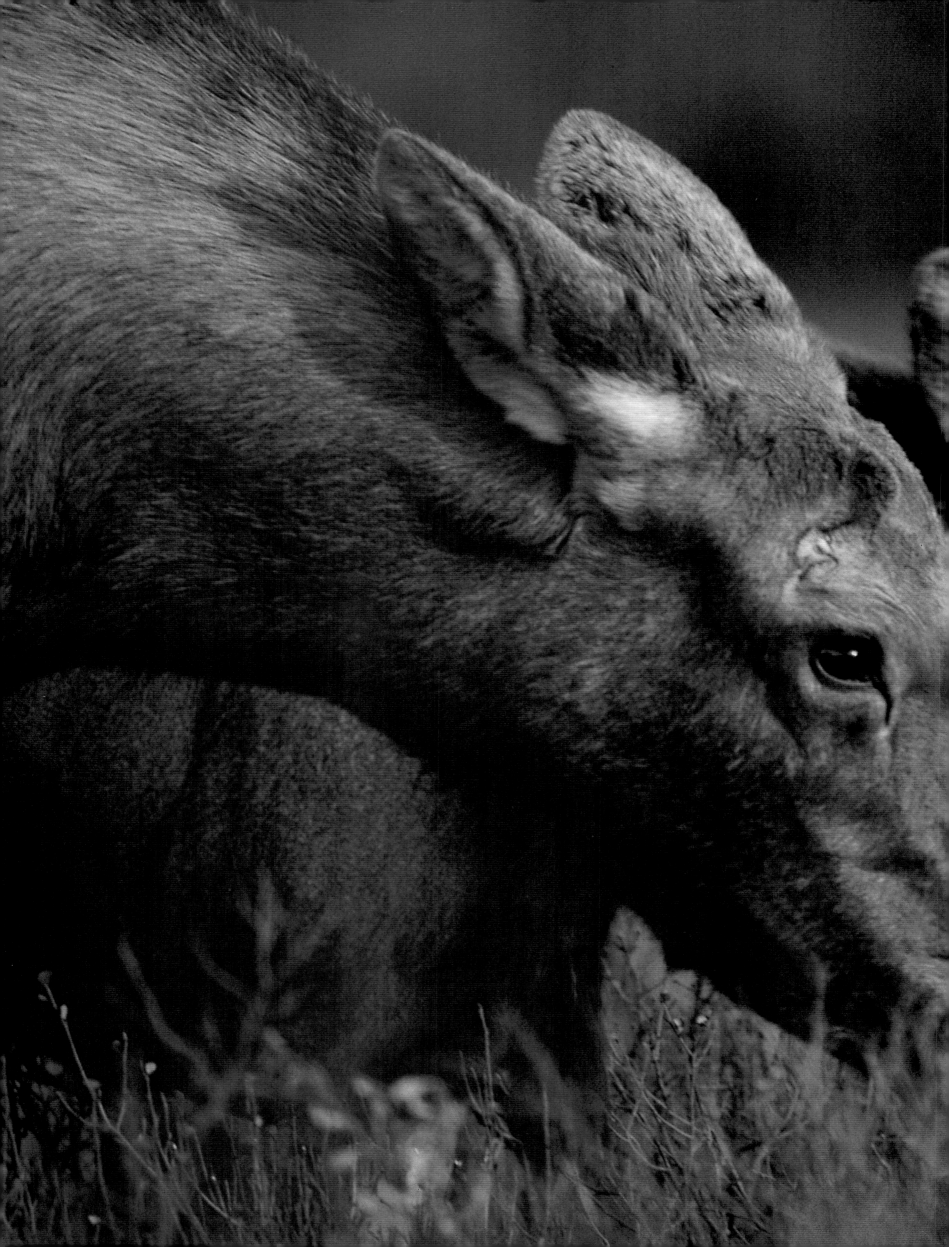

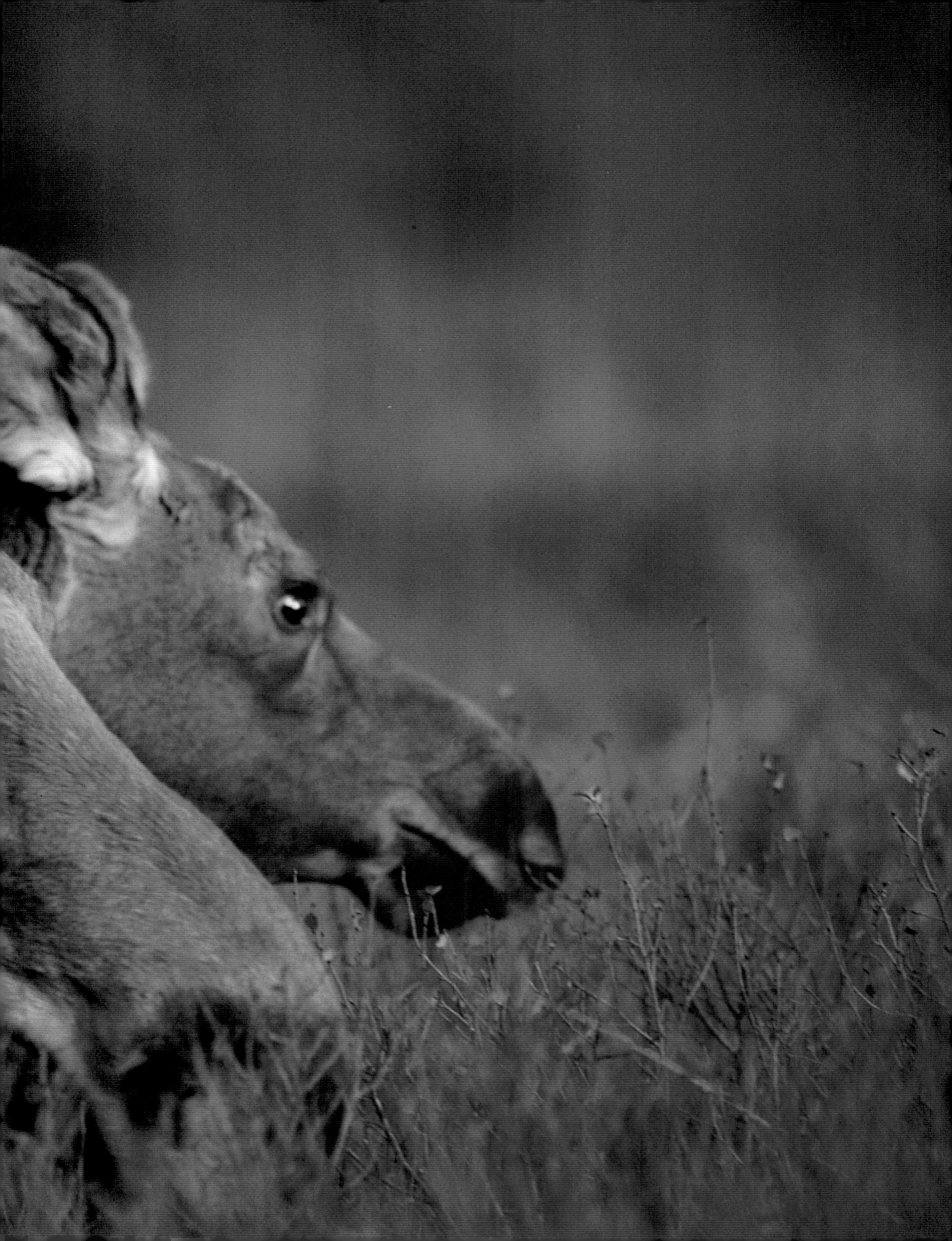

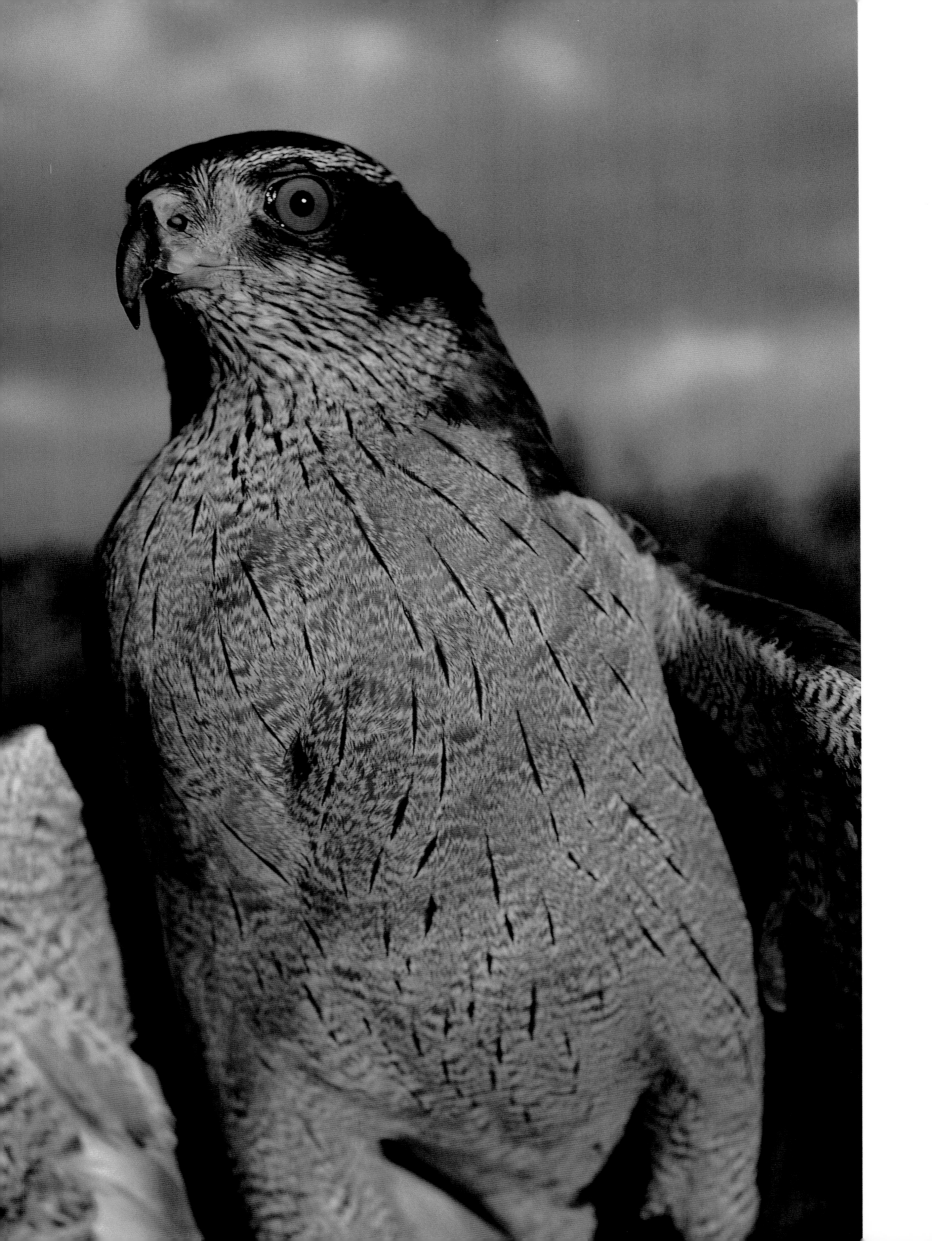

A fierce goshawk in the Tangle Lakes region of the Denali Highway. This area has more nesting birds of prey than any other part of Alaska.

A loon hatching in the backwater swamps of the Chugach Forest on the Kenai Peninsula.

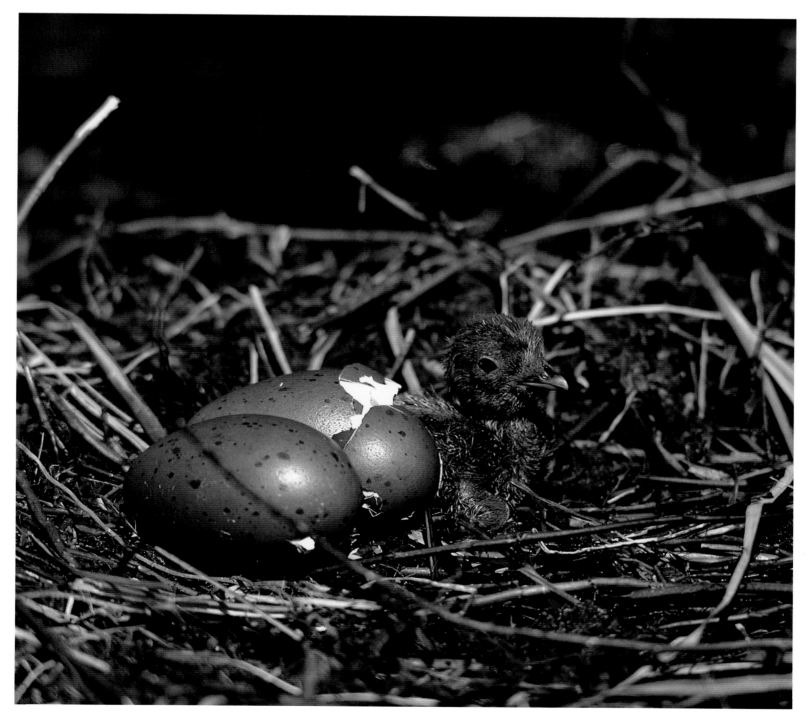

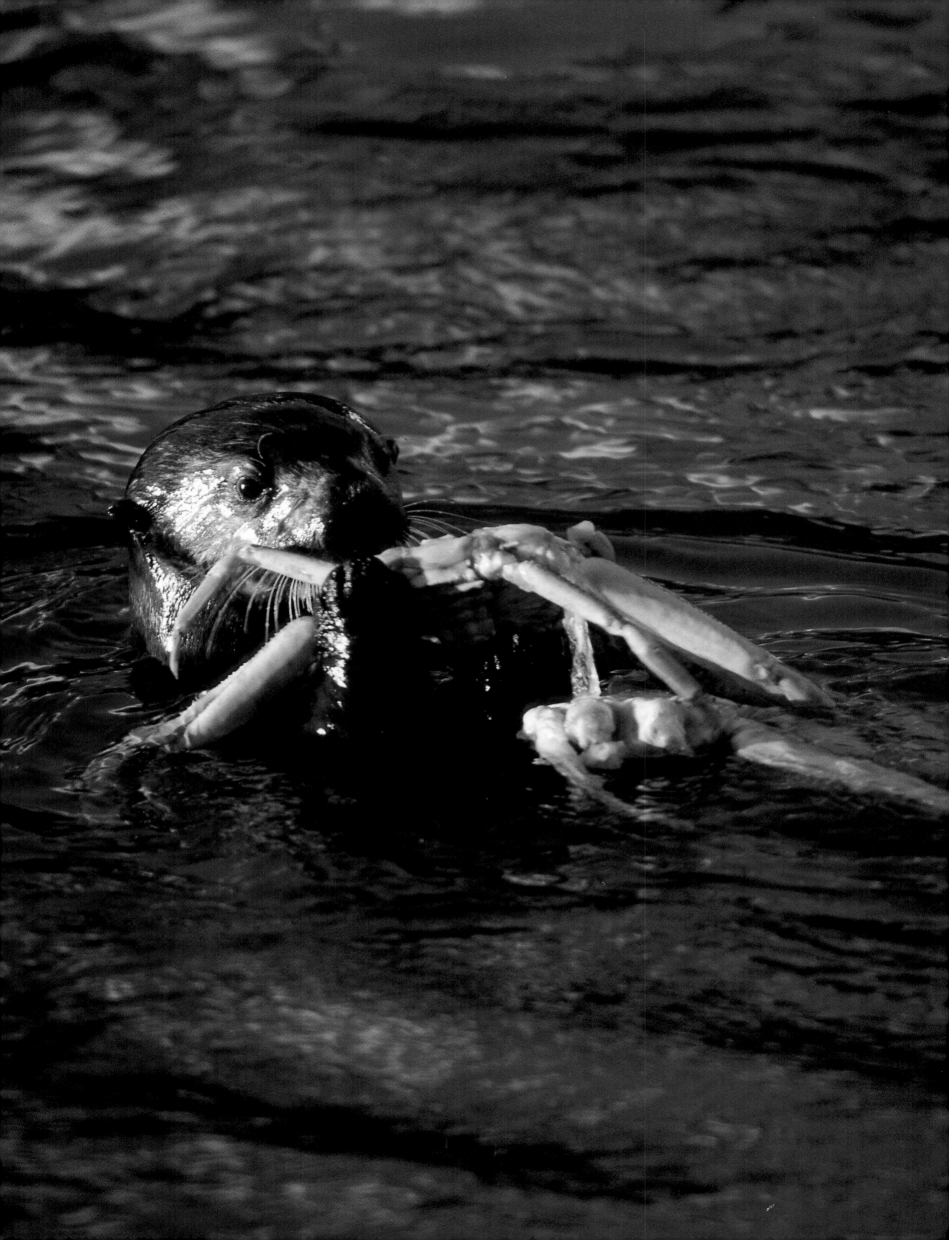

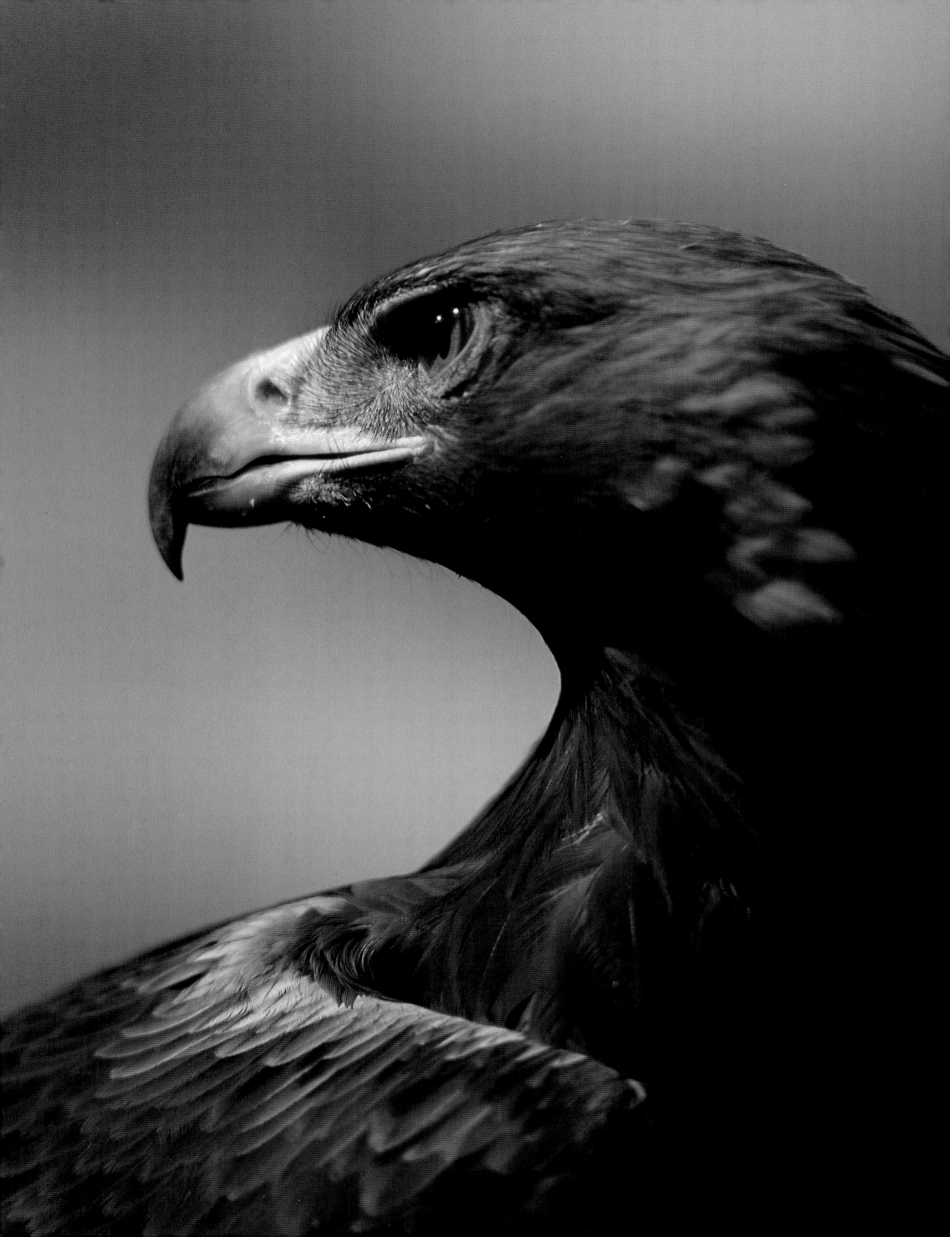

A sea otter dines on his favorite meal, king crab. Shemya, Aleutian Islands.

A golden eagle surveys his domain high up in the Talkeetna Mountains.

Windswept snow at sixty-five degrees below zero. Bering Sea, Nome.

The rich colors of fall and a grizzly bear seeking food for its winter hibernation. Igloo Creek area, Denali Park and Preserve.

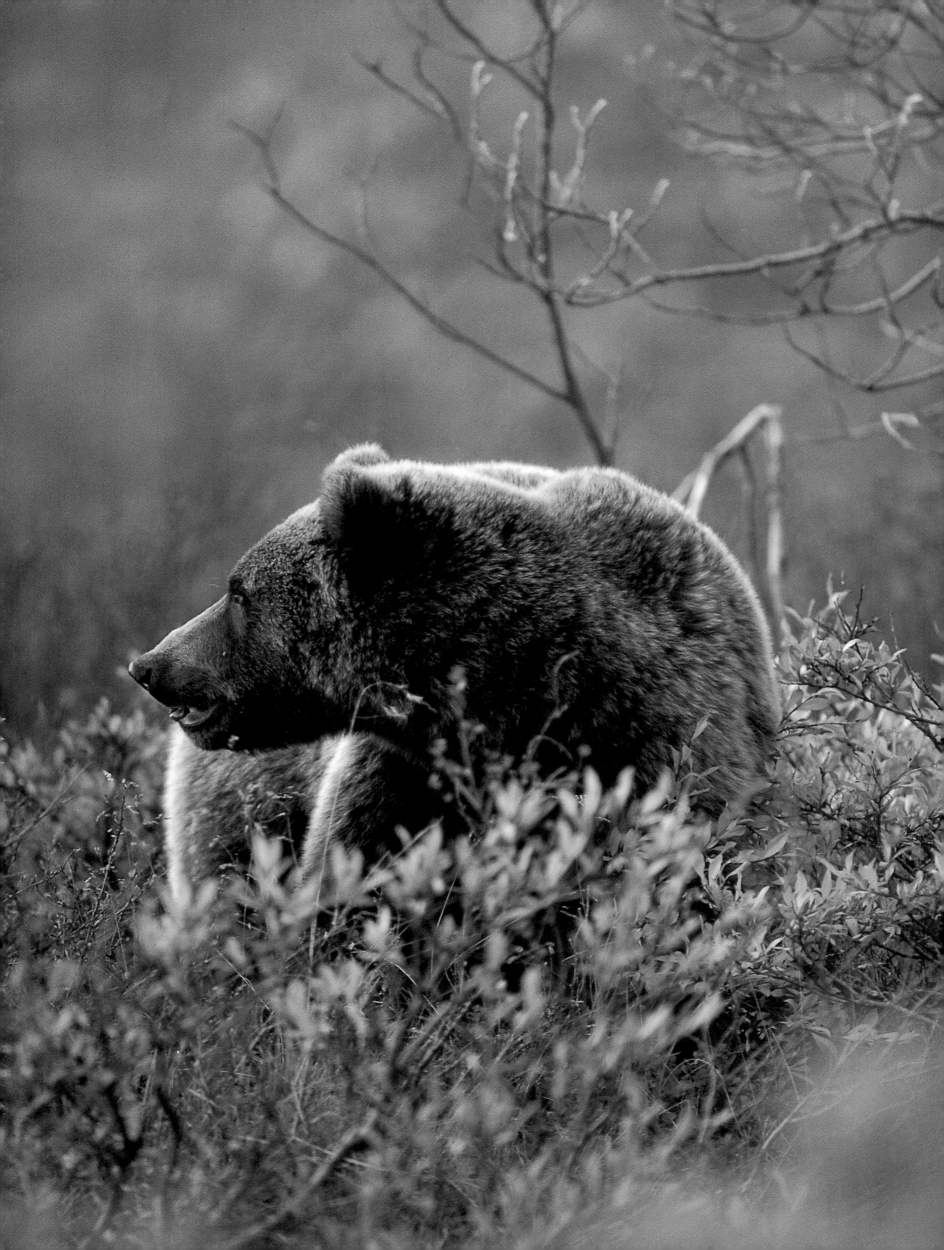

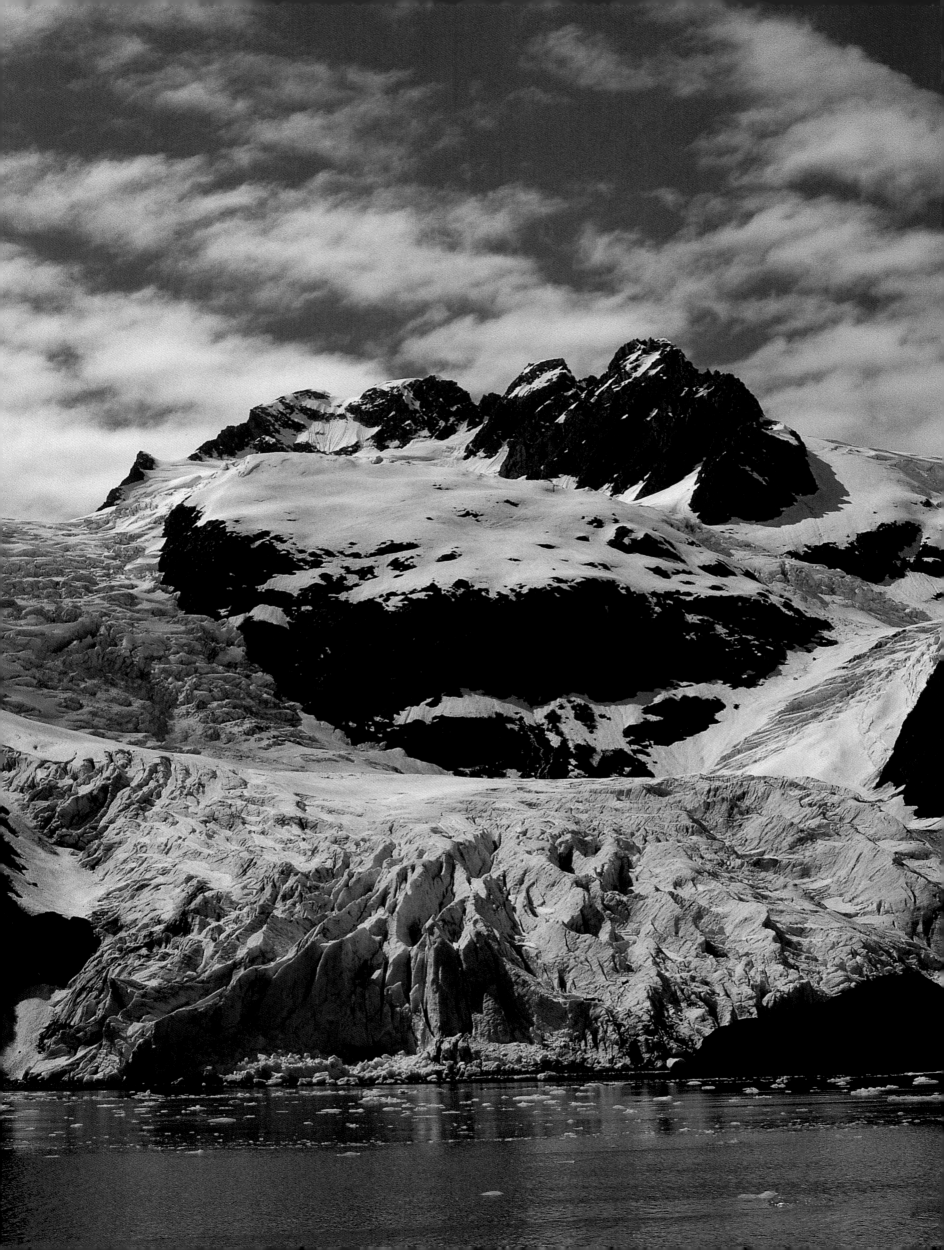

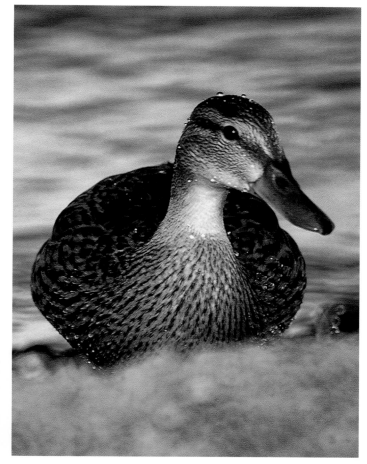

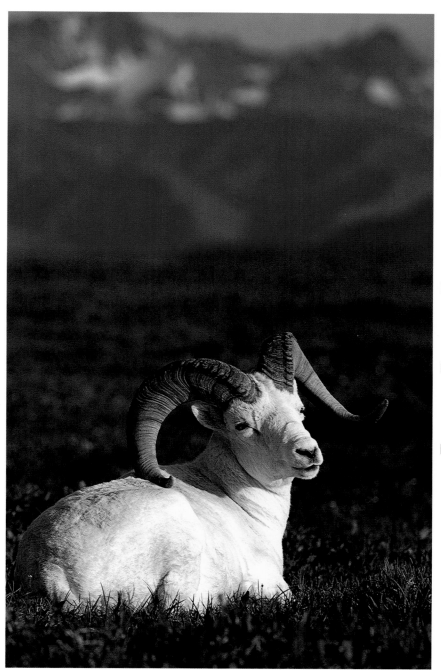

OPPOSITE PAGE

Holgate Glacier flows from the Harding Icefield into the ocean. Harding Icefield is one of the largest continuous icefields in the world. Kenai Fjords National Wildlife Refuge.

ABOVE

Water droplets catch the sun as a female mallard emerges from the waters of the Gulkana River.

LEFT

This Dall sheep relaxes in the midnight sun atop Primrose Peak in Denali Park and Preserve.

FOLLOWING PAGES

Iliamna Volcano and its sister peaks as a spring storm passes. This volcano, although active, has not had a major eruption for a few thousand years.

A Photographic Journey Through the Last Wilderness

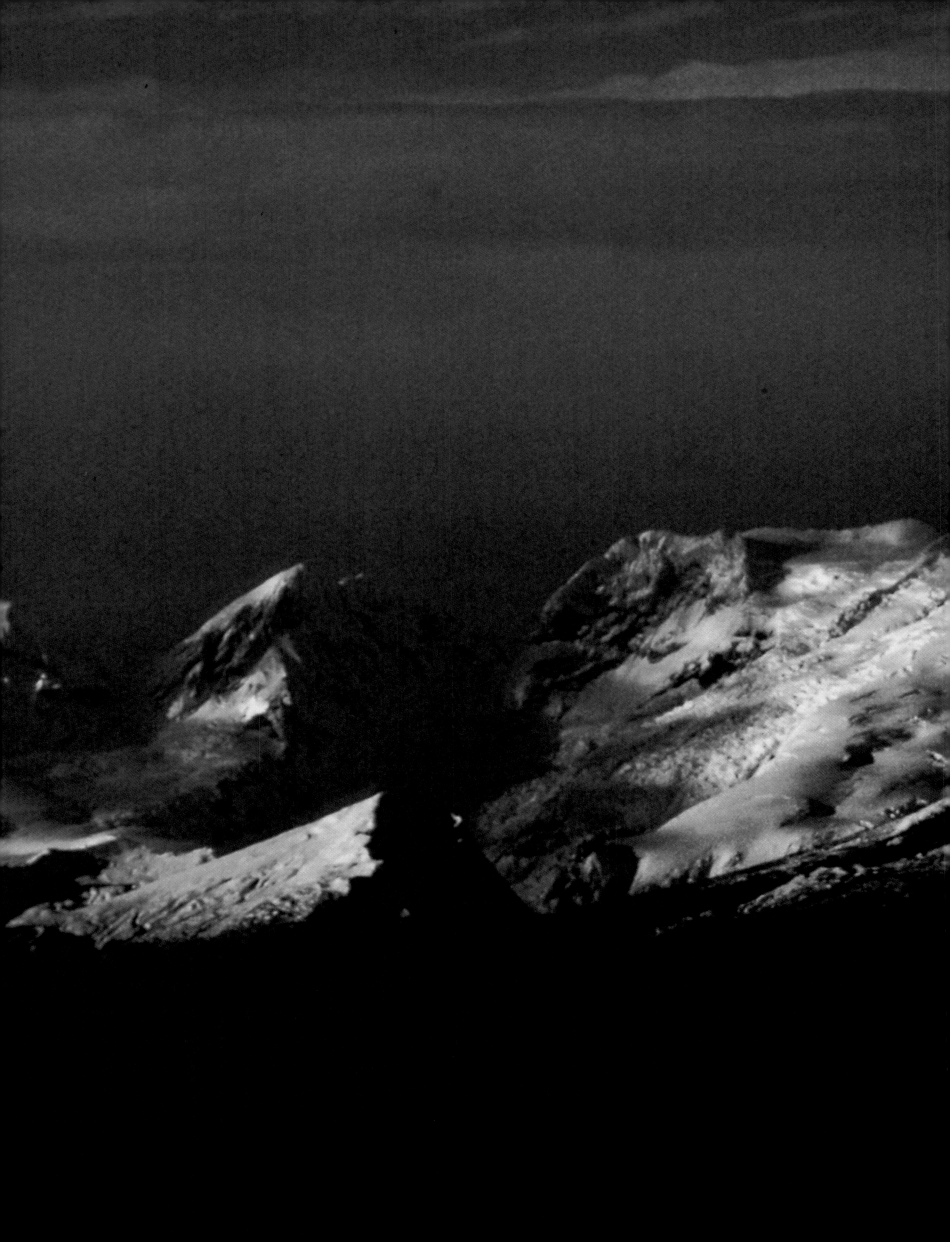

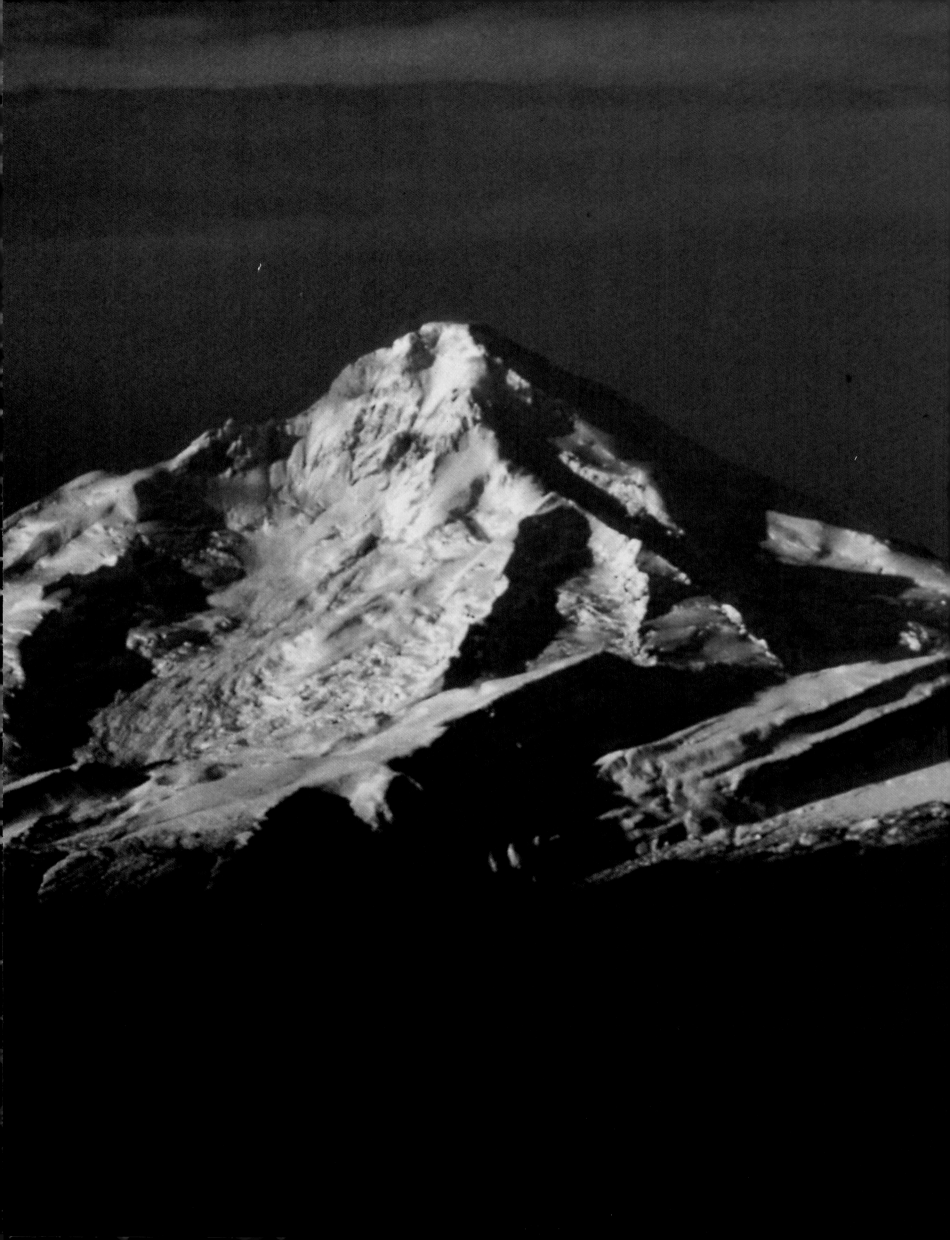

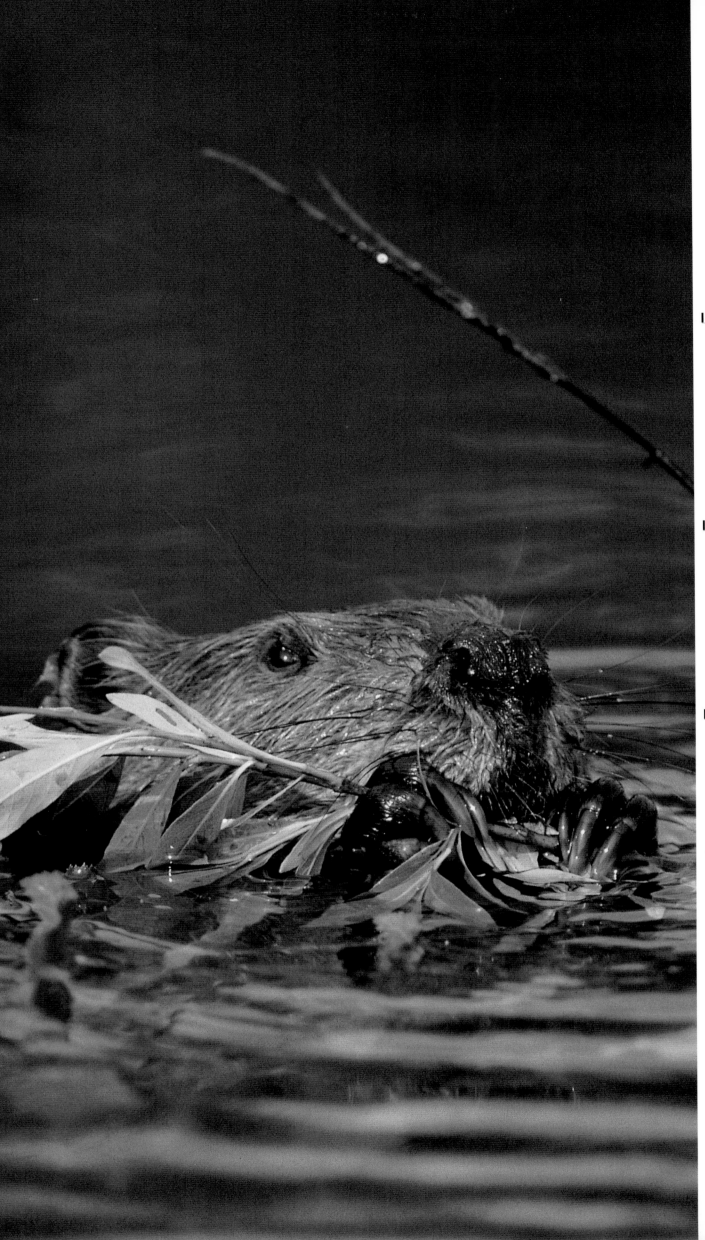

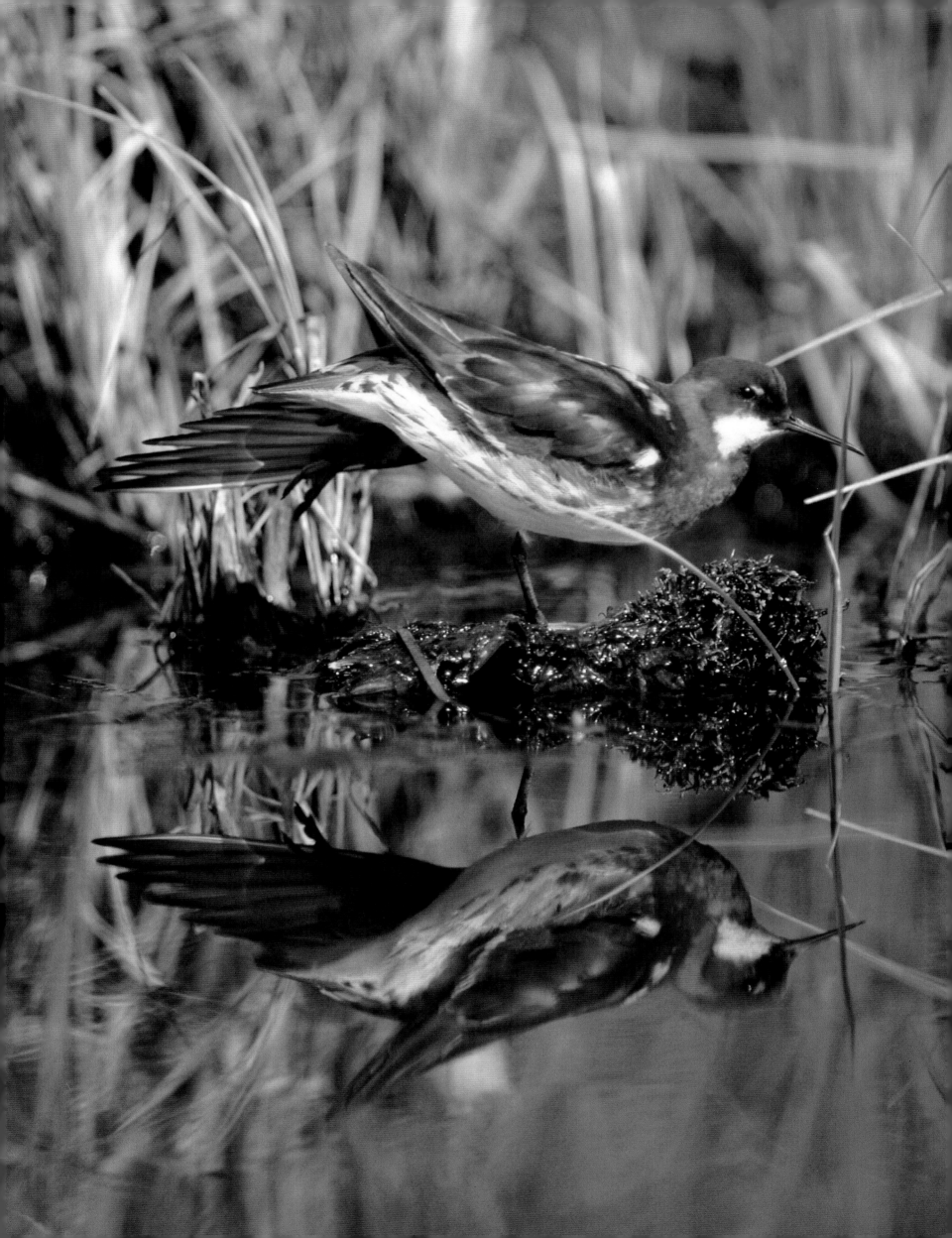

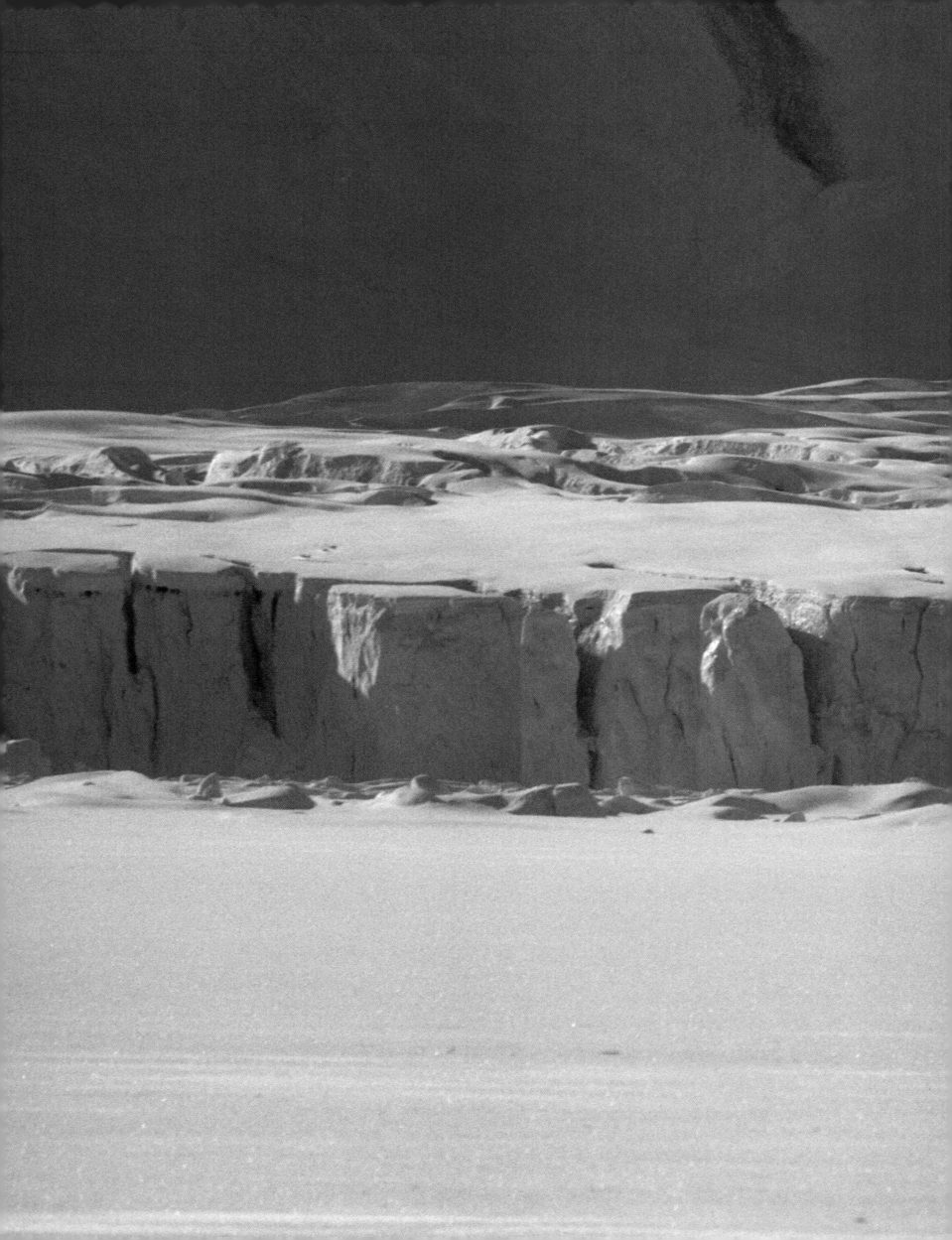

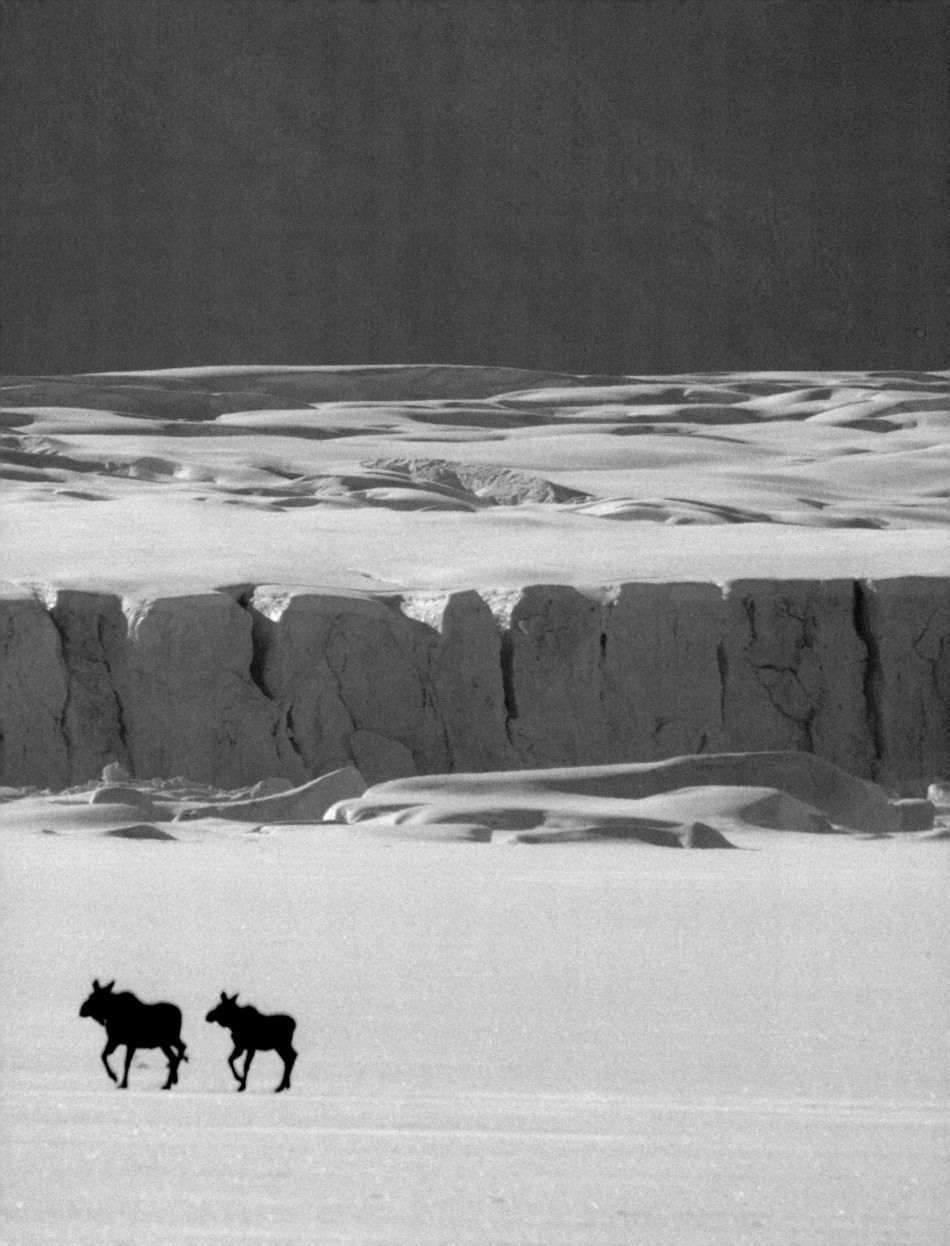

ALASKA

OPPOSITE PAGE

Spring poppies, just hours before they bloom. Naknek Lake, Katmai National Park.

BELOW

The look in this brown bear's eyes and the hair raised on his back indicate the author is much too close. Southeast Alaska, Admiralty Island.

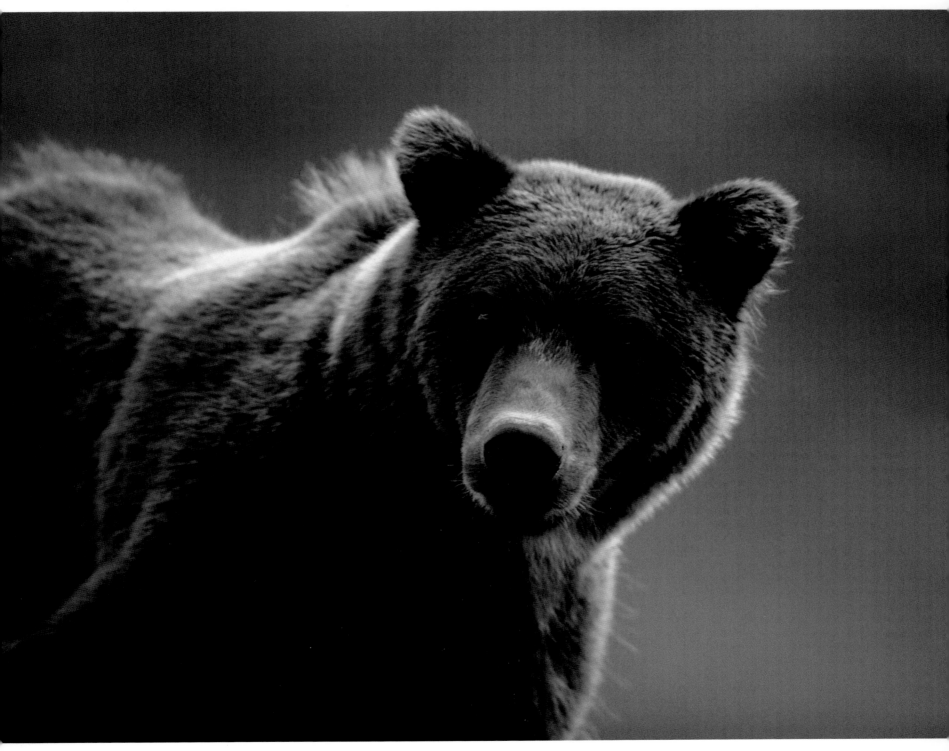

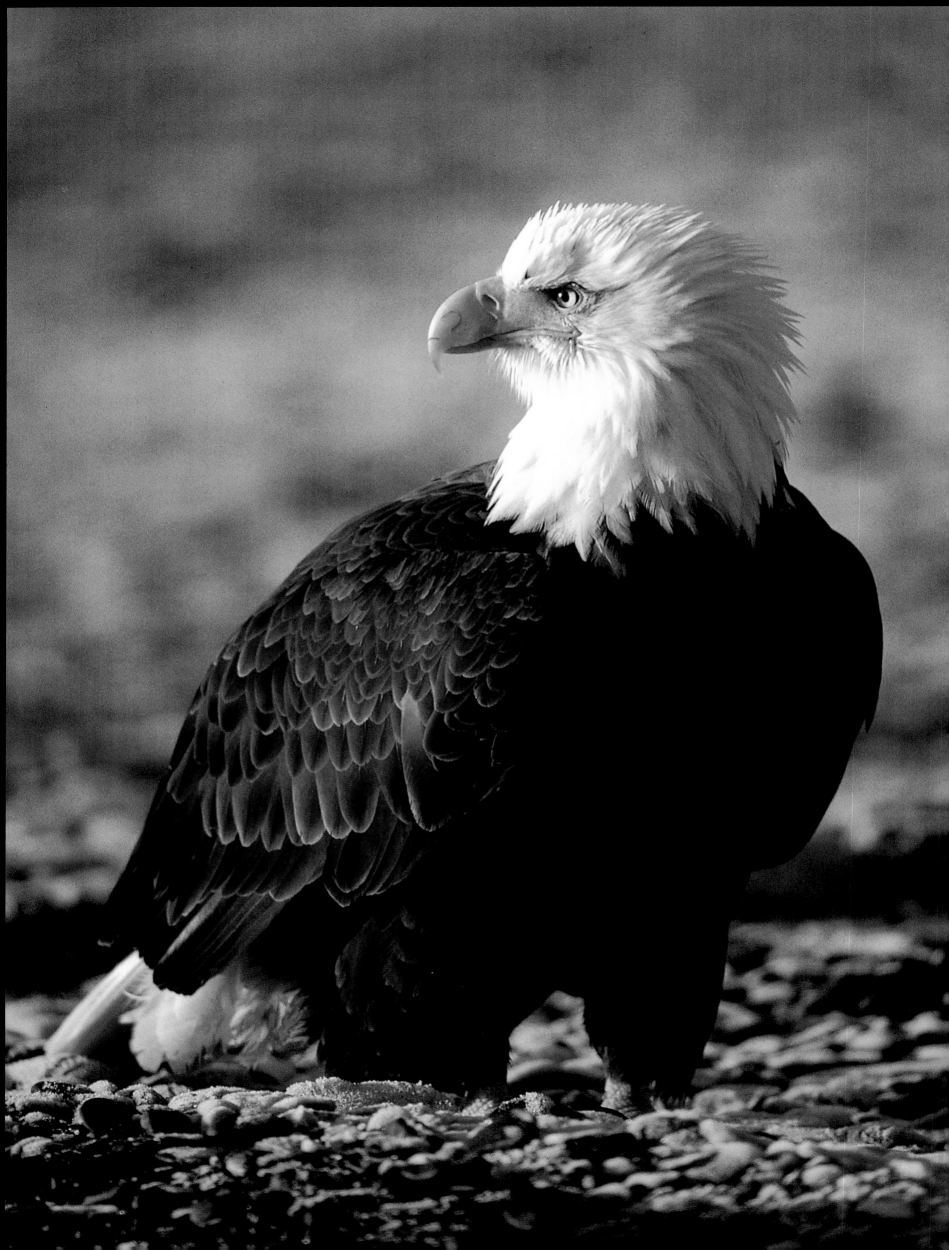

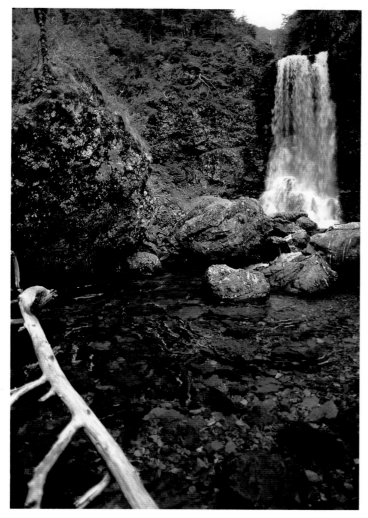

A mature bald eagle bristles his feathers in an attempt to appear larger to another eagle looking to encroach on his fishing spot. Kenai River, Kenai National Wildlife Refuge.

Humpy Cove teeming with salmon. Resurrection Bay, near Seward.

On the banks of the Upper Kenai River, a mature bald eagle and his shadow plummet toward his mate as she eats a spawned-out silver salmon carcass. The Upper Kenai River hosts the second-largest concentration of wintering eagles in the world.

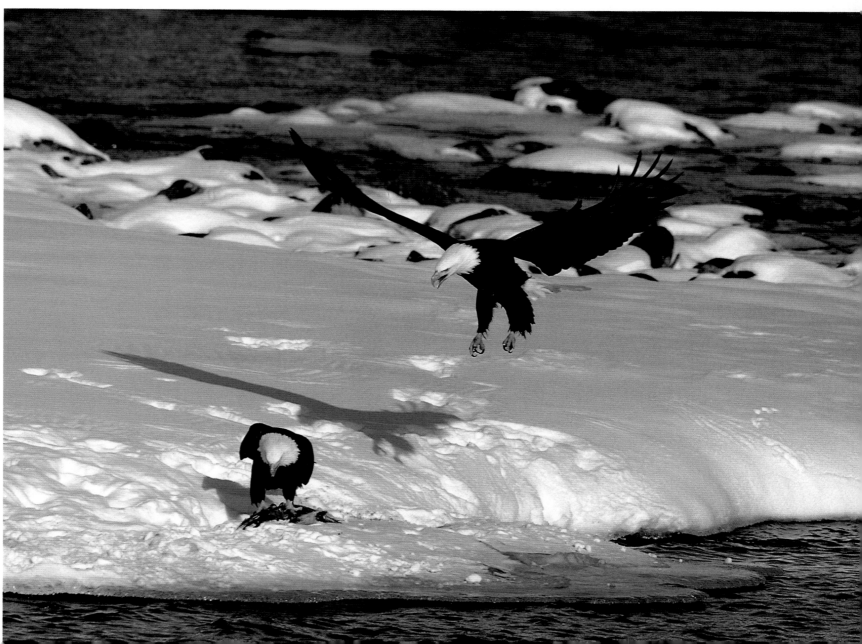

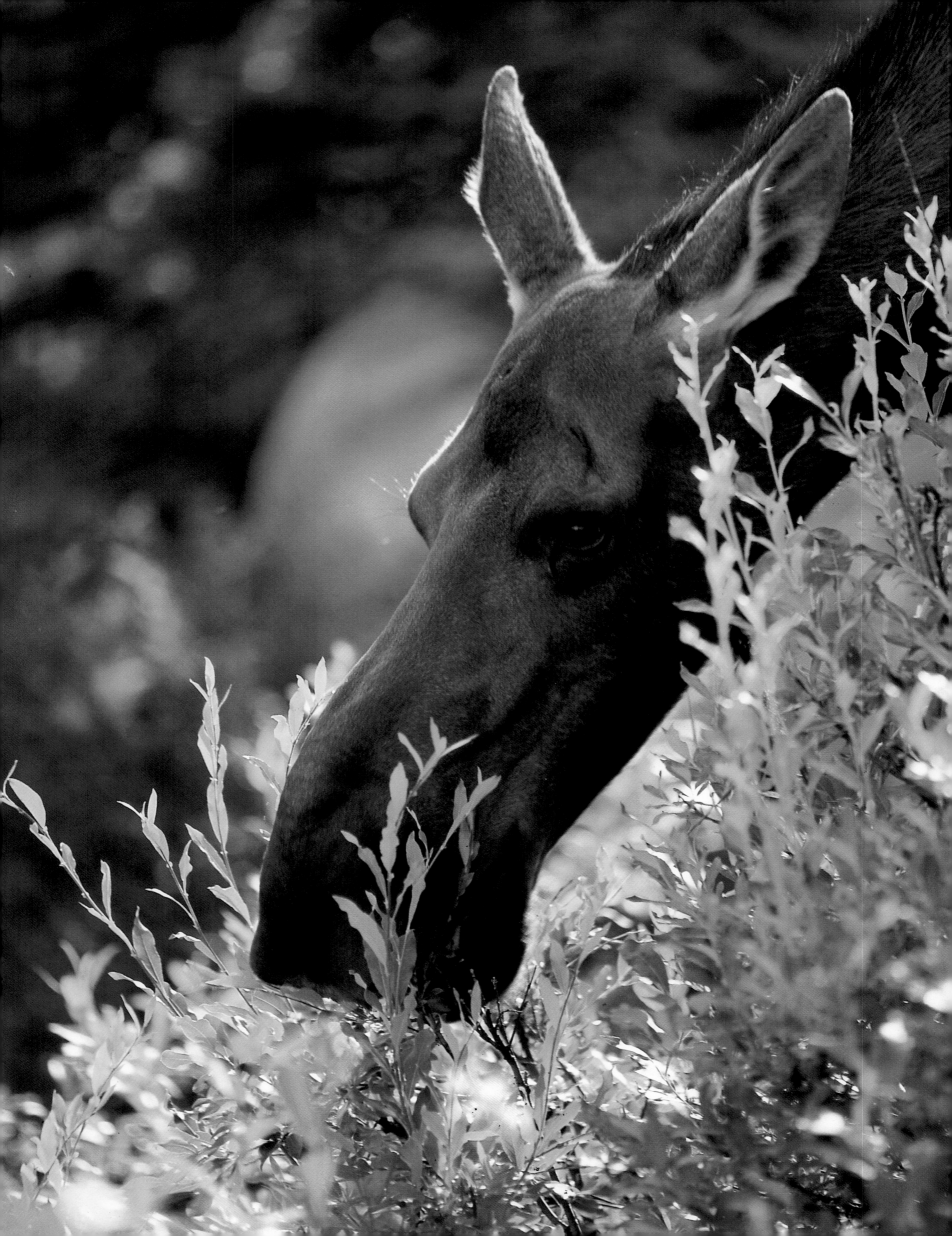

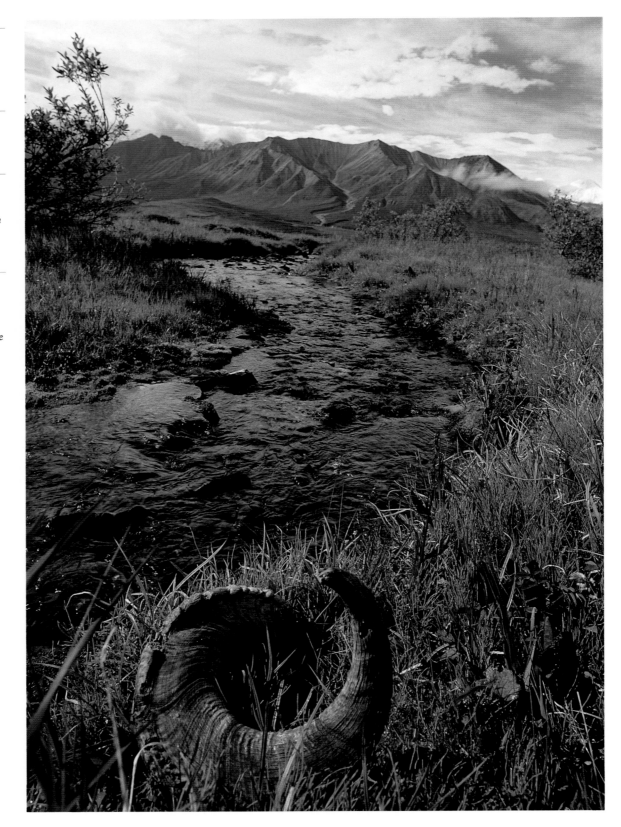

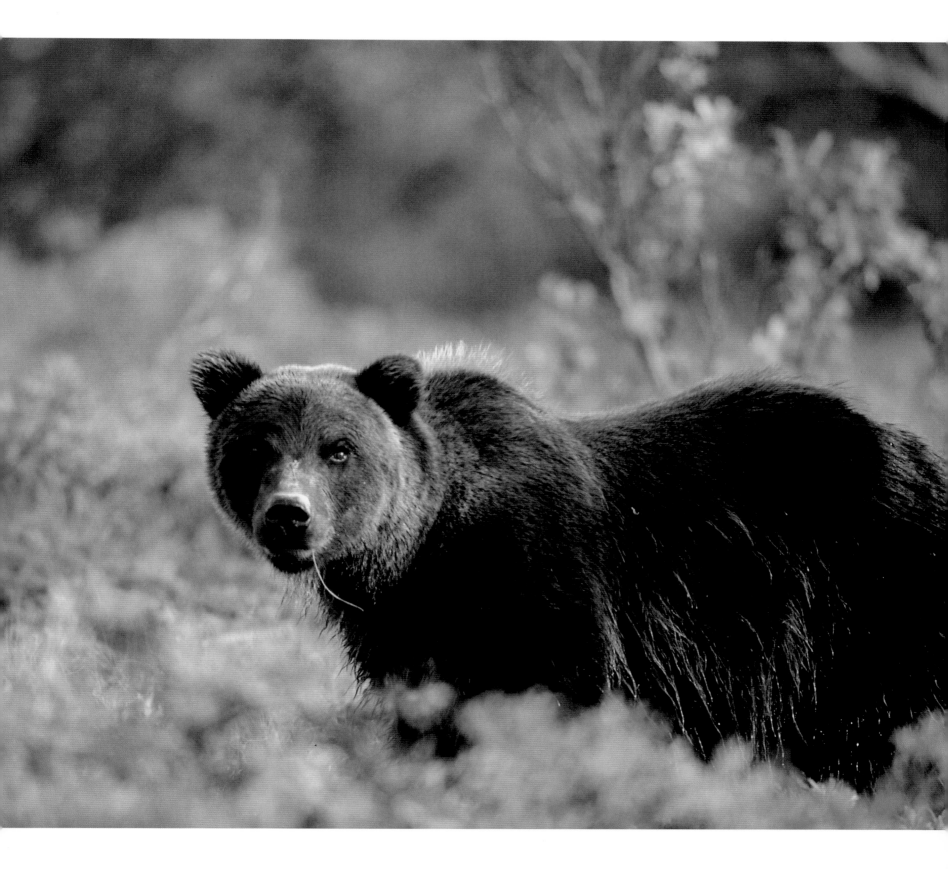

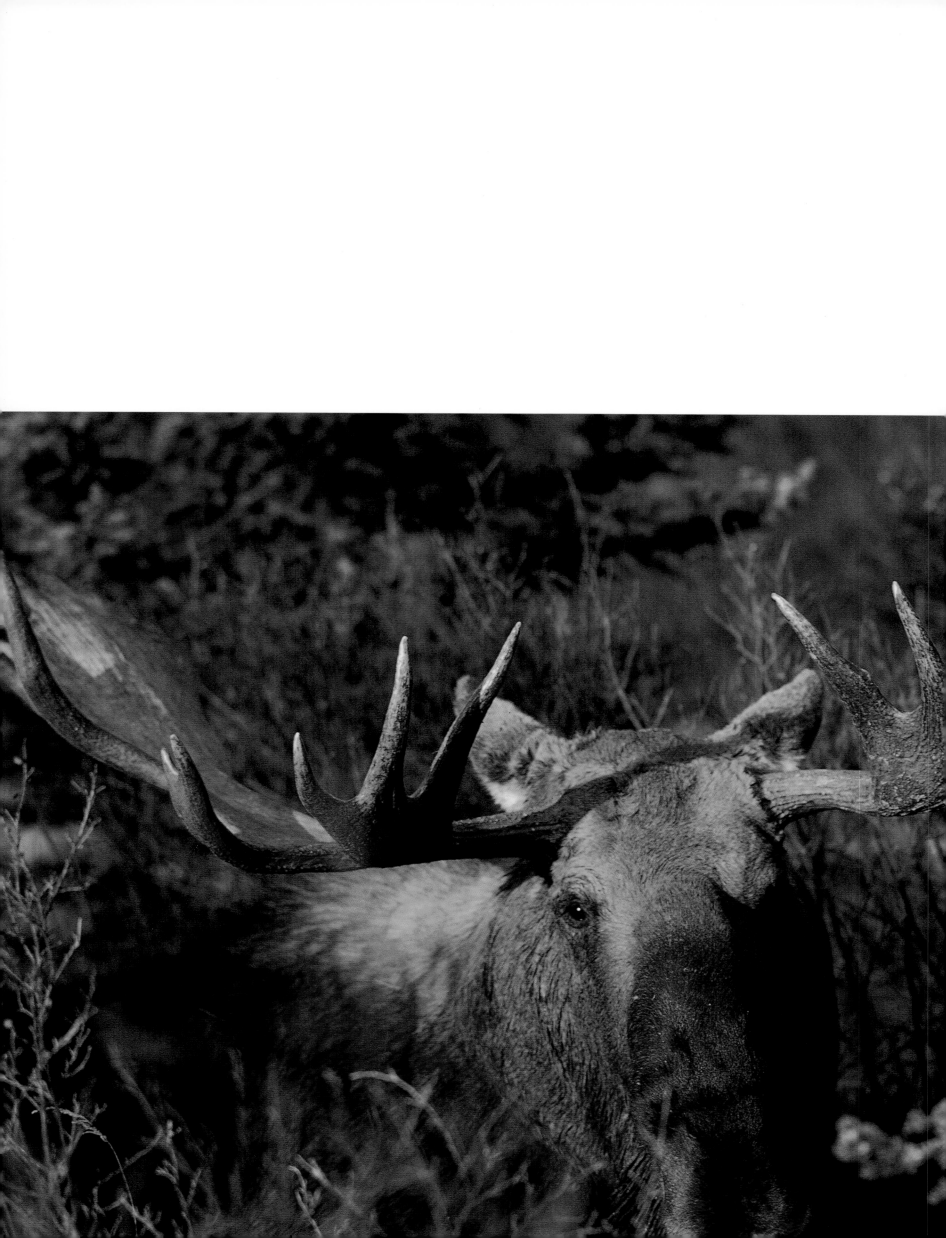

Windblown snow from hurricane-force winds of more than one hundred and forty miles per hour atop the Sargent Icefield—concealing dangerous crevices. Sargent Icefield near Icy Bay, Prince William Sound.

Only male moose have antlers—which can grow to a staggering width of more than seventy inches. Bull moose use their antlers in courtship displays and to fight off rival bulls.

On certain mornings along the windswept beaches of Cook Inlet, one can count as many as a hundred bald eagles. They come to clam, fish, or scavenge. Their playful antics are rarely serious. However, in this situation one mature bald eagle attempts to knock another from the sky.

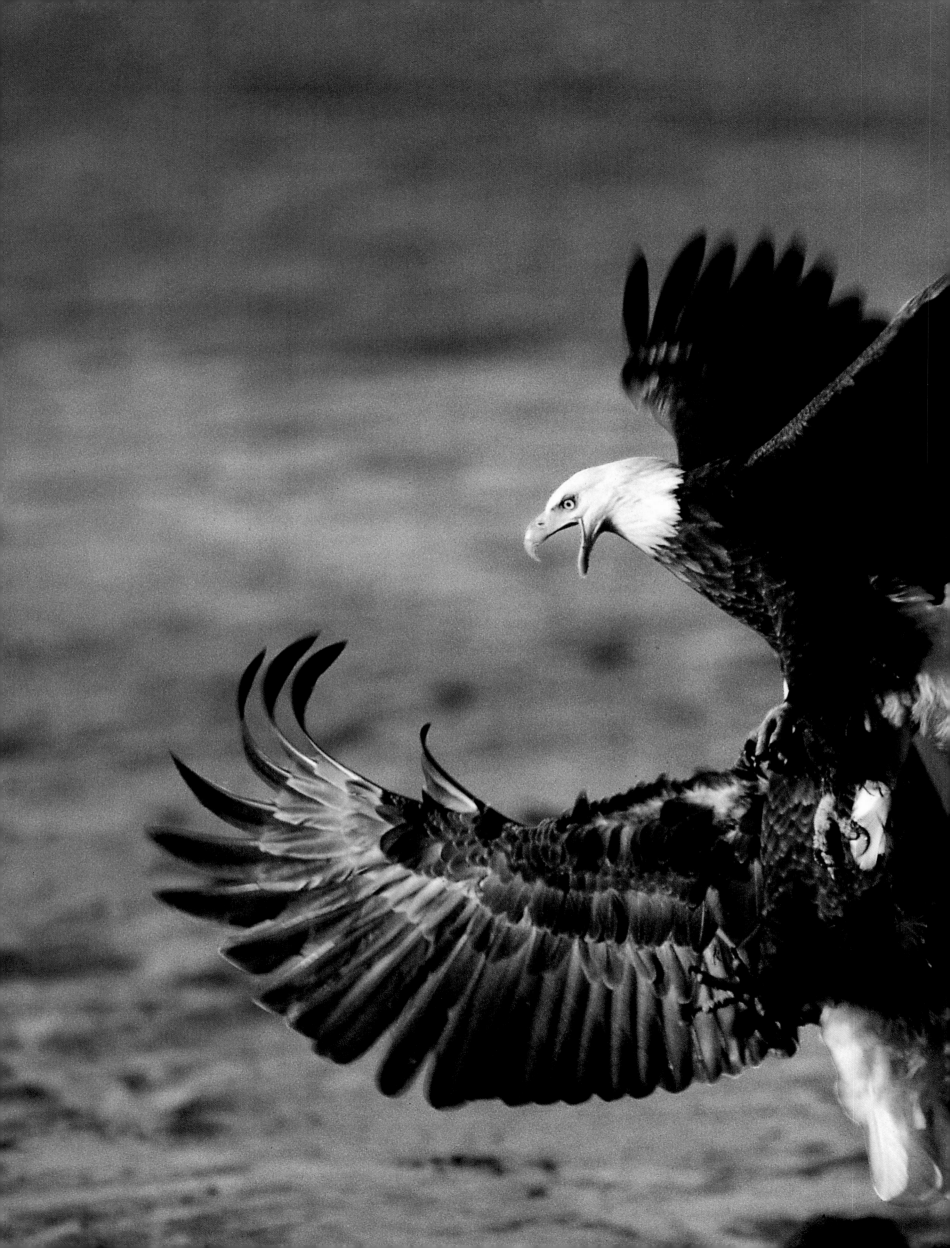

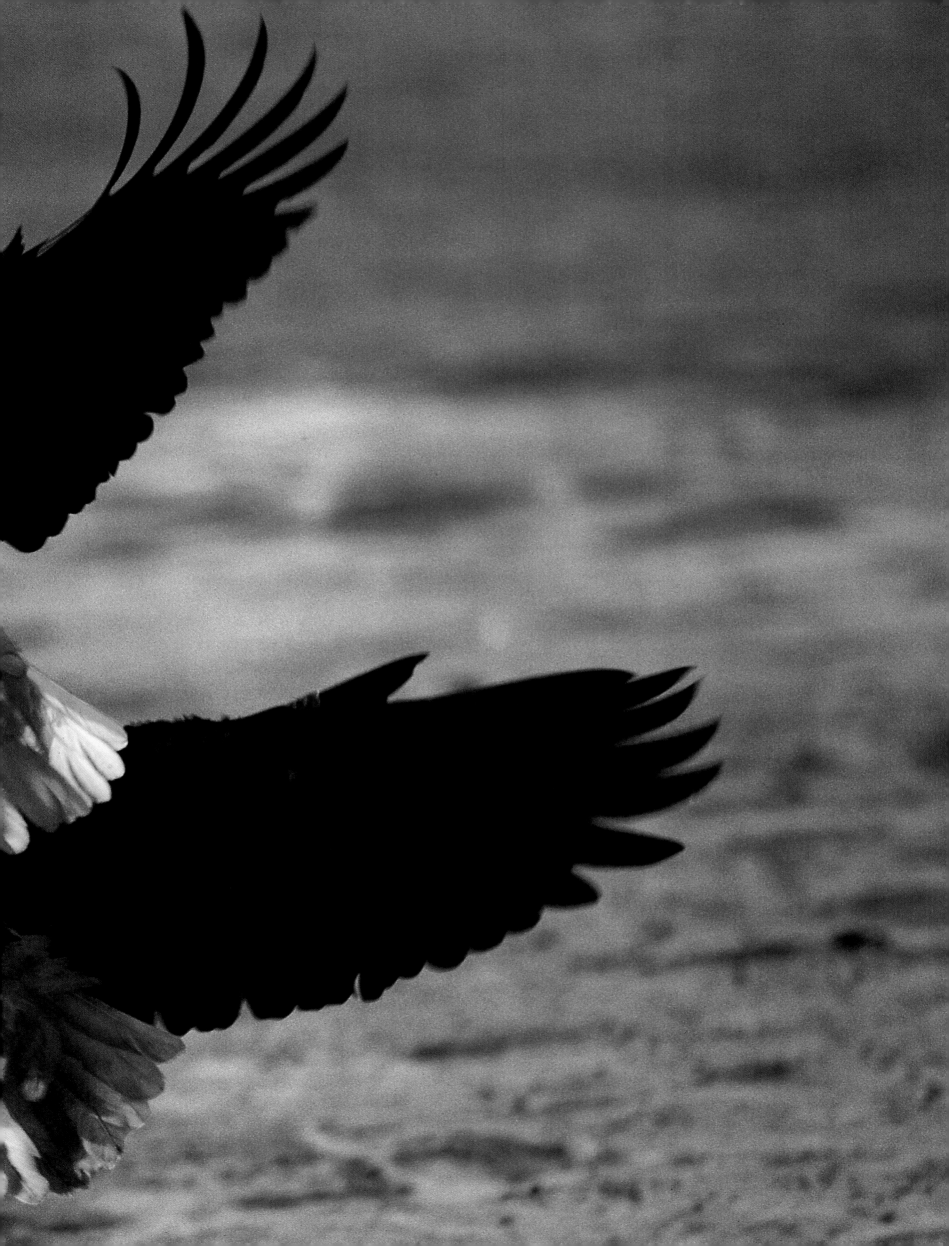

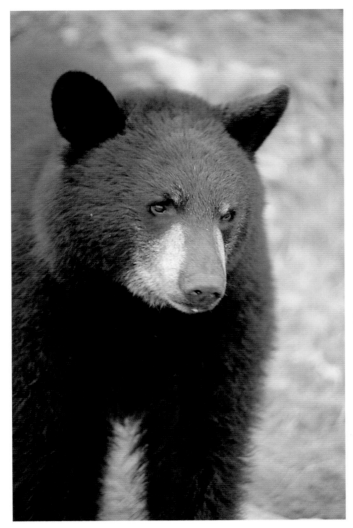

The estimated population of Alaska's
black bears exceeds fifty thousand.
They are found in all regions of Alaska
except the high Arctic and prefer deeply
forested areas. Black bears come in many
color phases, from black and brown to
tan and cinnamon, but can generally
be distinguished from grizzlies by their
smaller size. Hyder Alaska, near
British Columbia.

In fall, caribou—the nomads of the
north—come together to form large herds.
There are more than a million caribou in
Alaska forming twenty-five such herds.

Point Woronzof. Anchorage, Alaska.

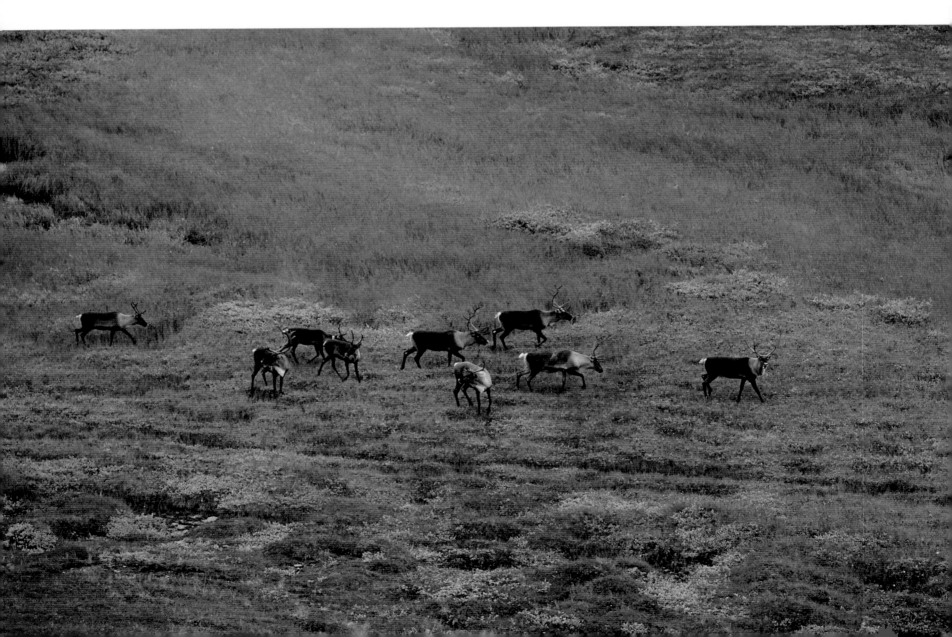

Salmon jumping. Brooks Falls, Katmai
National Park.

California snow geese, on their way to
Siberia, stop near the mouth of the Lower
Kenai River, attracted by the rich nutrients
in the river's delta flats.

Turnagain Arm, named by the famous
explorer Captain James Cook, branches off
Chickaloon Bay and lies just southeast of
Anchorage. Seward Highway runs along
the north coast and around the easternmost
tip of this treacherous body of water and is
considered by many to be one of the most
beautiful drives in the world.

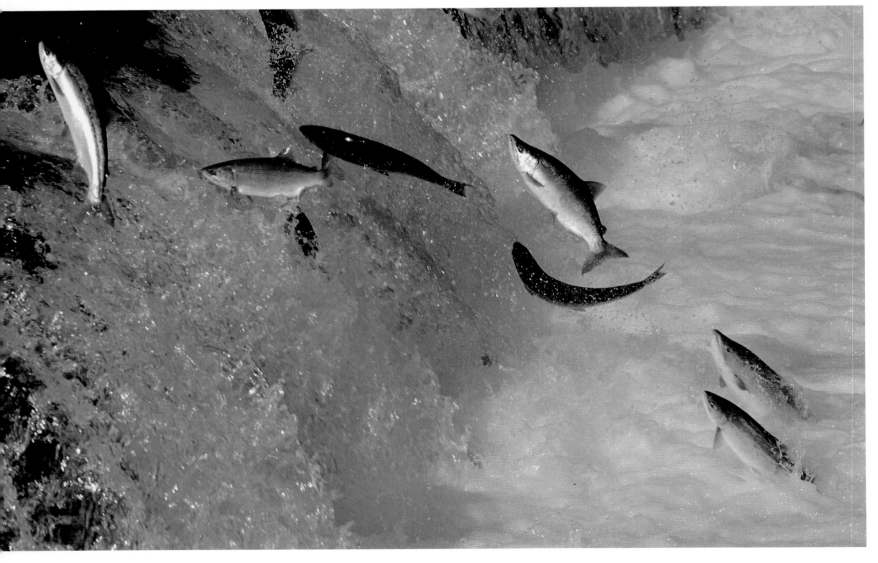

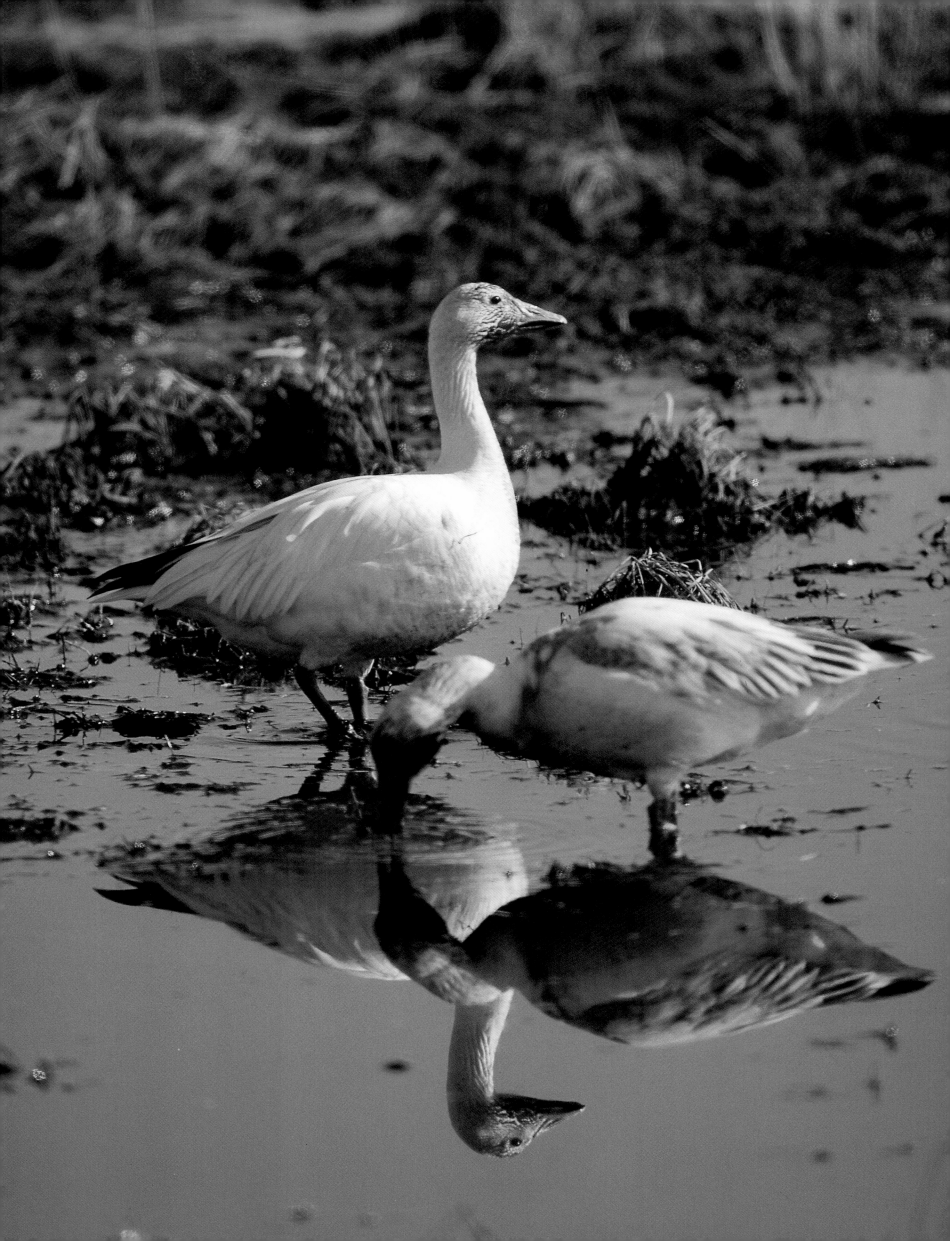

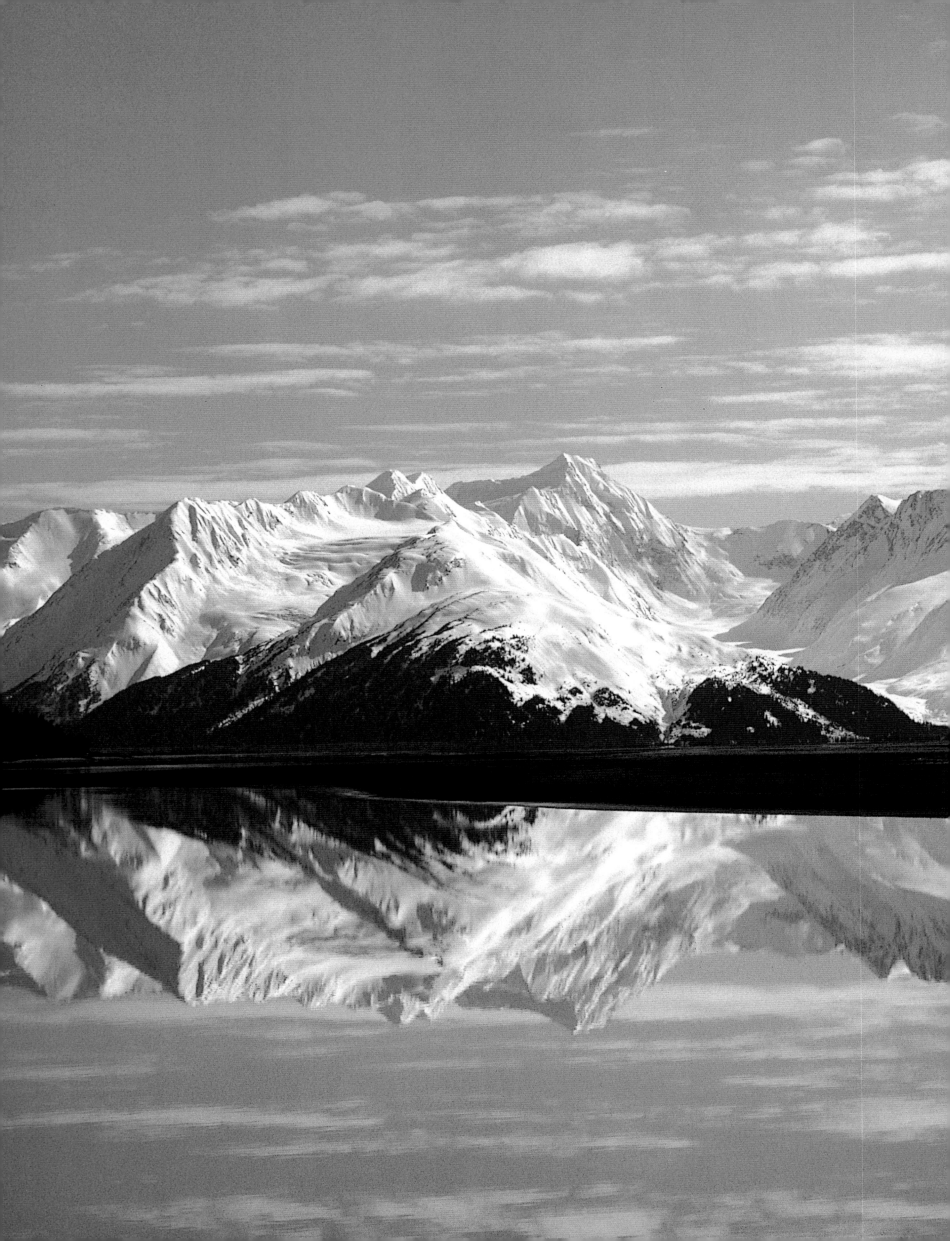

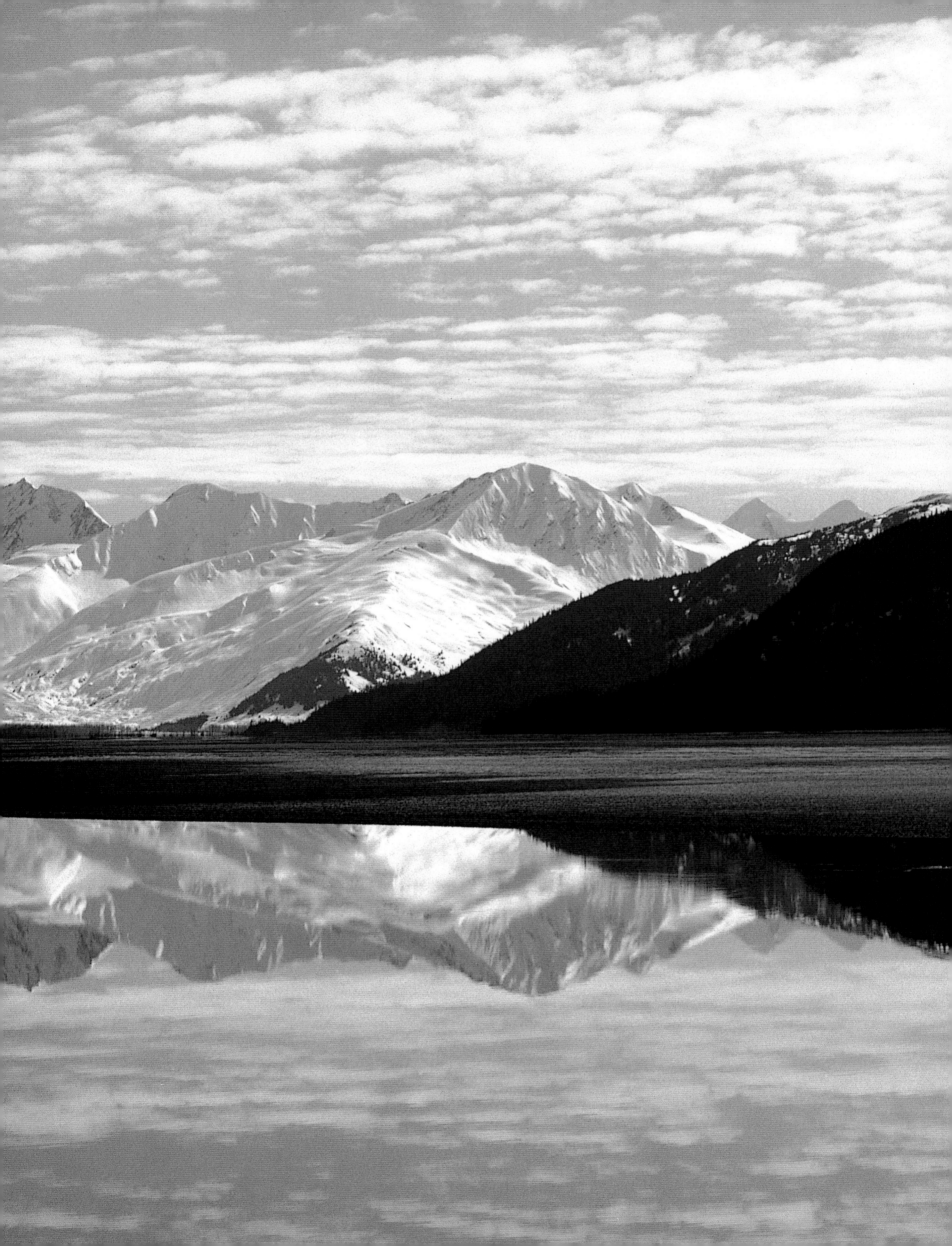

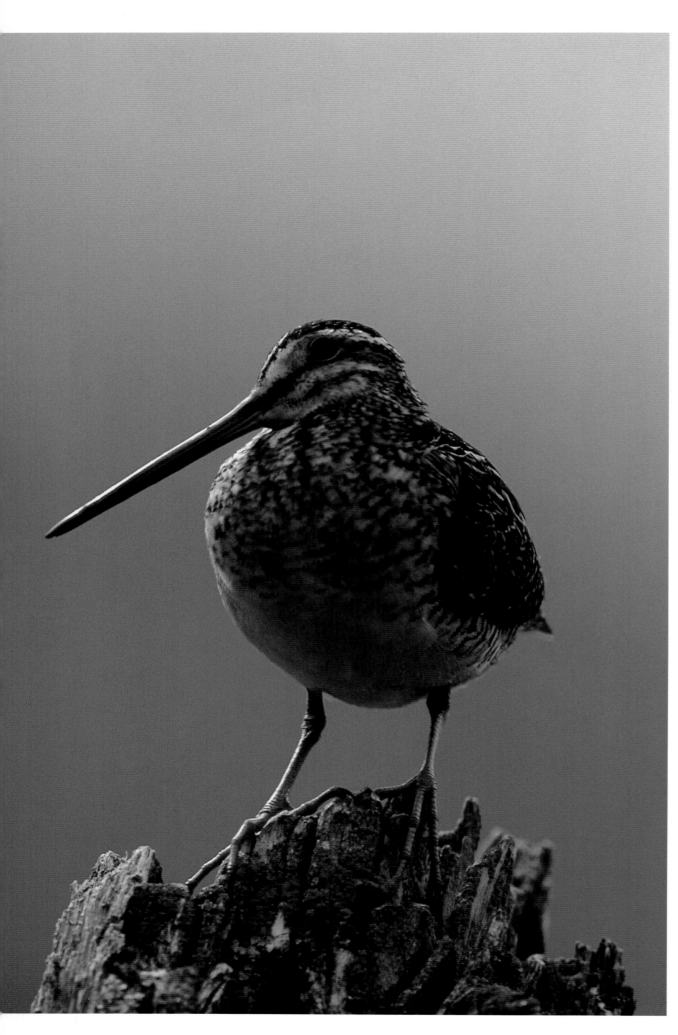

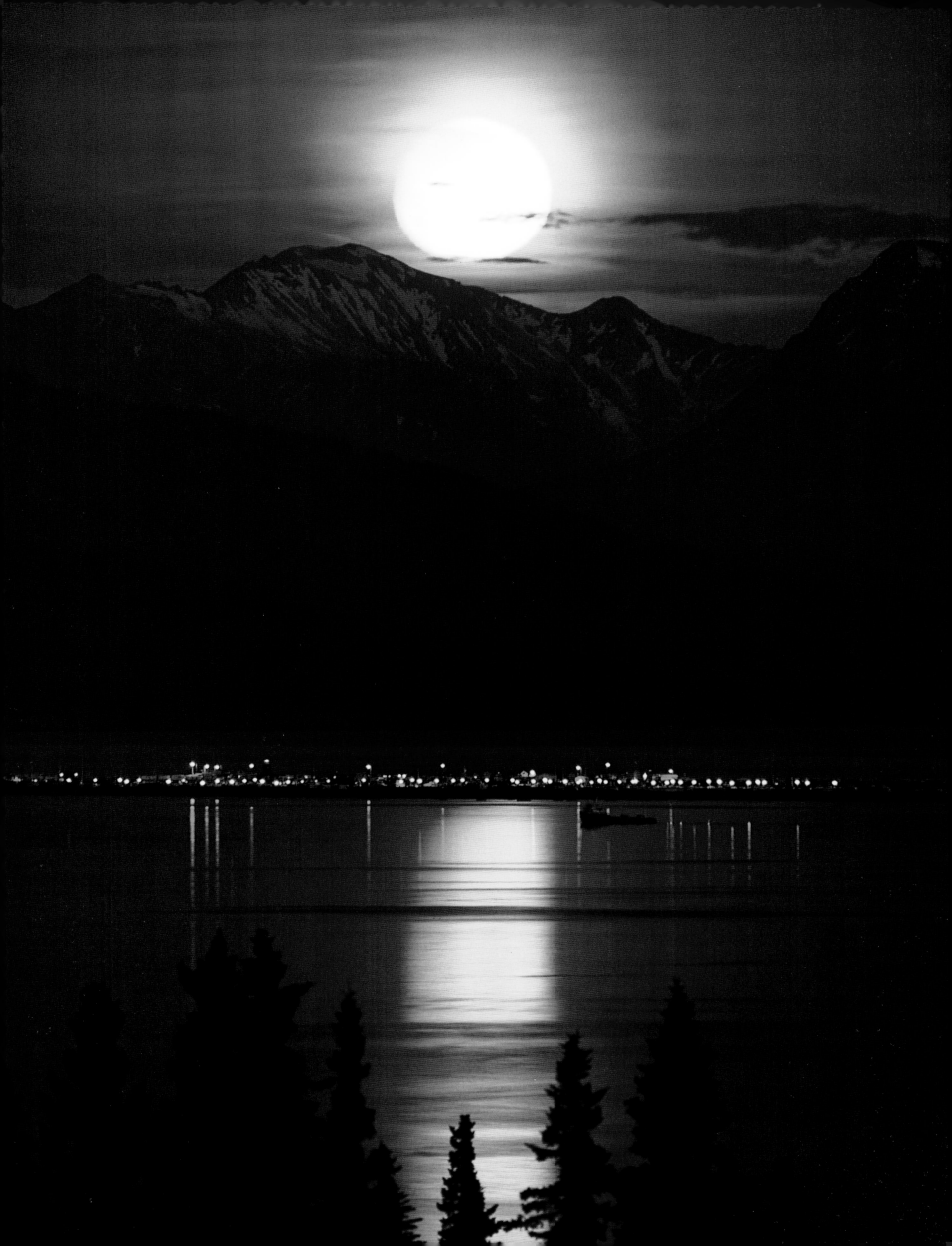

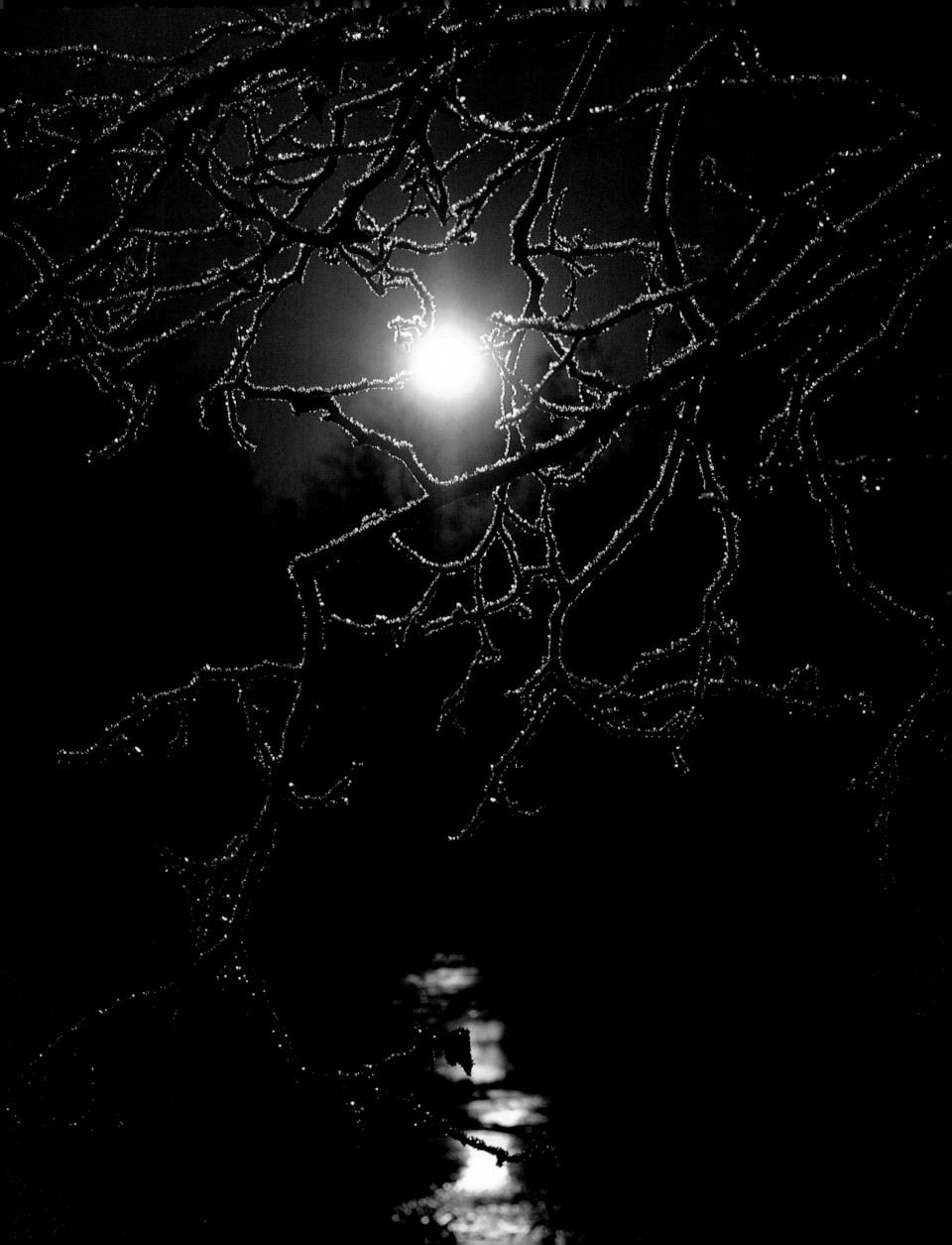

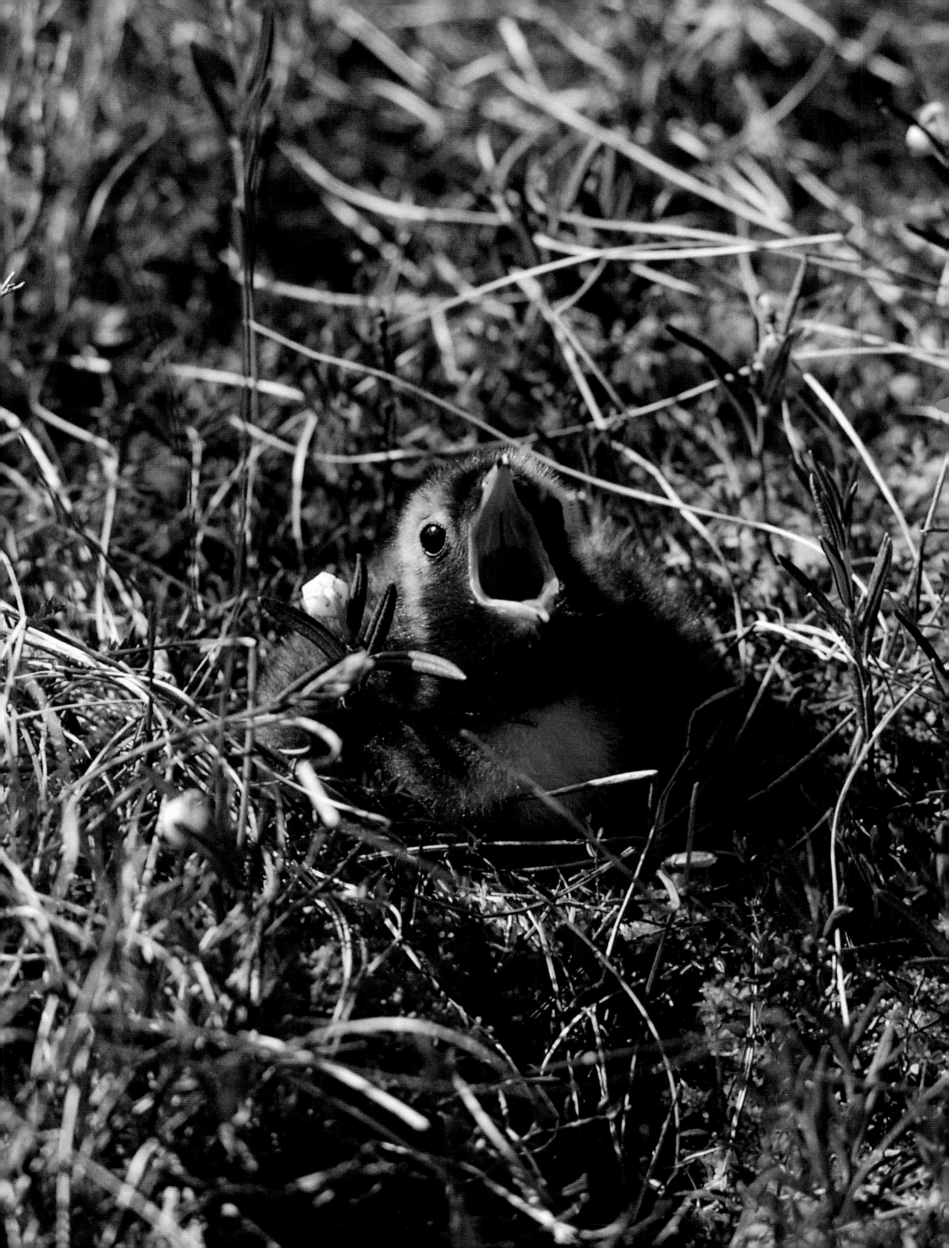

OPPOSITE PAGE

A baby tern, less than a day old, cries out to be fed. Tern Lake, Chugach National Forest.

BELOW

The 1990 eruption of Mount Redoubt thrusts a huge ash cloud more than forty thousand feet in the air. This event caused local power outages and school closures, and disrupted air traffic as far away as south Texas. It also buried the author's homestead under four feet of ash.

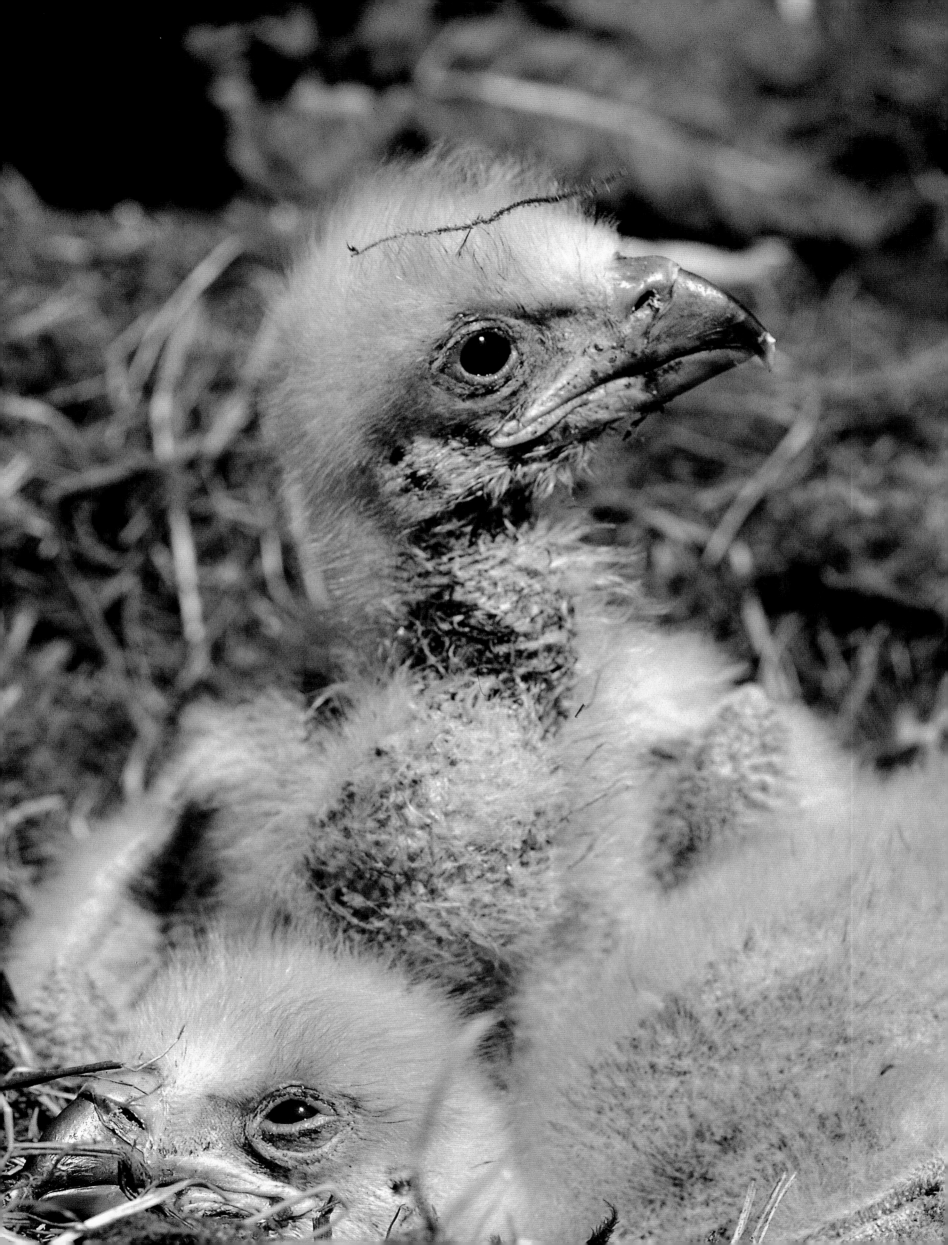

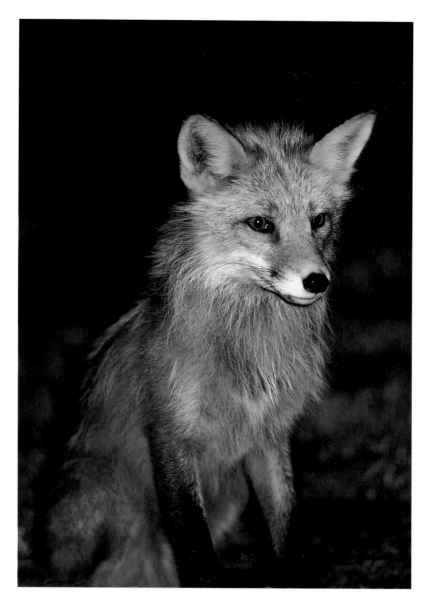

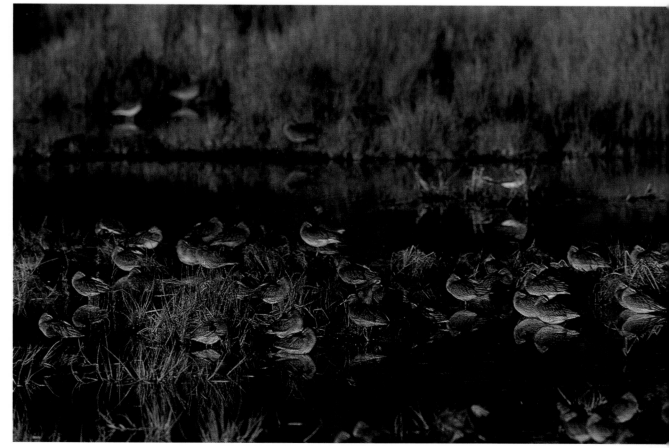

ALASKA

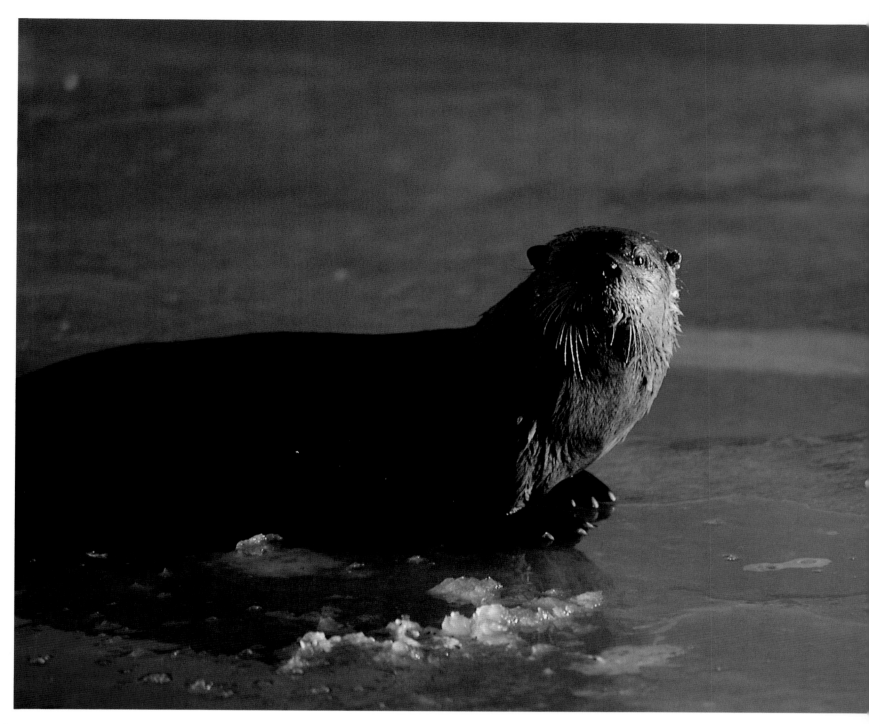

| OPPOSITE PAGE

*A spruce grouse poses in the evening sun.
Cecil Rhode Mountain National Dall
Sheep Preserve, Kenai Peninsula.*

| ABOVE

*This river otter is searching for small fish
through the ice. When he sees one, he'll
dive in and give chase until he catches it.
River otters are very curious, but shy of
humans. One can only enjoy their playful
antics from a distance. Kuskokwim River
near Aniak.*

A Photographic Journey Through the Last Wilderness

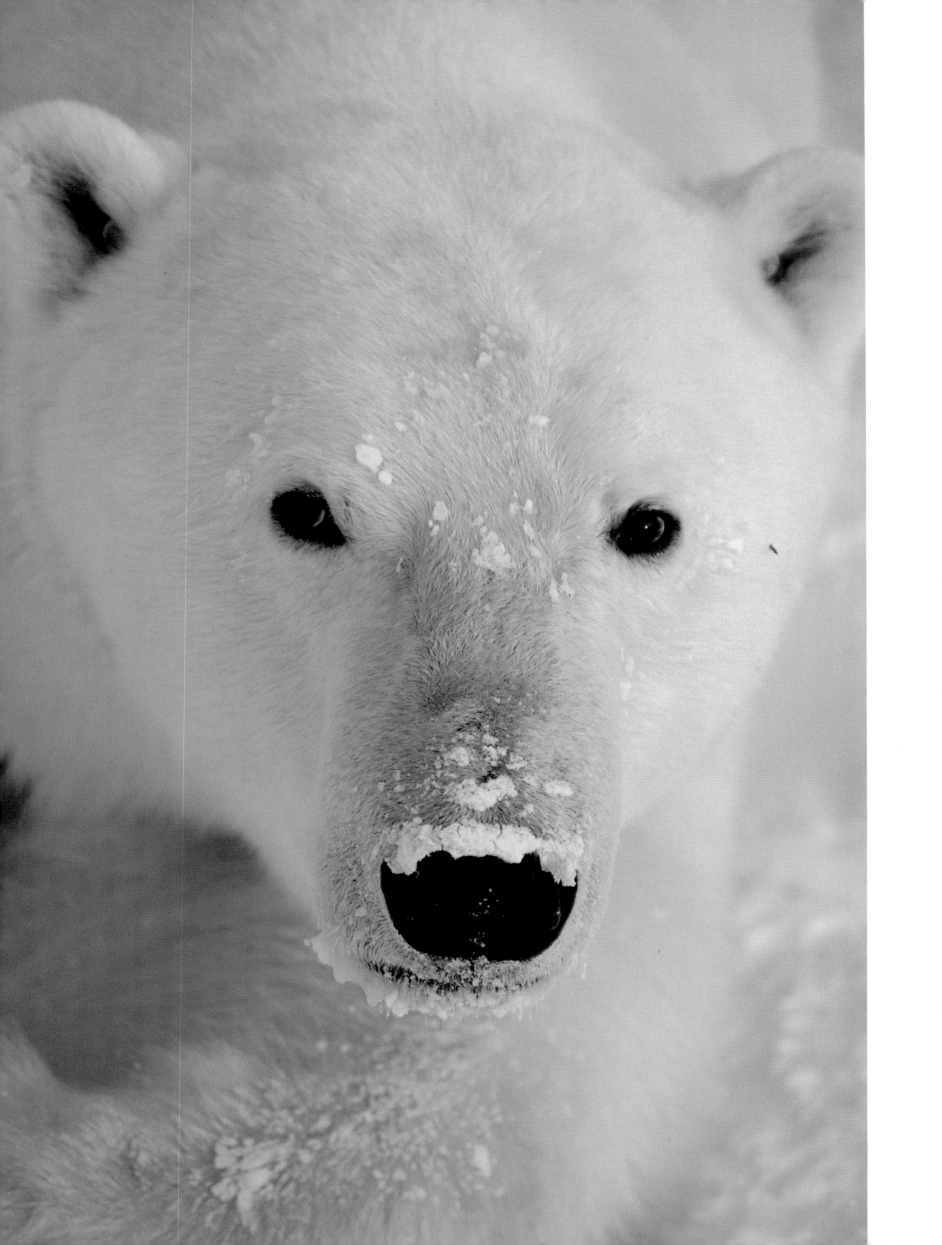

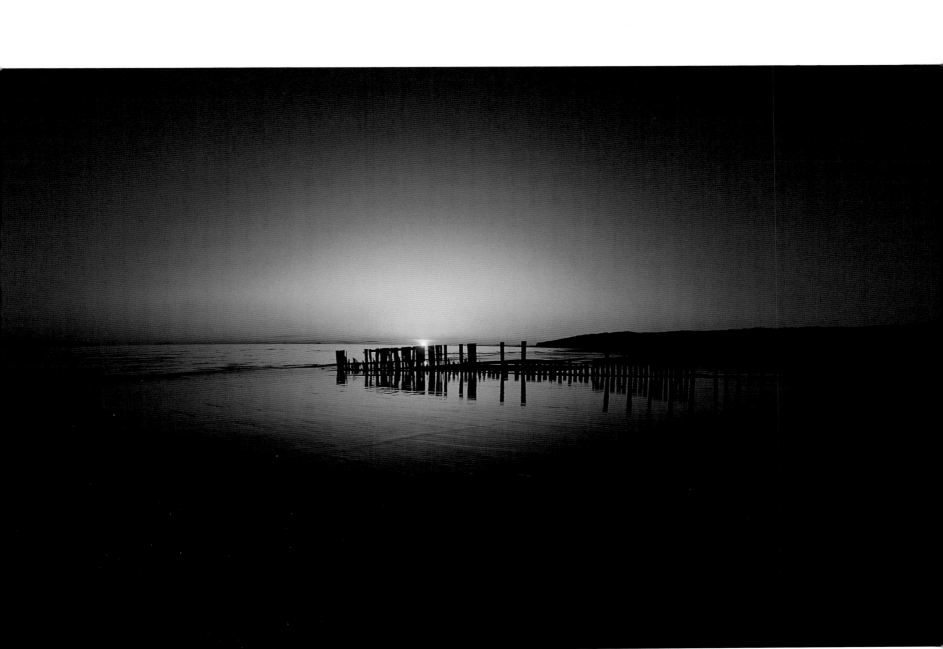

OPPOSITE PAGE

Polar bears are the largest carnivores on earth and the true nomads of the north. They roam across the Arctic and, in the span of a few years, can migrate as far as Russia, Canada, or even Greenland and Norway. A polar bear will cover its black nose with snow while hunting seals—thus making itself nearly invisible against the frozen snow and ice. Kaktovik, Barter Island, in the Beaufort Sea.

ABOVE

The sun sets on an old cannery dock left over from the late 1800s when herring was king of the Alaskan fisheries. Kachemak Bay.

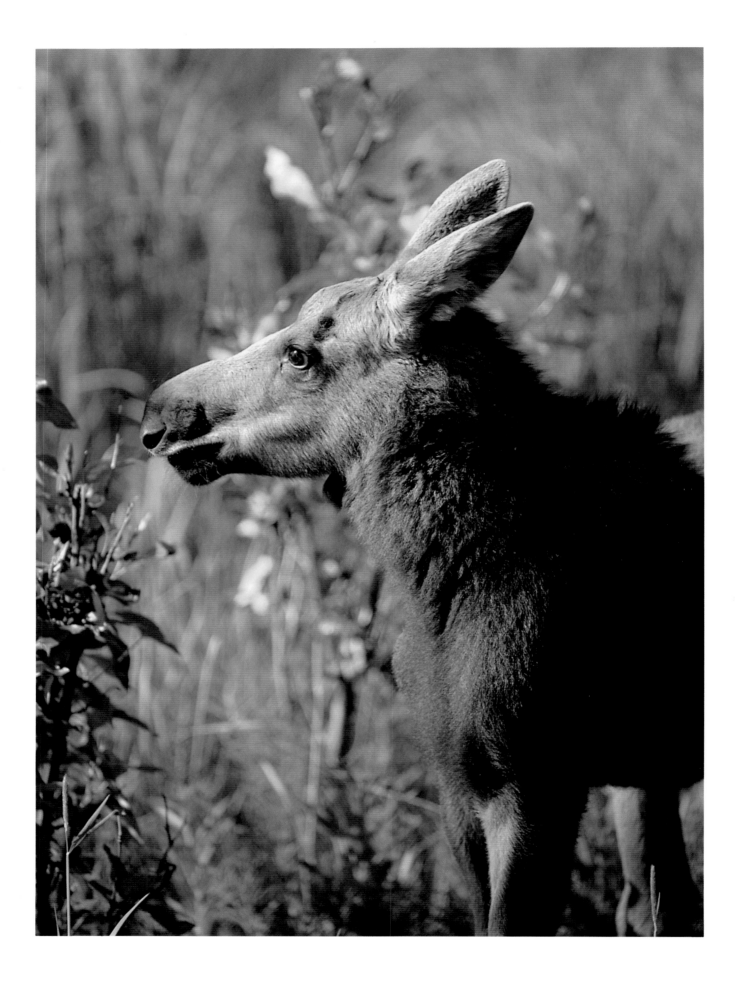

ALASKA

OPPOSITE PAGE

After dancing and playing with the very surprised author, this first-year moose calf stops to listen to its mother's warnings. In areas of dense bear populations, young moose have a high mortality rate. Manley Hot Springs, Elliott Highway area.

RIGHT

Dwarf fireweed, or river beauty, occur naturally on riverbars throughout Alaska.

BELOW

Mount McKinley from the road at Reflection Pond near Cantwell, Alaska.

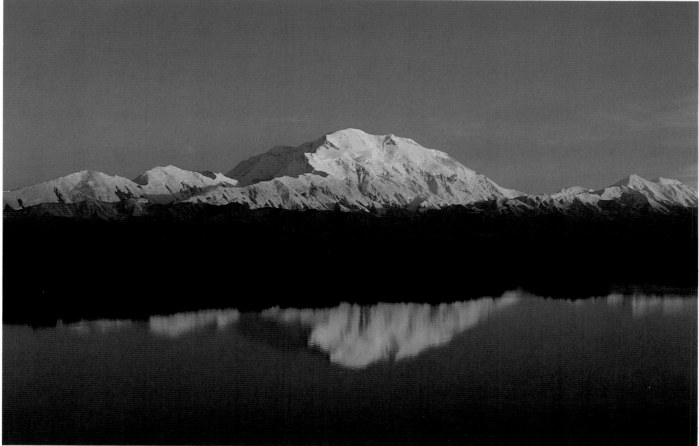

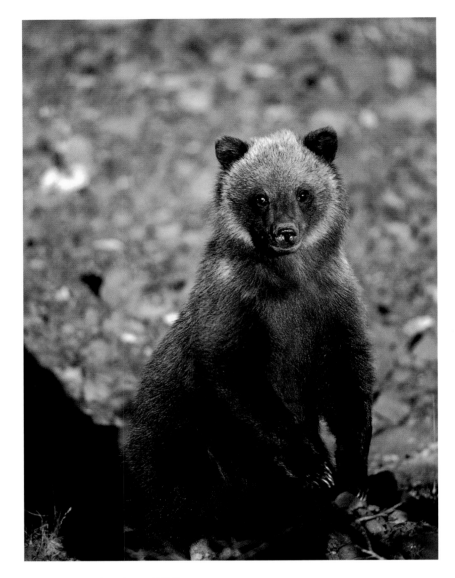

ABOVE

A spring grizzly cub stands up to take a playful leap at the author. Fortunately, the cub's mother was a few hundred feet away at the time. Most bear violence on humans occurs when someone happens to come between a bear cub and its mother.

LEFT

Oyster catchers are shy and comical shorebirds along Alaska's rocky shorelines.

OPPOSITE PAGE

Sugarloaf Mountain looms over Tangle Lakes at sunrise. The air is filled with smoke and haze from forest fires. Off the Denali Highway, near Paxson.

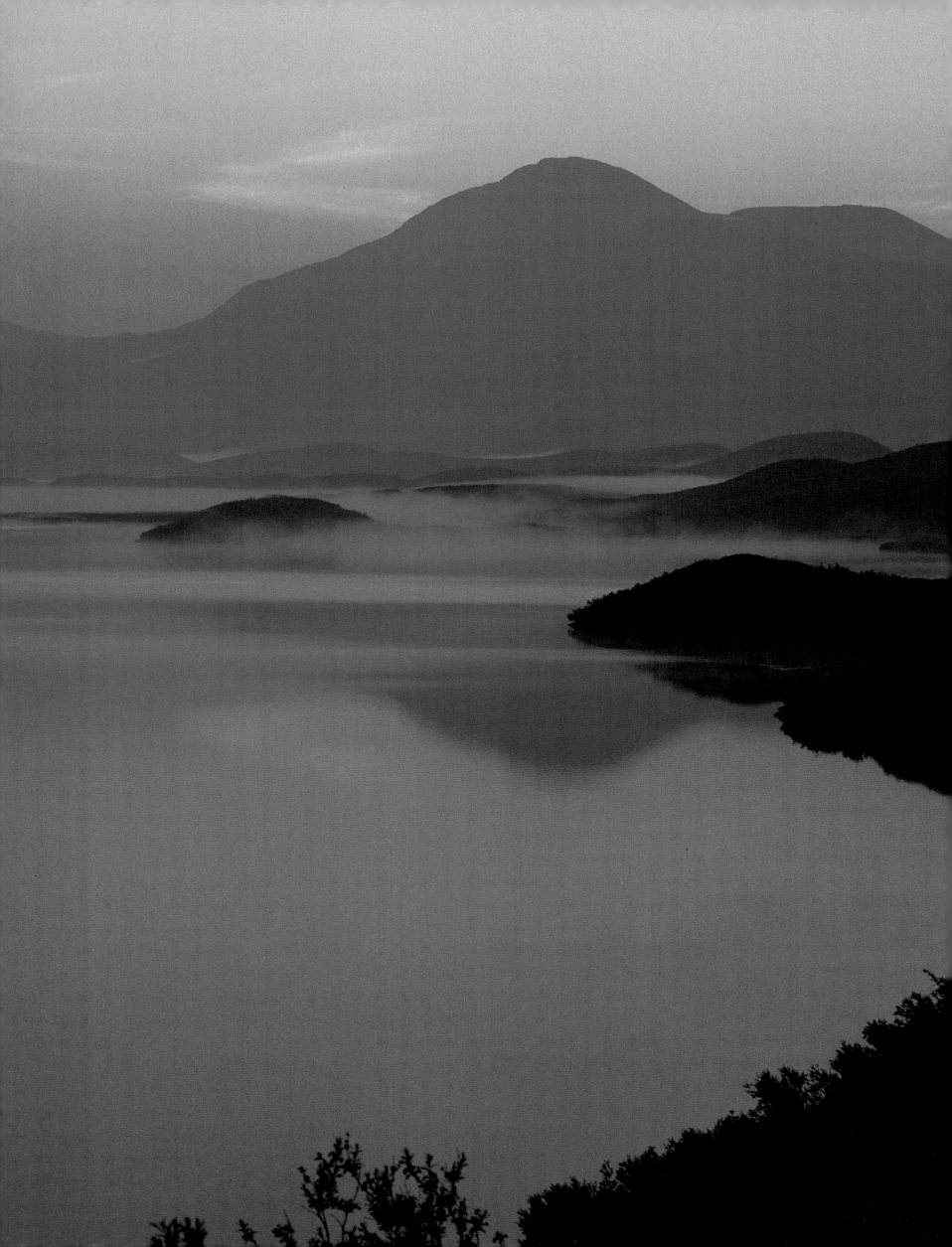

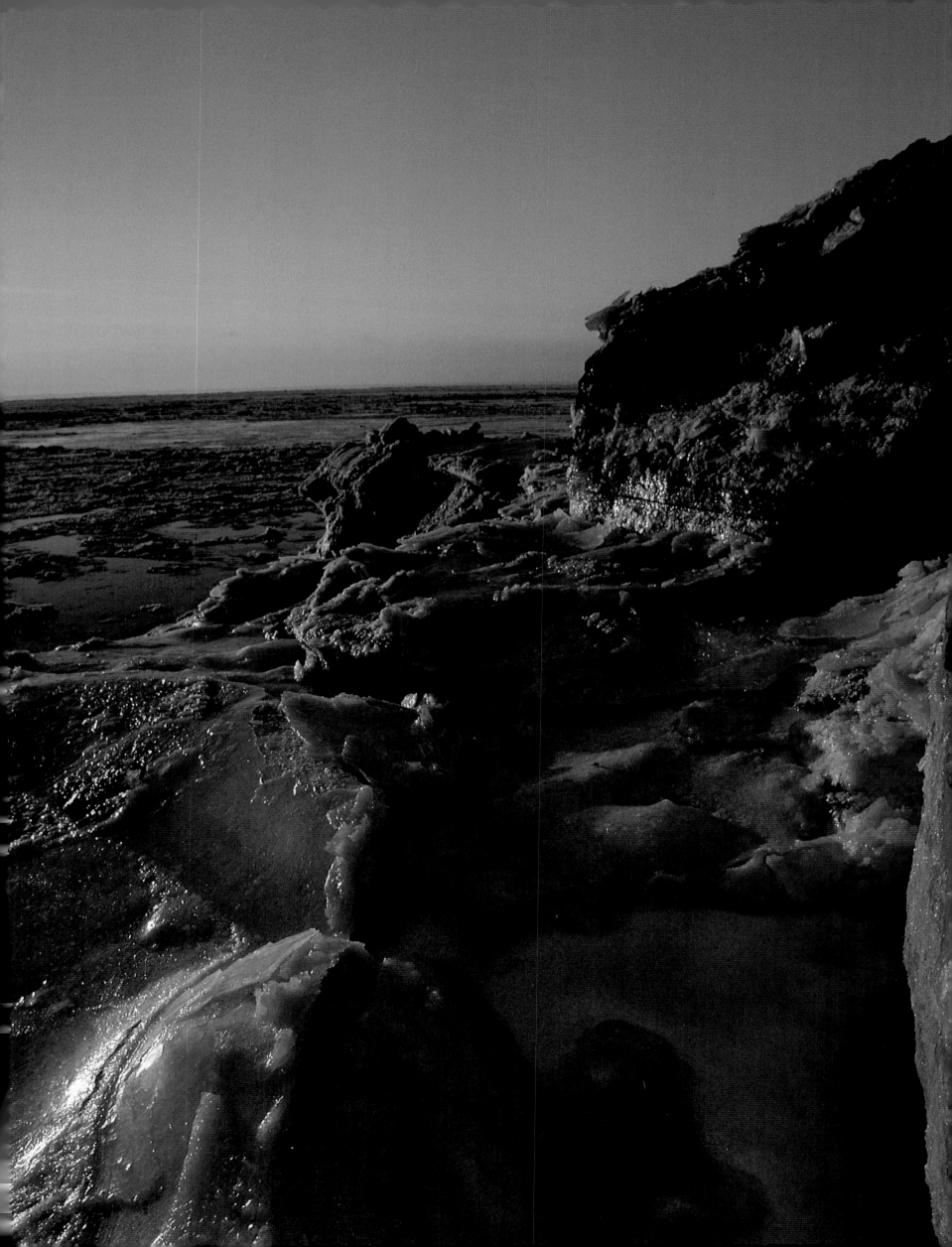

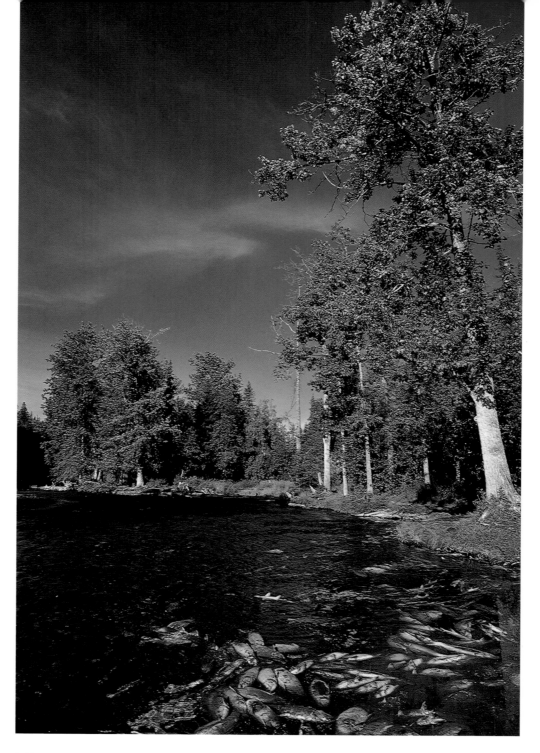

OPPOSITE PAGE

Tidal ice along Knik Arm Bay can continually thaw and refreeze, causing eerie formations north of Anchorage.

ABOVE RIGHT

Thousands of dead salmon and millions of eggs will wash down the Russian River after the spawning cycle. This same scene is to be found in rivers throughout Alaska.

RIGHT

A rock ptarmigan blends in well with its surroundings. The ptarmigan, a member of the grouse family, is Alaska's state bird.

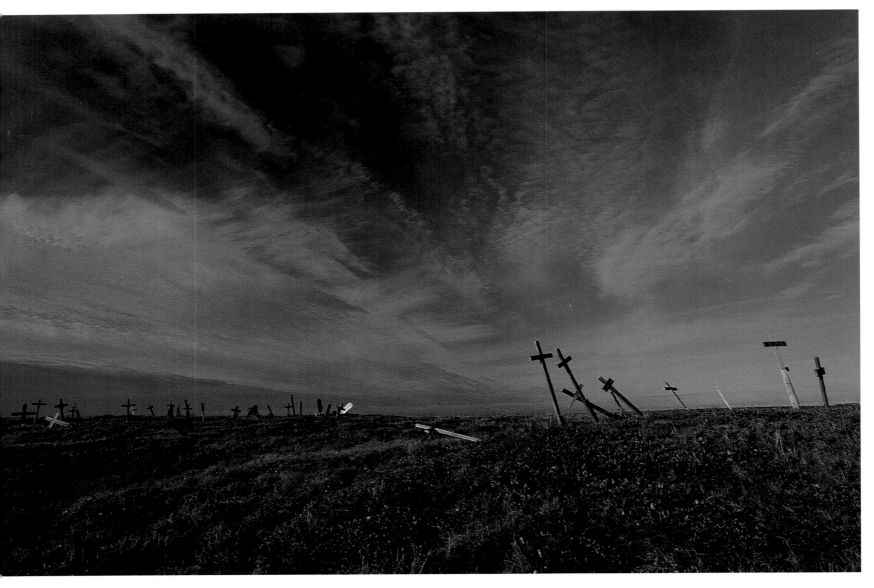

Age-old burial grounds along remote Arctic
Coast. Village of Point Lay.

A mature bald eagle roosts on a branch
overlooking Lake Iliamna.

Sub-zero temperatures and vast unfrozen
stretches of Cook Inlet cause vapor mirages
during a winter sunset.

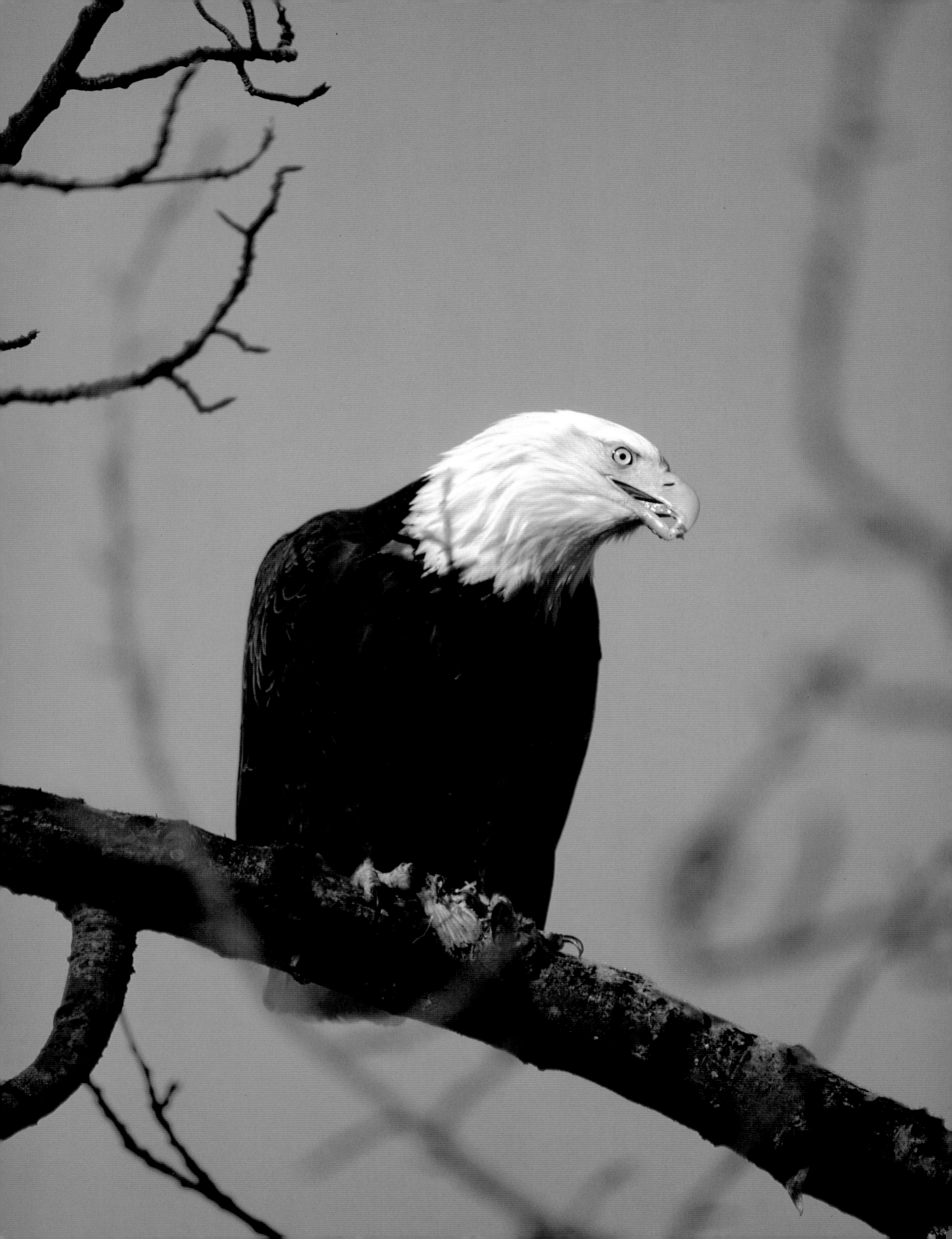

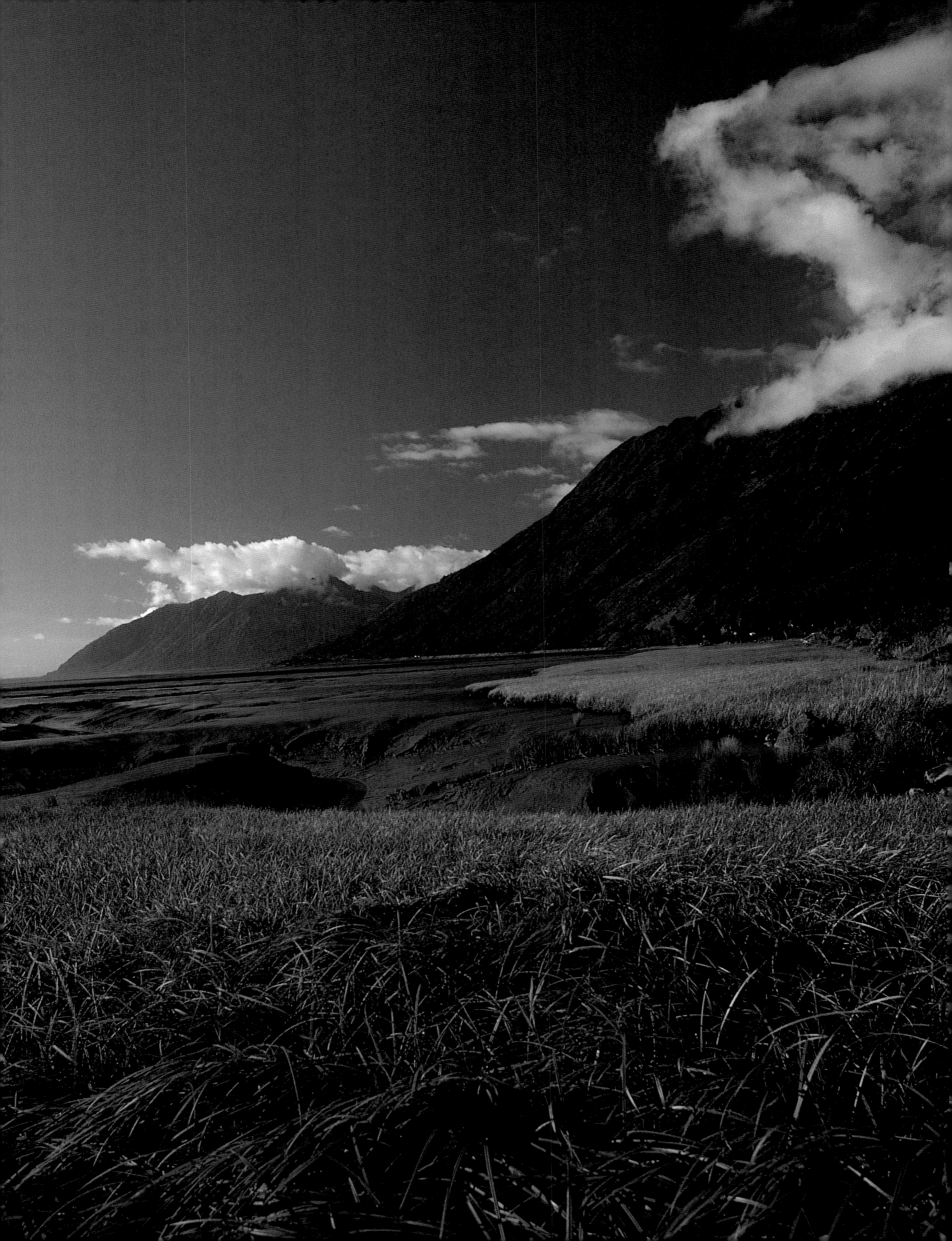

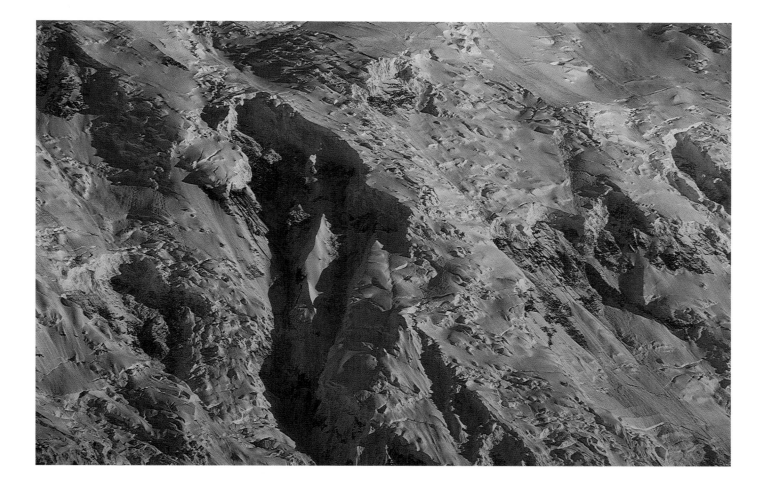

The first sign of an early winter is the changing colors of the tops of tidal swamp grass.

Mount McKinley's Wickersham Wall rises 18,000 vertical feet—the highest vertical rise in the world. North side of Mount McKinley, Denali Park and Preserve.

Alaska's bald eagles have helped to replace stocks in the Lower 48 states.

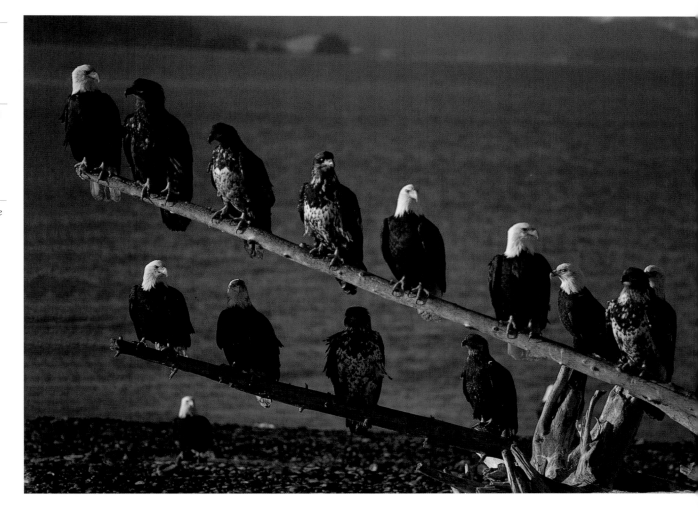

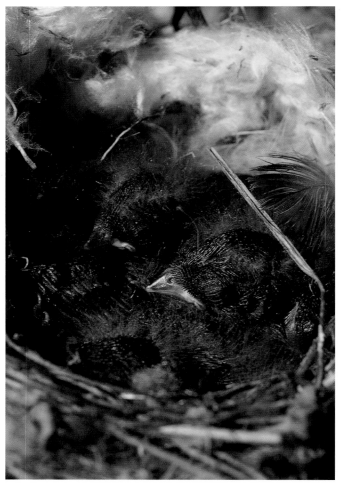

LEFT

*The nest of a Lincoln's sparrow is lined
with wild cotton and straw and is home to
five newly hatched chicks. They take turns
sitting on top of one another to keep warm.
Arctic Ocean, Prudhoe Bay.*

BELOW

*Lesser Canada geese are found
throughout Southcentral and Interior
Alaska. They travel in huge flocks and
gather on the Palmer Flats in numbers
of ten thousand to thirty thousand prior
to departure on their winter migration
to the Pacific Coast states. This photograph
was taken in the Minto Flats area
near Fairbanks.*

OPPOSITE PAGE

*An erupting Mount Augustine, sixty-five
miles away, spews an angry cloud of ash
over Anchor Point, Alaska. Melting ice
crystals cause sinking moist air and ash
to form the pendulous puffs.*

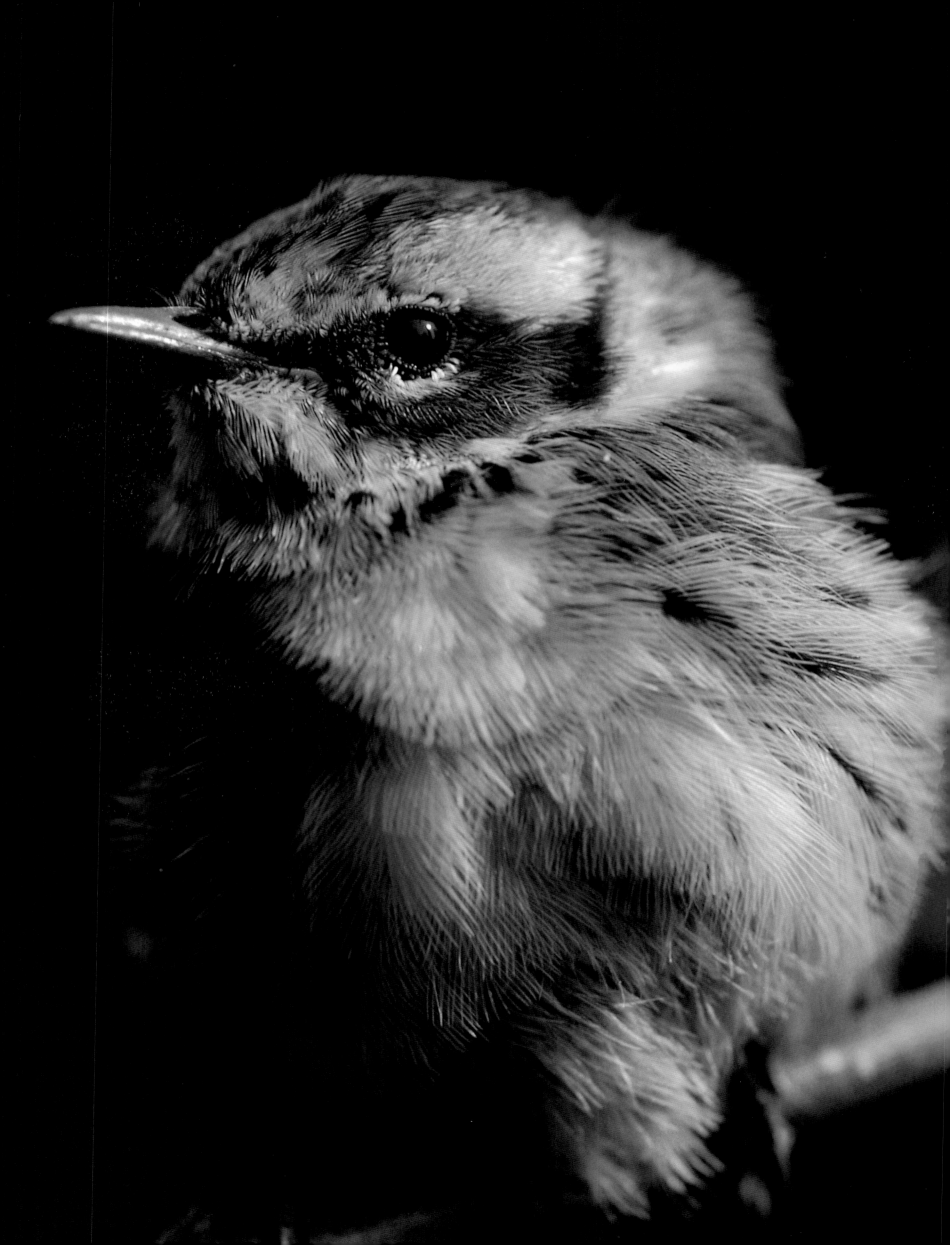

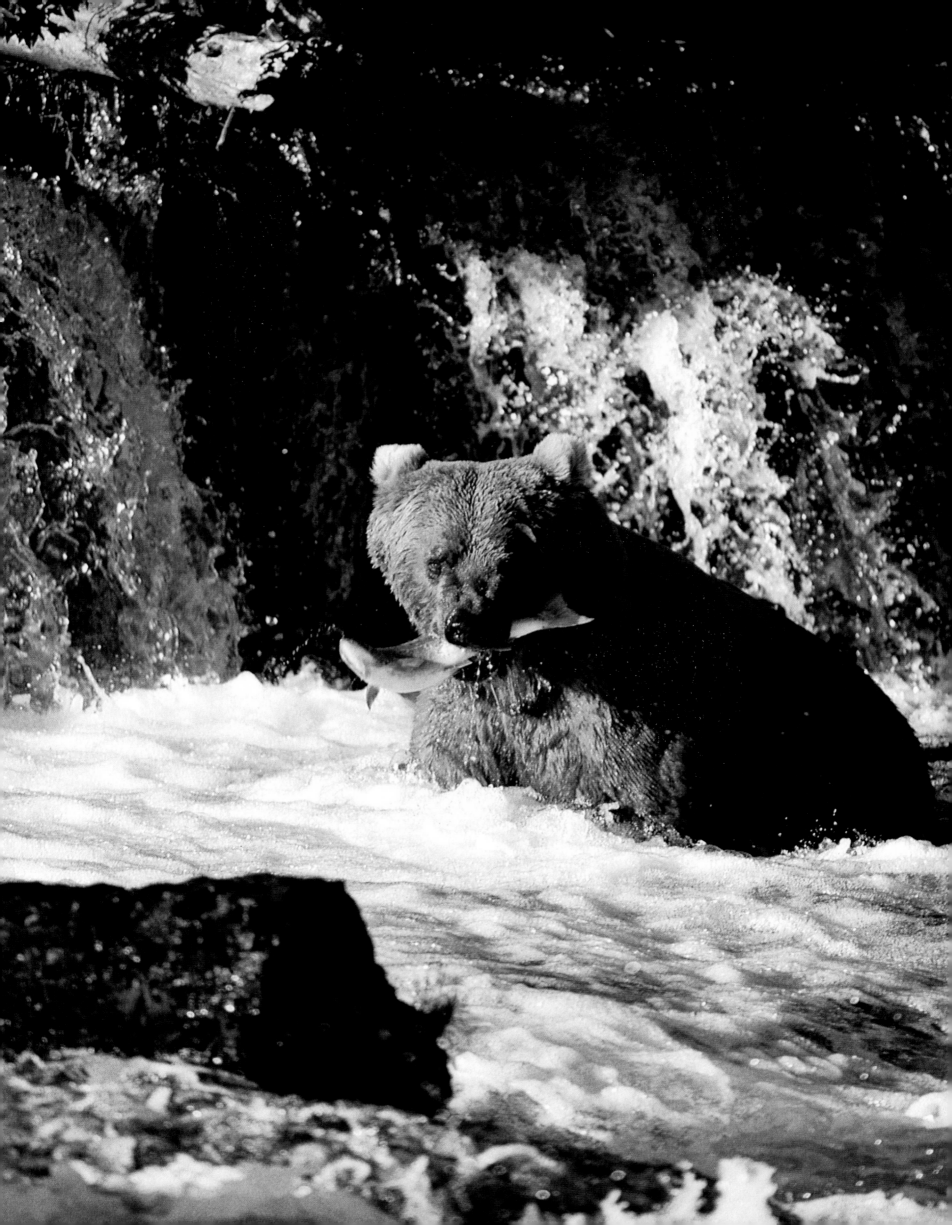

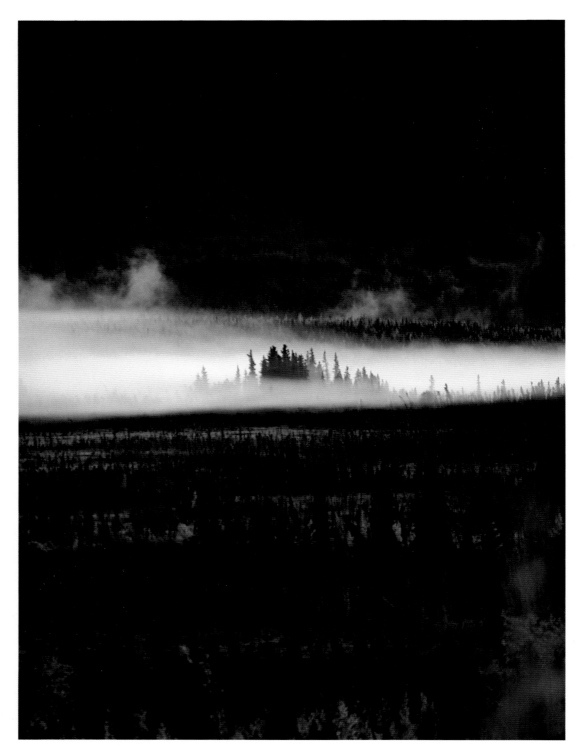

*Low fall temperatures create fog along
Skilak Lake Road on the Kenai Peninsula.*

*Various forms of lichen engulf a group
of rocks on Caribou Mountain in the
Kanuti National Wildlife Refuge on
the Arctic Circle.*

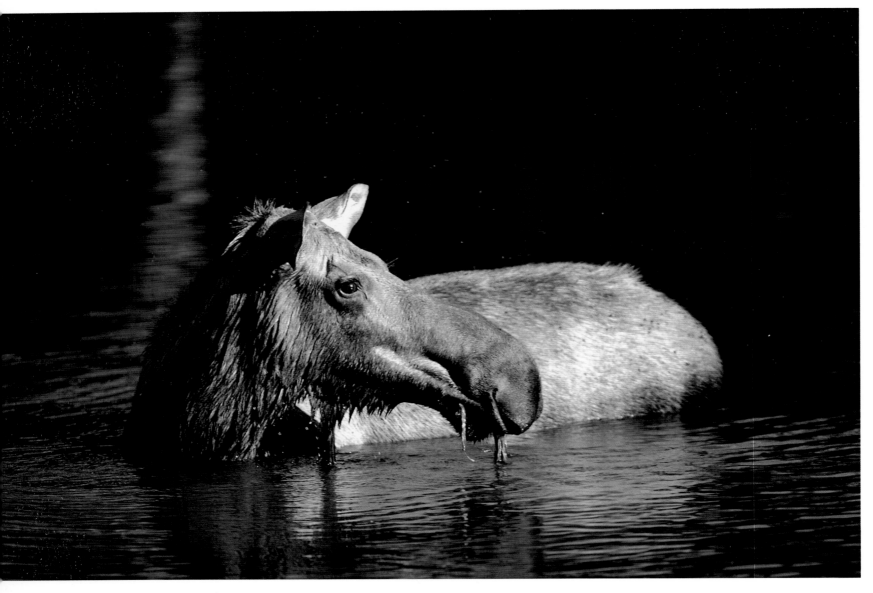

A female moose stands in Galbarth Lake in the Brooks Range to get some relief from biting insects.

OPPOSITE PAGE

Portage Glacier is now Alaska's most visited tourist attraction, but it is fast receding at a rate of seven hundred feet a year.

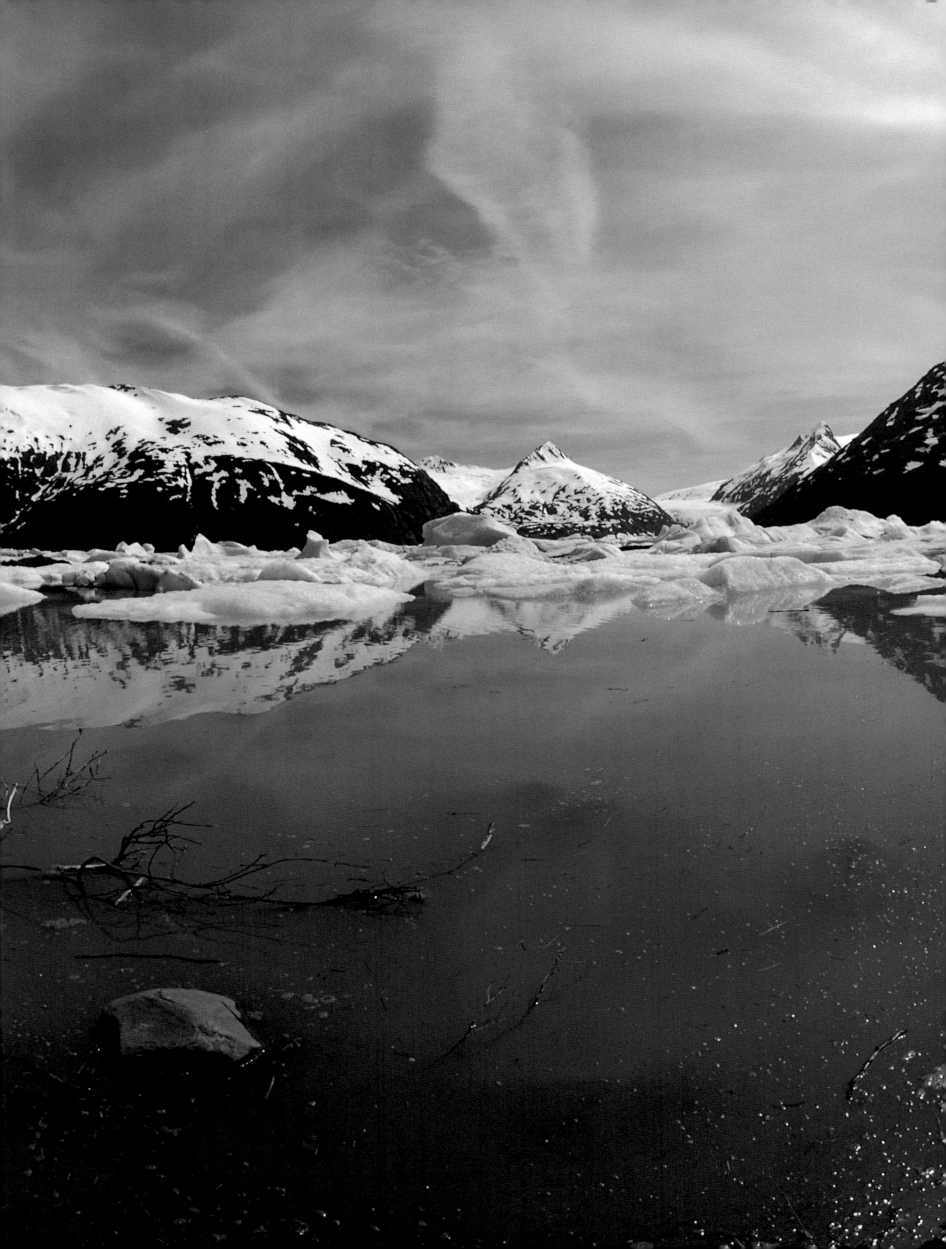

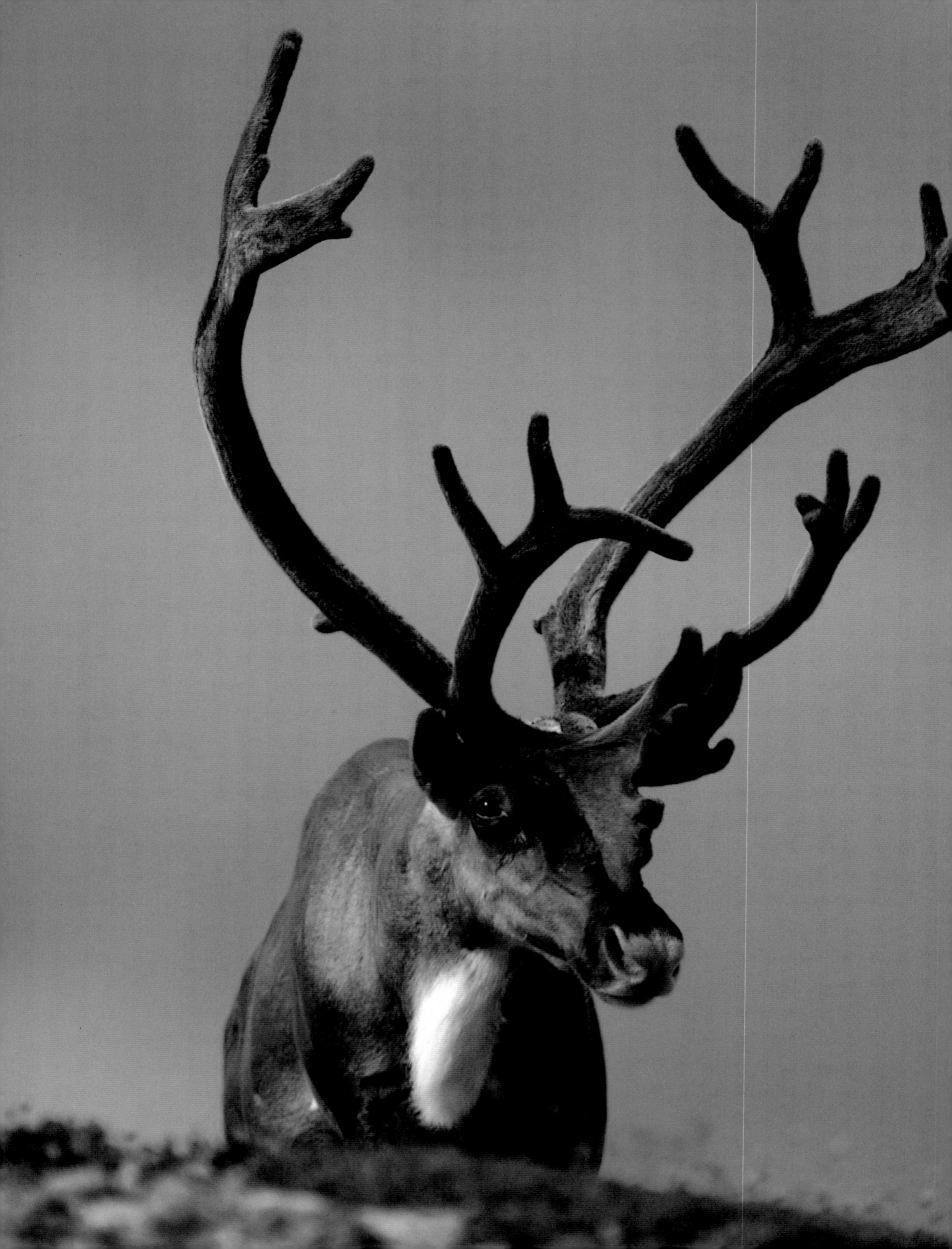

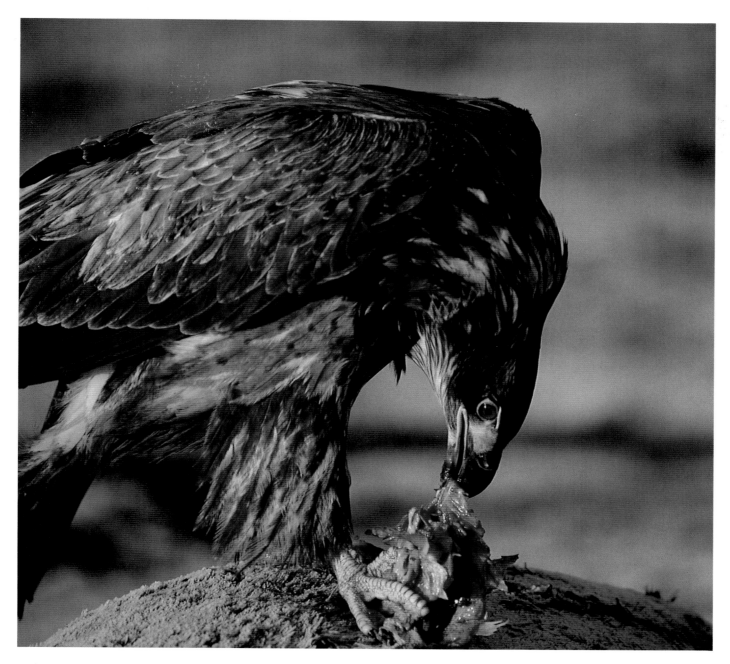

*A barren ground caribou atop a knoll in
the Amatusak Hills near Cape Beaufort
on the Arctic Ocean.*

*An immature bald eagle feeds on a fish
carcass near Yakutat.*

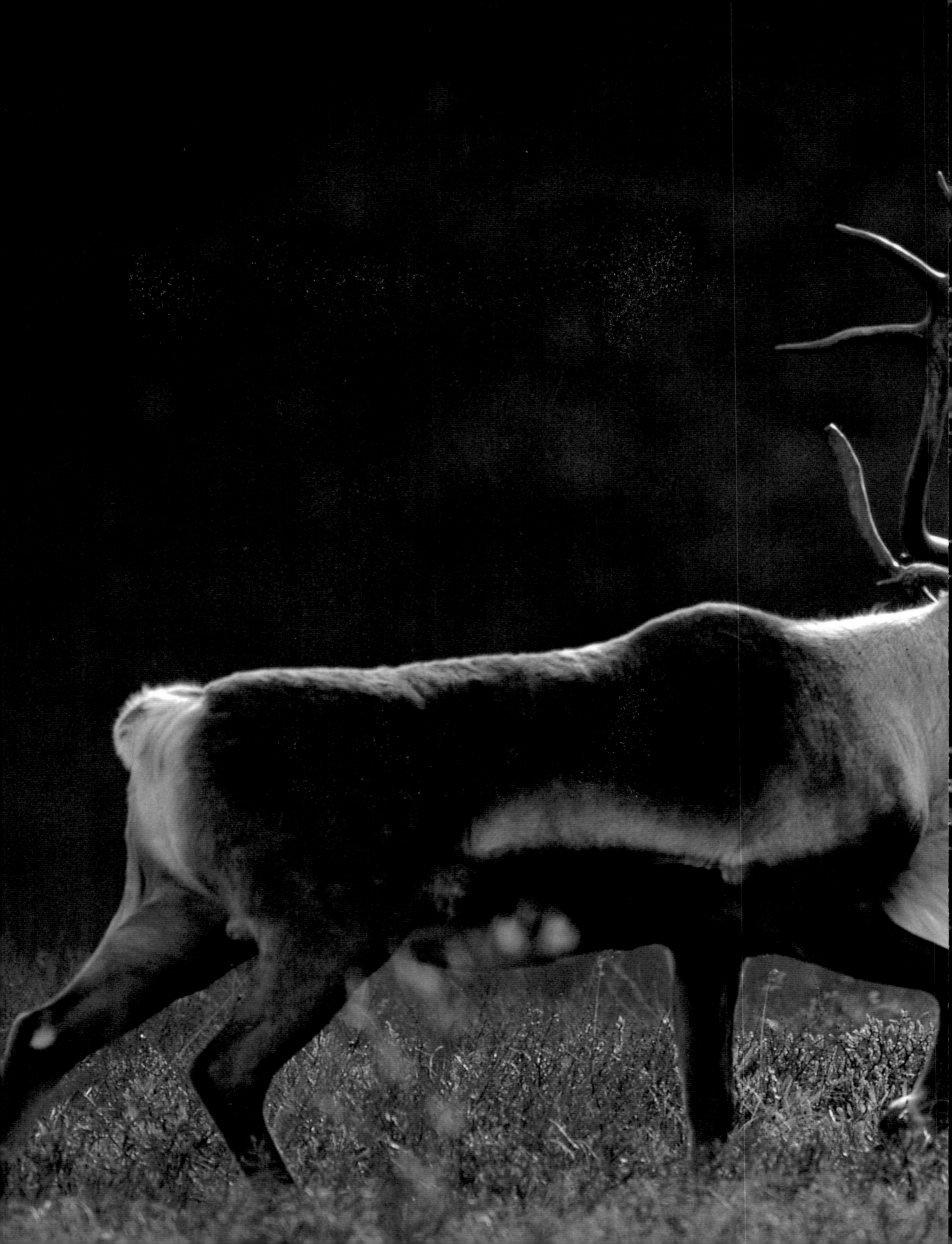

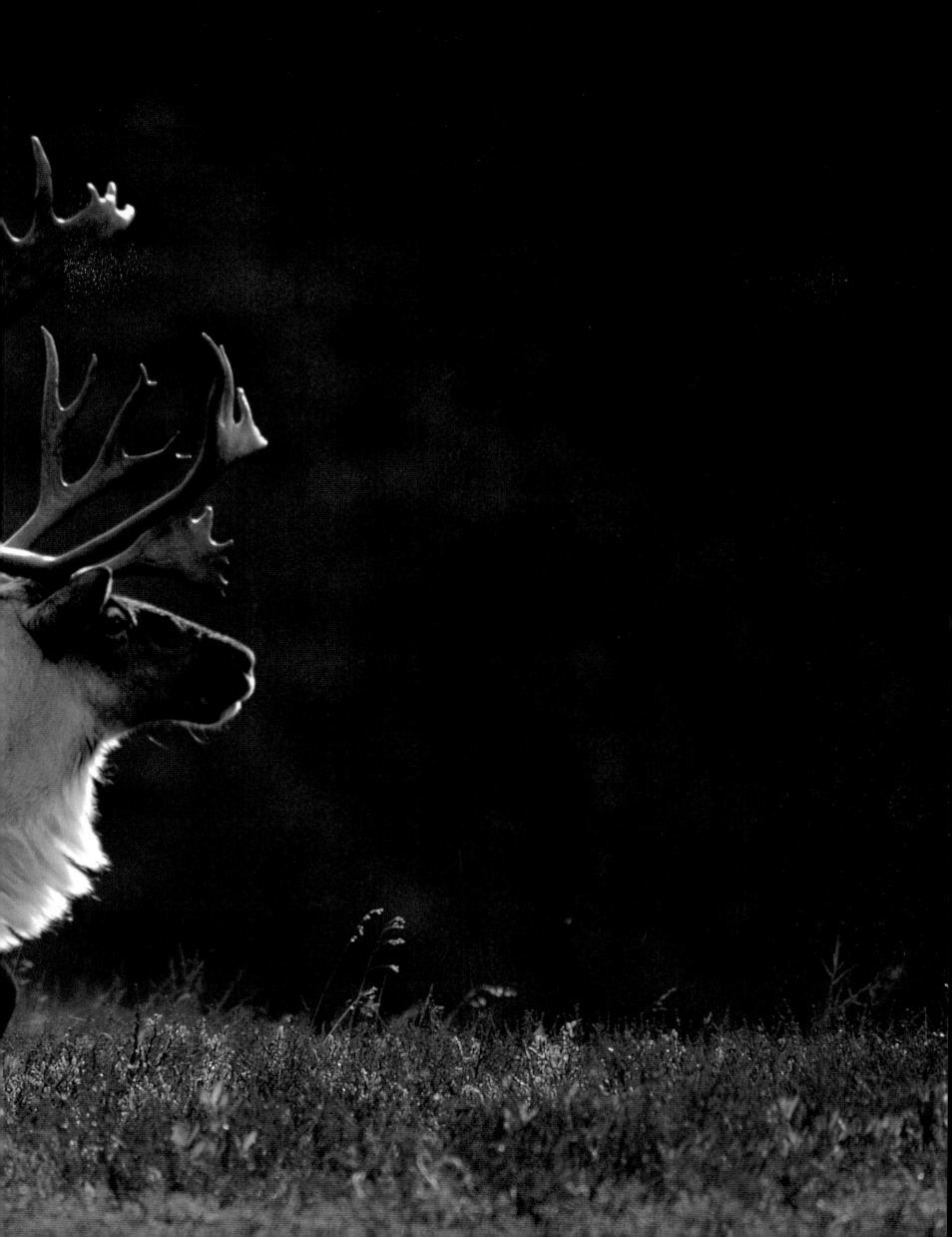

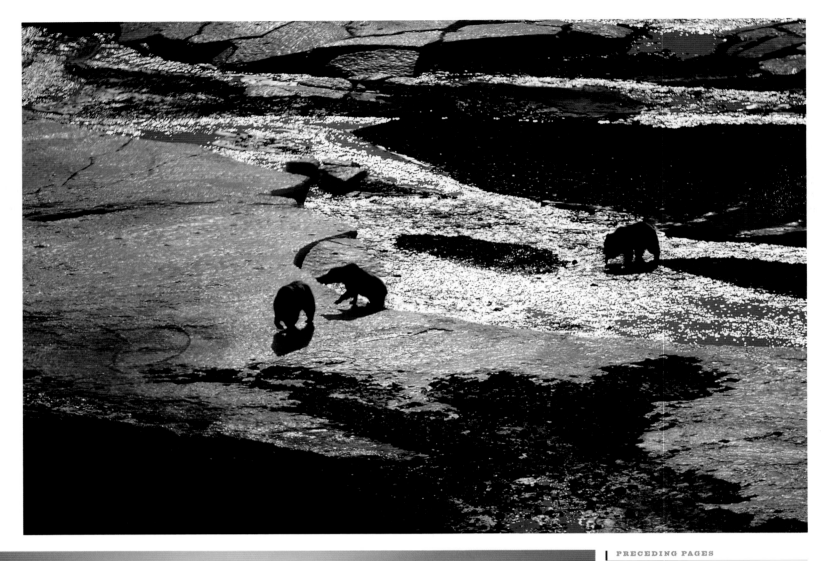

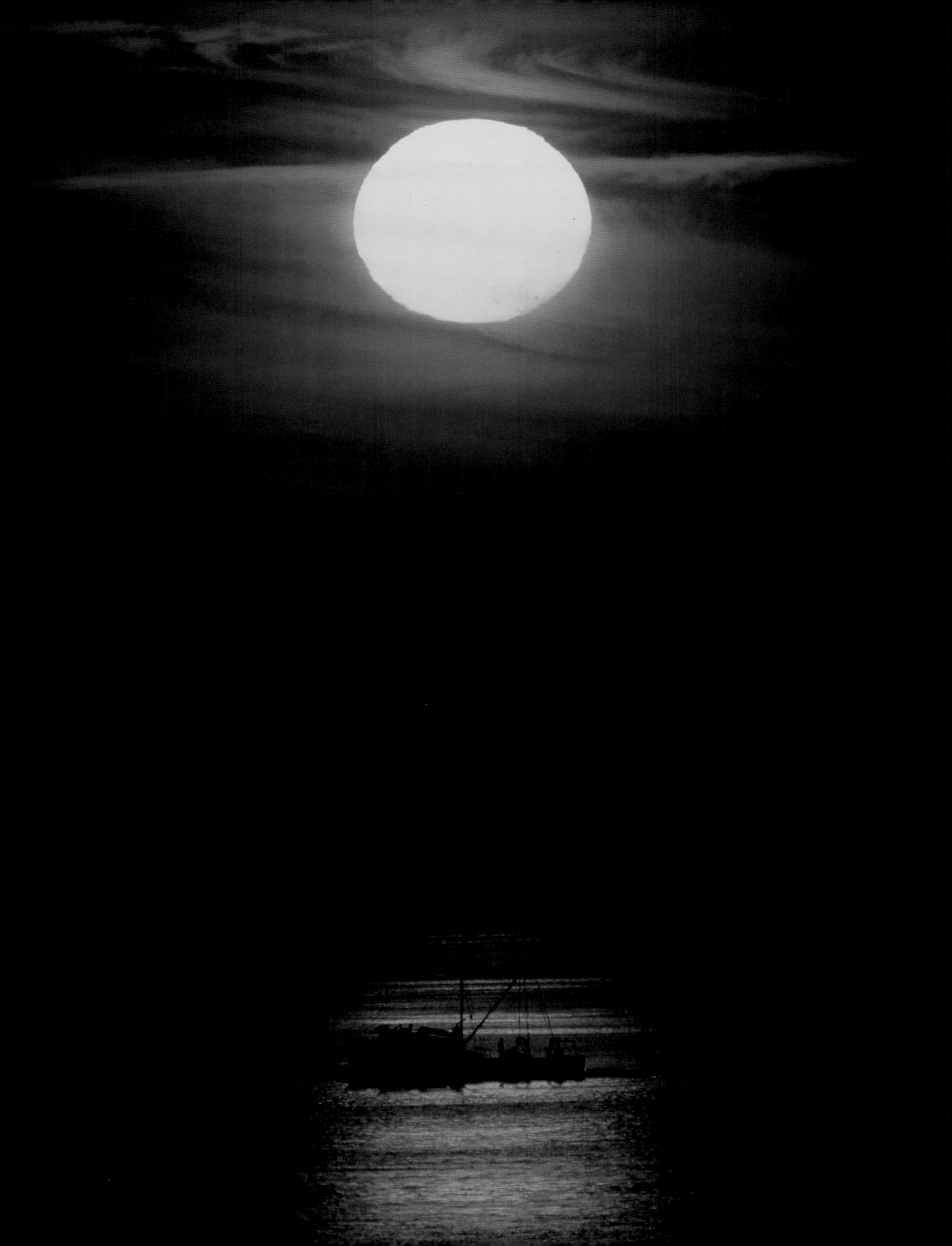

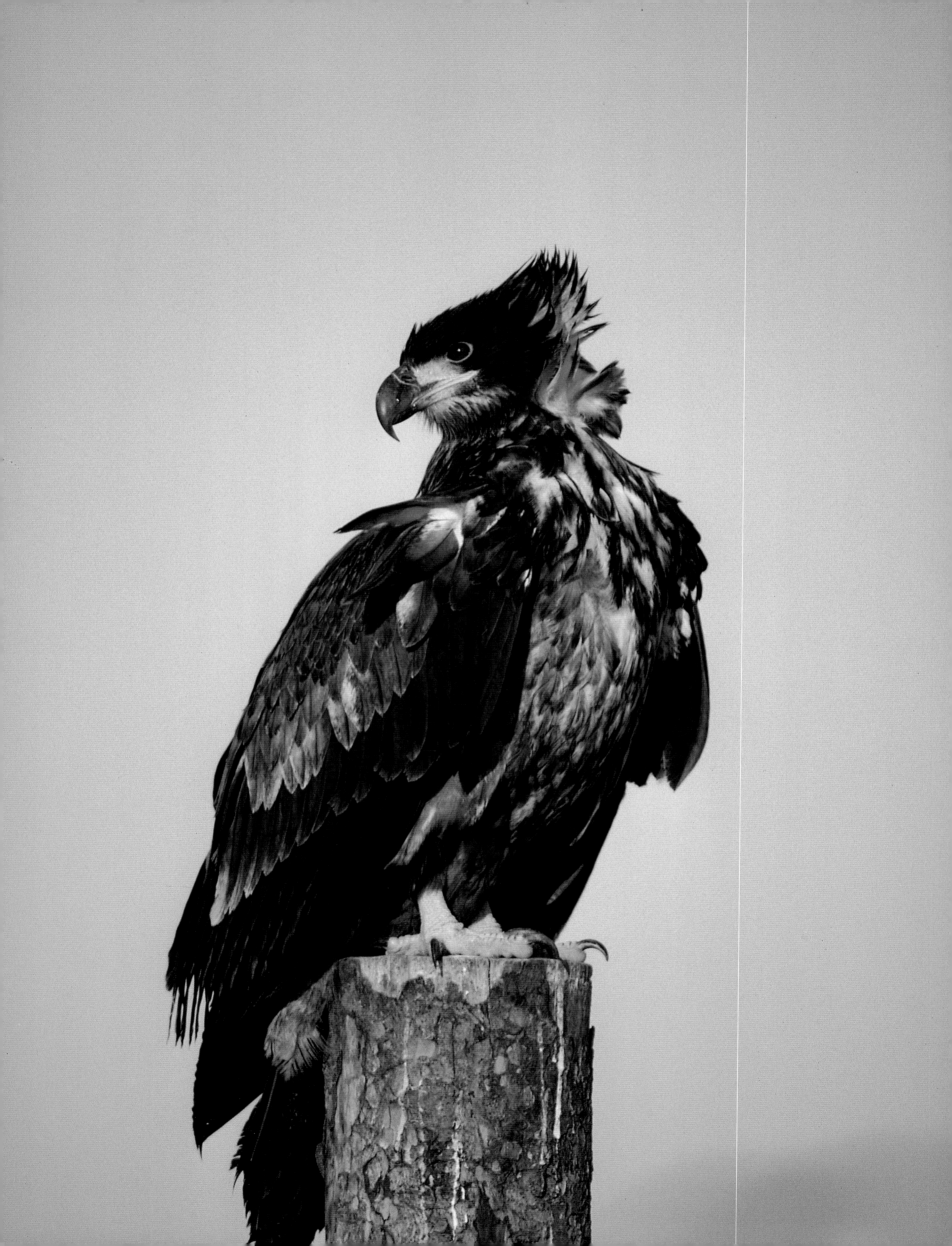

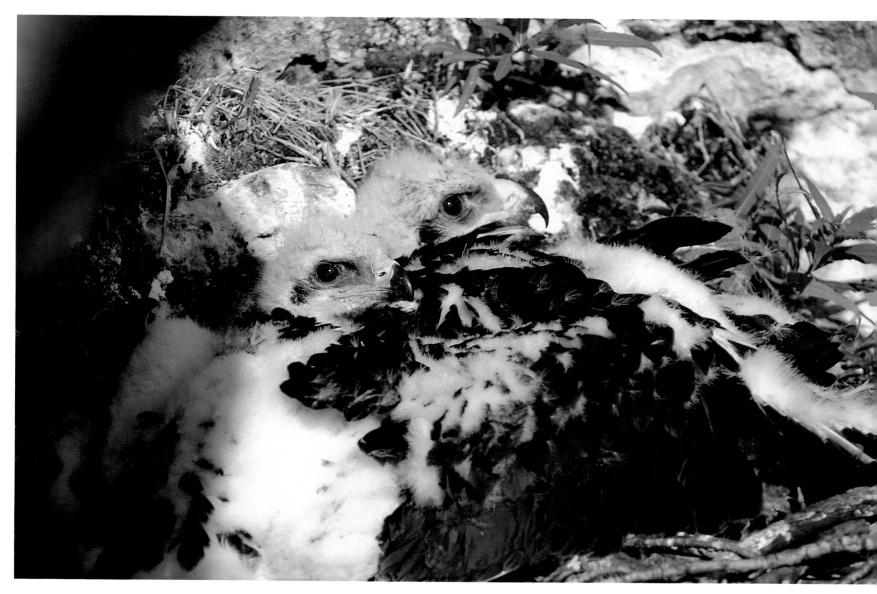

OPPOSITE PAGE

Immature bald eagles are larger than mature eagles. The added size helps them survive during their first few years of life, when their mortality rate is highest.

ABOVE

Two baby golden eaglets huddle in their rock ledge nest, high in the Talkeetna Mountains.

RIGHT

In 1990, stellar sea lions were added to the endagered species list. Gulf of Alaska

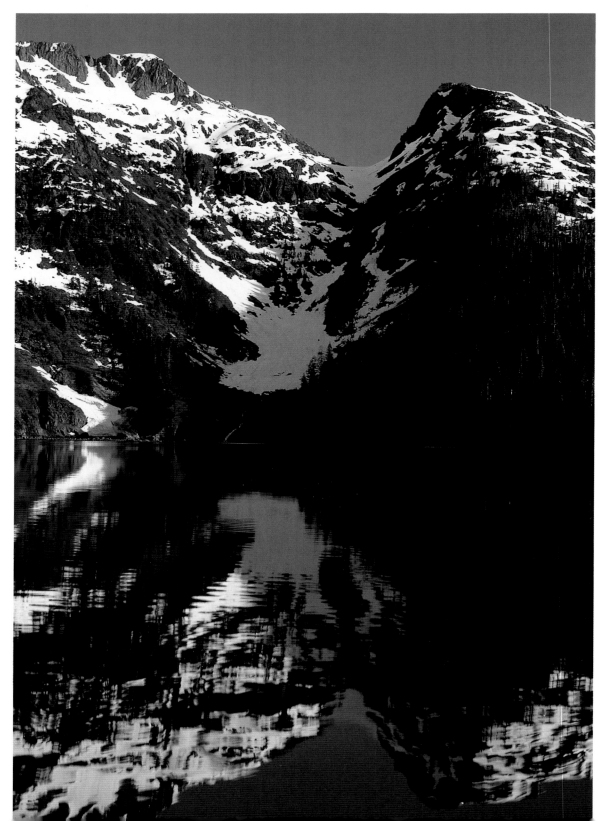

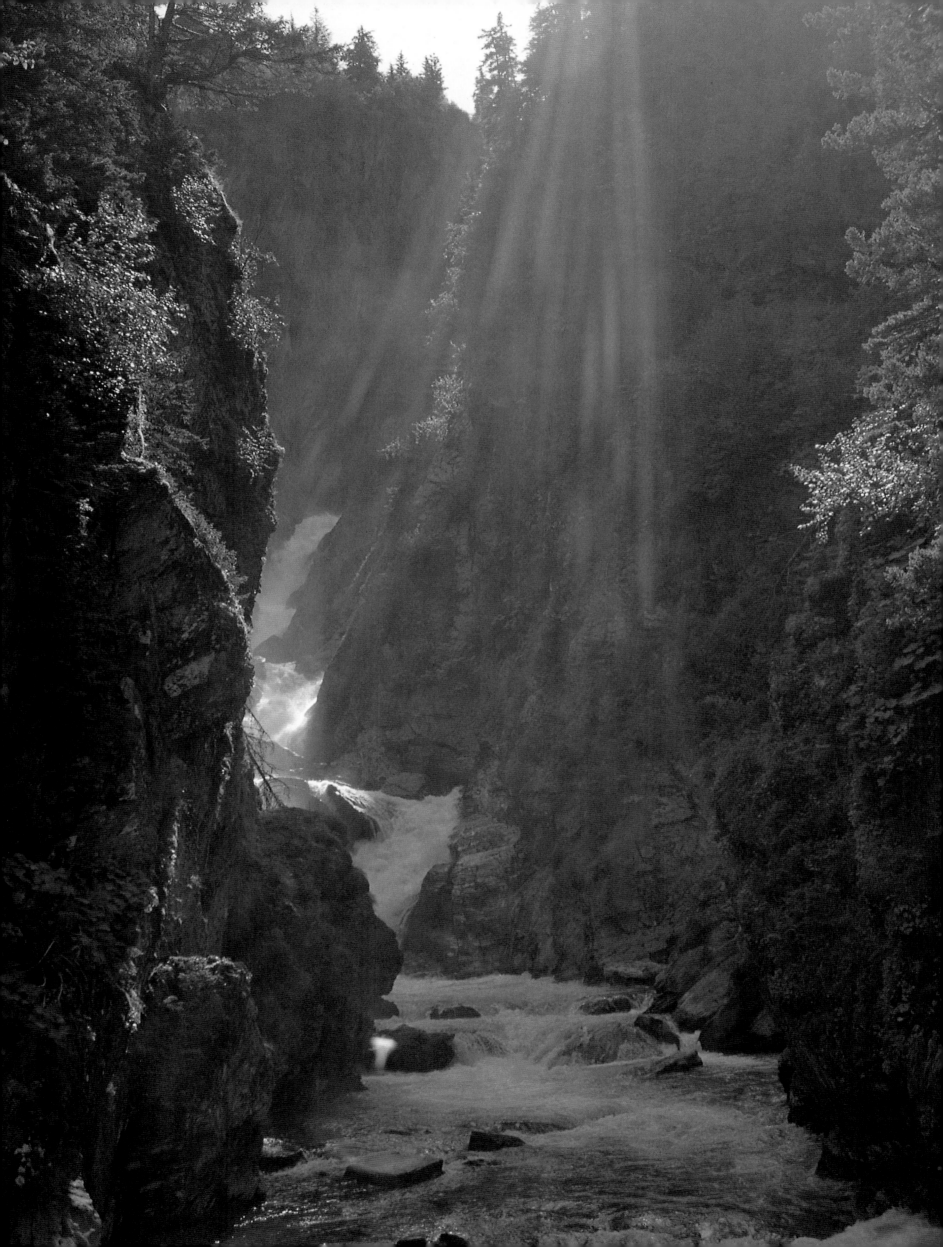

LEFT
One of Alaska Nellie's first railroad cabins near Lawing, Alaska, on Kenai Lake.

OPPOSITE PAGE ABOVE
The Nenana River in all its fury. Healy, Alaska.

OPPOSITE PAGE BELOW
Fireweed abounds along peaceful meandering Quartz Creek, in the Kenai Mountains.

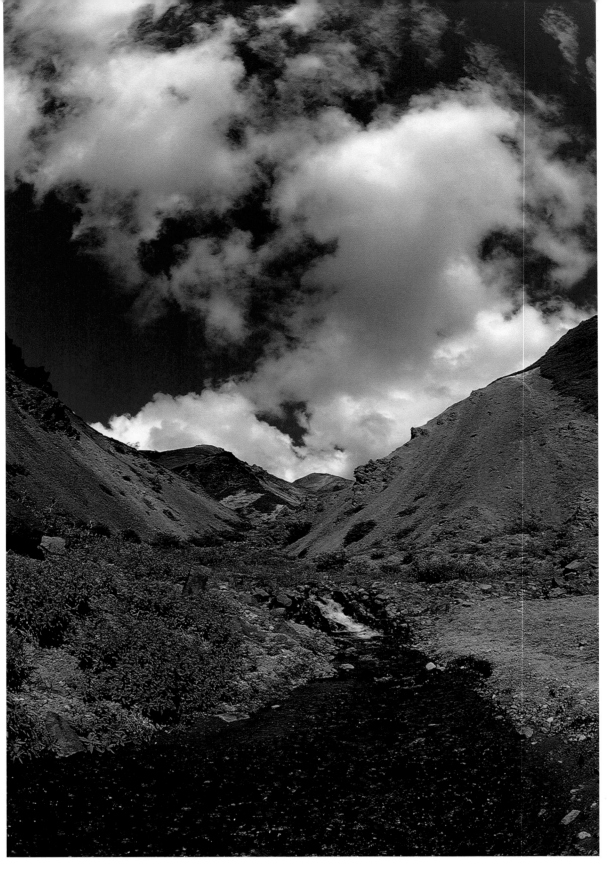

ABOVE

A no-name creek in the Alaska Range.

OPPOSITE PAGE

*To the surprise and delight of the author,
this bull moose—weighing over sixteen
hundred pounds—lies down to take a nap
at his feet.*

FOLLOWING PAGES

*Spouting humpback whales cruise the
water of Prince William Sound near
Bainbridge Glacier.*

ALASKA

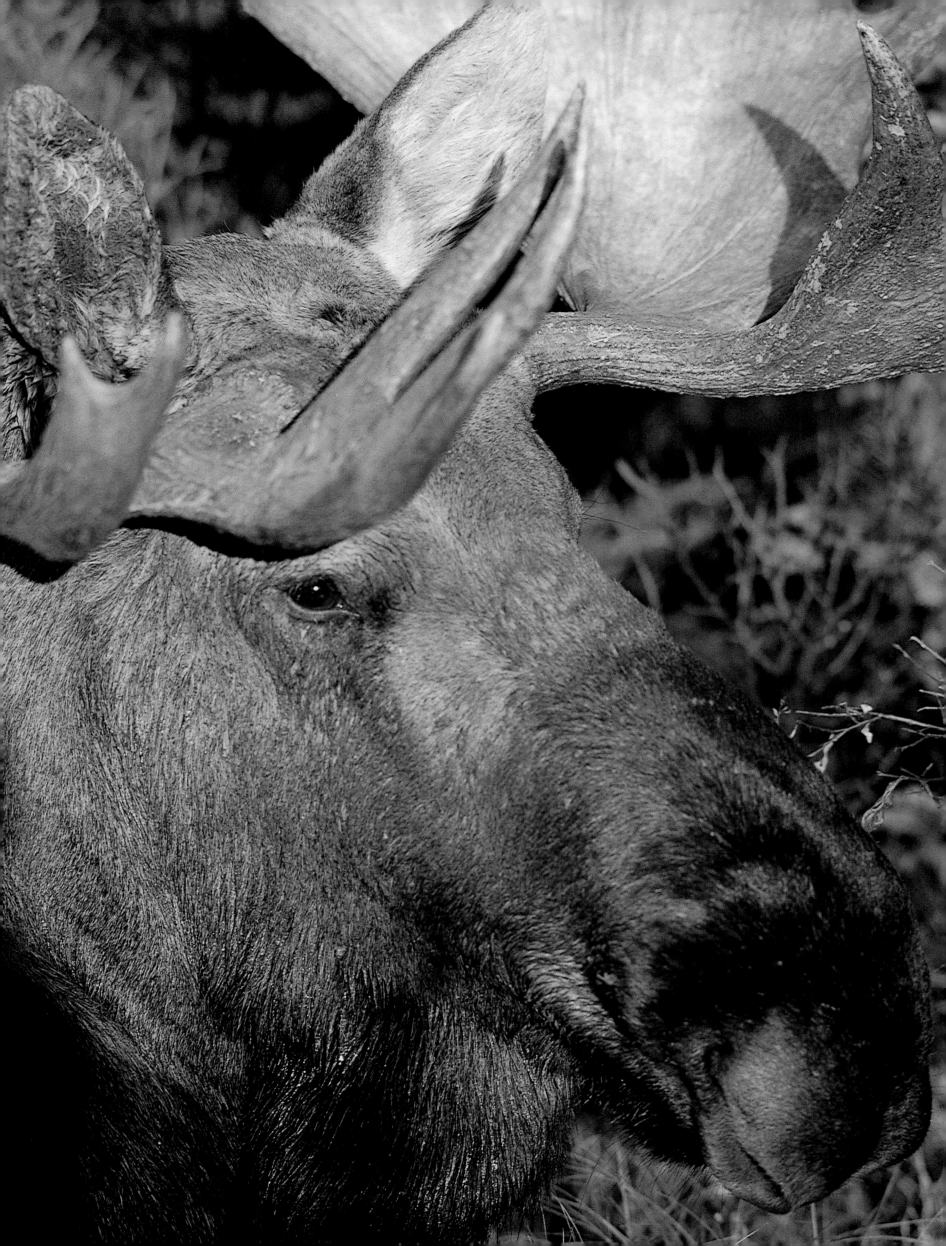

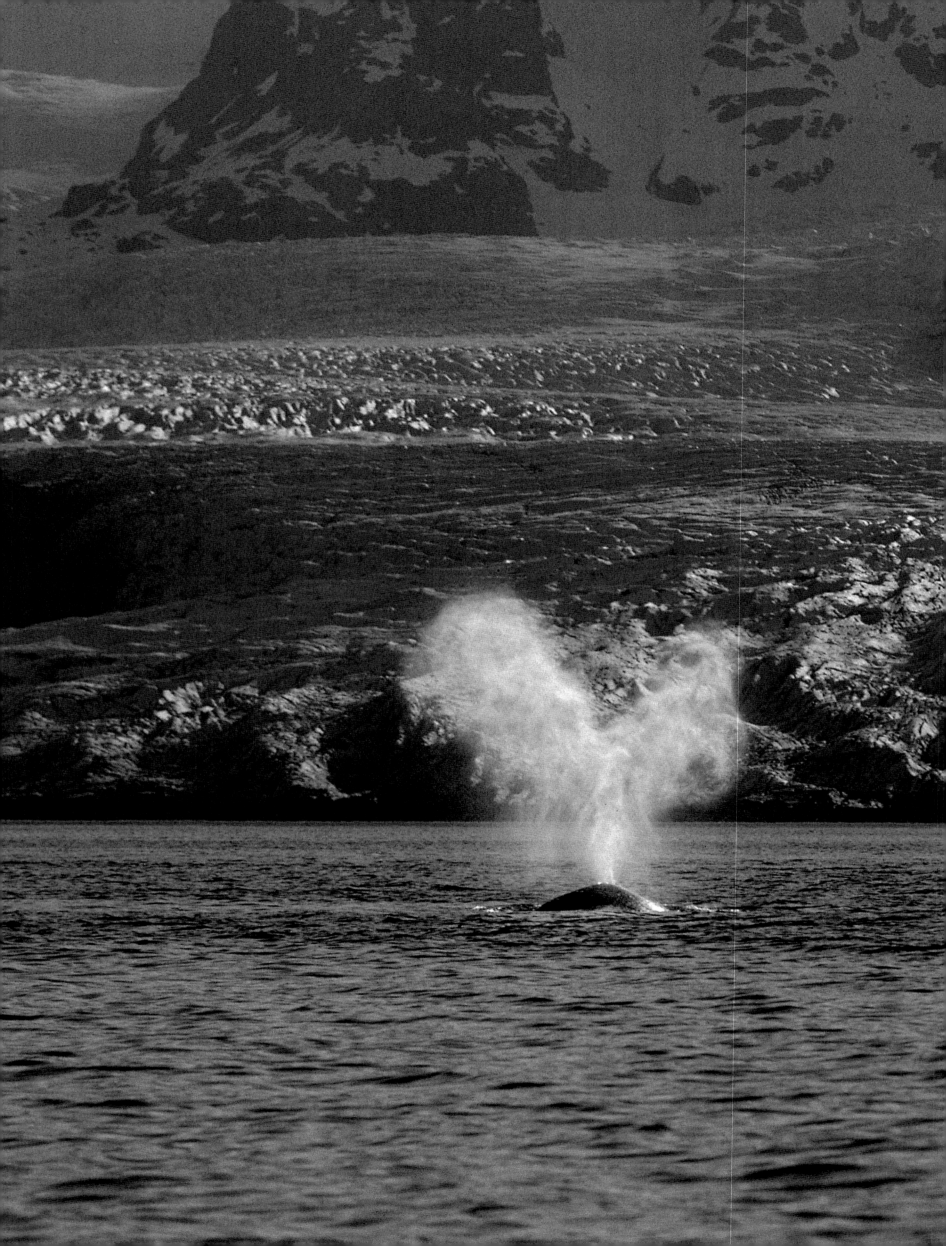

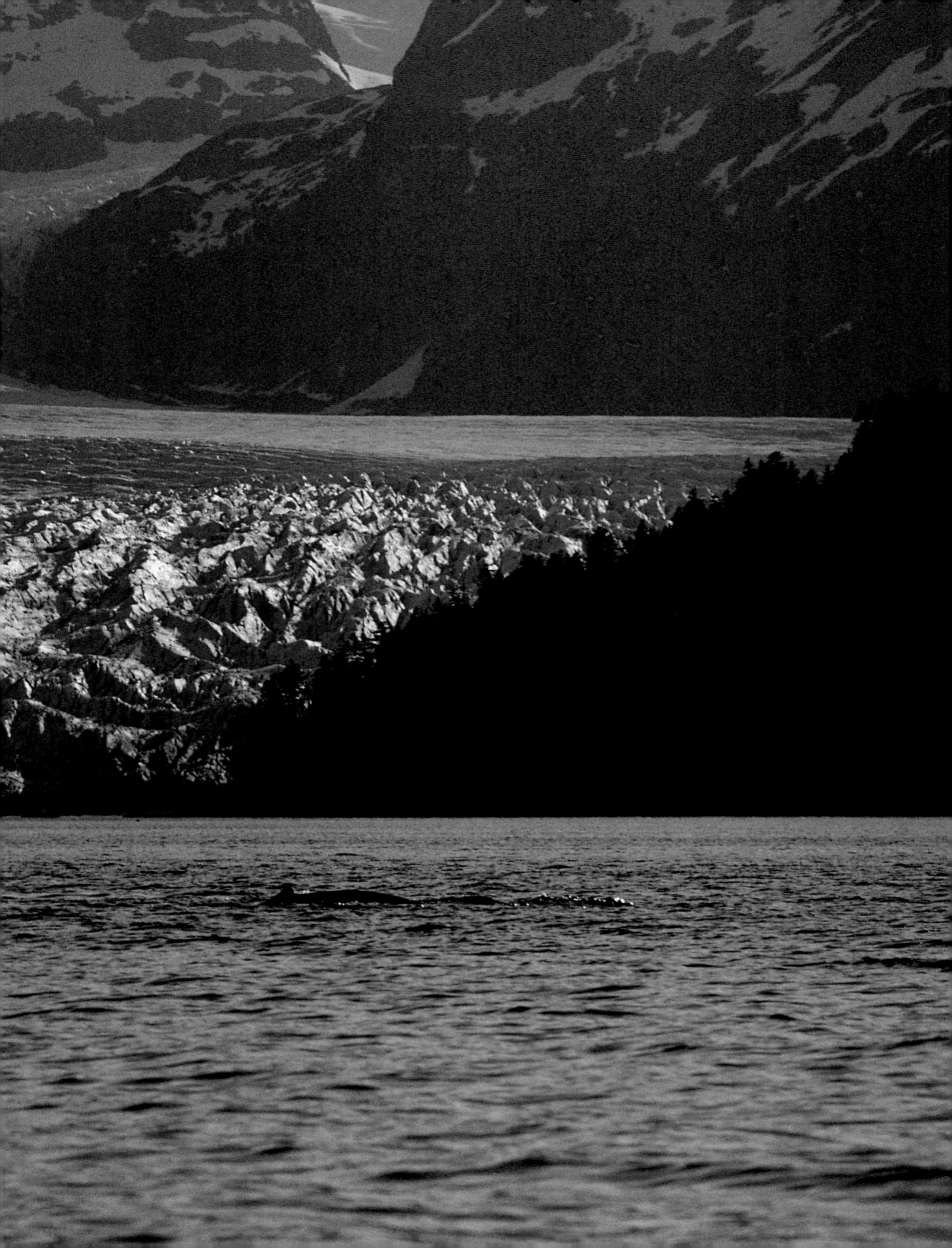

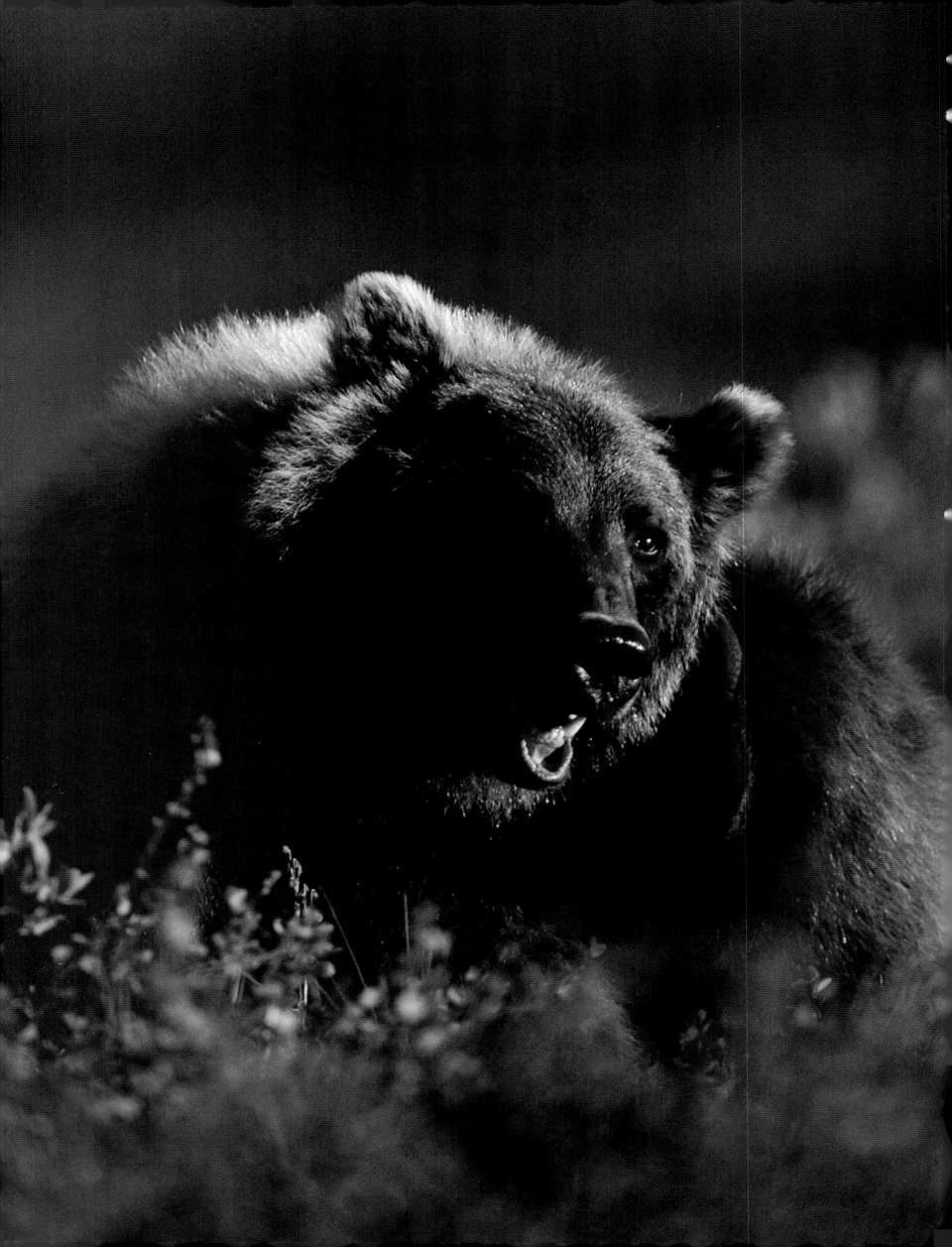

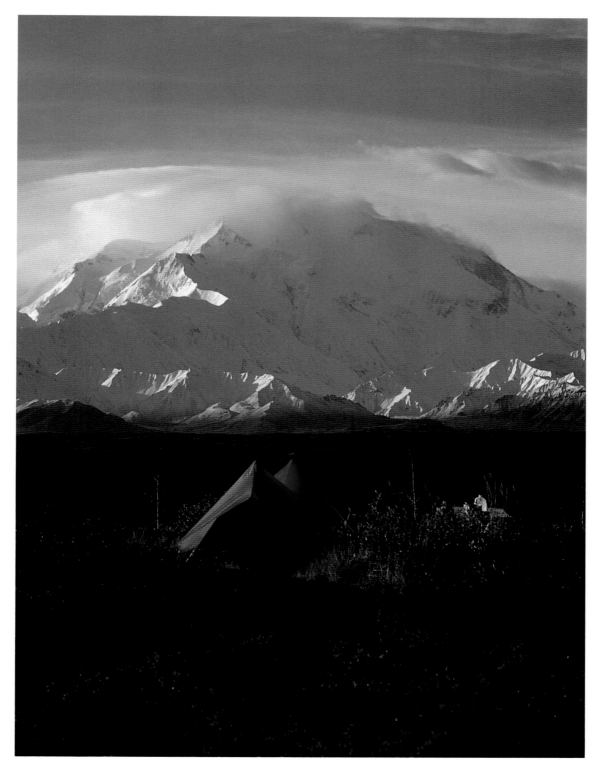

A Photographic Journey Through the Last Wilderness

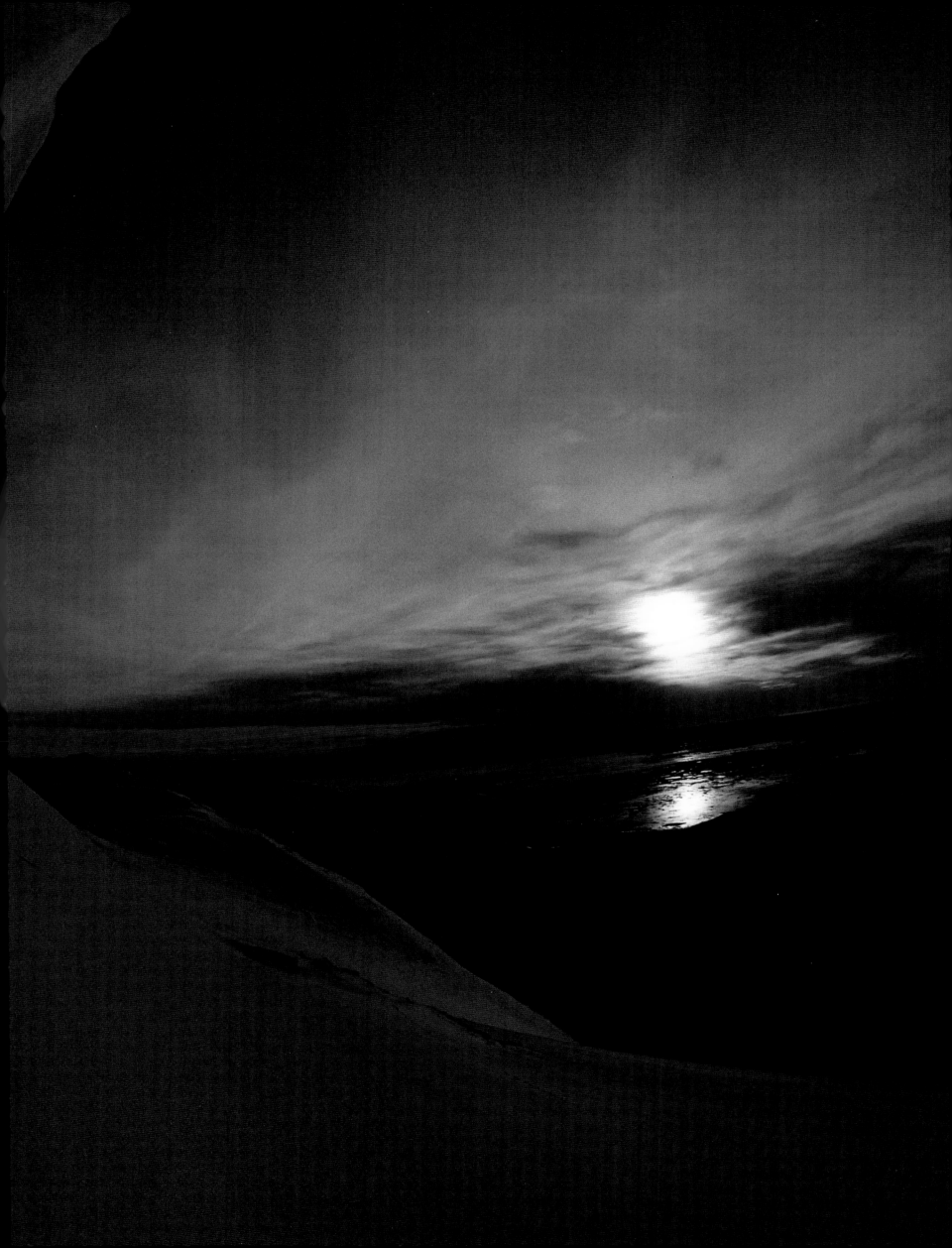

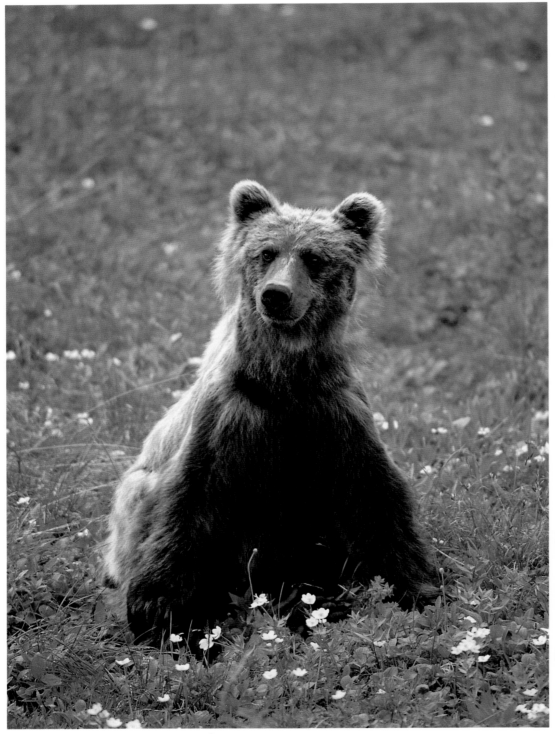

LEFT

A three-year-old grizzly cub loses his winter fur—and his mother—in early spring. A mother grizzly will leave cubs to fend for themselves after they reach two or three years of age.

OPPOSITE PAGE

Wolves are found throughout Alaska. Katmai, the sixteen-year-old timber wolf pictured here, has lived with the author since he was a puppy and lost his parents.

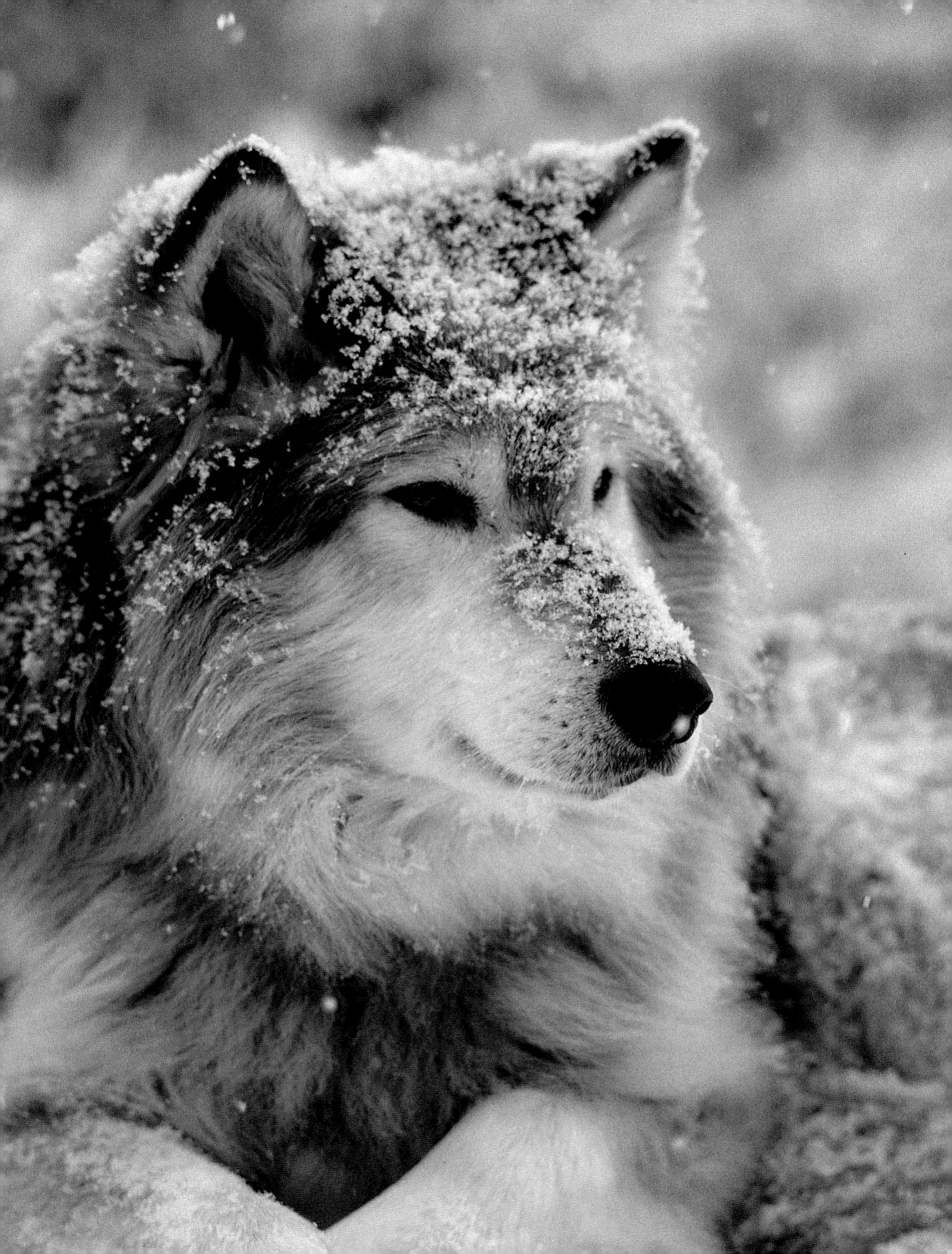

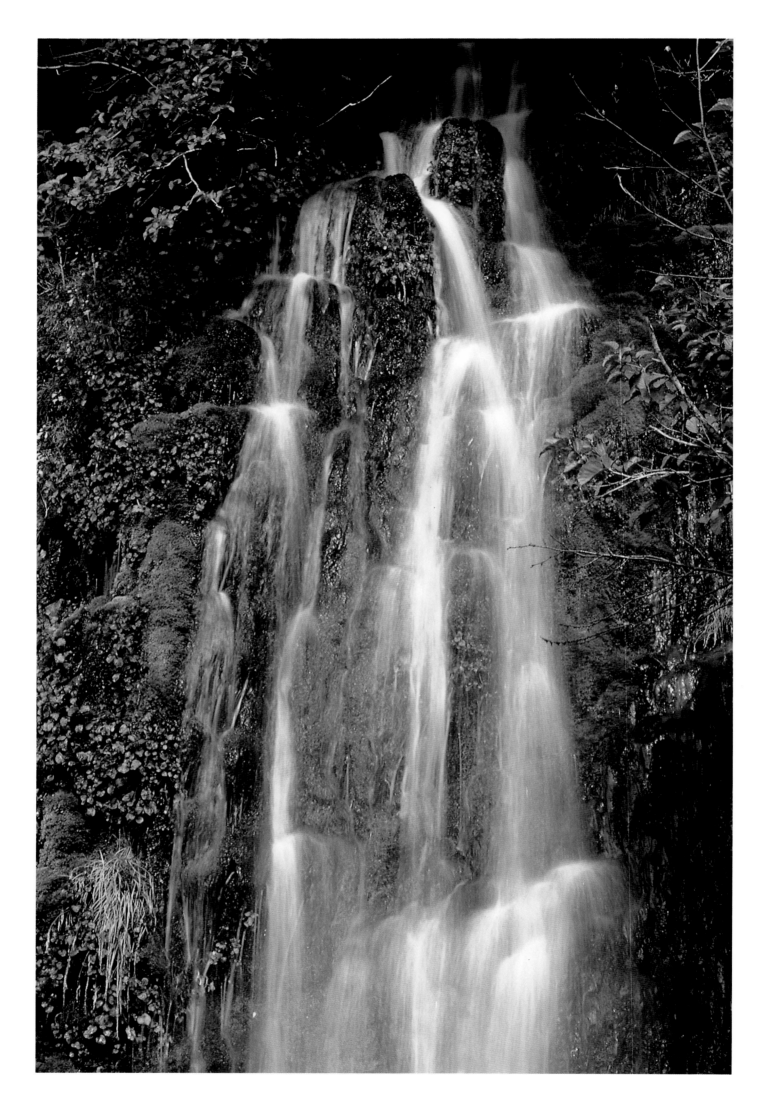

ALASKA

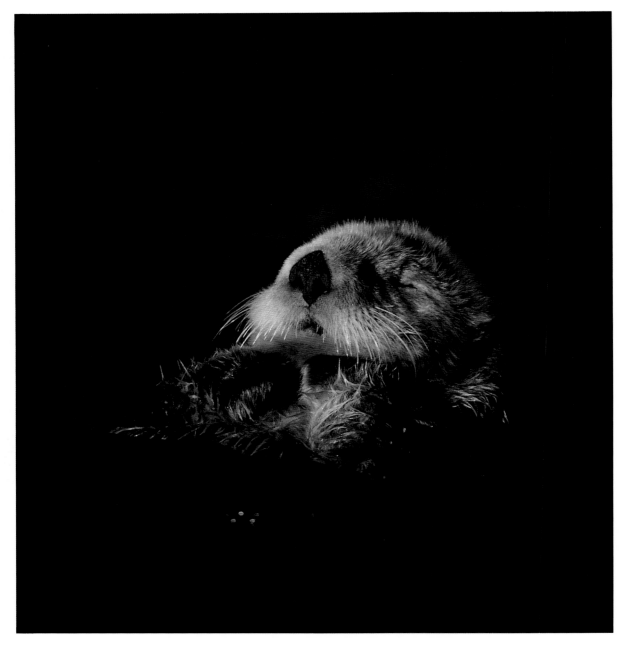

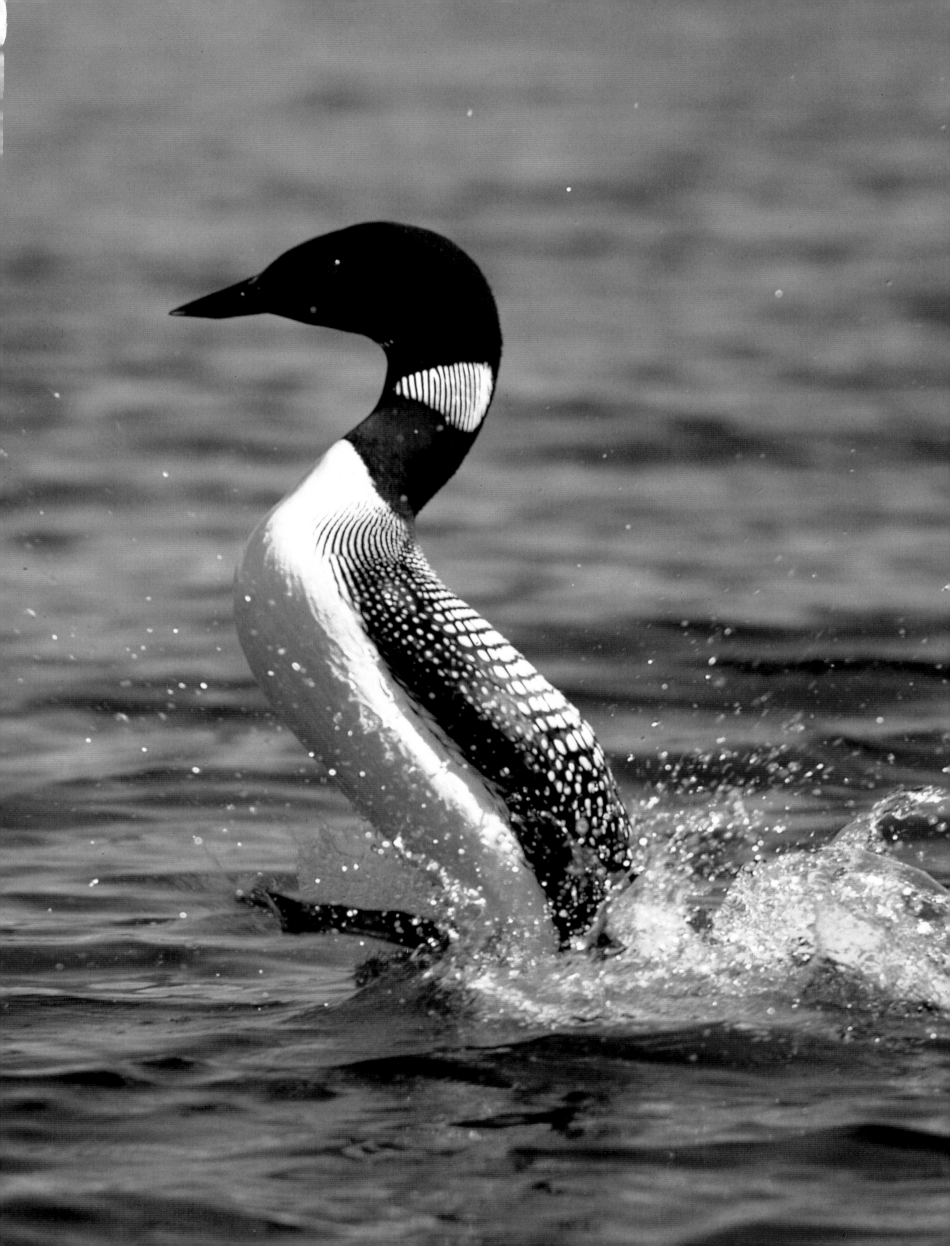

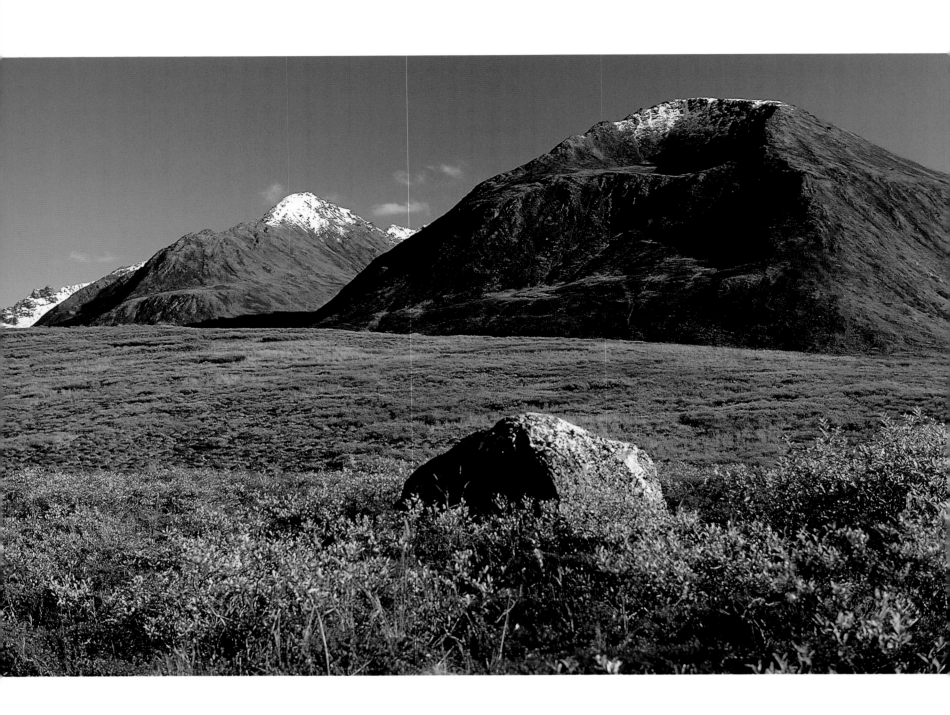

ALASKA

OPPOSITE PAGE

Fall, Hatcher Pass in the Talkeetna Mountains.

ABOVE

Tanner crabs fight their way to the top of a fisherman's crab pot in Unalaska.

FOLLOWING PAGE LEFT

An immature bald eagle sheds its remaining brown head feathers, a clue that it is about four years old. In Southeast, near Sitka.

FOLLOWING PAGE RIGHT

A forest fire in the Interior near Fairbanks creates massive smoke and heat that distorts the sun, pictured here.

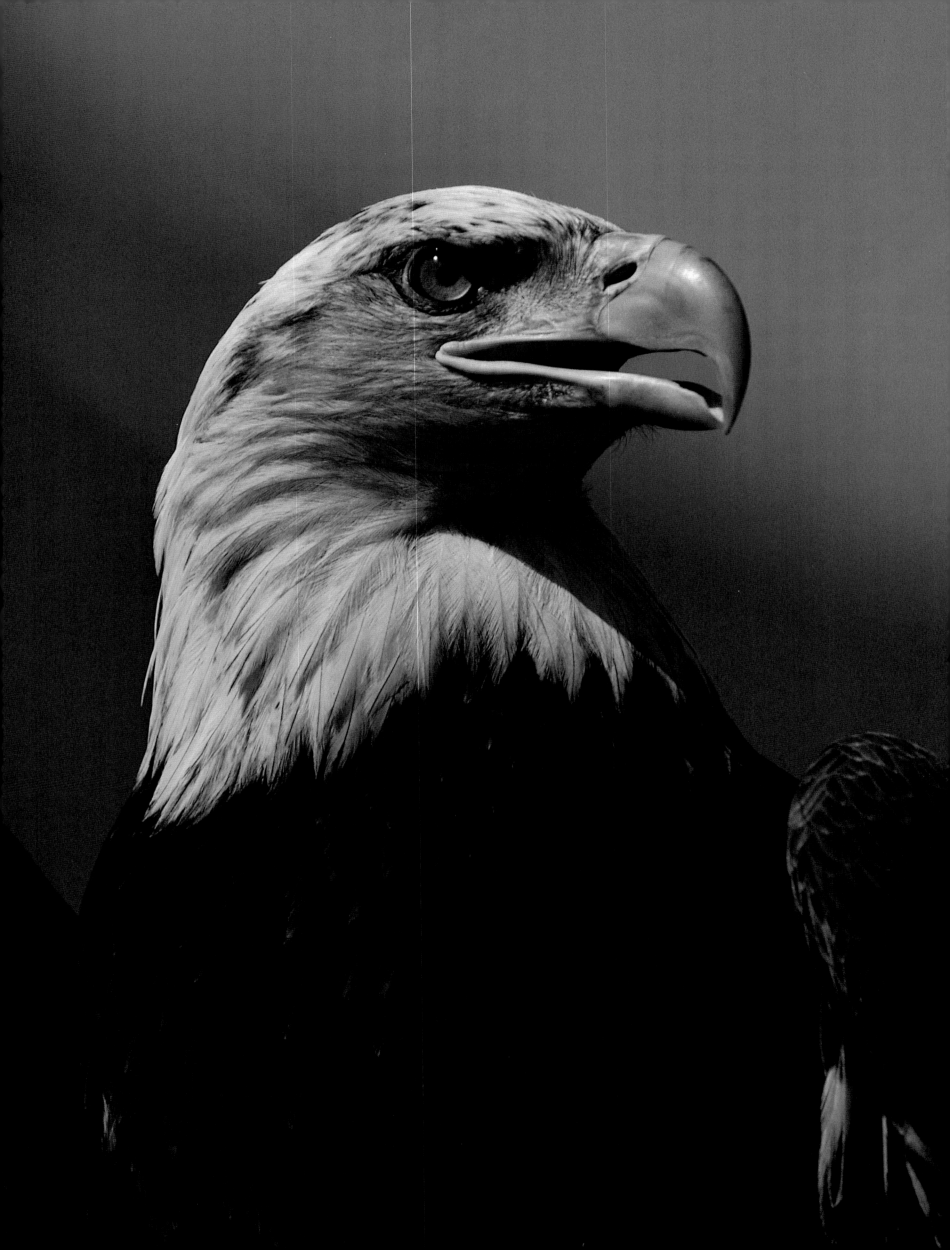

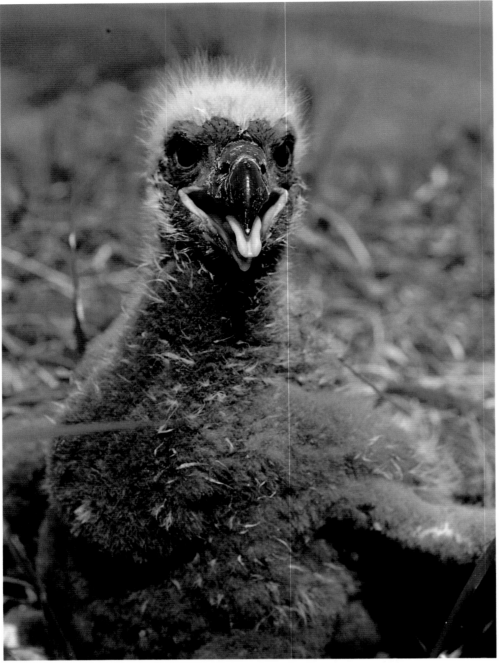

LEFT

A bald eaglet sits atop its ground nest on Adak Island in the Aleutian Islands.

BELOW

A female merganser catches an eel with her serrated bill in Brooks River, Katmai National Park.

OPPOSITE PAGE

Arctic terns, Yukon River.

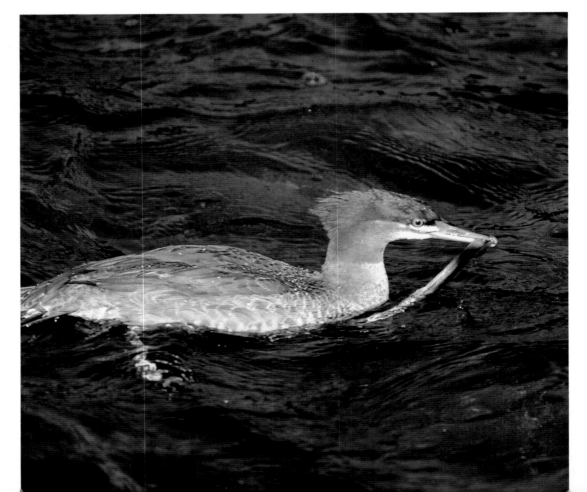

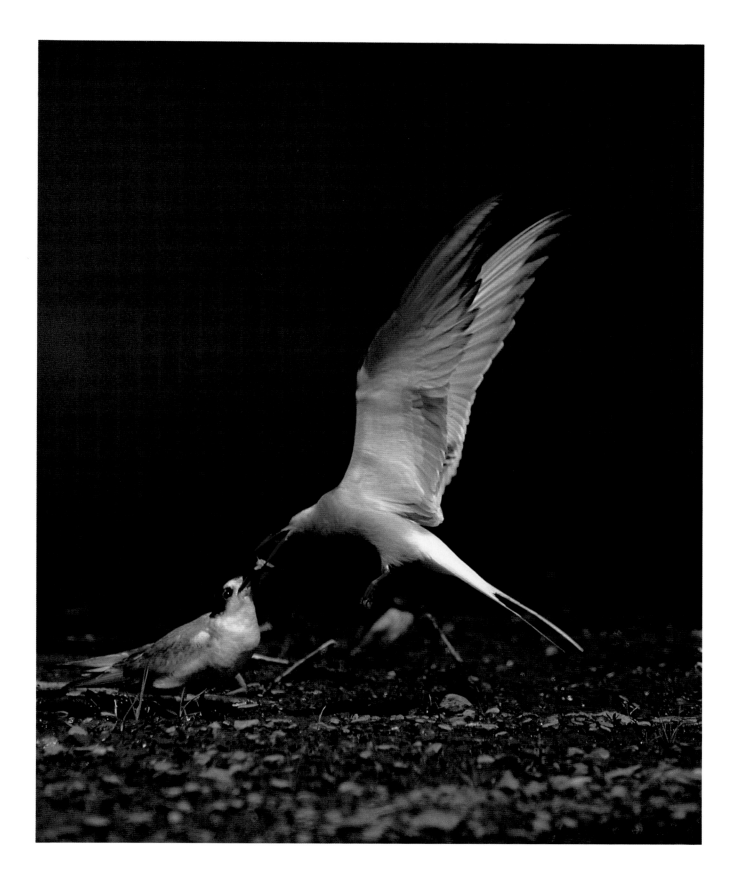

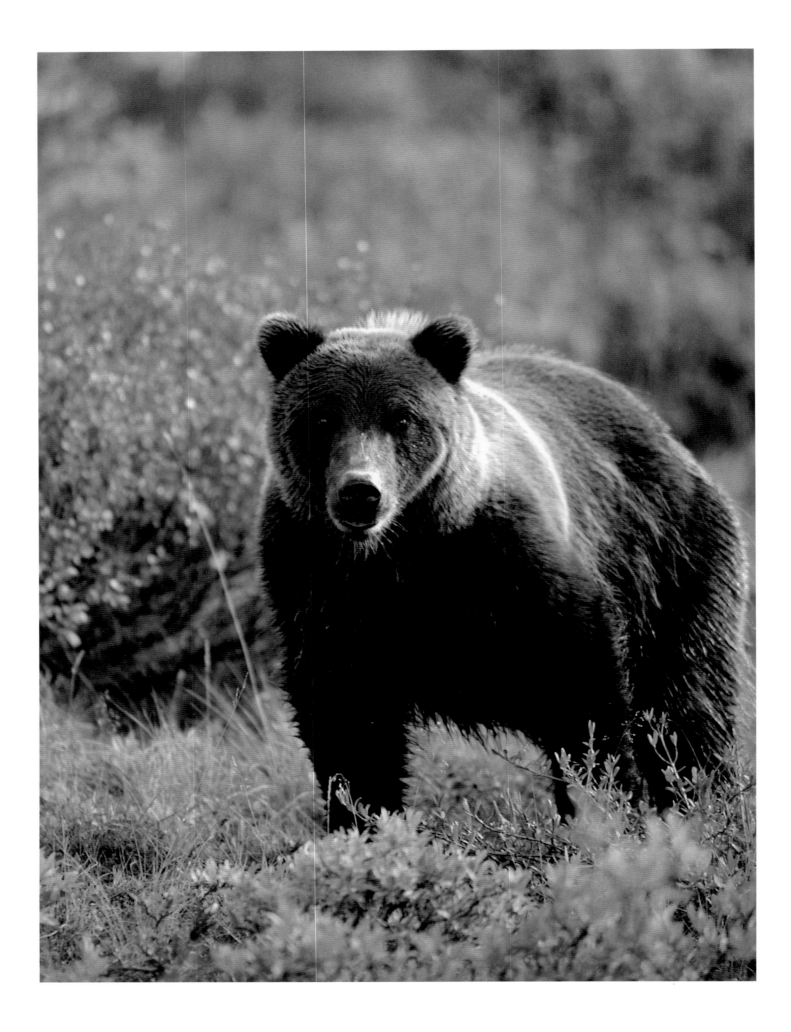

ALASKA

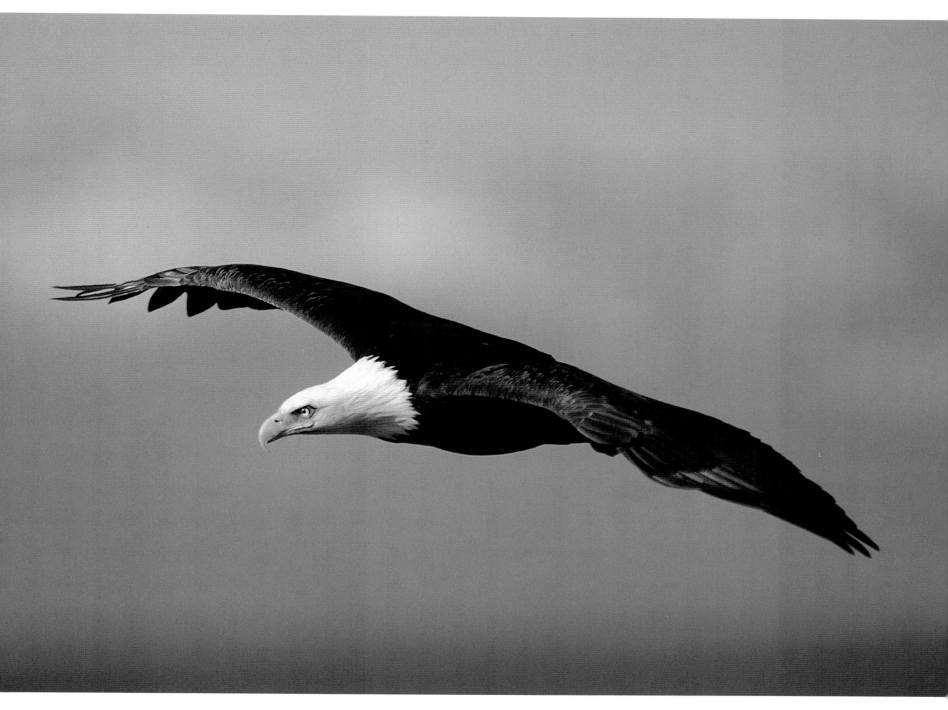

A Photographic Journey Through the Last Wilderness

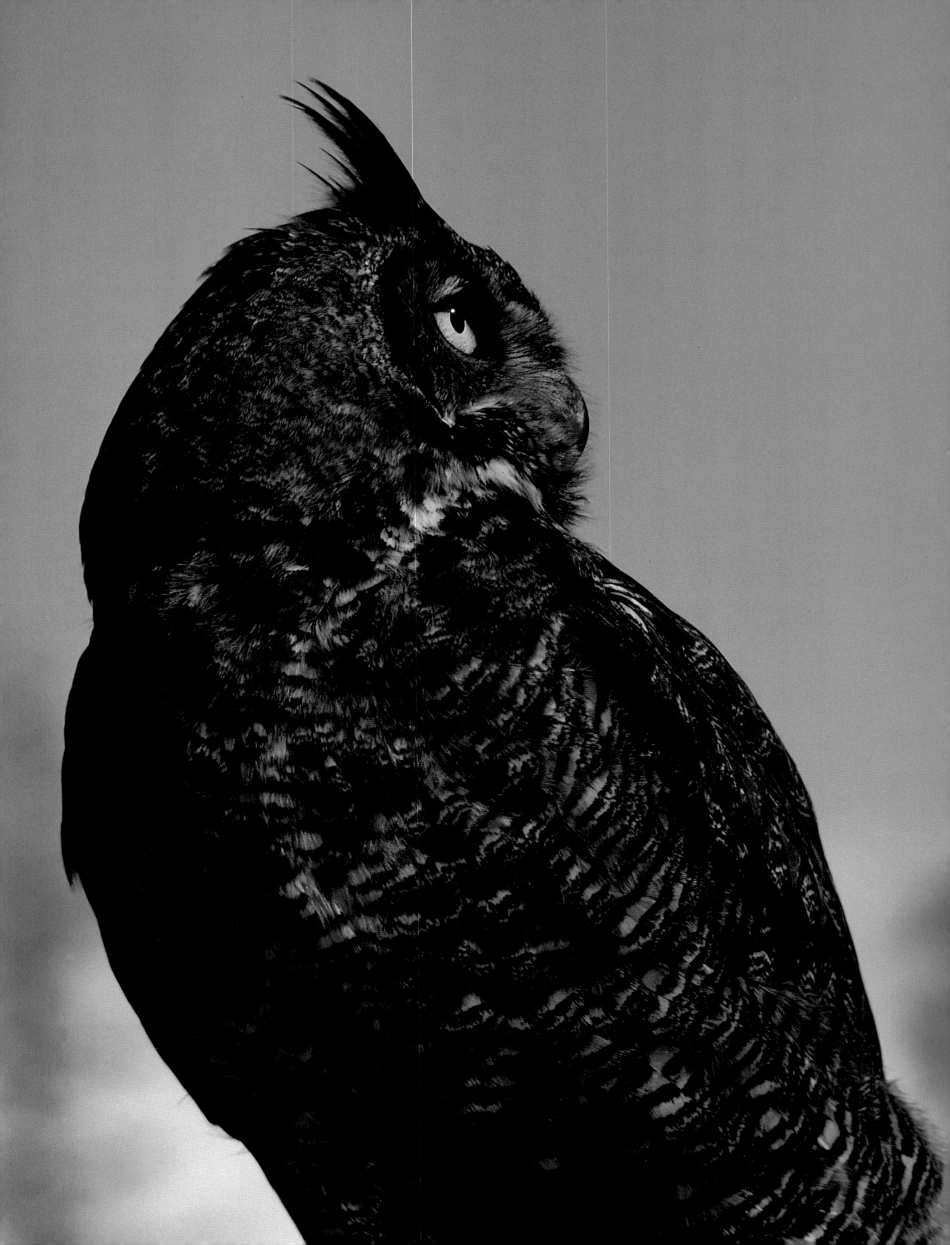

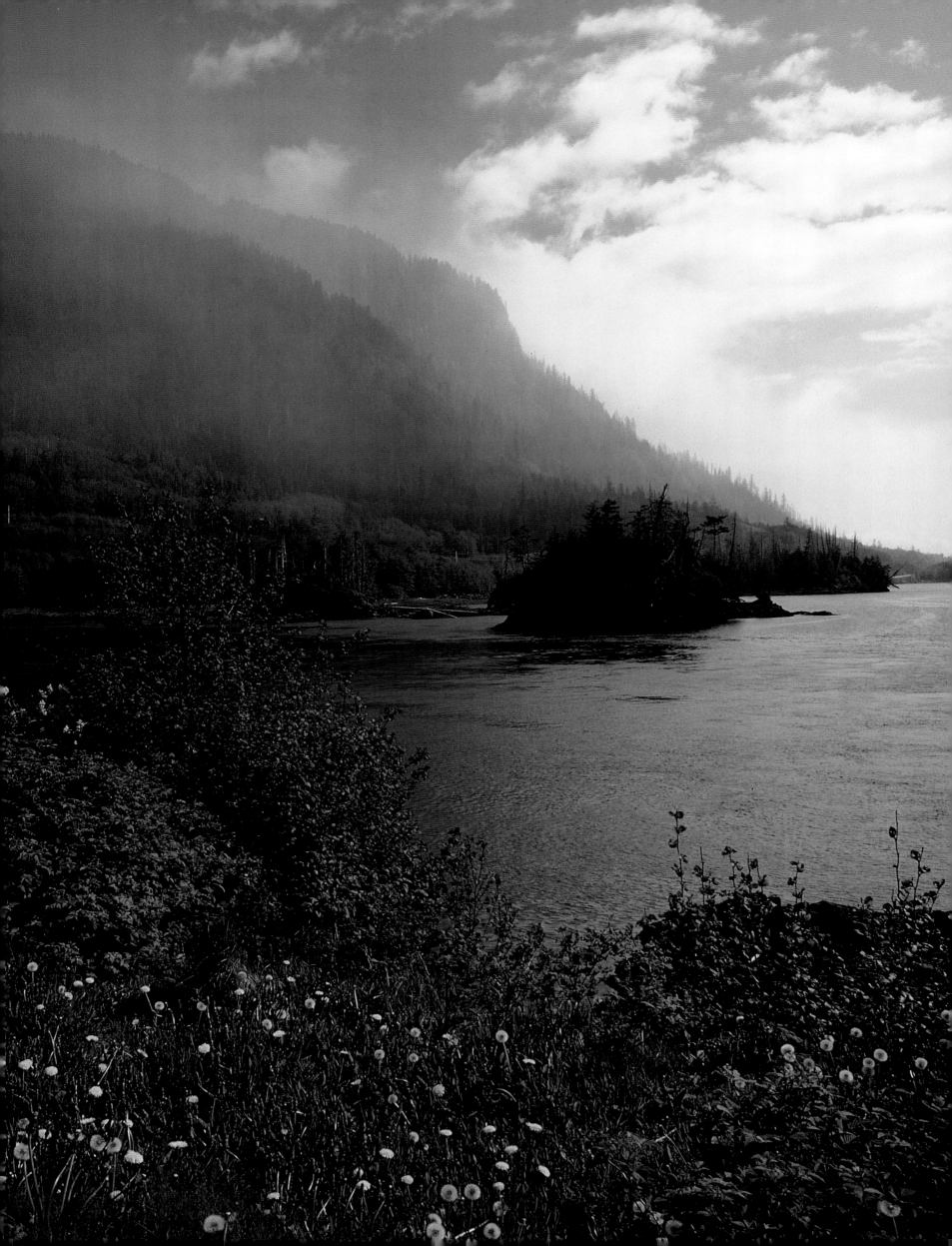

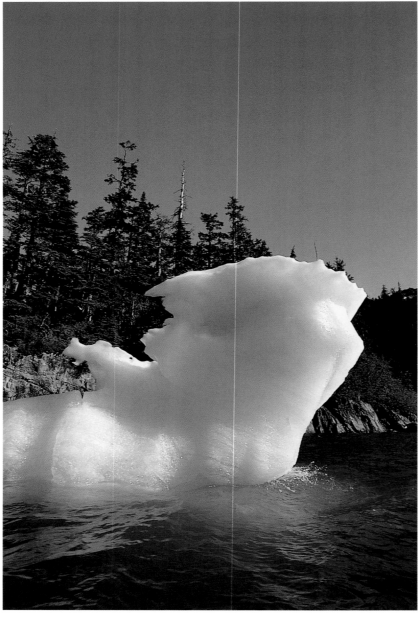

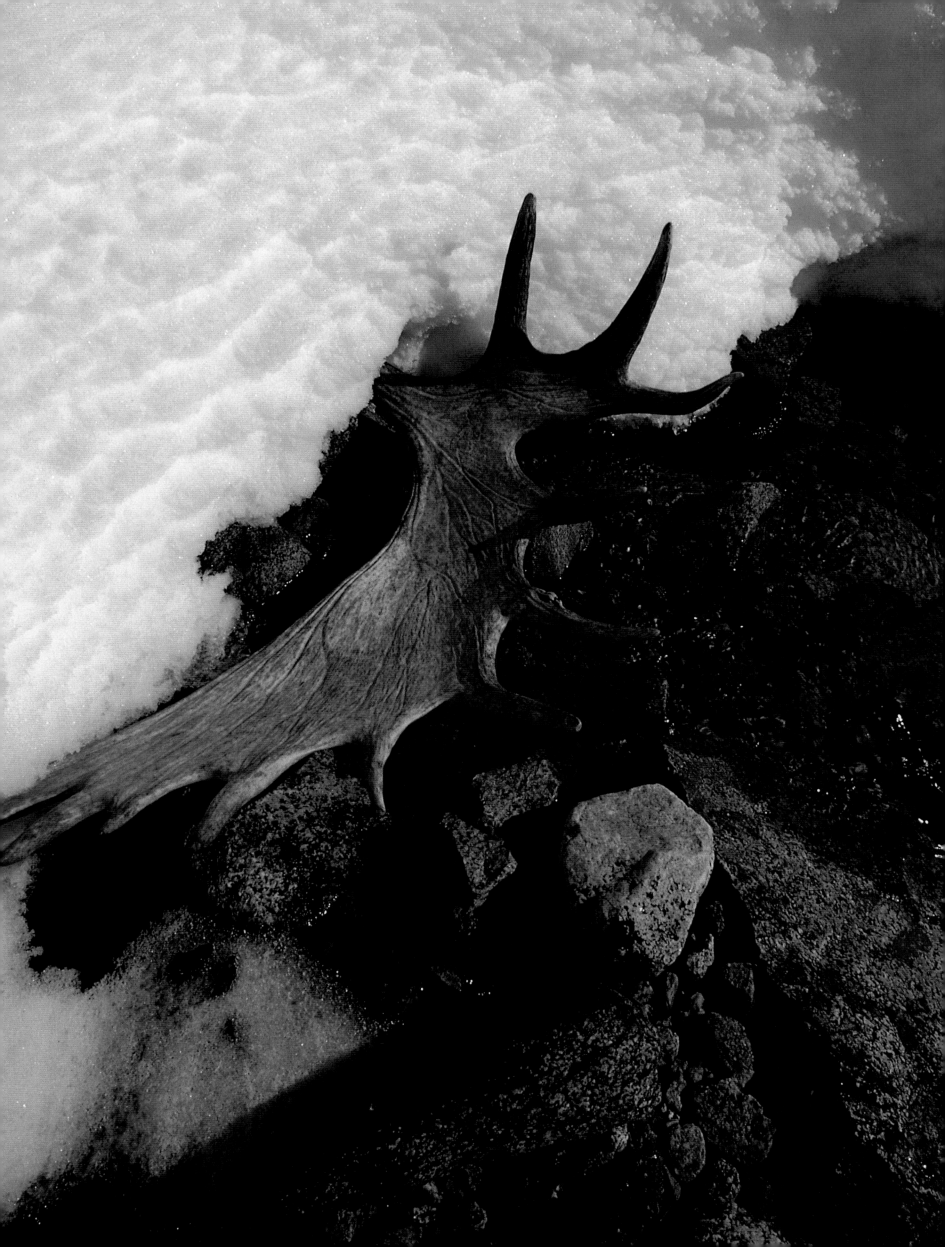

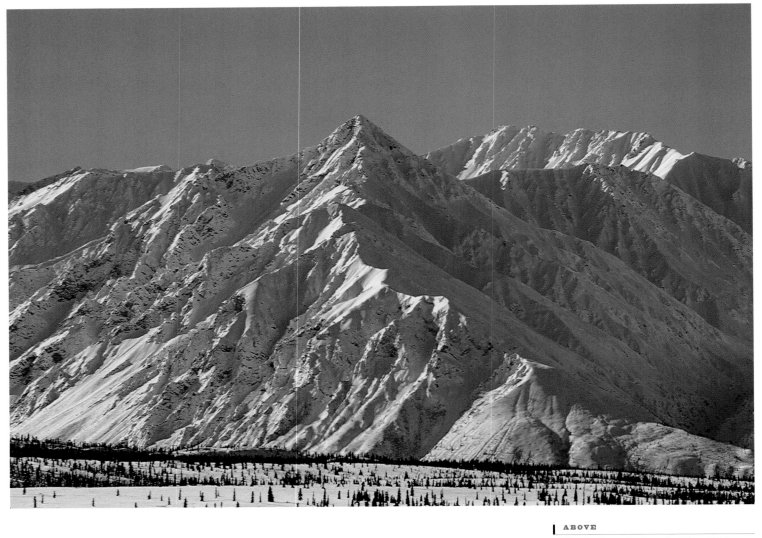

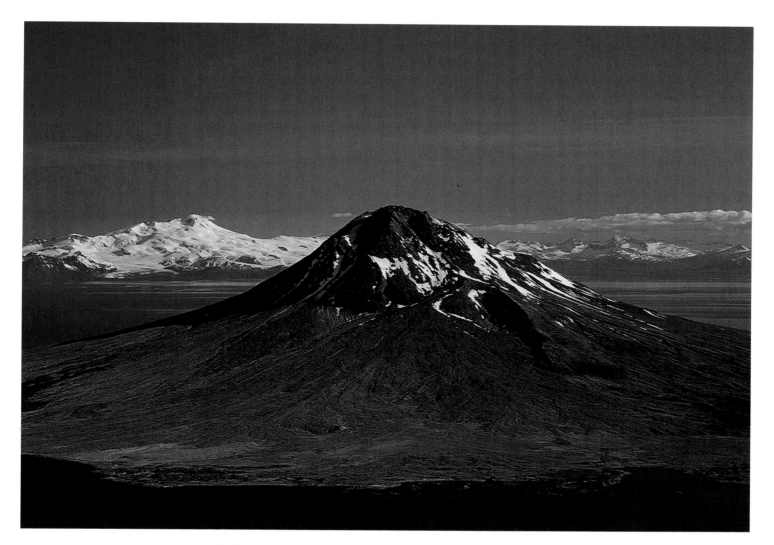

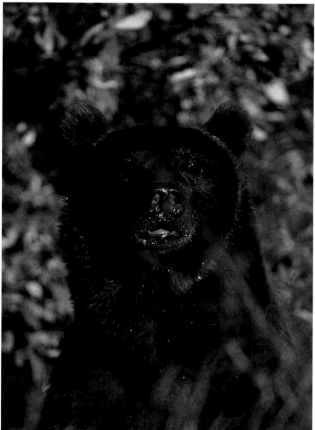

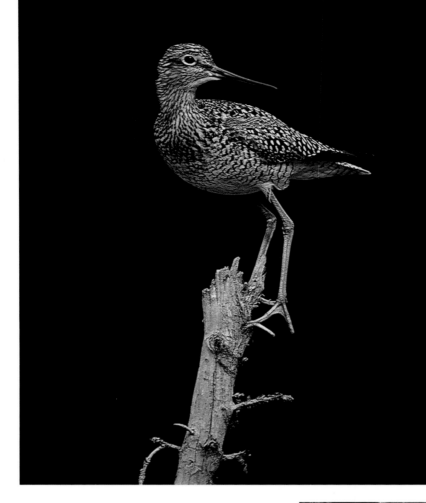

LEFT

The greater yellow legs of Alaska's swamps, marshes, and ponds are the only members of the sandpiper family to feed on small fish. They range throughout all of Alaska.

BELOW

Alaska has thousands of unnamed creeks and waterfalls.

OPPOSITE PAGE

The isolation of Alaska's Arctic Coast.

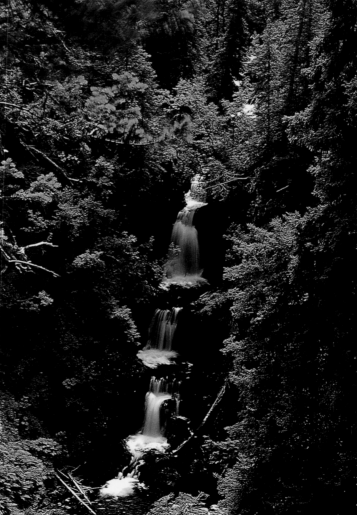

ALASKA

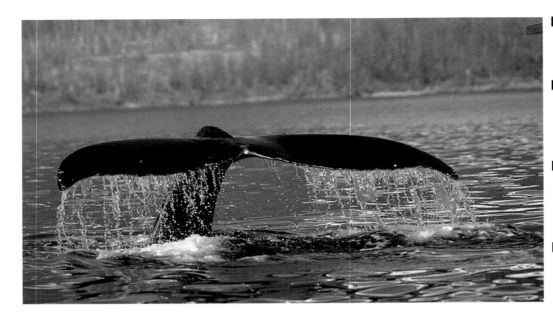

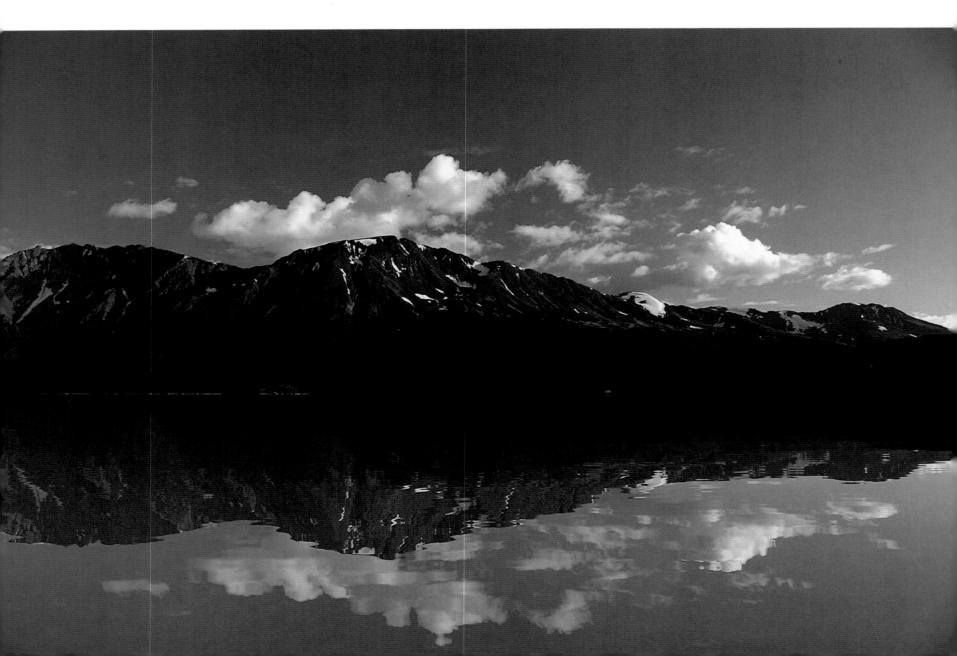

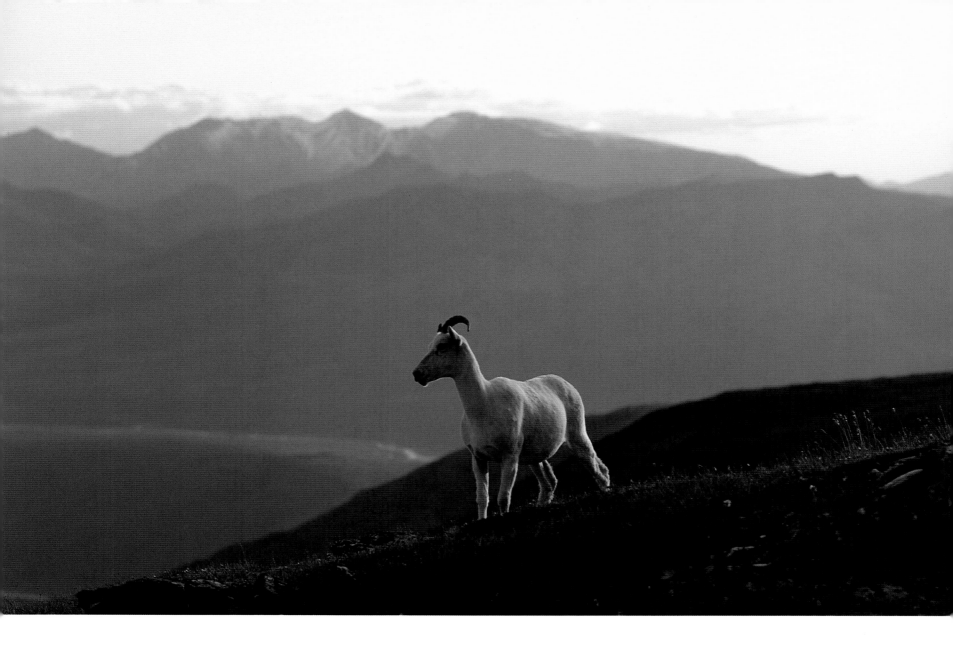

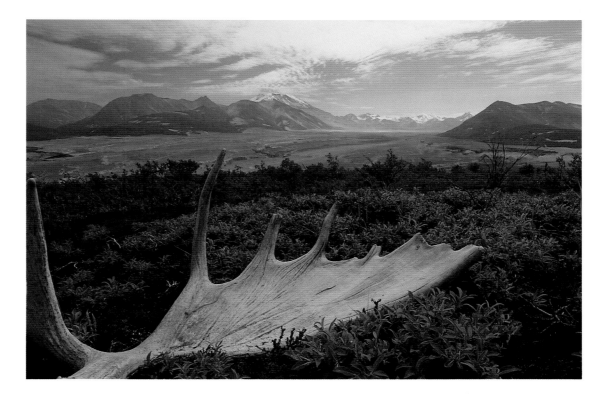

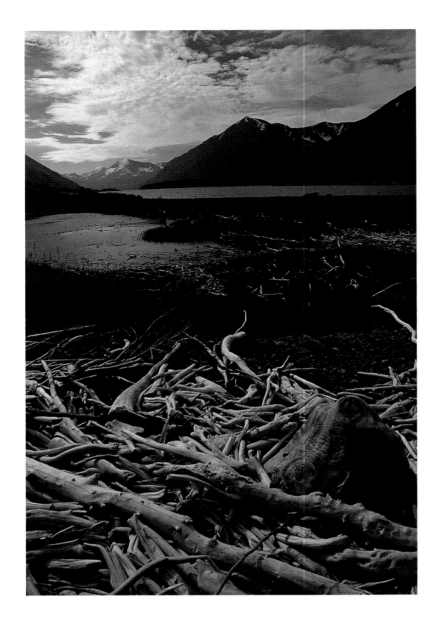

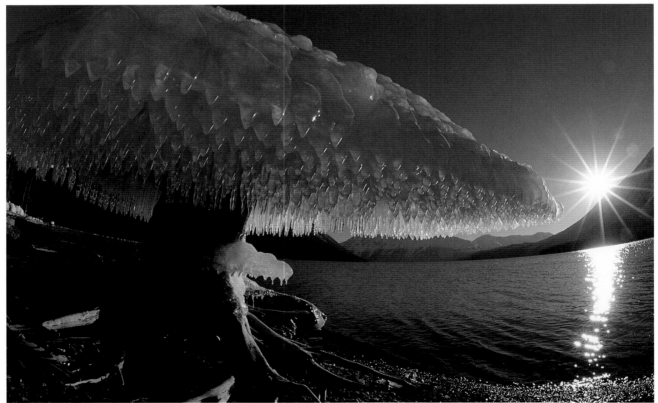

Cooper Lake, Kenai Mountains.

On the banks of Kenai Lake, a three-foot-thick, nine-foot-long ice formation is evidence of a sub-zero flood. The rupture of a pothole dam underneath a glacier in midwinter released millions of gallons of water at temperatures of thirty degrees below zero and lower. As the floodwater recedes from this twenty-six-mile-long lake, the temperature rises to forty degrees above zero. This pothole dam breaks approximately every few years, but hardly ever at sub-zero temperatures.

The largest documented bull moose in the world. This mighty Lord of the Forest weighs more than twenty-two hundred pounds and stands about twelve feet tall—including his antlers.

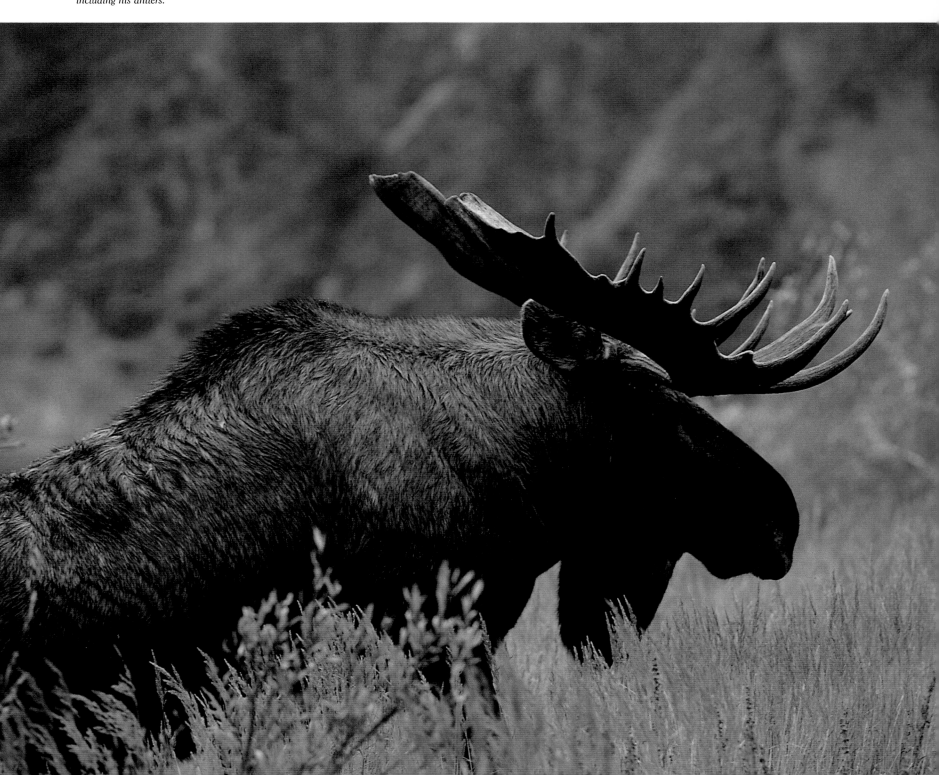

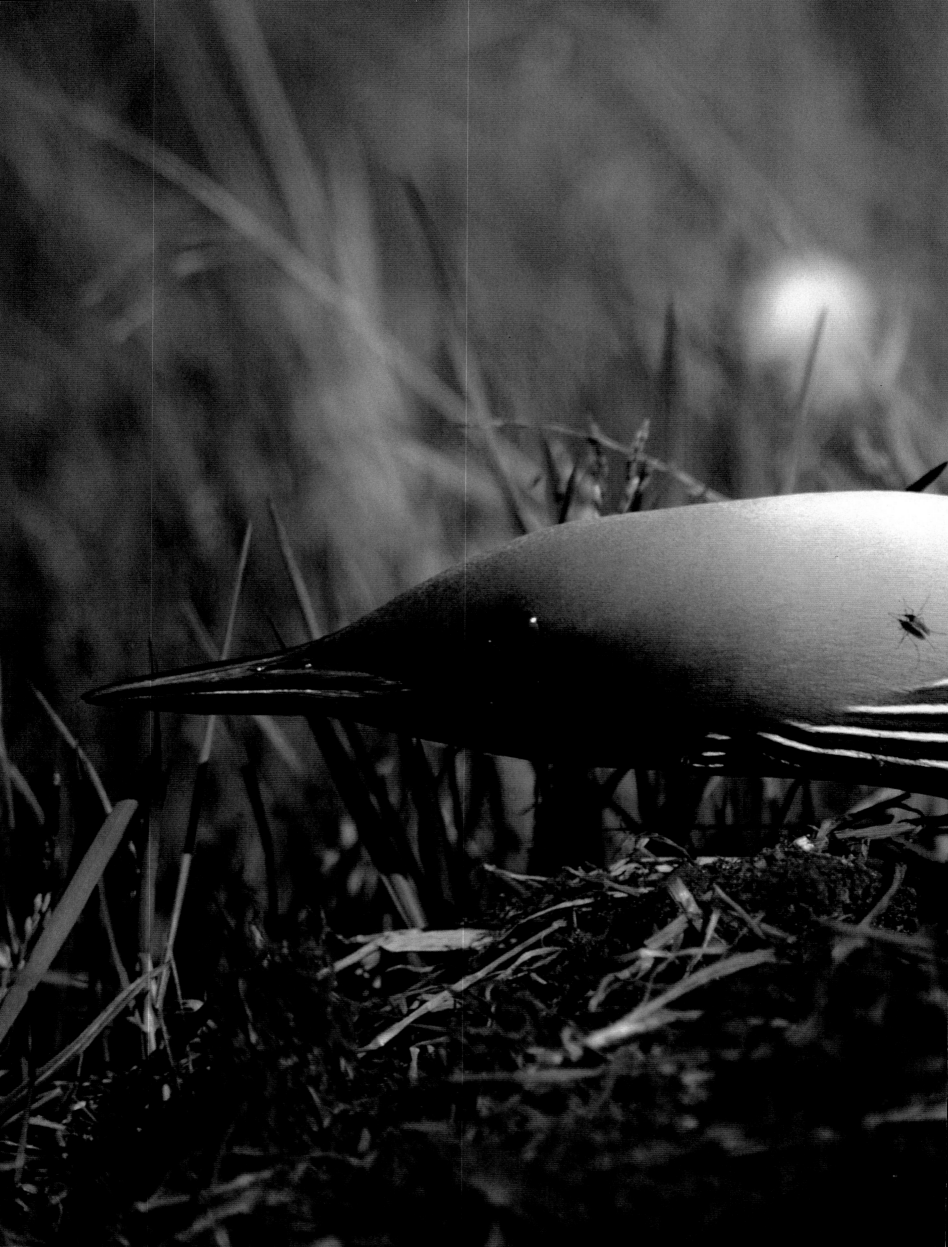

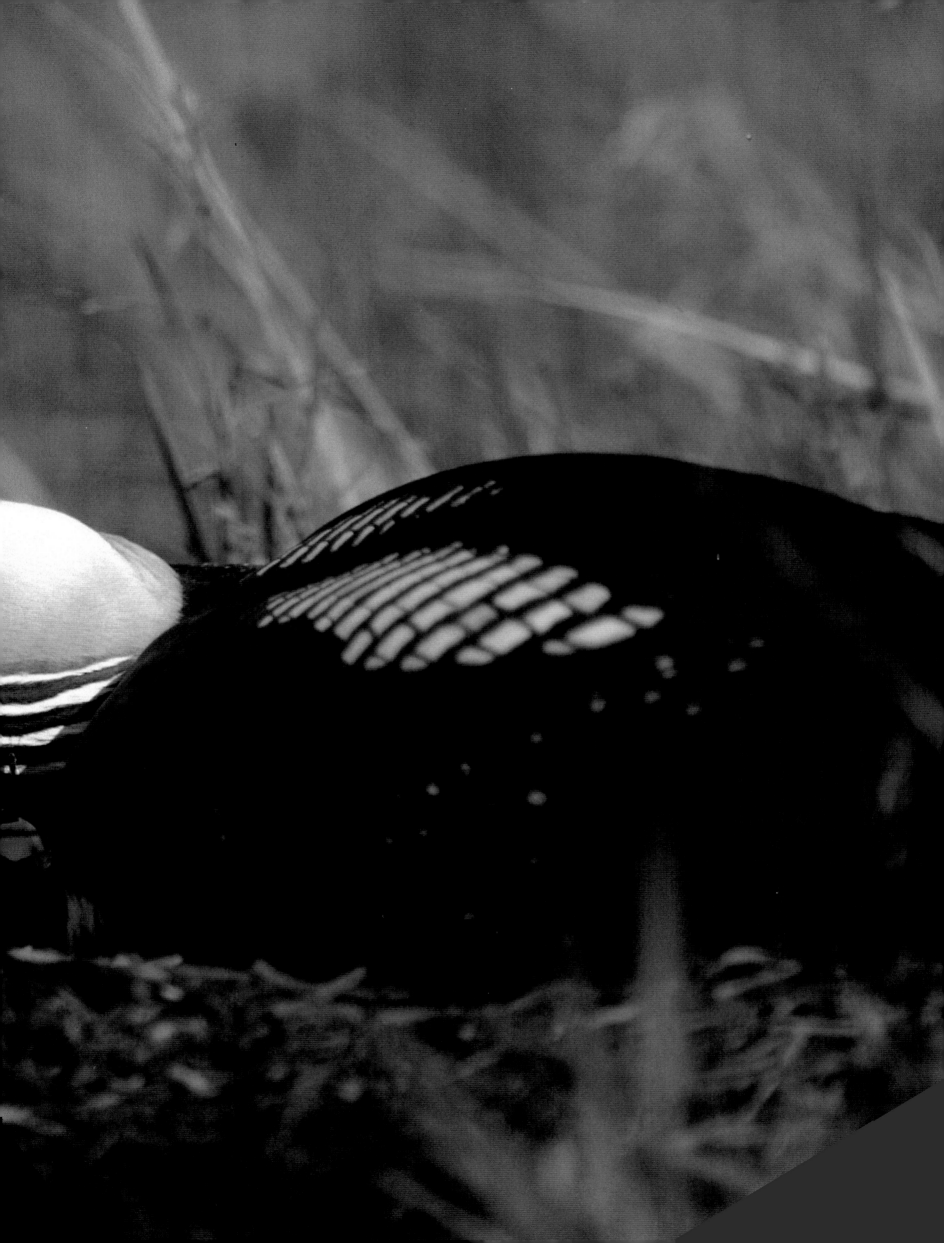

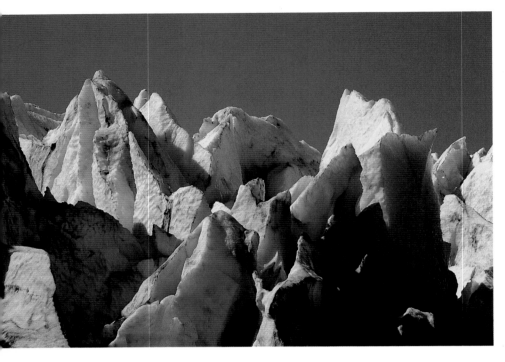

PRECEDING PAGES

An Arctic loon sits gently on her eggs to protect them from the cold ocean winds in June. Prudhoe Bay, Arctic Ocean.

ABOVE

Jagged ice crags on the Columbia Glacier before they break off—calve—into Prince William Sound.

RIGHT

A raven carrying a squirrel flies near Igloo Mountain in Sable Pass, Denali Park and Preserve.

OPPOSITE PAGE

King Mountain with the Matanuska River in the foreground. Chugach Mountains.

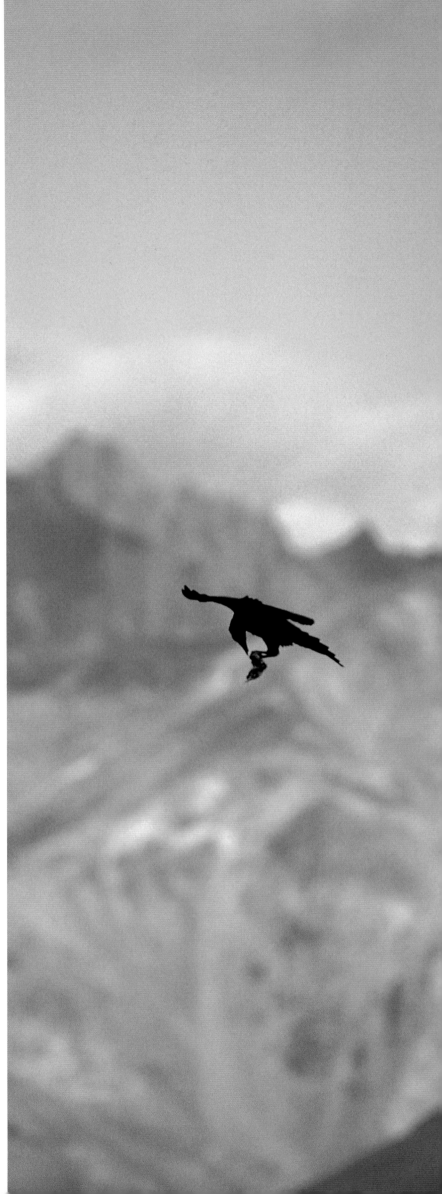

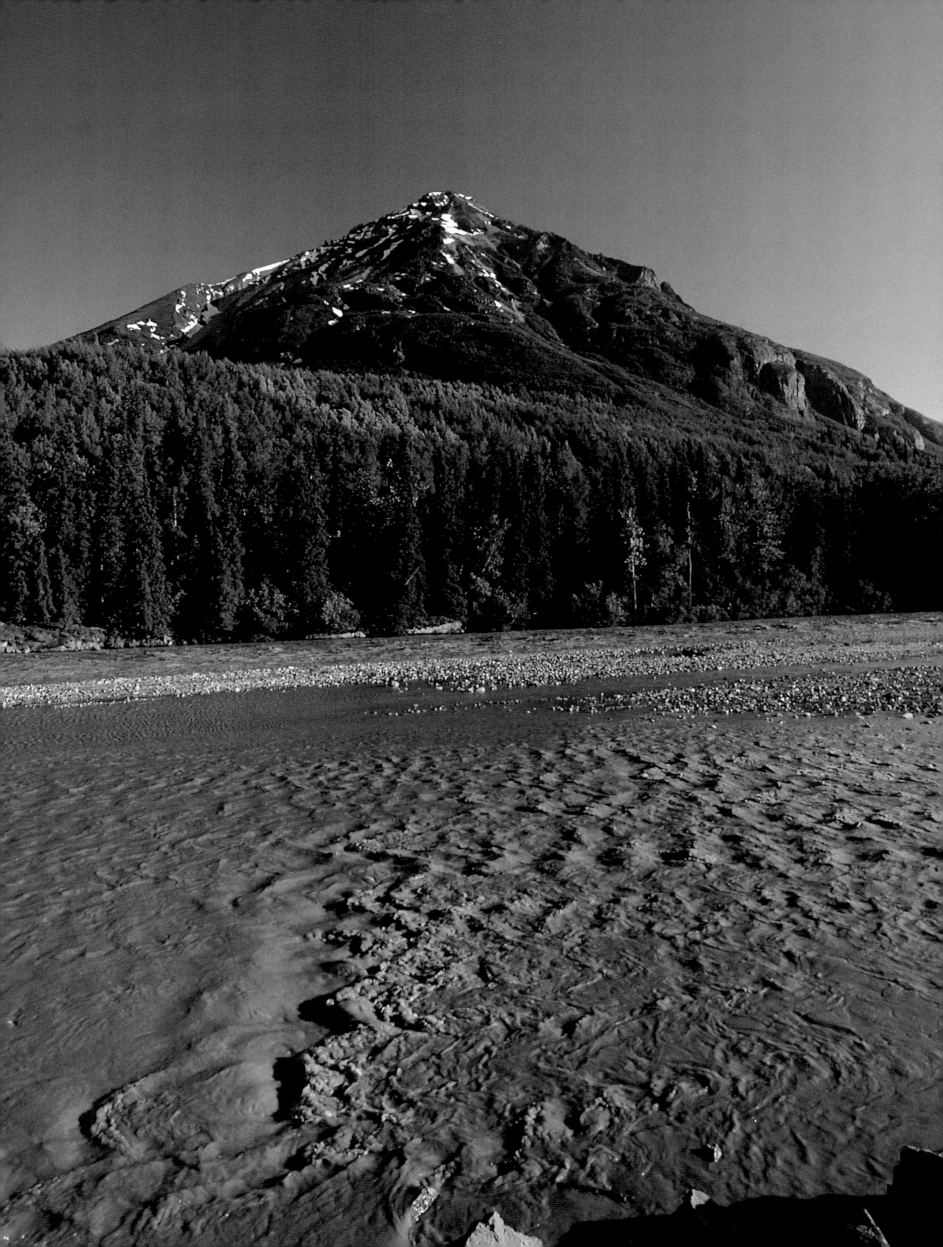

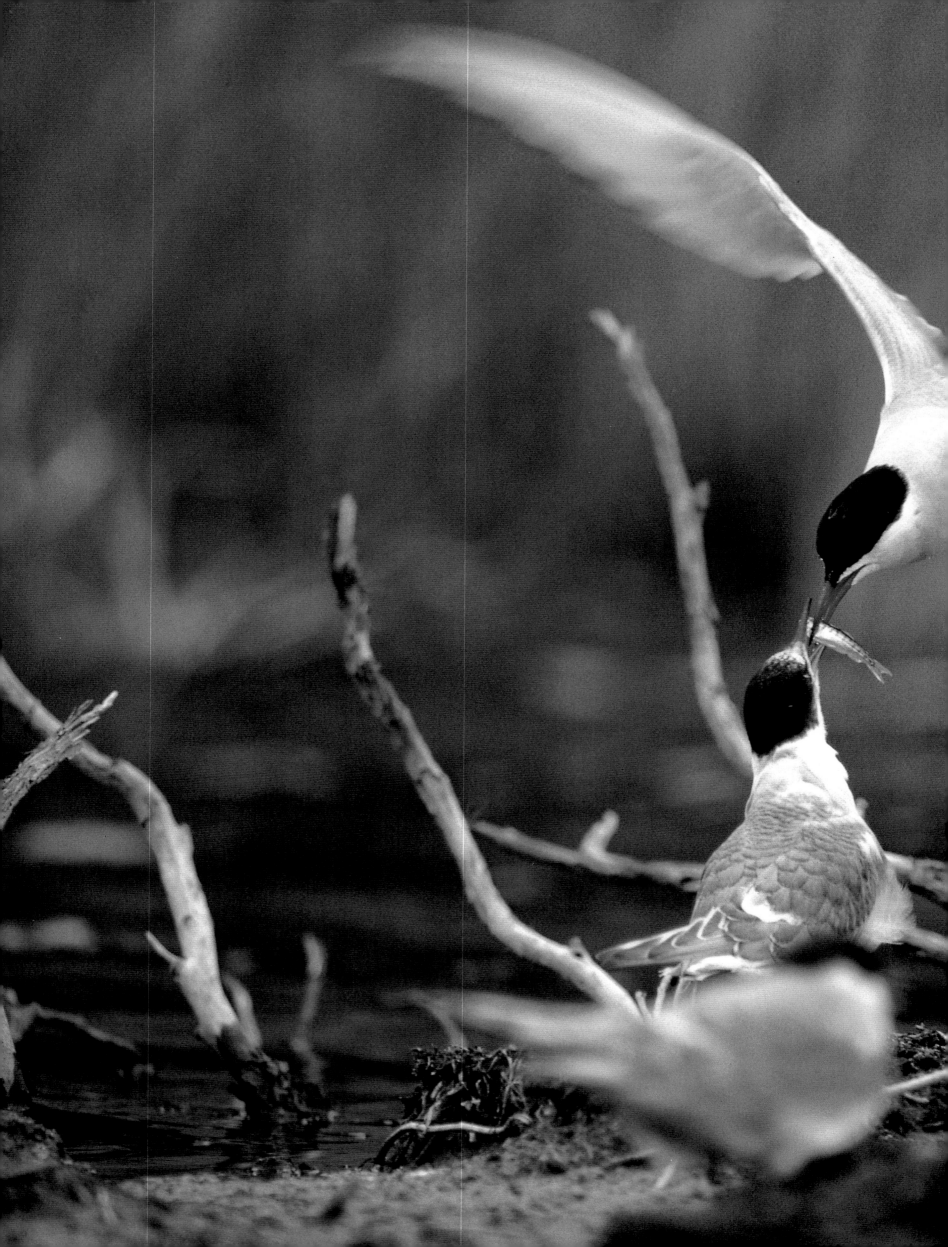

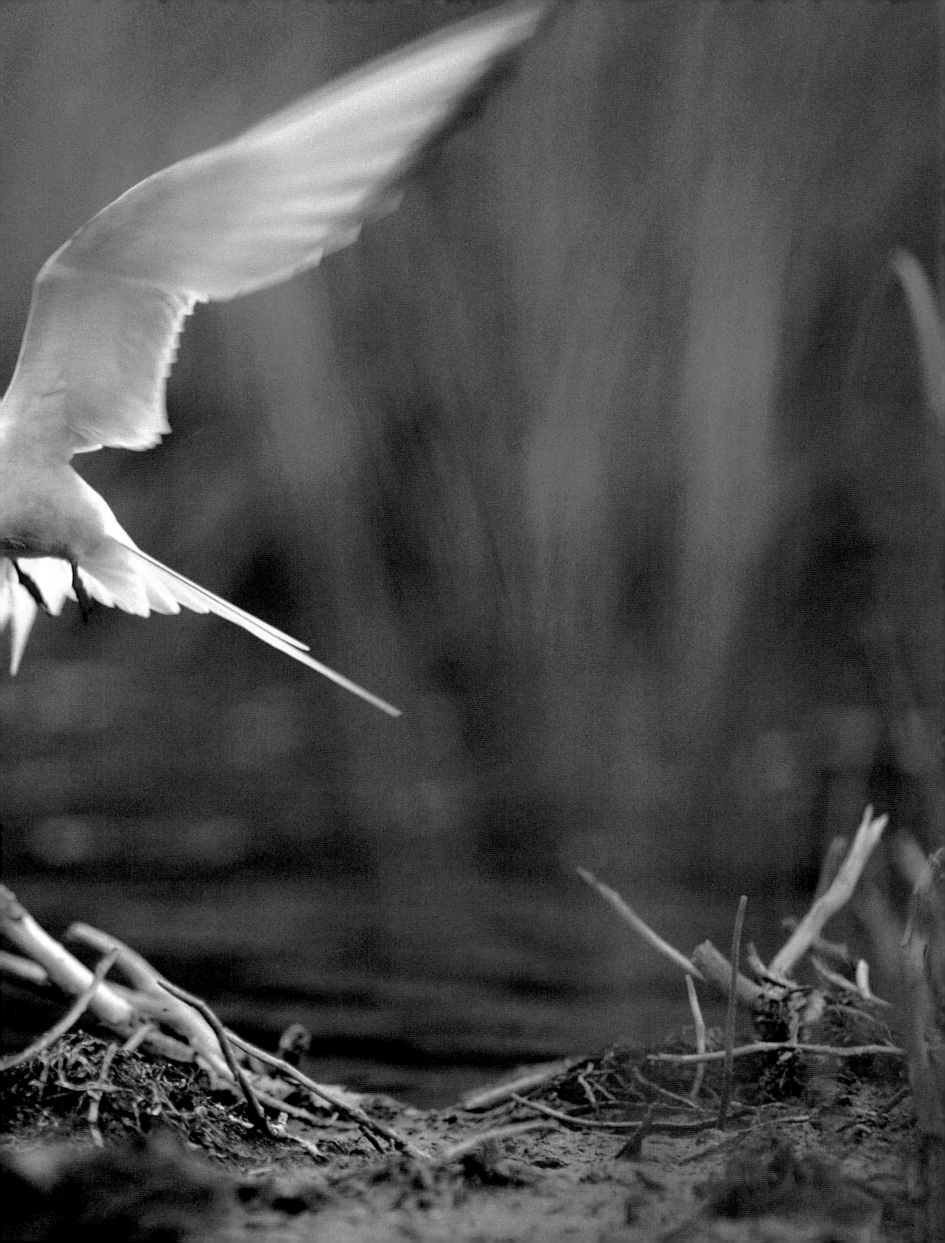

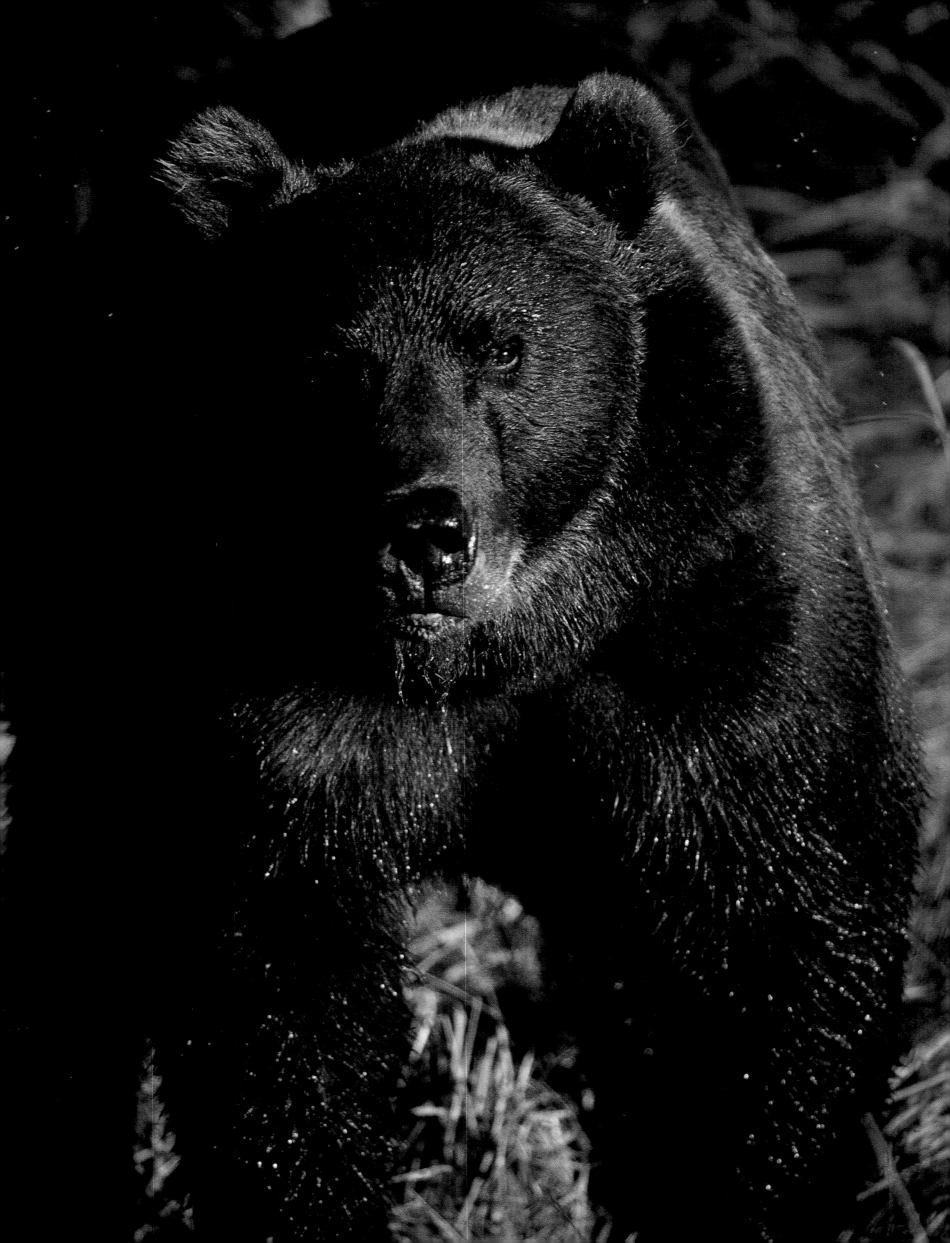

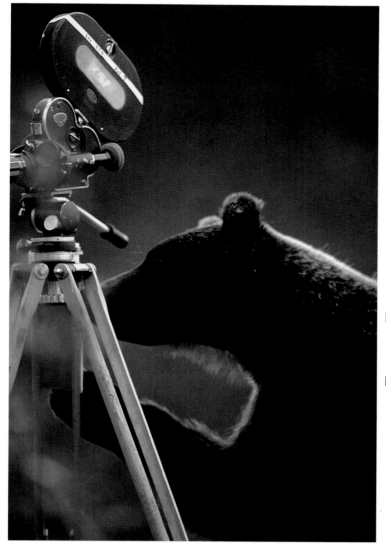

PRECEDING PAGES

An adult Arctic tern feeds his young a salmon fry while hovering in midair. Arctic terns range throughout Alaska's inland coastal waters and migrate to Antarctica, a distance of twenty-five thousand miles— the longest migration route of any bird in the world.

OPPOSITE PAGE

A giant brown bear emerges from a creek after gorging on salmon at the head of Uyak Bay in Kodiak's National Brown Bear Preserve. Kodiak brown bears are the largest omnivores in the world and can weigh in excess of twelve hundred pounds and stand over ten feet tall.

LEFT

This bear came a little too close for comfort.

BELOW

Volcano clouds.

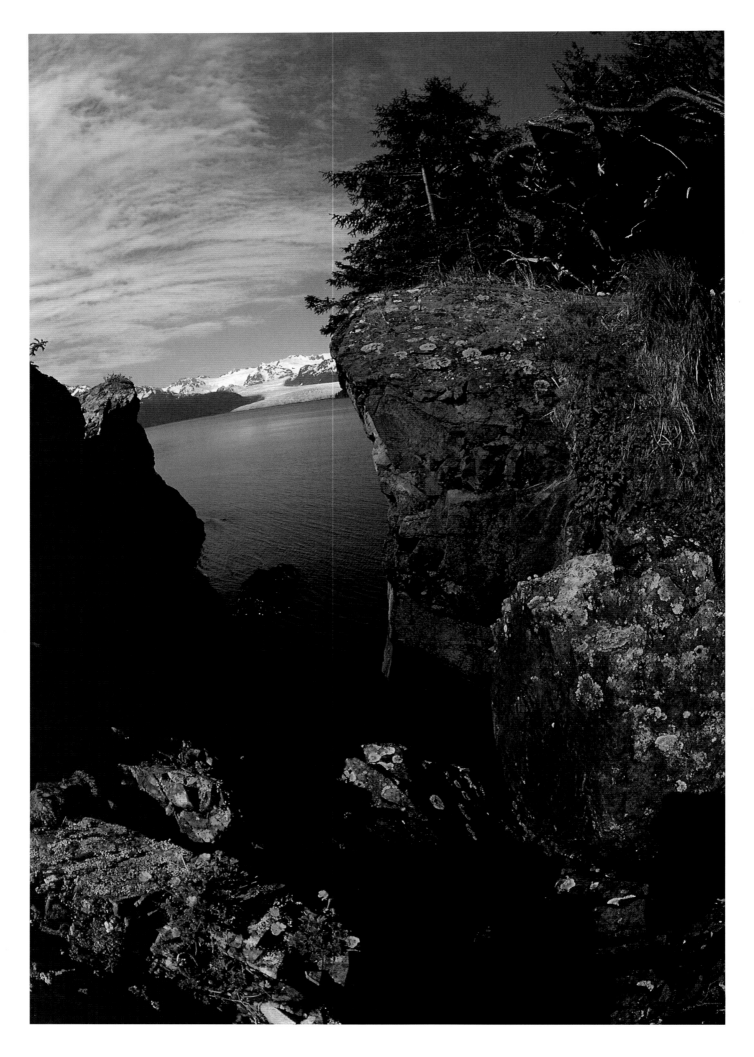

ALASKA

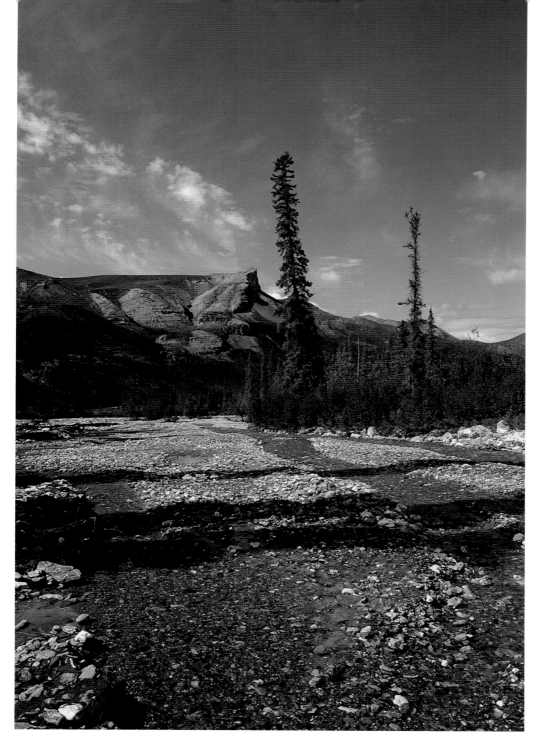

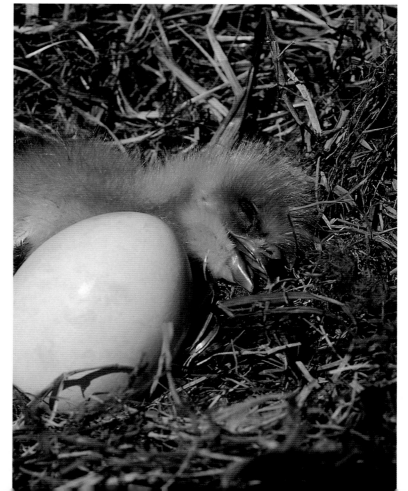

GRI

THE ROLLING TUNDRA BEAR,
LIKE MOST BEARS, TH MADE
OF SUCCULENT PLANT ROUND
SQUIRRELS, OR RARE BLIND
AND NAKED IN SNUG OW FOR
THREE YEARS. WH N OFF HER
CAPABLE OFFSPRING UNDS AND
CAN RUN FASTER O FEED THEM.
REMEMBER, YOU RESPECTS ONLY
THE LAW OF TH

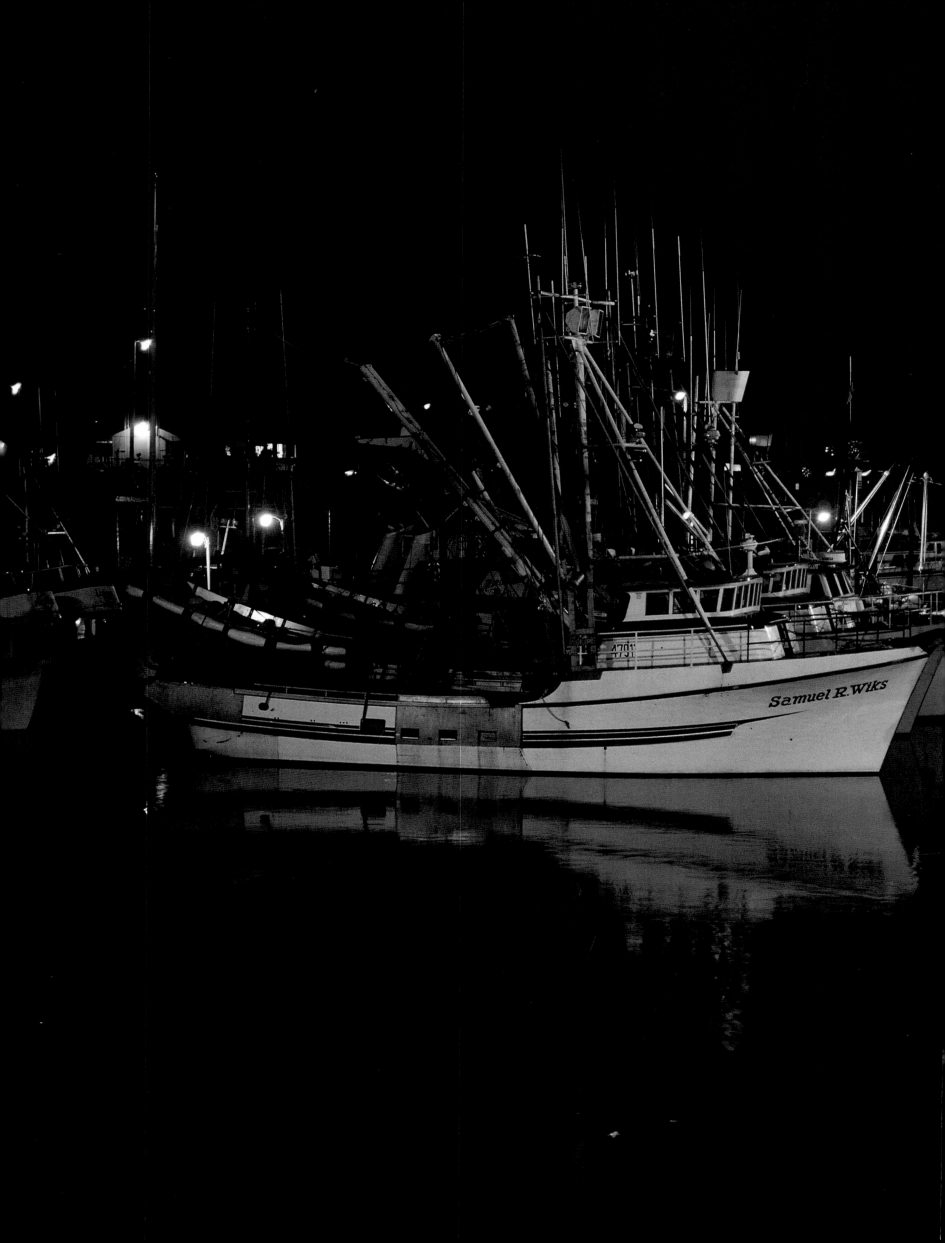

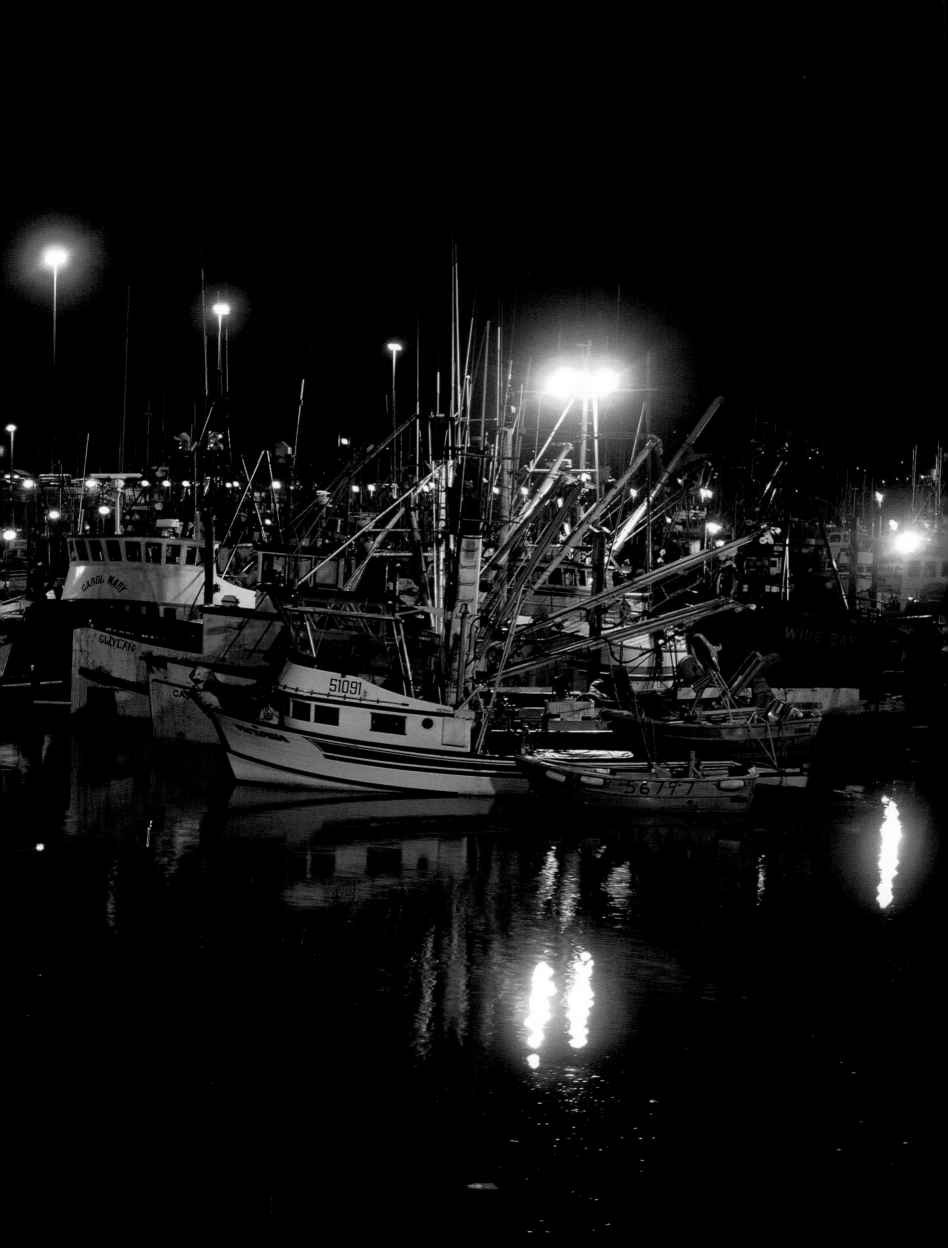

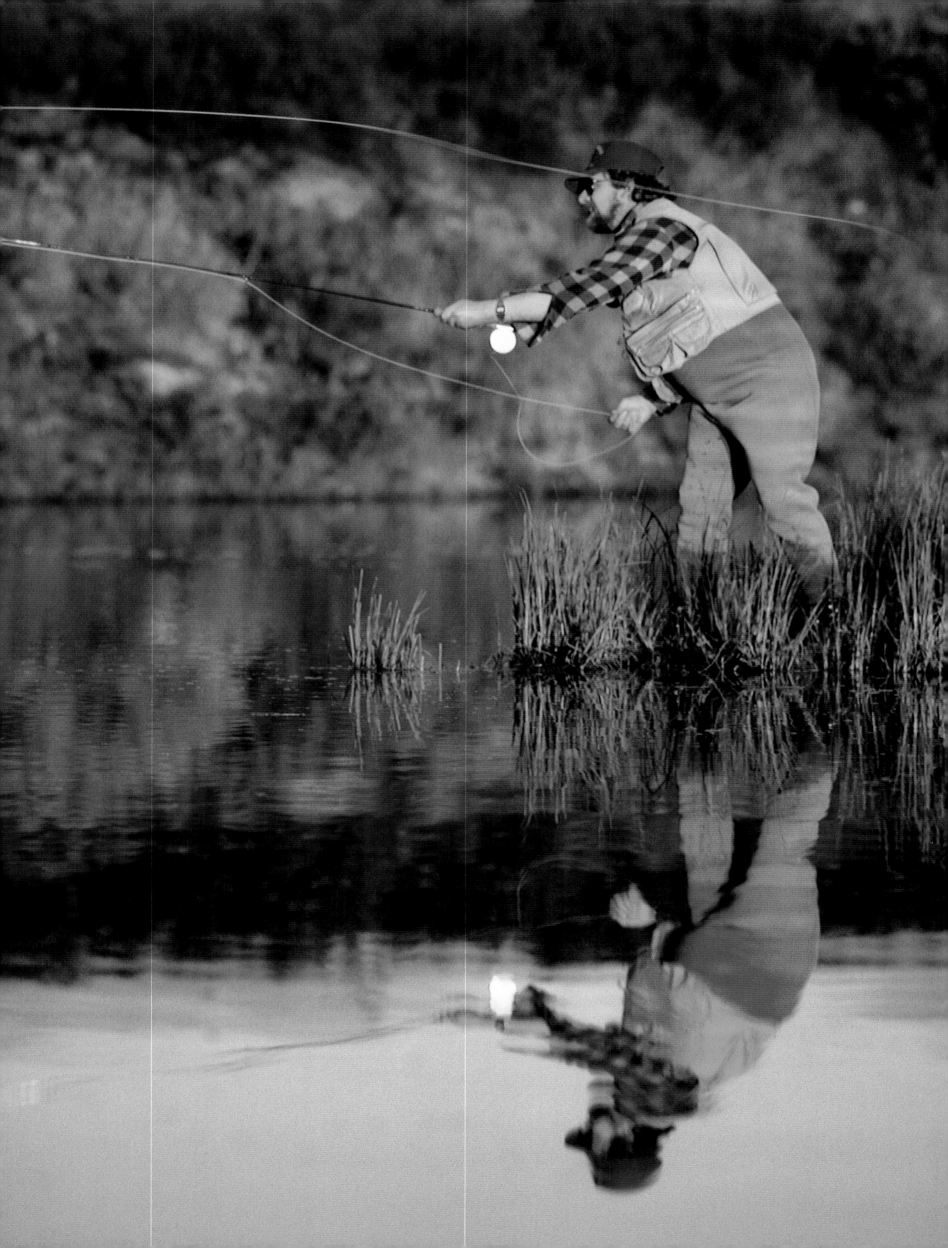

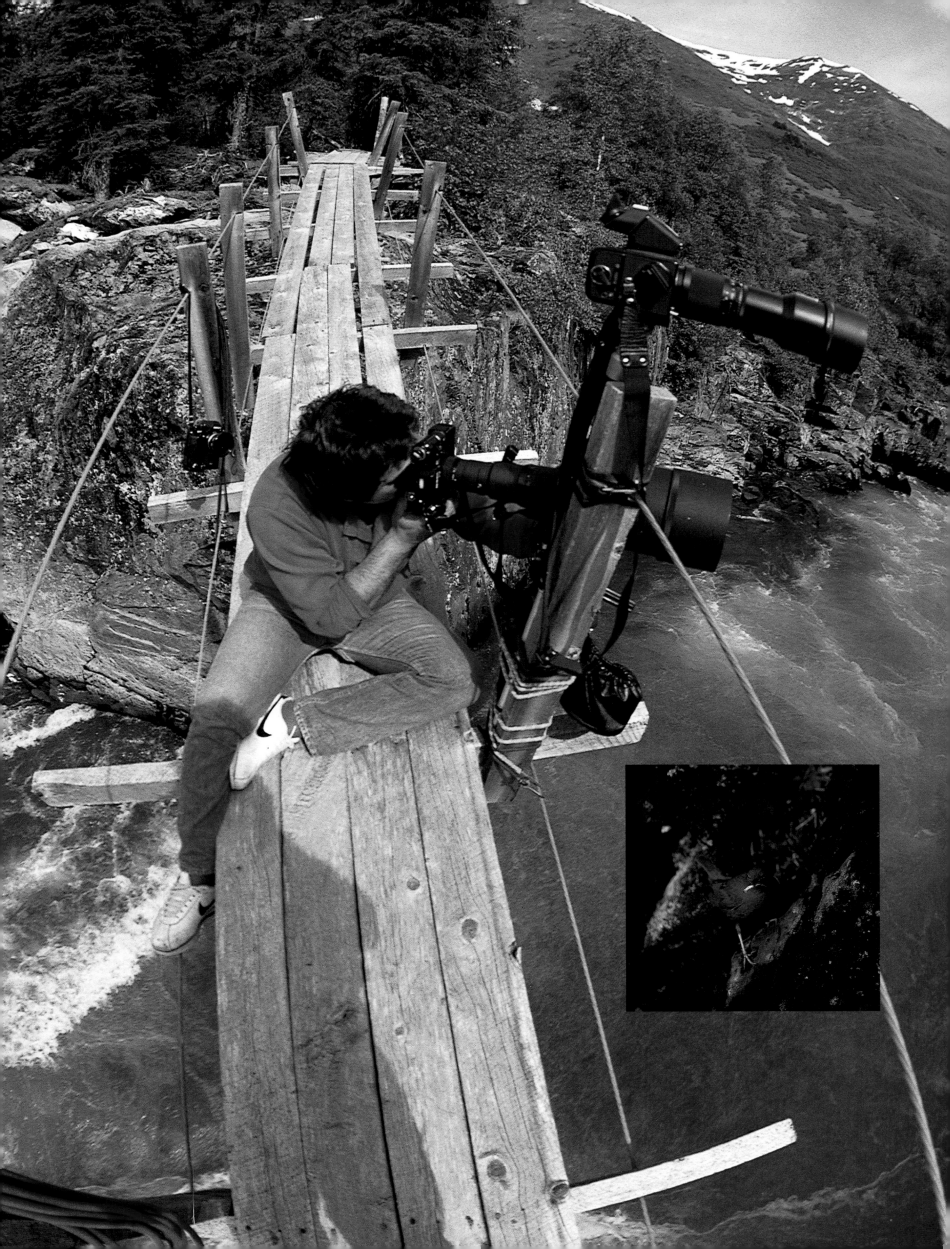

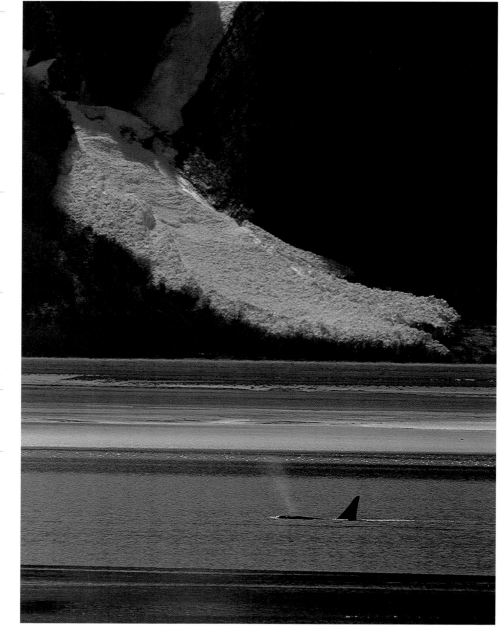

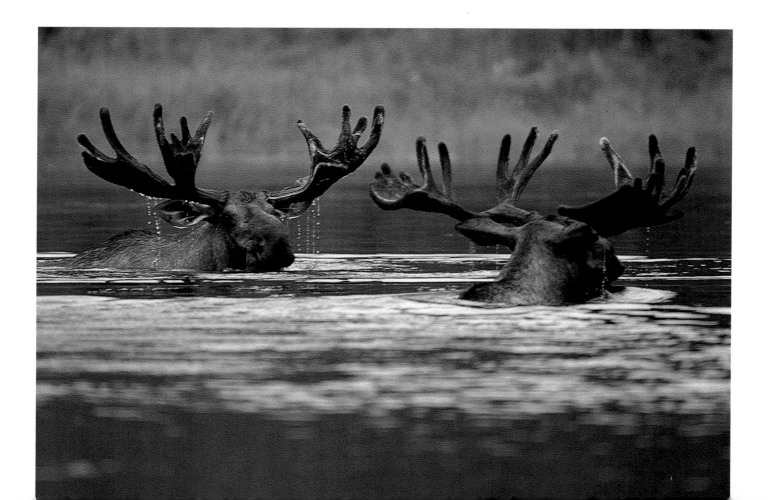

A Photographic Journey Through the Last Wilderness

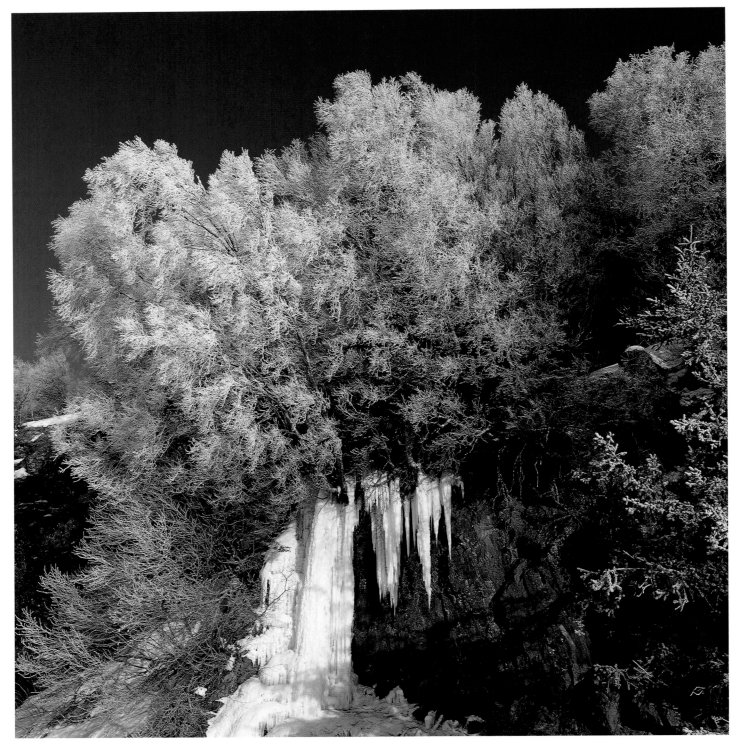

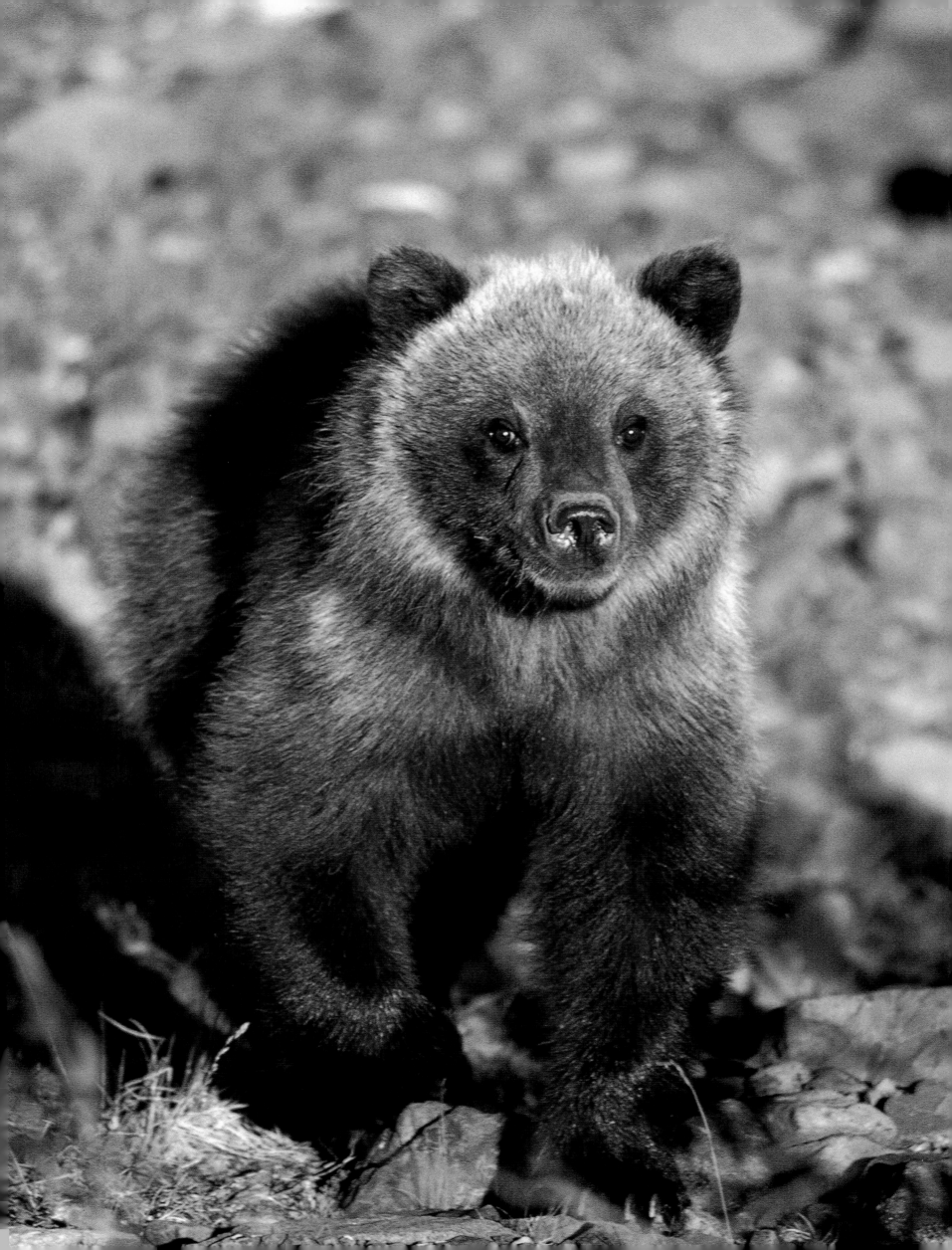

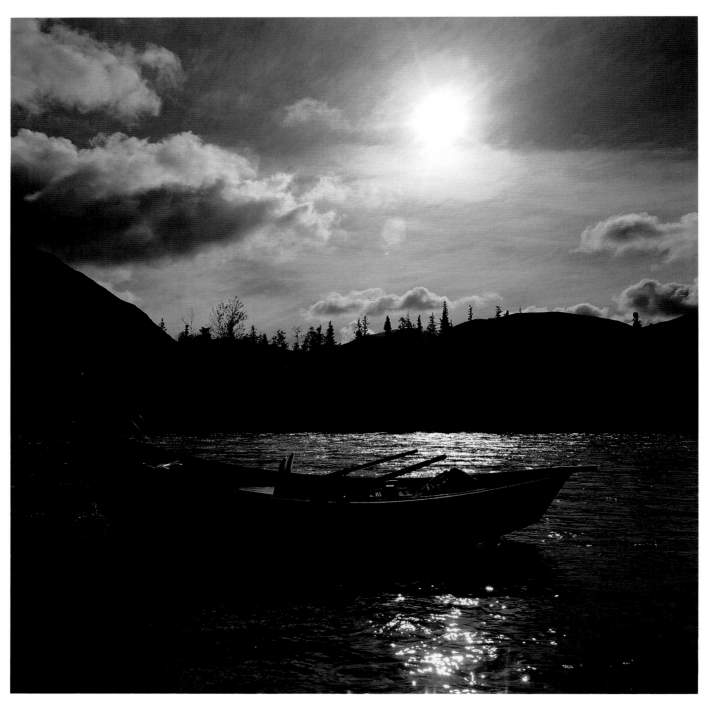

The sun, at four o'clock on a summer morning, silhouettes a fishing dory at the junction of the renowned Russian and Kenai Rivers. This is one of the best locations in the world to fish for giant rainbow trout.

Fall colors.

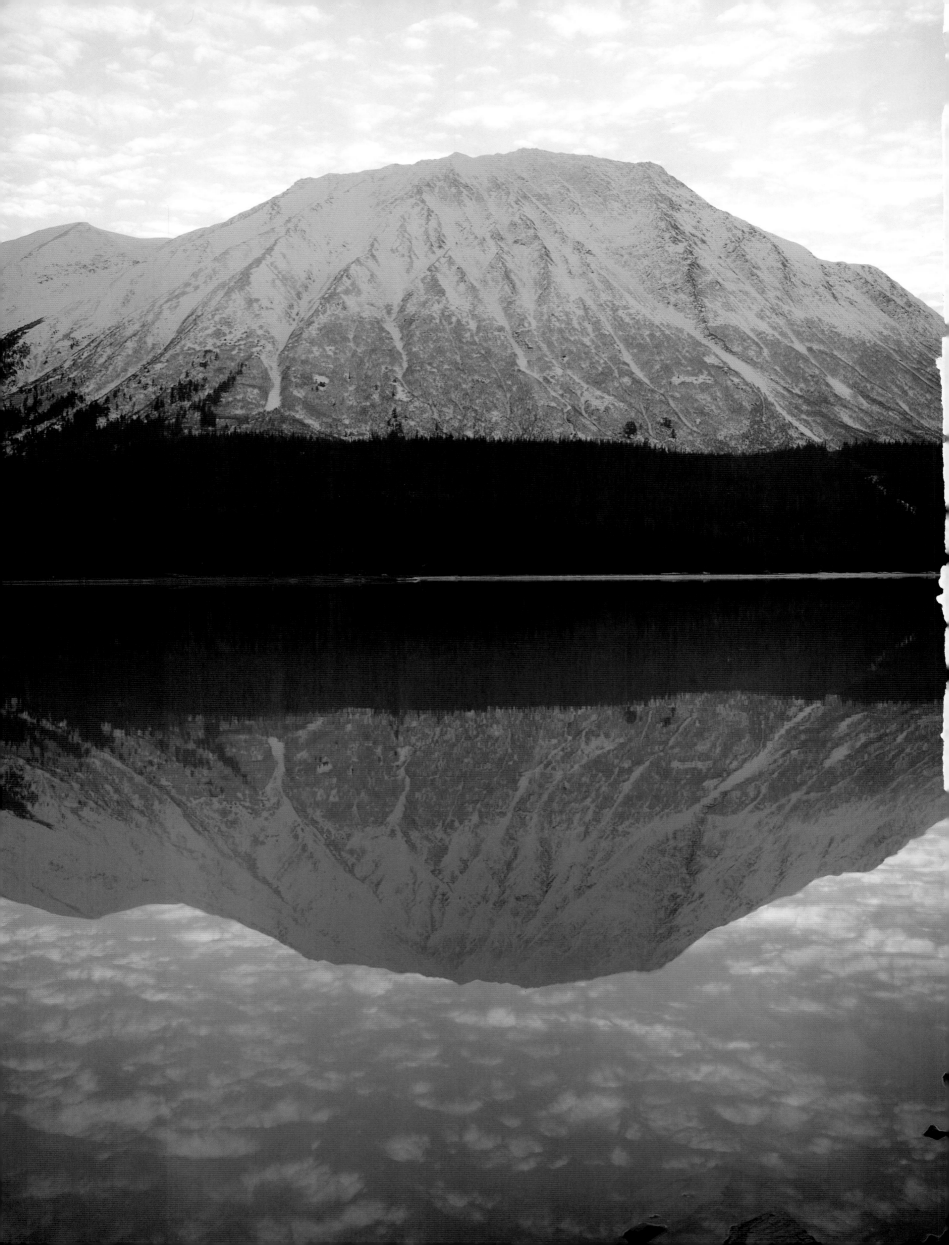

OPPOSITE PAGE
Cecil Rhode Mountain, Kenai Peninsula.

ABOVE
Homer Spit on Kachemak Bay in the eye of a storm.

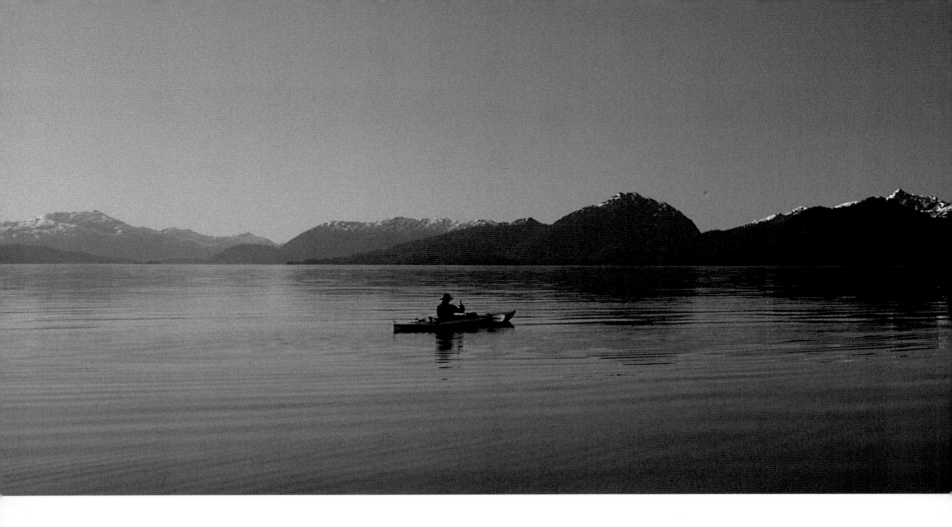

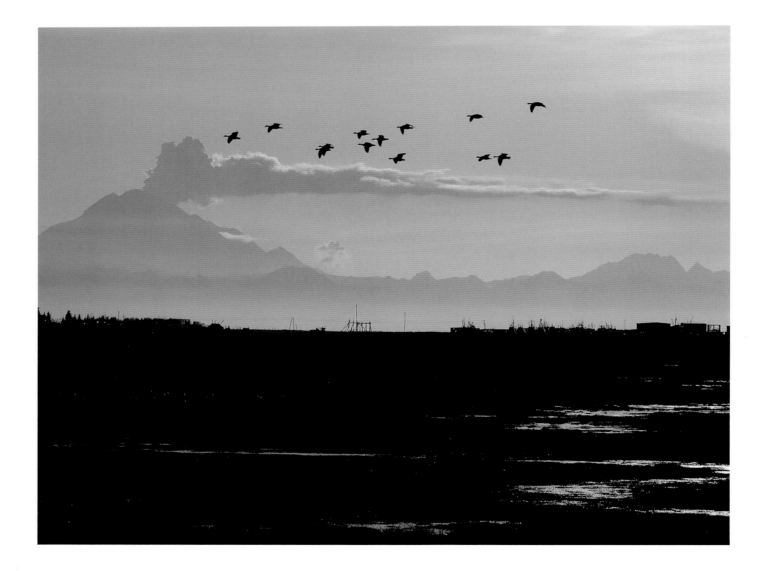

ALASKA

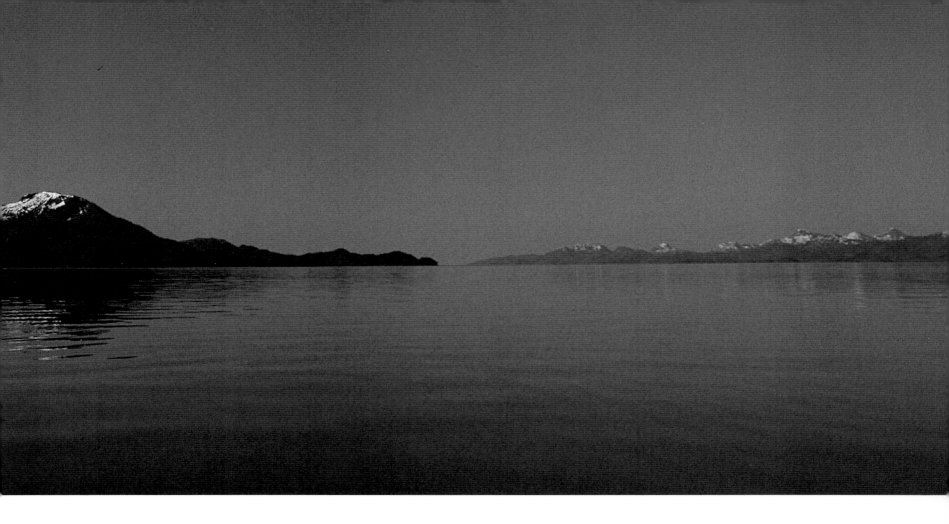

OPPOSITE PAGE BELOW
A smoking volcano begins to abate
alongside Cook Inlet in the Aleutian Range.

ABOVE
Kayaking the peaceful solitude of Prince
William Sound.

RIGHT
Kukak Bay.

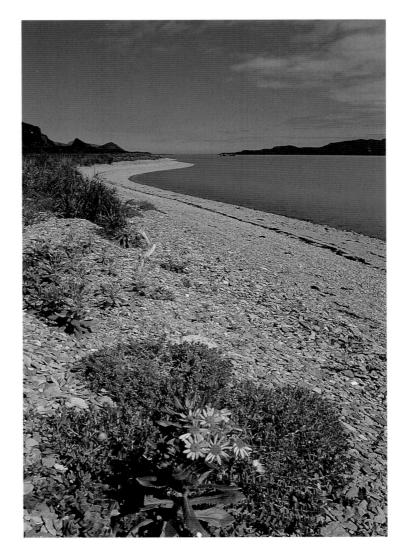

A Photographic Journey Through the Last Wilderness 211

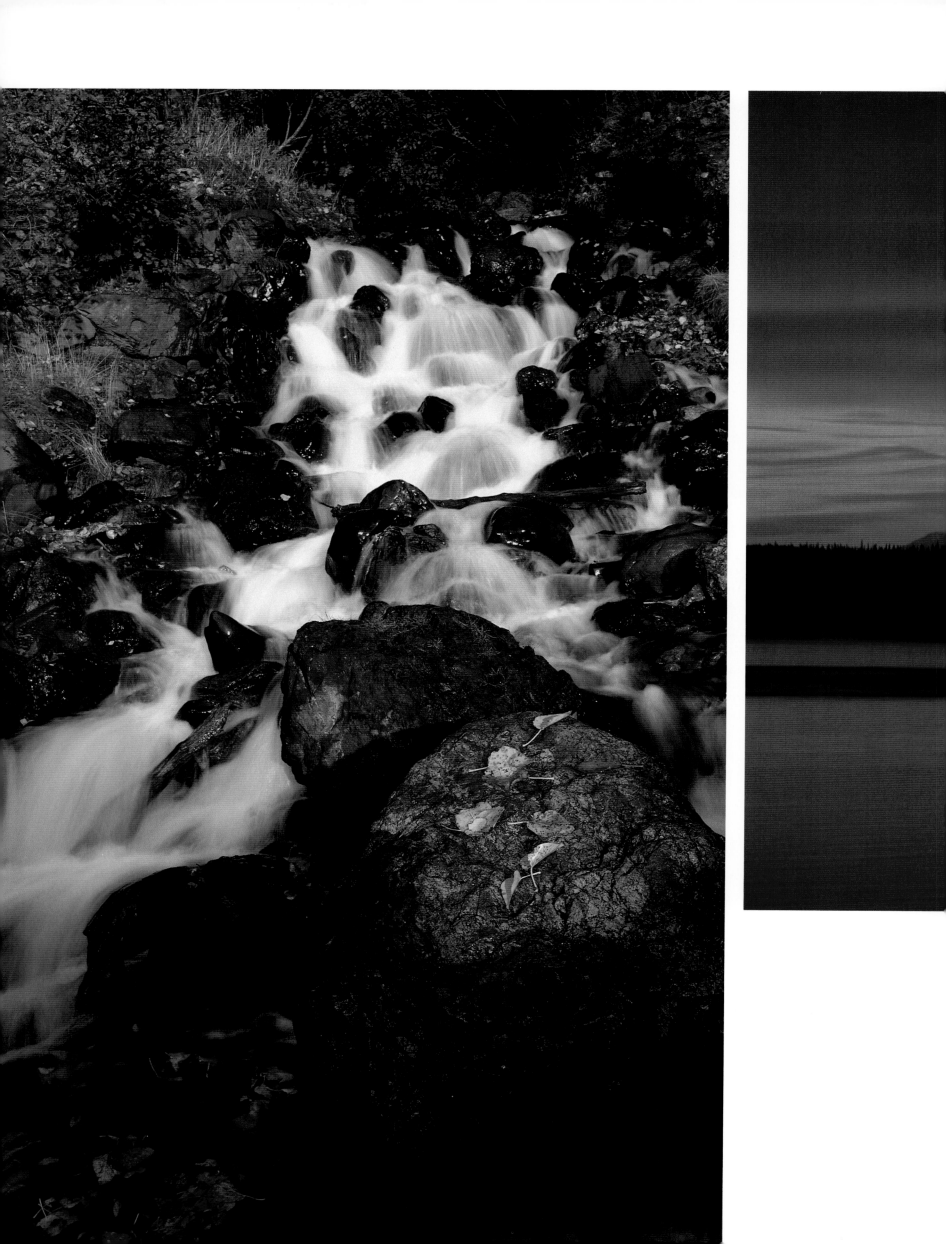

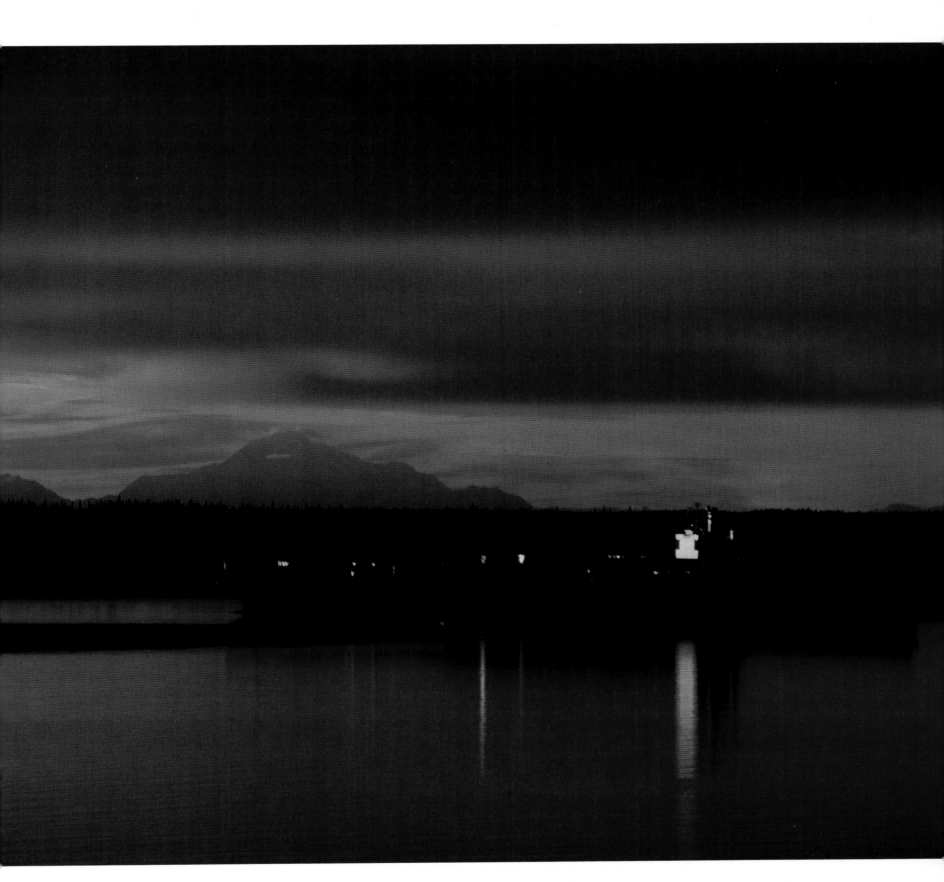

| OPPOSITE PAGE

A no-name creek in the Chugach
National Forest.

| ABOVE

An oil tanker leaving Anchorage, near
McKenzie Point. Mount McKinley stands
in the distance some hundred miles away.

A Photographic Journey Through the Last Wilderness 213

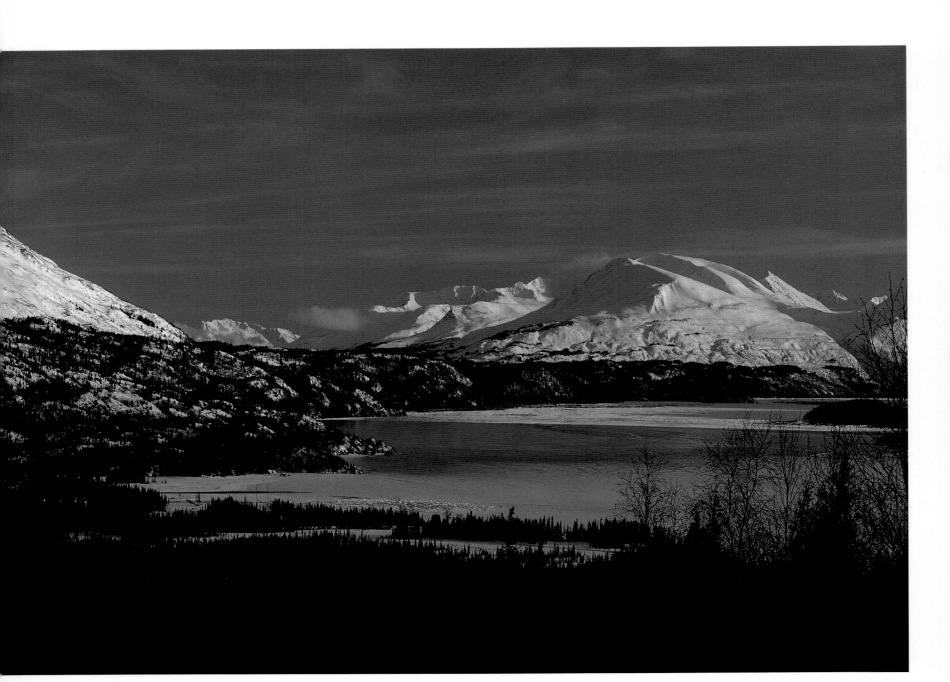

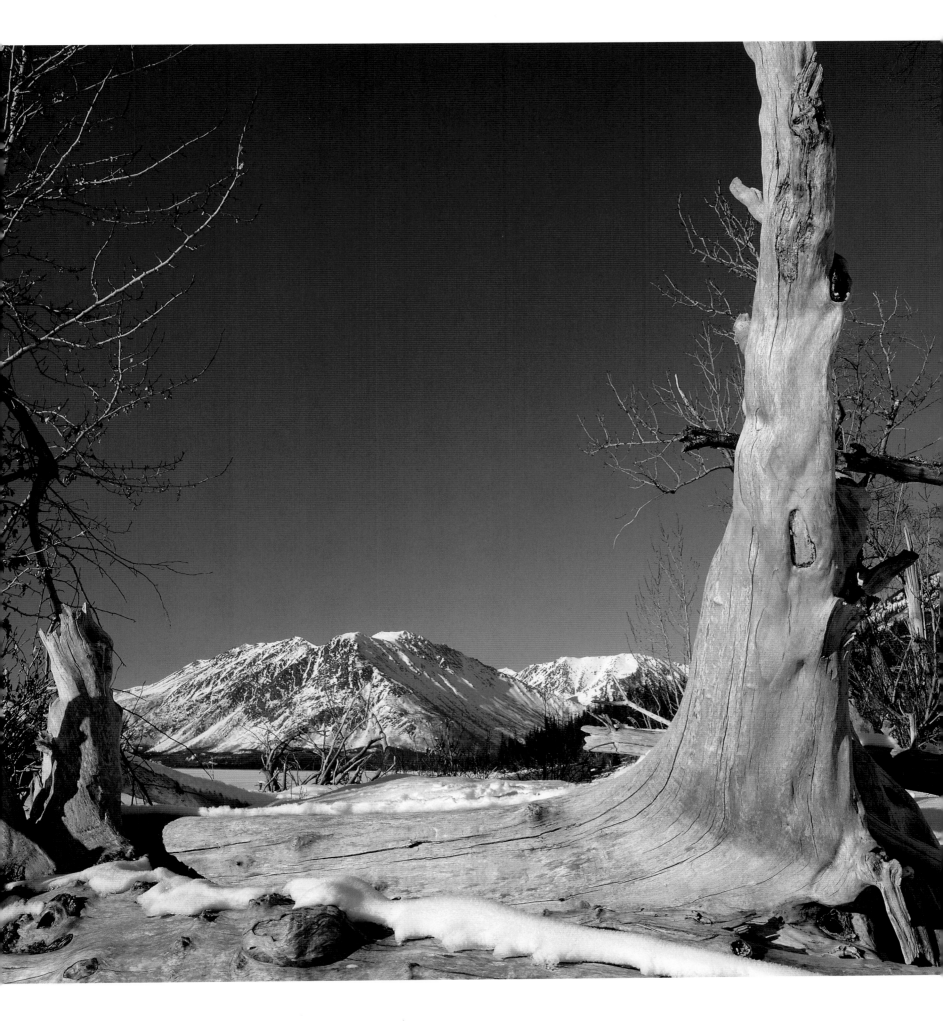

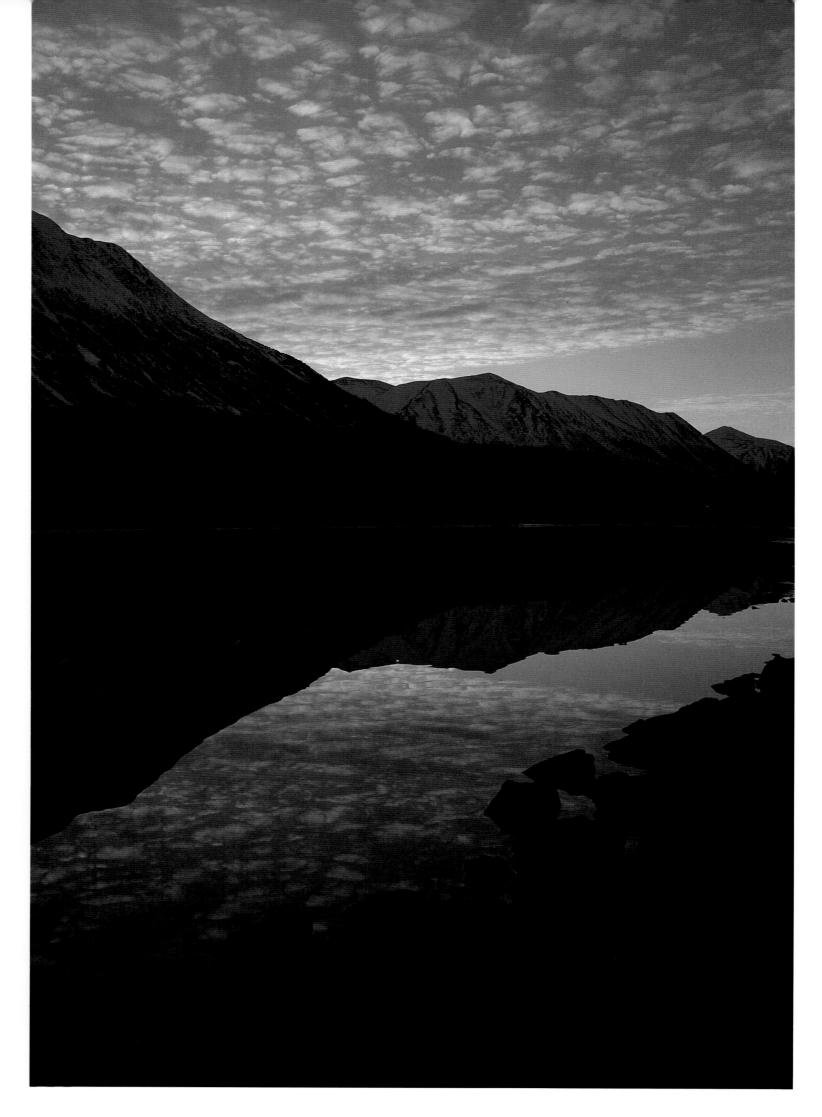

ALASKA

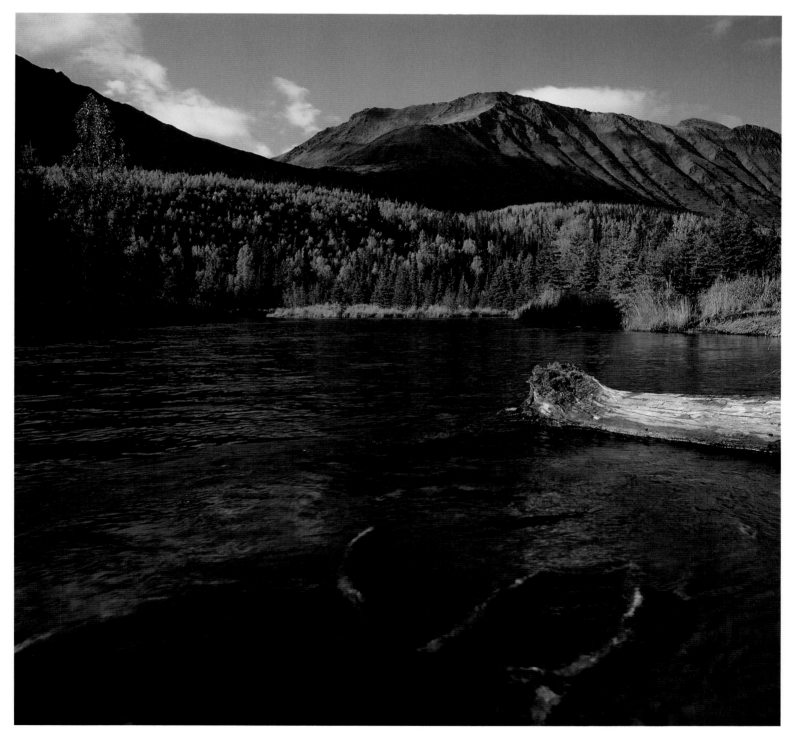

A Photographic Journey Through the Last Wilderness

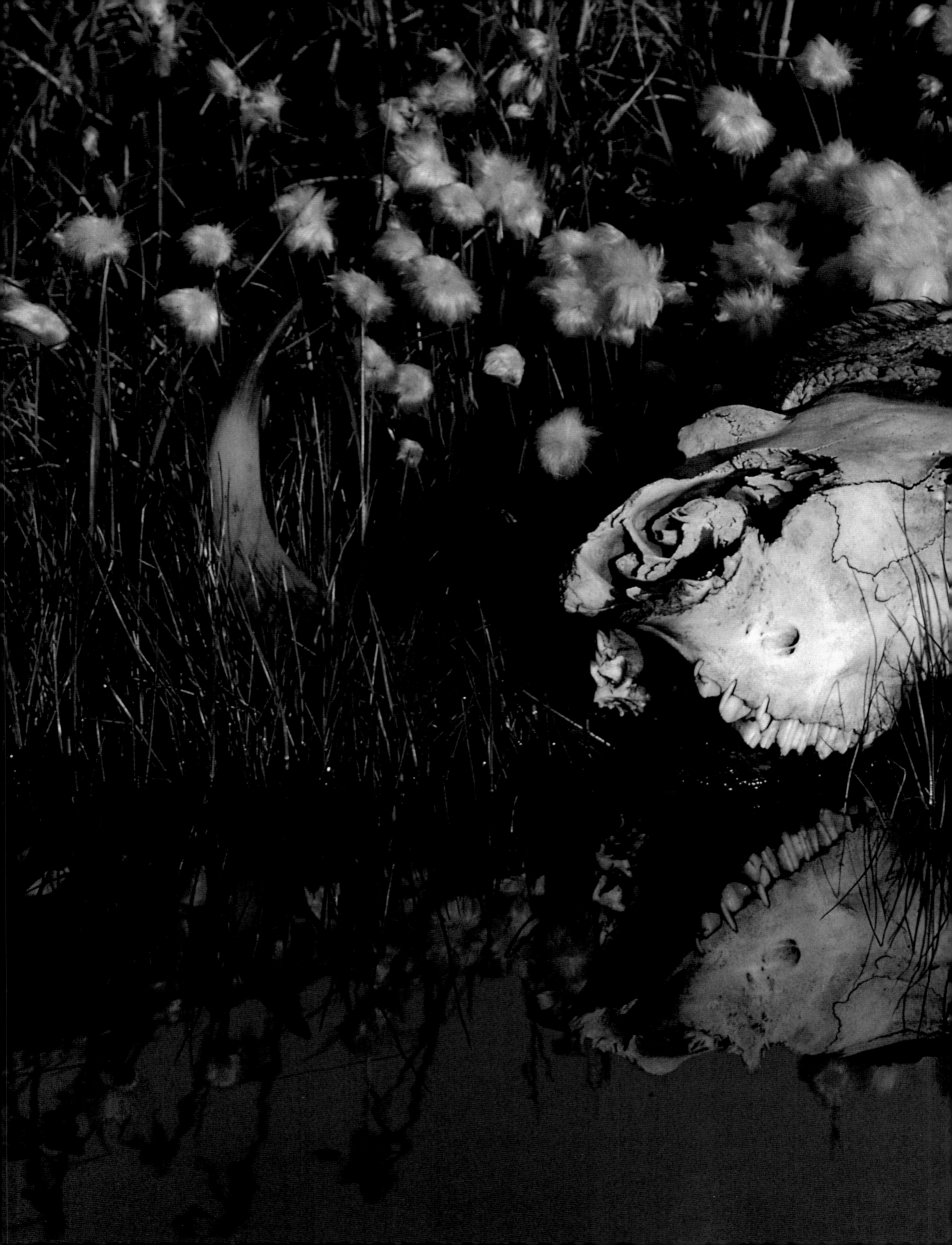

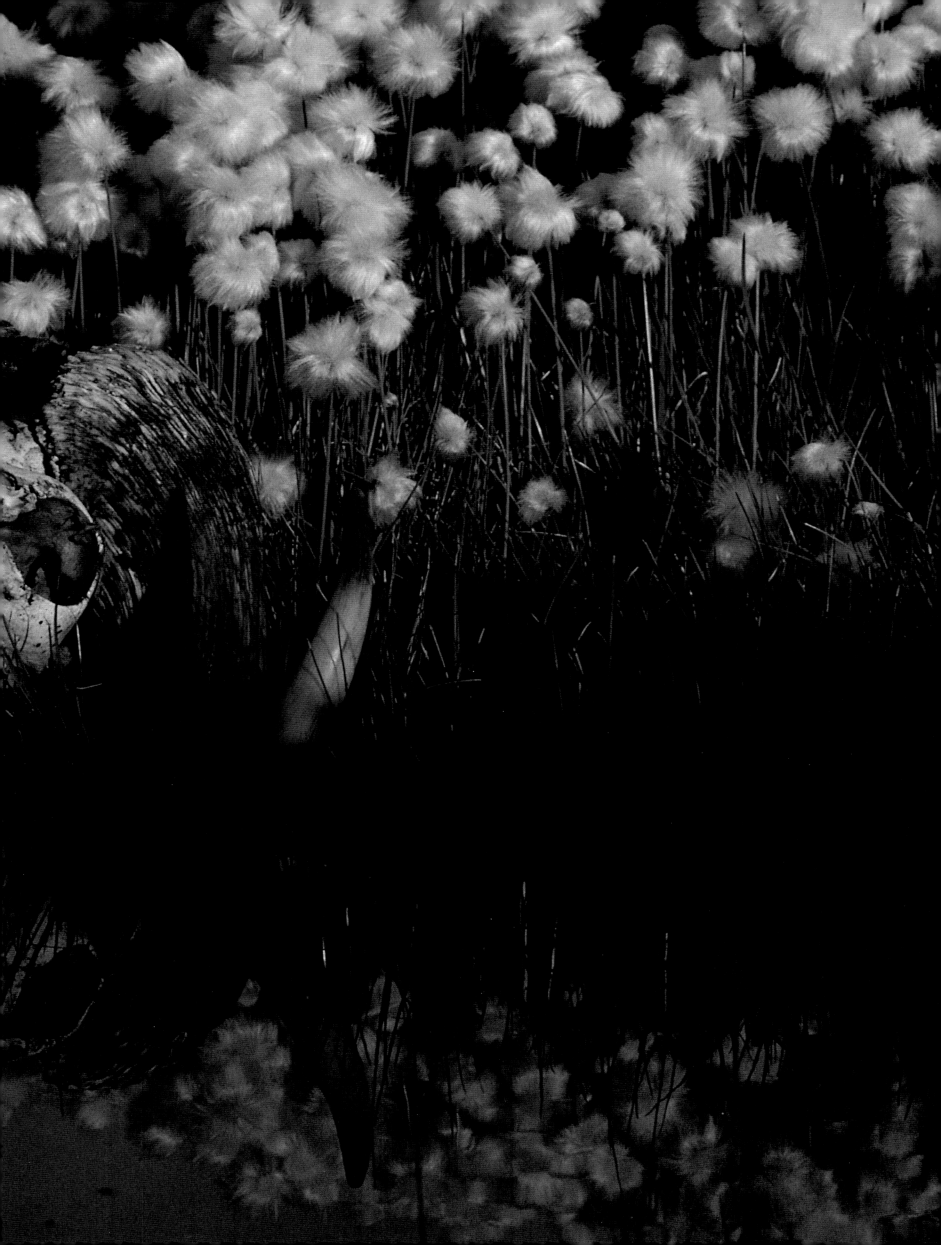